V&R

IMAGO AEGYPTI

Internationales Magazin für ägyptologische und koptologische
Kunstforschung, Bildtheorie und Kulturwissenschaft

Band 1 / 2005

Herausgeber:	Alexandra Verbovsek (München)
	Günter Burkard (München)
	Friedrich Junge (Göttingen)

| Mitherausgeber: | Deutsches Archäologisches Institut, Abteilung Kairo |

Advisory Board:	John Baines, Oxford
	Karl-Heinz Brune, Münster
	Vivian Davies, London
	Rita Freed, Boston
	Suzana Hodak, Münster
	Dieter Kessler, München
	David O'Connor, New York
	Daniel Polz, Kairo
	Ali Radwan, Kairo
	Regine Schulz, Baltimore
	Roland Tefnin, Brüssel

Redaktionelle Mitarbeit:	Véronique Bertaux (München)
	Nicolas Flessa (München)
	Mélanie-Catherine Floßmann (München)
	Catherine Jones (München)
	Barbara Magen (Hildesheim/München)

Adressen der beteiligten Institute:

Institut für Ägyptologie
Meiserstraße 10
D-80333 München
Deutschland
Tel.: 089-28927542
Fax: 089-28927545

Seminar für Ägyptologie und Koptologie
Weender Landstraße 2
D-37073 Göttingen
Deutschland
Tel.: 0551-394400
Fax: 0551-399332

Deutsches Archäologisches Institut, Abt. Kairo
31. Abu el-Feda
ET-11211 Kairo-Zamalek
Ägypten
Tel: +20-2-7351460
Fax: +20-2-7370770

IMAGO AEGYPTI

Internationales Magazin für ägyptologische
und koptologische Kunstforschung, Bildtheorie
und Kulturwissenschaft

herausgegeben von
Alexandra Verbovsek, Günter Burkard und Friedrich Junge

in Zusammenarbeit mit dem
Deutschen Archäologischen Institut, Abteilung Kairo

Mit 10 Abbildungen und 29 Tafeln

Vandenhoeck & Ruprecht

Gedruckt mit Unterstützung
des Deutschen Achäologischen Instituts, Abteilung Kairo.

Bibliografische Informationen der Deutschen Bibliothek

Die Deutsche Bibliothek verzeichnet diese Publikation
in der Deutschen Nationalbibliografie;
detaillierte bibliografische Daten sind im Internet
über ‹http://dnb.ddb.de› abrufbar.

ISBN 10: 3-525-47009-6
ISBN 13: 978-3-525-47009-1
ISSN 1862104X

Umschlagabbildung: *Standfigur des Gottes Amun*, 19./20. Dynastie (um 1200 v. Chr.),
Holz, bemalt und vergoldet, Bronze, H. 48 cm, wohl aus Theben-West,
Roemer- und Pelizaeus-Museum, Hildesheim

Schrift: Times
Satz: SchwabScantechnik, Göttingen
Druck und Bindung: ⊕ Hubert & Co, Göttingen

Gedruckt auf alterungsbeständigem Papier.

Inhalt

Vorwort

Das Selbstverständnis von Kulturen, vor allem der antiken Kulturen, wird auf kaum einer anderen Ebene so deutlich zum Ausdruck gebracht wie in ihrer bildlichen Hinterlassenschaft. Neben der Sprache gehören Bilder daher zu den bedeutendsten Ausdrucksformen von Gesellschaften.

Durch die mediale Funktion, die Bilder in sozialen und damit kommunikativen Prozessen einnehmen, rückten sie in den letzten zwei Jahrzehnten zunehmend in den Blickpunkt des wissenschaftlichen Interesses. Ihre außergewöhnliche Tragfähigkeit entspricht dabei ihrer besonderen funktionalen Flexibilität: Bilder stehen nicht nur für sich selbst, vielmehr projizieren sie komplexe Eindrücke innerer und äußerer Zusammenhänge, die, mit entsprechender Rezeptionskompetenz verarbeitet, auch dem fremden Betrachter zugänglich gemacht werden können.

So bieten gerade die zahlreichen altägyptischen Darstellungen nicht nur umfassende Einblicke in eine andere Vorstellungswelt; als ikonisch kodierte Deutungsschemata stehen sie für reale oder virtuelle Wirklichkeiten und vermitteln auf diese Weise ein »Bild Ägyptens«, dass keinesfalls nur als »Abbild« aufgefasst werden darf. Dieses bereits im Titel *Imago Aegypti* zum Ausdruck gebrachte Spannungsfeld, das weitreichende Möglichkeiten der wissenschaftlichen Beschäftigung eröffnet, bildet den zentralen Gegenstand des neuen Magazins.

Das Vorhaben, eine ägyptologisch-kunstwissenschaftlich ausgerichtete Zeitschrift ins Leben zu rufen, war im Wesentlichen durch die Überlegung motiviert, dem Umgang mit diesem Fachgebiet neue Impulse zu verleihen, es für weitere Interessenten zu öffnen und somit Anschluss an den inter- beziehungsweise transdisziplinären Diskurs zu gewinnen. Mit der Zusammenstellung von Beiträgen zu den Schwerpunkten ägyptologische und koptologische Kunstforschung, Bildtheorie und Kulturwissenschaft setzt sich *Imago Aegypti* daher verschiedene Ziele: Das Jahrbuch will ein auf die Auseinandersetzung mit diesen Themen spezialisiertes Forum bilden, das zur Diskussion anregen und künftige Arbeiten forcieren soll. Durch das relativ weite Konzept erhält der Leser zudem einen Überblick über den aktuellen Forschungsstand. Auf diesem Wege wird nicht nur Fachkollegen und Studierenden, sondern auch Vertretern der Nachbardisziplinen und interessierten Laien der Zugang zu diesem Bereich erleichtert. Das Projekt *Imago Aegypti* begreift sich bewusst als internationale Plattform, die Beiträge können demnach auch in englischer und französischer Sprache abgefasst werden.

Neben Untersuchungen zur Kunst der pharaonischen Zeit steht *Imago Aegypti* auch für die Behandlung von Themen der spätantiken und frühchristlich-koptischen Periode offen. Ausblicke auf die Nachbargebiete sind ebenso erwünscht wie philologische Betrachtungen zur Begriffsgeschichte der ägyptischen Kunst. Ein spezieller Fokus soll überdies auf die Untersuchung von theoretischen, methodischen und didaktischen Fragestellungen gelegt werden. Daneben wird ein fester Platz für die Erstpublikation von Museumsobjekten zur Verfügung ste-

hen. Die Veröffentlichung von Grabungsberichten ist nicht vorgesehen, eine angemessene wissenschaftliche Präsentation einzelner Funde oder Fundkomplexe soll jedoch möglich sein. Auch kulturwissenschaftlichen Fragestellungen wird eine größere Bedeutung zugemessen.

Das Magazin, das zunächst einmal jährlich erscheinen soll, wird von den Ägyptologischen Instituten in München und Göttingen sowie vom Verlag Vandenhoeck & Ruprecht redaktionell betreut. Unser besonderer Dank gilt neben allen Mitwirkenden vor allem dem Deutschen Archäologischen Institut, Abteilung Kairo, ohne dessen finanzielle Unterstützung das Unternehmen nicht hätte umgesetzt werden können.

Für das Gelingen unseres Vorhabens hoffen wir auf die Beiträge zahlreicher Kollegen, die Rezeption durch eine Reihe von Interessenten und die Zufriedenheit unserer Leser.

Alexandra Verbovsek, Günter Burkard, Friedrich Junge

Gerald Moers

Ägyptische Körper-Bilder in physischen, visuellen und textuellen Medien

1. Einführung

Was sich in den letzten Jahren anhand von Kolloquien mit Titeln wie »Bild und Wirklichkeit«[1] oder einzelnen Vorträgen[2] bereits abzuzeichnen begann, ist jetzt spätestens mit der Gründung der Zeitschrift *Imago Aegypti* manifest geworden: Die Bildwissenschaft hält auch in die Ägyptologie Einzug. Tatsächlich war dies nur eine Frage der Zeit und passt zumindest insofern ins Bild unserer derzeitigen Wissenschaftslandschaft, als es sich im Rahmen einer meines Wissens von ägyptologischer Seite bisher zwar nicht näher definierten, andererseits aber auch immer wieder postulierten kulturwissenschaftlichen Öffnung unseres Faches geradezu aufdrängt,[3] ein Modul des umfänglichen, mithin disparaten kulturwissenschaftlichen Theorie- und Methodenangebots zu rezipieren, das andernorts schon lange Konjunktur hat. Was unter den Schlagwörtern von *Bildwissenschaft* und *Bildanthropologie* bereits eigene Kapitel in eher allgemein gehaltenen Einführungsbänden in die Gegenstände, Methoden und Arbeitsweisen der Kulturwissenschaften bekommen hat,[4] scheint also auf dem besten Weg zu sein, sich auch in unserem Fach zu einem differenzierten Forschungsprogramm[5] zu entwickeln.

Nun ist andererseits die Rezeption fachfremder Theorien und Methoden auch nicht immer ganz unproblematisch, zumal dann, wenn die rezipierende Disziplin das Rezipierte nur in bereits aufbereiteter Form wahrnimmt. Fachfremdes wird im ägyptologischen Alltagsgeschäft

1 Bei dem vorliegenden Aufsatz handelt es sich um die erheblich erweiterte und mit Anmerkungen versehene Fassung eines Vortrags, der am 27.11.2003 anlässlich der *Neuen Forschungen zur ägyptischen Kultur und Geschichte* an der Arbeitsstelle *Altägyptisches Wörterbuch* zum Thema *Bild und Wirklichkeit* in Berlin gehalten wurde. Ich danke den Veranstaltern für die Einladung sowie den Diskussionsteilnehmern, Albrecht Endruweit, Ralf Ernst und Hubertus Münch für zahlreiche Hinweise, Anregungen und Anmerkungen.

2 Vgl. etwa den anlässlich der *Ständigen Ägyptologenkonferenz* 2003 in Basel unter dem Titel »Wirkungsstrukturen der Bildsprache und ihre Rezeption« gehaltenen Vortrag von A. Verbovsek, dessen Druckfassung sich auf S. 145–155 befindet.

3 Die derzeitige Praxis ägyptologischer »Kulturwissenschaft« lässt sich demgegenüber bis heute mit einer Definition beschreiben, die J. Assmann, Ägyptologie im Kontext der Geisteswissenschaften, in: W. Prinz / P. Weingart (Hg.), Die sog. Geisteswissenschaften: Innenansichten, Frankfurt a. Main 1990, S. 335 gegeben hat: »Die Ägyptologie ist eine Kulturwissenschaft, d. h. sie beschäftigt sich mit allen Aspekten der altägyptischen Kultur: Sprache, Literatur, Religion, Wirtschaft, Kunst, Archäologie usw.«. Demnach wäre ägyptologisches Tun per se kulturwissenschaftlich. Dass sich das aus »echter« kulturwissenschaftlicher Perspektive etwas defizitär ausnimmt, versteht sich von selbst.

4 Vgl. etwa M. Fauser, Einführung in die Kulturwissenschaft. Einführungen Germanistik, Darmstadt 2003, S. 94ff.

5 So auch jüngst im ägyptologischen Teilprojekt »The Image of Writing – Das Bild der Schrift« in dem seit kurzem vom Schweizerischen Nationalfond (SNF) geförderten Nationalen Forschungsschwerpunkt *Iconic Critcism – Bildkritik* an der Universität Basel.

eben nicht selten nur aus allgemeinen Einführungswerken übernommen. Im themenbezoge-
nen ägyptologischen Fachgespräch handelt es sich dann häufig nur noch um die Sekundärre-
zeption eines bereits verkürzten oder gar mangelhaften Vorverständnisses der Gegenstände.
Originale Sekundärliteratur jedenfalls wird in den seltensten Fällen konsequent zur Kenntnis
genommen. So etwas hat in der Regel Folgen, wie sich kurz am Beispiel der ägyptologischen
»Literaturwissenschaft« erläutern lässt.[6]

Die allgemeine Literaturwissenschaft, wichtiger theoretischer Fluchtpunkt der Ägyptolo-
gie in den 1980er und 1990er Jahren, ist ägyptologisch verbraucht, bevor sie wirklich durch-
gearbeitet ist. Dementsprechend ist das ägyptologische literaturwissenschaftliche Projekt
nicht nur Fragment geblieben,[7] sondern hat vor allem für die Studierenden zur Folge, dass sie
sich einem Forschungsfeld gegenüber sehen, in dem wie in kaum einem anderen Teilgebiet
unseres Faches wenig komplexe ägyptologische Versuche *gleichberechtigt* neben komplexen
Theorieadaptionen stehen,[8] deren Wert andererseits auch nicht immer unmittelbar und schon
gar nicht von selbst einleuchtet. Das hat in meinen Augen zwei Gründe: Einerseits ging es,
wie immer, wenn etwas Konjunktur hat, in vielen ägyptologischen Beiträgen zum Thema oft
nur um die Teilhabe an einem offensichtlich prestigeträchtigen In-Diskurs. Im Normalfall sah
das so aus, dass man durch Jargon-Adaption alte Hüte aufdampfte, die im Regelfall schon
lange an der eigenen Garderobe hingen. Andererseits werden konsequente Anwendungen
fachfremder Theorievorgaben grundsätzlich nur mit erheblichen Reibungsverlusten rezipiert.
Sie werden, häufig genug mit einem Seitenblick auf Stand und Status der betreffenden Auto-
ren, weniger diskutiert als vielmehr entweder hingenommen oder verdrängt, beides interes-
santerweise jedoch aus identischem Grund: Gemessen an klassisch-ägyptologischer Praxis ist
Theorie- und Begriffsarbeit zu anstrengend. Liest man jüngste Einführungen zum Thema, in
denen Begriffsarbeit als »hartes Brot« und »Geistreichelei« abgetan und Studienanfängern
mit Nachdruck nahegelegt wird, es sei »vielleicht besser [...] Literaturwerke selbst sprechen
zu lassen, als über Literaturwerke zu reden«,[9] dann muss man sich tatsächlich fragen, was all
die mehr oder weniger gelungenen, immer aber ernst gemeinten Versuche der letzten 20 Jah-
re, die diesbezügliche ägyptologische Diskussion durch Methodenimport voranzubringen, an
der philologistischen Grundstruktur unseres Faches geändert haben.

All dies ist umso erstaunlicher, als es gerade die durch Methodenimport generierten Pro-
bleme sind, die man als die Bedingung der Möglichkeit für die wissenschaftliche Evolution

6 Vgl. nun auch ausführlicher G. Moers, Der Spurensucher auf falscher Fährte. Überlegungen zu den Voraus-
 setzungen einer *ägyptologischen* Literaturwissenschaft, in: G. Burkard / A. Grimm / S. Schoske / A. Verbov-
 sek (Hg. unter Mitarbeit von Barbara Magen), Kon-Texte. Akten des Symposiums »Spurensuche – Altägyp-
 ten im Spiegel seiner Texte«, München 2. bis 4. Mai 2003, ÄAT 60, Wiesbaden 2004, S. 37ff.

7 Wo etwa sind die Antworten auf die von H. U. Gumbrecht, Does Egyptology Need a »Theory of Literature«?,
 in: A. Loprieno (Hg.), Ancient Egyptian Literature: History & Forms, PÄ 10, Leiden / New York / Köln 1996,
 S. 2ff. aufgeworfenen Fragen nicht nur nach dem Skopus, sondern vor allem nach dem Sinn ägyptologisch
 literaturwissenschaftlichen Arbeitens?

8 Vgl. generell etwa die disparate Sammlung unterschiedlichster Standards in A. Loprieno (Hg.), Ancient
 Egyptian Literature: History & Forms, PÄ 10, Leiden / New York / Köln 1996, oder – etwas jüngeren Datums
 – die Divergenz zwischen G. Burkard / H. J. Thissen, Einführung in die altägyptische Literaturgeschichte I.
 Altes und Mittleres Reich, Einführungen und Quellentexte zur Ägyptologie 1, Münster / Hamburg / London
 2003 einerseits und andererseits R. B. Parkinson, Poetry and Culture in Middle Kingdom Egypt. The Dark
 Side to Perfection, London 2002.

9 G. Burkard / H. J. Thissen, Einführung, S. 17, 26, 186.

unseres Faches ansehen sollte.[10] So trägt etwa die Frage, ob ein Text wie die *Erzählung des Sinuhe* in literaturwissenschaftlichem Verständnis überhaupt ein fiktionaler Text sein kann, eventuell mehr zum Verständnis der pharaonischen Kultur bei als die Frage, ob der Text als Zeugnis für eine Koregentschaft von Sesostris I. und Amenemhet I. angesehen werden muss.

2. Bildwissenschaft, Bildtheorie und Bildbegriffe

Warum nun ein solch langer Umweg, der zudem so offensichtlich nichts zu tun hat mit dem Thema dieses Aufsatzes »Körper-Bilder«? Zum einen, weil man bezüglich der Lesbarkeit pharaonisch-ägyptischer Bilder ägyptologische Positionen findet, die strukturell ebenso philologistisch sind wie die oben zitierten zur unmittelbaren Lesbarkeit ägyptischer Texte. So etwa kann man in einem Ausstellungskatalog aus den frühen 1990er Jahren Folgendes lesen:

> »Zudem mag die Aufwertung der Bildinformation zu einer der Textinformation gleichrangigen Quelle über den Bereich der Religionswissenschaft hinaus allgemeine Relevanz für die Beschäftigung mit Altägypten haben. Jede Art historischer Forschung sieht sich in hohem Maße dem Problem der Übersetzbarkeit der Primärquellen konfrontiert. Der Informationsverlust ist dort am geringsten, der Wirklichkeitsgehalt dort am größten, wo die Übersetzung des Textes oder des Bildes in unsere Begrifflichkeit und Sprache nicht nötig ist, da die Quelle in ihrer eigenen Sprache verständlich zu uns spricht.
>
> Zweifellos ist hier das Bild dem Text überlegen. Es ist über Sprach- und Epochengrenzen hinweg zumindest in seinen äußeren Schichten unmittelbar zugänglich. Während zu fremdsprachigem Textmaterial nur der Sprachkundige Zugriff hat, ist das Bild sprachunabhängig kommunikativ. Für Altägypten heißt das, dass sich dem Nichtägyptologen nur im außersprachlichen Bereich eine direkte Begegnung eröffnet. Sie wird zwar ohne die Präzisierung durch Textinformationen nicht voll befriedigen können, aber sie setzt sich auch nicht der Gefahr der Verfälschung durch das subjektive Urteil eines modernen Interpreten aus.
>
> Eine Religion, deren Textzeugnisse in hohem Maße in bildhafter Sprache formuliert und in einer bildträchtigen Schrift aufgezeichnet sind und auf Grab- und Tempelwänden, auf Särgen und Papyri fast ausnahmslos in enger Symbiose mit dem Medium des Bildes niedergelegt sind, ist prädestiniert, auch heute in diesen Bildern begriffen zu werden.«[11]

Zum anderen bietet sich die einleitende Analogie zur ägyptologischen »Literaturwissenschaft« an, weil entgegen der im Zitat vermittelten Auffassung auch die Begreifbarkeit der ägyptischen Bilder so einfach nicht zu haben ist, es dazu vielmehr einer spezifischen Bildwissenschaft bedarf und man deswegen – um im Bilde zu bleiben – schon im Bilde sein muss, wenn man sich daran macht, die komplexen bildwissenschaftlichen Theorievorgaben an das ägyptische Material heranzutragen. Und weil diese Bildwissenschaft andernorts eben schon so sehr Konjunktur hat, dass man, wie oben bereits angedeutet, in Analogie zum *Linguistic Turn* der 1960er Jahre oder dem *Cultural Turn* in den 1990ern mittlerweile ganz selbstverständlich vom *Iconic Turn* spricht – so etwa Gottfried Boehm in seinem einleitenden

10 Der in Fußnote 7 zitierte Beitrag von H. U. Gumbrecht zeigt deutlich, dass es erst die im Rahmen von Theorieadaption und Begriffsarbeit wahrnehmbaren Widerständigkeiten des ägyptischen Objektes sind, die zu wirklich Perspektiven eröffnenden Fragestellungen führen.

11 S. Schoske / D. Wildung, Gott und Götter im Alten Ägypten (Katalog zur Sonderausstellung), Mainz 1992, S. 3.

Aufsatz aus dem mittlerweile klassischen Sammelband »Was ist ein Bild?« von 1994[12] – und man dabei als fachfremder Rezipient sehr leicht übersehen kann, dass sich unter dem Sammelbegriff *Bildwissenschaft* bereits eine Vielzahl von Forschungsfeldern subsumiert findet, die sich zwar im deutschen Begriff des Bildes berühren oder überschneiden, nach Herkunft und Genese aber doch recht disparater Natur sind.[13] Das mag man schon an der Differenzierungsleistung der englischen Sprache erkennen, in der neben dem Begriff des *Iconic Turn* auch noch *Pictorial Turn* und *Imagic Turn* kursieren.[14] Während die beiden erstgenannten in der Regel auf die Domäne der klassischen Kunstgeschichte bezogen werden, die auch in der Tat den Kernbereich bildwissenschaftlichen Arbeitens darstellt, stammt der Begriff des *Imagic Turn* ursprünglich aus der Kognitionswissenschaft. Bereits das mag anzeigen, dass es sich beim Bildbegriff im Rahmen der bildwissenschaftlichen Diskussionen um einen transdisziplinär erweiterten Begriff handelt,[15] der eben nicht mehr allein auf das bezogen bleiben kann, was man intuitiv oder alltagshermeneutisch gemeinhin darunter versteht – grob gesagt wären das mit dem Auge wahrnehmbare Gegenstände, die etwas darstellen oder abbilden und meist aus dem Bereich der zweidimensionalen bildenden Kunst stammen. Das etwa führt dann einerseits dazu, dass sich die Kunstgeschichte in diesem Zusammenhang herausgefordert sieht, sich zugunsten des Bildes von ihrem herkömmlichen Kunstbegriff und damit von der impliziten Ordnung ihrer Gegenstände zu verabschieden – nicht jedes Bild ist automatisch Kunst[16] –, andererseits ist der Bildbegriff nicht mehr an die physikalische Materialität des Gegenständlichen gebunden. Das ist nun auch nicht neu. Immer schon gab es vor dem Hintergrund eines als primär aufgefassten sogenannten natürlichen Bildbegriffs, der an die Materialität äußerer Bilder gekoppelt war, die als metaphorisch aufgefasste Verwendung des Bildbegriffs etwa für innere oder mentale Bilder. Neben diesen mentalen Bildern gibt es die Metaphern vom Sprachbild – die Metapher selbst wäre so eines – sowie die Metaphern vom Vorbild oder vom Weltbild. Nun ist aber selbst das metaphernhafte dieser angeblich metaphorischen Sekundärverwendungen des Bildbegriffs keinesfalls zweifelsfrei bewiesen, da zum Beispiel in der Wahrnehmungstheorie noch gar nicht klar ist, in welcher Weise sich die faktische Bildhaftigkeit des Kognitiven von angeblich vorgängigen äußeren Bildern unterscheiden lässt. Für diese inneren mentalen Bilder kommt zudem hinzu, dass sie doppelt codiert sind und vom Gehirn gleichzeitig sprachlich und ikonisch aufgefasst werden.

Obwohl es bis jetzt ganz offensichtlich keine durchgearbeitete Auffassung darüber gibt, wie die verschiedenen bisher angesprochenen Bildbegriffe im Einzelnen miteinander korrelierbar sind, scheint es allerdings so zu sein, als sei der Repräsentationscharakter des Bildes eine Möglichkeit, die verschiedenen Bildbegriffe in Zusammenhang zu bringen.[17] So führen Jakob Steinbrenner und Ulrich Winko in ihrem Einleitungsaufsatz »Die Philosophie der Bilder« zu der von ihnen herausgegebenen Vortragssammlung mit dem Titel »Bilder in der Philosophie & in anderen Künsten & Wissenschaften« aus dem Jahre 1997 aus: »Bilder sind Re-

12 G. Boehm, Die Wiederkehr der Bilder, in: G. Boehm (Hg.), Was ist ein Bild? Bild und Text, München 1994, S. 13.

13 Eine konzise Einleitung in die Problemstellung gibt auch H. Belting, Bild-Anthropologie. Entwürfe für eine Bildwissenschaft. Bild und Text, München 2001, S. 11ff.

14 M. Fauser, Einführung, S. 94.

15 M. Fauser, Einführung, S. 96f.; J. Steinbrenner / U. Winko, Vorwort, in: J. Steinbrenner / U. Winko (Hg.), Bilder in der Philosophie & in anderen Künsten & Wissenschaften, Paderborn 1997, S. 8.

16 Vgl. etwa M. Fauser, Einführung, S. 97. Zu den sich daraus für die ägyptologische Kunstwissenschaft ergebenden Konsequenzen vgl. A. Verbovsek in diesem Band, S. 145–155.

17 M. Fauser, Einführung, S. 96.

präsentationen und haben aufgrund ihres repräsentationalen Charakters eine im allgemeinen Sinne objektbildende, kognitive und handlungsleitende Funktion. Bilder stehen für etwas und können potentiell etwas vermitteln und bewirken.«[18] Das ist ein Repräsentationsbegriff, der zumindest behauptet, dass in ihm nicht auch gleichzeitig die Begriffe Darstellung, Vorstellung und Stellvertretung ineinander fließen. Steinbrenner und Winko wenden sich damit gegen ältere Ähnlichkeits- oder Kausalhypothesen, nach denen das Spezifikum von Bildern ihre Ähnlichkeit mit den von ihnen dargestellten Gegenständen ist oder sie gar durch diese bedingt sind und deswegen stellvertretend für die im Bild dargestellten Gegenstände stehen.[19] All dies würde jeweils vorgängige Realitäten beziehungsweise Wirklichkeiten implizieren, wogegen sich Steinbrenner und Winko über die Formulierung von der *objektbildenden* Funktion der Bilder rückversichern. Sie unterscheiden in ihrer Typologie der Bildbegriffe schließlich zwischen dem *materiellen*, dem *metaphysischen*, dem *mentalen*, dem *sprachlichen* und dem *ethischen* Bildbegriff, ohne dass diese sich immer klar vom jeweils anderen unterscheiden ließen.[20] Da sich anhand ihrer Typologie Möglichkeiten zur Vorstrukturierung der in der Folge vorzustellenden ägyptischen Körperbilder ergeben, soll sie hier kurz vorgestellt werden.

In gewisser Hinsicht übergeordnet über alle anderen Bildbegriffe ist der *metaphysische* Bildbegriff. Danach sind Bilder immer Bilder von etwas, wobei dieses Etwas von ontisch durchaus fragwürdigem Charakter sein kann. In der idealistischen Philosophie Fichtes etwa sind die Gegenstände nur als die Erscheinungen zugänglich, als die Bilder also, als die wir sie wahrnehmen, selbst wenn wir dazu tendieren, analytisch zwischen Gegenständen und unseren Vorstellungen von ihnen zu unterscheiden.[21] Der klassische Fall des metaphysischen Bildbegriffs wäre hingegen Platons Urbild-Abbild-Theorie, nach der sich materielle, sinnlich wahrnehmbare Bilder ihren abstrakten Urbildern – Platons »Ideen« – verdanken.

Auf heute ähnlich problematisch gewordene Kausal- oder Ähnlichkeitstheorien baut sodann der so genannte *materielle* Bildbegriff auf, über den ein konkretes Bild mit einem realen Gegenstand relationiert wird. Was es mit dieser Problematik auf sich hat, mag ein Blick auf Tafel 1a mit einer Darstellung vom *Erschlagen der Feinde* verdeutlichen. Der Realitätsbezug solcher Szenen wurde lange Zeit diskutiert, wenn auch aufgrund des hohen Wiedererkennungswertes vornehmlich im Rahmen der Frage nach Original und Kopie in den monumentalen Varianten des Bildes auf den Pylonen ägyptischer Tempel. Während solche Realismusdiskussionen recht eigentlich einen *materiellen* Bildbegriff voraussetzten, der das Bild jeweils auf eine konkrete historische Situation bezog, geht man heute davon aus, dass es sich bei diesen Bildern um die Repräsentation eines *Weltbildes* im Sinne des ethischen Bildbegriffs (s. u.) handelt.[22] Sollte dem hingegen das tausendfach reproduzierte Bild vom *Erschlagen der*

18 J. Steinbrenner / U. Winko, Die Philosophie der Bilder, in: J. Steinbrenner / U. Winko (Hg.), Bilder in der Philosophie & in anderen Künsten & Wissenschaften, Paderborn 1997, S. 15.

19 Sowohl J. Steinbrenner / U. Winko, Philosophie der Bilder, S. 18f. als auch H. Belting, Bild-Anthopologie, S. 29 setzen die vormoderne Praxis der *Personalisierung* des Bildes in archaischen Riten bzw. die *Stellvertretung* des Körpers des Verstorbenen in antiken Totenkulten durch ein Bild (»Verkörperung«) demgegenüber als die archetypische Bilderfahrung.

20 J. Steinbrenner / U. Winko, Philosophie der Bilder, S. 18ff.

21 J. G. Fichte, Ueber das Verhältniß der Logik zur Philosophie oder transcendentale Logik, in: I. H. von Fichte (Hg.), Fichtes Werke, Bd. 9: Nachgelassenes zur theoretischen Philosophie I, Fotomechanischer Nachdruck Berlin 1971, S. 392.

22 Vgl. in aller Kürze E. Graefe, »Propagandaritual« oder Realität? Abschreckung durch Bild und Wort, in: S. Petschel / M. von Falck (Hg.), Pharao siegt immer – Krieg und Frieden im Alten Ägypten (Katalog zur Sonderausstellung Hamm, 21. März bis 31. Oktober 2004), Bönen 2004, S. 54f.

Feinde tatsächlich überhaupt jemals auf eine konkrete vorgängige historische Wirklichkeit referiert haben, so kann man für seine sukzessiven Wiederverwertungen also bestenfalls noch auf Interikonizität plädieren.

Mit Blick auf das Bild eines sich vor dem löwenhaften Pharao einnässenden Nubiers jedoch (Taf. 1b) – im Übrigen ebenso eine bildmetaphorische Variante des Bildes vom *Erschlagen der Feinde* (Taf. 1a) wie ein Körper-Bild – wird man sogar so unvorsichtig sein dürfen zu behaupten, dass es zu dieser Szene mit an Sicherheit grenzender Wahrscheinlichkeit niemals eine historische Wirklichkeit gegeben hat, die so und nur so aussah und auf die und nur die sich das Bild bezieht.

Der nächste mit Steinbrenner und Winko abzugrenzende Bildbegriff ist der *mentale*. Dieser ist eine Weiterentwicklung aus dem metaphysischen Bildbegriff und bezieht sich auf die Bildhaftigkeit des Kognitiven, hat also die so genannten »inneren Bilder« zum Gegenstand. Kernpunkt ist dabei die Überlegung, dass bereits materielle Gegenstände nur Erscheinungen sind, Repräsentationen der Gegenstände, die dem Bildwahrnehmenden in ihrer wirklichen Seinsweise entzogen bleiben. Ähnliches lässt sich dann auch über mentale Repräsentationen sagen. Mentale wie materielle Wirklichkeiten wären in dieser Perspektive nichts anderes als unterschiedliche Bilder eines Gegenstands, dessen Dinglichkeit *an sich* verborgen bleibt.

Wirkungsmächtiger waren jedoch Positionen zum mentalen Bildbegriff, die sich im weitesten Sinne auf die doppelte, das heißt imaginale und gleichzeitig sprachliche Codierung mentaler Bilder beziehen. Augustinus etwa beschreibt Sprache als Denken in Bildern und meint damit, dass wir mit einem Ausdruck auf einen Begriff Bezug nehmen, der ein mentales Bild repräsentiert.[23] Sprache also expliziert mentale Bilder, und demnach wären letztgenannte vorgängige und deswegen auch verschiedenartig angereicherte Erinnerungsbilder, die dem sprachlichen Ausdruck Bedeutung verleihen.

Der *sprachliche* Bildbegriff bezieht sich demgegenüber auf verbal oder schriftlich geäußerte bildhafte sprachliche Repräsentationen. Die Metapher etwa wäre ein solches Sprachbild, und ihr kognitiver Gehalt sorgt dafür, dass der sprachliche Bildbegriff eng mit dem mentalen Bildbegriff verbunden bleibt, denn das sprachliche Bild evoziert eine innere Vorstellung. Ältere Vergleichs- und Substitutionstheorien zur Erklärung der Metapher sind heute zugunsten von Interaktions- und Übertragungstheorien aufgegeben. Danach entsteht eine Metapher durch die Übertragung eines Zeichenschemas, das normalerweise zur Strukturierung eines Gegenstandsbereichs A benutzt wird, auf die Strukturierung eines anderen Gegenstandsbereichs B. Das lässt sich in groben Zügen am ägyptologisch wohlbekannten Sprachbild »Der Asiat ist ein Krokodil auf seinem Uferdamm« aus der »Lehre für Merikare« E 97–98 exemplifizieren:[24] 1. »Krokodil« denotiert in Gegenstandsbereich A: »Tierwelt«, ein Krokodil. 2. ein Krokodil exemplifiziert relativ zum pharaonischen Beschreibungsschema für die ägyptische Tierwelt »Gewalt« und »Raffgier«.[25] 3. Gewalt und Raffgier denotieren in Gegenstandsbereich B: »Menschen«, den Asiaten. Auf die Tatsache, dass es sich bei diesem Sprachbild von der Krokodilität des Asiaten obendrein um ein Körper-Bild handelt, wird unten noch näher einzugehen sein.

23 Augustinus, Bekenntnisse, eingel. u. übertr. von W. Thimme. Bibliothek der Alten Welt, München / Zürich 3. Aufl. 1982, S. 256.

24 A. Merikare E 97f.; Text bei J. F. Quack, Studien zur Lehre für Merikare, GOF IV/23, Wiesbaden 1992, S. 186.

25 Ägyptologisches Material dazu bei G. Moers, Fingierte Welten in der ägyptischen Literatur des 2. Jahrtausends v. Chr. Grenzüberschreitung, Reisemotiv und Fiktionalität, PÄ 19, Leiden / Boston / Köln 2001, S. 191ff.

Beim letzten von Steinbrenner und Winko vorgestellten Bildbegriff handelt es sich um den sogenannten *ethischen* Bildbegriff. Dieser ist für die folgenden Ausführungen deswegen von besonderer Relevanz, weil er sich in erster Linie auf Menschenbilder bezieht und dabei die gesamte Spannbreite zwischen einem deskriptiven Abbild und einem normativen Idealbild vom Menschen umfasst. Während sich der ethische Bildbegriff, dem man intuitiv zunächst ebenso Eigenschaften des metaphysischen oder auch des mentalen Bildbegriffs beimessen könnte, aufgrund seiner normativen Aspekte auf keinen anderen Bildbegriff reduzieren lässt, können die Menschenbilder in den verschiedensten Repräsentationsmedien zum Ausdruck gebracht werden. Sie tauchen also ebenso als materielle Bilder oder als sprachliche Bilder auf – siehe den sich einnässenden Nubier und das Asiatenkrokodil –, wie sie die Form komplexer handlungsleitender Theorien annehmen können. Zwar ist mit letzterem für Ägypten wohl kaum zu rechnen, allerdings könnte man versuchsweise den ägyptologisch gern so genannten weisheitlichen (oder sozialethischen) Diskurs als prä-theoretischen Ausdruck eines spezifisch ägyptischen Menschenbildes verstehen, welches handlungsleitend und damit normativ auf einen gewünschten idealen Weltzustand bezogen ist.[26] Steinbrenner und Winko betonen in diesem Zusammenhang, dass die Normativität des idealen Menschenbildes und seine handlungsleitende Funktion an einen normativen Personenbegriff gebunden ist, mit Hilfe dessen zwischen (nur) physisch menschlichen Wesen und kommunikativ relevanten und handelnden Personen unterschieden werden kann, wobei relevant natürlich heißt: im Sinne des normativ-idealen Menschenbildes relevant.[27]

3. Ägyptische Körper-Bilder

In der Folge sollen nun verschiedene empirisch nachweisbare physische, materielle und sprachliche Menschenbilder aus Ägypten auf diesen ethischen Bildbegriff bezogen werden.[28] Dreh- und Angel-, aus anderer Perspektive möglicherweise auch Fluchtpunkt aller diesbezüglichen Überlegungen ist der menschliche Körper, an dem sich die Interrelation von kognitiven, visuellen und sprachlichen Aspekten der vorgestellten Bildbegriffe exemplifizieren lassen.

Ich behaupte also, dass der Körper, den ich mit einem Begriff *von*, jedoch nicht unbedingt *im Einklang mit* Hans Belting als ein *Trägermedium* unter vielen verstehe,[29] ein zentraler Ort

26 Explizit in dieser Hinsicht zuletzt etwa F. Junge, Die Lehre Ptahhoteps und die Tugenden der ägyptischen Welt, OBO 193, Freiburg / Göttingen 2003, bes. S. 169ff.

27 J. Steinbrenner / Winko, Philosophie der Bilder, S. 36. Hier bieten sich dann die Anschlussmöglichkeiten an die weiter unten eingeführten systemtheoretischen Überlegungen zum Personenbegriff, s. u. Fußn. 38 u. 39.

28 Dass die hier gewählte Verbindung nicht ganz willkürlich ist, wird auch von der Existenz eines Kapitels wie »Das Körperbild als Menschenbild« bei H. Belting, Bild-Anthropologie, S. 87ff. bestätigt.

29 H. Belting, Bild-Anthropologie, S. 13, 26f., 34 ist an diesem zentralen Punkt leider ein wenig inkonsistent. Soweit ich ihn richtig verstehe, ist der menschliche Köper für ihn *kein* Trägermedium. Belting spricht zwar vom Körper als »Ort der Bilder« (S. 12) in dem Sinne, dass im Körper »wie in einem lebenden Trägermedium« Bilder entstehen, doch bleibt es für ihn bezüglich des Verhältnisses zwischen Körper und der Medialität der Bilder bei einer »Körperanalogie« (S. 13), da für ihn Trägermedien »von echten Körpern unterscheidbar sein« müssen. (S. 27). Andererseits führt er jedoch gerade bzgl. der Zurichtungen lebendiger menschlicher Körper diesen echten Körper wieder als Trägermedium ein (S. 34): »Die Frage nach Bild und Medium führt zum Körper zurück, der nicht nur, kraft seiner Imagination, ein ›Ort der Bilder‹, sondern auch, mittels seiner äußeren Erscheinung, ein Bildträger gewesen und geblieben ist. [...] Der Körper ist dann eher ein Bildträger, also ein *Trägermedium* [Kursive G. M.]«; s. a. M. Fauser, Einführung, S. 98, der diese Inkonsistenz jedoch unterschlägt.

der Repräsentation des normativen Menschenbildes in Ägypten ist. Sowohl körperliche, sprachliche als auch bildliche Repräsentationen des idealen Menschenbildes kommunizieren den menschlichen Körper als das *Trägermedium* dieser Vorstellungen, und zwar dergestalt, dass sekundäre Zurichtungen der primären Physis aus dieser einen idealen Körper machen, an dem man den idealen Menschen erkennen kann. Körperbilder verschiedener medialer Qualitäten zeigen also, dass das kulturelle Imaginäre vom idealen Menschen an dessen Körper konkrete Form gewinnt. Beginnen wir mit zwei ramessidischen Textbeispielen aus den »Miscellanies« und den »Liebesliedern«:

Ex. 1 Mir wurde berichtet, dass du die Schriften vernachlässigst und hinter Vergnügungen her bist. Du ziehst von Viertel zu Viertel und es stinkt nach Bier, wann immer man dir nahekommt. Bier lässt ihn aufhören *(rwj=f)*, Mensch *(rmṯ)* zu sein und deinen Geist unstet werden. Du bist wie ein krummes Steuerruder in einem Schiff, das zu keiner Seite reagiert, wie ein gottleerer Schrein und wie ein Haus ohne Brot. Man erwischte dich beim Übersteigen der Mauer, nachdem du ausge<büxst> bist und die Leute vor dir flohen, weil du ihnen Wunden geschlagen hast. […] Du sitzt auf der Straße, Freudenmädchen um dich herum. Dann stehst du auf und springst herum. Es […] dich. Du hast dich vor der Hure niedergelassen und bist tropfnass vom Öl, deinen Kranz Vergissmeinnicht(?) um deinen Hals. Du trommelst auf deinem Bauch und torkelst, fällst lang hin und bist mit Scheiße gesalbt.[30]

Ex. 2 Es hüpft *(jfd)* mein Herz vor Unrast, wenn ich an Deine Liebe denke. Es verwehrt mir menschliche Umgangsformen *(šmj mj rmṯ)*, denn es ist fortgerissen <von> seinem rechten Platz. Es verhindert, dass ich mein Gewand anlege, und auch bin ich nicht in der Lage, meinen Fächer zur Hand zu nehmen. Es verhindert, dass ich meine Augen schminke, und mich bloß zu salben bin ich nicht in der Lage. »Verharre nicht, damit Du das Ziel erreichst!« sagt es zu mir, wann immer ich an ihn denke. »Mach mir, mein Herz, nicht Kummer! Warum handelst du töricht? Warte geduldig, dann kommt der Bruder zu Dir und zahlreiche Augen ebenso. Lass nicht die Menschen *(rmṯ.w)* über mich sagen: ›Das ist eine Frau, die der Liebe verfallen *(hꜣj.tj)* ist.‹! Sei standhaft wann immer Du an ihn denkst! Mein Herz, hüpfe *(jfd)* nicht!«[31]

Das interessante an diesen Textpassagen ist, dass sie sich über die Art und Weise der Verwendung des Terminus *rmṯ* »Mensch« auf den ethischen Bildbegriff beziehen lassen.[32] Diese spezifische Verwendung impliziert in beiden Passagen, dass hier ein Menschenbild involviert ist, das jenseits der Deskription des Natürlich-Biologischen angesiedelt ist. Im Negativen scheint hier auf, was sonst durch die Normalität eines positiv bewerteten *rmṯ*-Seins verdeckt bleibt: dass es nämlich *Normalitätsnormen* für das Idealbild vom Menschen gibt; und diese wiederum sind durchaus an spezifische Formen von Körperlichkeit gebunden.

In Ex. 2 steht ein von einer liebeskranken Dame erwünschtes und doch zumindest zeitweise unmögliches »sich bewegen wie ein Mensch« *(šmj mj rmṯ)* einem durch Liebestaumel hervorgerufenen unerwünschten und doch zumindest zeitweise unvermeidlichen »tierisch hüp-

30 pAnastasi IV 11,9–12,6; Text bei A. H. Gardiner, Ancient Egyptian Miscellanies, BAeg VII, Brüssel 1937, S. 47,6–48,3.

31 pChester Beatty I vso. C2,9–3,4; Text bei B. Mathieu, La poésie amoureuse de l'égypte ancienne. Recherches sur un genre littéraire au Nouvel Empire, BdÉ 115, Kairo 1996, Taf. 2,9–3,4.

32 Ausführlicher dazu G. Moers, Auch der Feind war nur ein Mensch. Kursorisches zu einer Teilansicht pharaonischer Selbst- und Fremdwahrnehmungsoperationen, in: H. Felber (Hg.), Feinde und Aufrührer. Konzepte von Gegnerschaft in ägyptischen Texten besonders des Mittleren Reiches, Abhandlungen der Sächsischen Akademie der Wissenschaften zu Leipzig, Philologisch-historische Klasse, Bd. 78 Heft 4, Leipzig 2004 S. 239–294.

fen« *(jfd)* gegenüber – ein Gegensatz, der sich auf die Blockade der »selbstverständlichsten und alltäglichsten Beschäftigungen der ägyptischen Dame« bezieht.[33] In Ex. 1 sind es die unkontrollierten Bewegungen des betrunken-lüsternen Schreiberschülers, die ihn vom »Mensch-Sein abhalten« *(rwj m rmṯ)*. Mit Blick auf die Normativität des hier zugrunde zu legenden idealen Menschenbildes heißt das, dass Ankleiden, Ausstaffieren, Schminken und Salben auf der einen und ein unauffälliger, nüchtern-getragener Bewegungsablauf auf der anderen Seite eine offensichtlich distinkte Form von Körperlichkeit produzieren, die es einem Gegenüber im nicht durch rauschhafte Abweichung verdeckten Normalfall erlaubt, ein biologisch als menschlich zu klassifizierendes Wesen auch als idealen Menschen im Sinne des normativen Menschbildes zu erkennen. Die »Klagen des Ipuwer« zeigen, dass dazu auch eine angemessene Haartracht gehört:[34]

Ex. 3　Wahrlich, der Besitzlose ist zu einem Wohlhabenden geworden, und die, die Menschen *(rmṯ.w)* waren, sind <zu> anderen *(ky.w)* <geworden>, die man entfernt. Wahrlich, jedermann ist das Haar [ausgefallen(?)], und man kann den Sohn eines Mannes von Rang nicht mehr vom Habenichts unterscheiden.[35]

Stellen wie diese machen klar, dass die Erkennbarkeit eines biologisch voll individuierten Körpers als menschlich in bestimmten kommunikativen Kontexten keinesfalls ausreicht, um auch als »Mensch« durchzugehen. Vielmehr ist der biologische Körper, in Fällen wie den vorgestellten, der Ort ganz offensichtlich normierender und normierter Zurichtungen, die aus einem in biologischer Hinsicht menschlichen Organismus einen Typ von Mensch machen, den man mit Blick auf den oben eingeführten ethischen Bildbegriff als »idealen« Menschen bezeichnen würde. Solches Idealmensch-Sein ist das Ergebnis normorientierter Umgangsformen, die von denjenigen, die die eingeforderten Normen als Trägergruppe kommunizieren, als »eigen« im Sinne des von ihnen kommunizierten Norm- und Verhaltensinventars wiedererkannt wird. Das sind im Fall von Ex. 1 genau die *rmṯ.w*, von denen die Dame weiß, dass sie sie als eine Gefallene *(hȝj.tj)* erkennen würden. Diese Erkennbarkeit jedoch, und das ist entscheidend, liegt nicht nur vor jeder Form verbaler Kommunikation oder zielgerichteter Interaktion, sondern wird bereits über den beobachtbaren Körper vermittelt. Das aufgrund von Körperlichkeitswahrnehmungen verliehene Prädikat »Mensch« *(rmṯ)* dient als Identitätsausweis im Sinne einer erkennbaren Gruppenmitgliedschaft und damit zur Regelung von Inklusions- und Exklusionsoperationen.

　　Die bis hierhin gesammelten Beobachtungen, nämlich erstens: das Auftauchen des Terminus »Mensch« in Zusammenhängen, in denen offensichtlich zwischen einem deskriptiven Menschenbild und einem präskriptiven Bild vom idealen Menschen unterschieden wird, zweitens: die Erkennbarkeit einer »subidealen« Menschlichkeit an einer als negativ vorgestellten Körperlichkeit sowie drittens: die über Bilder vom idealen Menschen ausgehandelte Differenz zwischen Inklusion und Exklusion, deuten darauf hin, dass es in allen bisher vorgestellten Verwendungen des *rmṯ*-Begriffs um etwas geht, was man heute als *Person* bezeichnen

33　G. Fecht, Die Wiedergewinnung der altägyptischen Verskunst, in: MDAIK 19 (1963), S. 75f.

34　So zumindest in der Auffassung von H.-W. Fischer-Elfert, Die Lehre eines Mannes für seinen Sohn. Eine Etappe auf dem »Gottesweg« des loyalen und solidarischen Beamten des Mittleren Reiches, ÄA 60, Wiesbaden 1999, S. 304. Eindeutig ist in diesem Zusammenhang das unten als Ex. 6 zitierte Liebeslied aus dem pHarris 500.

35　pLeiden 344 rto. 3,14–4,1; Text bei A. H. Gardiner, The Admonitions of an Egyptian Sage from a Hieratic Papyrus in Leiden (Pap. Leiden 344 recto), Leipzig 1909, Taf. 3,14–4,1; S. 35f.

würde.[36] Unter einer Person kann man mit Niklas Luhmann im Gegensatz zu *Mensch* oder *Individuum* »eine andere Form [verstehen], mit der man Gegenstände wie menschliche Individuen beobachtet. Es kommt dann alles darauf an herauszufinden, was die andere Seite der Form ist, in welcher spezifischen Hinsicht eine Person also Unperson sein kann, ohne deswegen nicht Mensch, nicht Individuum zu sein. Das Ziel lässt sich dann erreichen, wenn man die Form ›Person‹ bestimmt als individuell attribuierte Einschränkung von Verhaltensmöglichkeiten«.[37] Über diese *Einschränkung* von Verhaltensmöglichkeiten wird geregelt, ob »im Kommunikationszusammenhang Menschen für relevant gehalten« werden, das heißt ob sie inkludiert oder exkludiert werden, denn »da Personen als Menschen erkennbar sind, bedarf ihre Exklusion typisch einer Legitimation. Hierfür gibt es zwei Möglichkeiten: Es handele sich um Menschen anderer Art oder es liege ein gravierender Normverstoß vor«.[38] Luhmann betont ferner, dass die Art und Weise, in der Personalität zur Lösung solcher Relevanzfragen herangezogen wird, mit der Komplexität des Gesellschaftssystems variiert. So reicht häufig der erkennbare, teils auch zugerichtete Körper des anderen aus, um beurteilen zu können, wer kommunikativ relevante Person ist und wer nicht.[39] Vor allem aber ist festzustellen, dass Menschen aus dem Exklusionsbereich (Unpersonen) selbst heute noch beinahe ausschließlich als Körper wahrgenommen werden.[40] All dies lässt sich mit Blick auf die bisher vorgestellten Beispiele auch umgekehrt formulieren: Vor allem die subideale und weniger relevante Unperson erkennt man im pharaonischen Ägypten an ihrer auffälligen, ja anormalen Körperlichkeit, wie auch immer diese zustande gekommen sei. Die öffentliche Zurschaustellung von Trunkenheit, Liebesrausch und nachlässiger Toilette jedenfalls zählt als Verstoß gegen die normierten Einschränkungen von Verhaltensmöglichkeiten, die bereits über eine abweichende Körperlichkeit beobachtbar werden und deren Beobachtung durch die Umwelt dann dazu führen, dass die so wahrgenommenen Menschen als subideal angesprochen werden können. Grundsätzlich muss man aber gar nicht darüber diskutieren, unter welchen Umständen Personen zu Unpersonen werden können, wie es die beiden ersten der obigen Beispiele tun. Wie Ex. 3 aus den »Klagen des Ipuwer« zeigt, reicht vielmehr ein einfacher Blick auf die Körperlichkeit von Menschen aus, um zwischen idealen Menschen beziehungsweise Personen und einer Restmenge von weniger idealen »Anderen« *(ky.w)* beziehungsweise Unpersonen zu unterscheiden. Die 13. Maxime der »Lehre des Ptahhotep« bringt das Phänomen auf den Punkt:

Ex. 4 Wenn Du in der Audienzhalle bist, steh und sitz entsprechend dem Wandel, der dir anbefohlen war am ersten Tag; geh nicht einfach hindurch, weil man dich dann abweisen wird![41]

36 S. o. Fußn. 29.

37 N. Luhmann, Die Form »Person«, in: Soziale Welt. Zeitschrift für sozialwissenschaftliche Forschung und Praxis 42/2 (1991), S. 170.

38 N. Luhmann, Inklusion und Exklusion, in: H. Berding (Hg.), Nationales Bewußtsein und kollektive Identität. Studien zur Entwicklung des kollektiven Bewußtseins in der Neuzeit 2, Frankfurt a. Main 1994, S. 20.

39 N. Luhmann, in: Soziale Welt 42/2 (1991), S. 173.

40 N. Luhmann, Inklusion und Exklusion, S. 44f.

41 pPrisse 8,2–3 (Ptahhotep 220–223); Text bei Žába, Les Maximes de Ptahhotep. Académie Tchécoslovaque des Sciences, Section de la linguistique et de la littérature, Prag 1956, S. 33; vgl. ferner F. Junge, Lehre Ptahhoteps, S. 176.

Maxime 14 aus der »Lehre des Ptahhotep« verdeutlicht darüber hinaus, dass über die Wahrnehmung des Körpers nicht nur die kommunikative Relevanz des betreffenden Menschen bestimmt wird, sondern dass der Körper selber zeichenhaft ist für die ihm innewohnenden Gesittung. Ein wohlsortiertes Innenleben resultiert genau so in satter Körperlichkeit, wie sich ein liederlicher Geist in einem verwahrlosten Körper zeigt:

Ex. 5 Ein Vertrauenswürdiger, der nicht das Sagen in seinem Leib hin und her wendet, wird zum Befehlshaber seiner selbst und zum Begüterten, dem das ›Wie‹ seines Verhaltens gegeben ist. Dein Ruf ist wohlangesehen, niemand gibt schlechtes Zeugnis über dich; dein Körper ist satt und deine Aufmerksamkeit deiner Umgebung zugewandt, sodass man sich dir zugesellt mit dem, was dir nicht bekannt ist. Setzt aber die Gesinnung dessen, der auf seinen Leib hört, Verachtung für ihn an die Stelle der Liebe zu ihm, ist der Geist blank und sein Körper verwahrlost.[42]

Maßvolles Auftreten also und ganz grundsätzlich *Haltung* sind das Zeichen einer gelungenen Disziplinierung von Körper und Geist des idealen Menschen im Sinne des ethischen Bildbegriffs: Ein idealer Mensch hat einen idealen Körper, was andersherum bedeutet, dass der physische Körper zum primären Trägermedium solcher Idealbilder wird. Deswegen konnte man im pharaonischen Ägypten eben auch immer schon am Körper erkennen, mit wem man es zu tun hatte.

Ich hatte nun bereits darauf hingewiesen, dass die im Rahmen des ethischen Bildbegriffs zu analysierenden Bilder vom Menschen in verschiedenen Repräsentationsmedien zum Ausdruck kommen können. So werden solche Körperbilder eben nicht nur sprachlich codiert, sondern in der Tat auch bildhaft, diesmal verstanden im Sinne des *materiellen* Bildbegriffs. Auch im Rahmen der visuellen Wahrnehmung von materiellen Bildern konnte man im pharaonischen Ägypten bereits am bildlich dargestellten Körper erkennen, wen man vor sich hatte. Das mag ein kurzer Seitenblick auf die so genannten »Beischläferinnen-Figurinen« aus dem Mittleren Reich verdeutlichen (Taf. 2a):

Nach allem, was man ägyptologisch über diese weiß, repräsentiert ihr Dekor Tätowierungen,[43] die sich im archäologischen Befund auch an ungefähr zeitgleich datierten Frauenmumien (Taf. 2b) nachweisen lassen.[44]

Unabhängig davon, ob es zutrifft, was man ägyptologisch zur erotischen Semantik dieses Tätowierungsphänomens sagt,[45] erzeugt doch allein schon die bildhafte Repräsentation eines durch Tätowierung zugerichteten Frauenkörpers Klarheit darüber, um wen es sich sozial handelte. Dass dasselbe erst recht für den vormals belebten Frauenkörper zutreffend gewesen ist, sollte man annehmen dürfen. Die Mumien jedenfalls belegen auch empirisch, dass es sich bereits beim lebendigen Körper des Menschen um ein *Trägermedium* im Sinne der obigen Definition handelt. Als Repräsentationen von Körperzurichtungen wären dann auch die ebenfalls als Tätowierungen interpretierten Darstellungen des Gottes Bes (Taf. 3a) zu sehen, die sich in

42 pPrisse 8,6–10 (Ptahhotep 234–245); Text bei Žába, Ptahhotep, S. 34f.; vgl. ferner F. Junge, Lehre Ptahhoteps, S. 176f.

43 L. Keimer, Remarques sur le tatouage dans l'Égypte ancienne, MIE 53, Kairo 1948, S. 17ff.; R. S. Bianchi, »Tätowierung«, in: LÄ VI (1986), Sp. 145f.

44 Vgl. L. Keimer, Remarques, S. 6ff.; R. S. Bianchi, in: LÄ VI (1986), Sp. 145.

45 Vgl. etwa J. Bourriau, Pharaos and Mortals. Egyptian Art in the Middle Kingdom, Cambridge 1988, S. 125f.; D. B. Spanel, in: A. C. Capel / G. E. Markoe (Hg.), Mistress of the House. Mistress of Heaven. Women in Ancient Egypt, Cincinnati (1996), S. 65f.; R. S. Bianchi, in: LÄ VI (1986), Sp. 145; G. Pinch, Votive Offerings to Hathor, Oxford 1993, S. 213.

Bildern aus dem Neuen Reich auf den Oberschenkeln von Tänzerinnen finden.[46] Diese dürften über dieses Körpermerkmal de facto auch dann als Tänzerinnen erkennbar geblieben sein, wenn sie gerade einmal nicht tanzten.

Nun wird man mit Sicherheit sagen können, dass spezifisch behandelte Frauenkörper dieser Art beziehungsweise deren visuell wahrnehmbare Repräsentationen nicht unbedingt als vorbildhaft im Sinne eines idealen Menschenbildes gelten können,[47] wie es etwa in der »Lehre des Ptahhotep« formuliert wird. Aber genau das ist auch der Punkt: Je »ausgezeichneter« ein Körper ist – und zum Markiert-Sein gehörte im pharaonischen Ägypten bereits das erkennbare Frau-Sein[48] –, desto weniger relevant *kann* der Mensch, der ihn besitzt, in der Wahrnehmung derjenigen Menschen angesehen werden, die das jeweilige Idealbild vom Menschen durch medial spezifisch codierte Kommunikation stabil halten.[49] Man könnte dieses Phänomen mit einem Blick auf die Literaturwissenschaft auch als Abweichungsästhetik bezeichnen. Dieselbe, bereits am physischen Körper ersichtliche *Haltung*, die die »Lehre des Ptahhotep« (Ex. 4–5) vom idealen Menschen fordert und deren Fehlen der Lehrer in den »Miscellanies« (Ex. 1) beim betrunkenen Schüler beklagt, taucht als das kanonische Maß wieder auf, mit dem der vorbildhafte Mensch in materiellen visuellen Bildern repräsentiert wird und welches der weniger vorbildhafte Mensch in denselben Bildern weniger hat. Auch auf die Gefahr hin, dass hier ein Nichtfachmann in Sachen ägyptischer »Kunst« durch eine unangemessene Begriffswahl überkommene Vorurteile reproduziert, könnte man sagen: Je statischer, je körperloser, je unauffälliger, je unmarkierter jemand in visuell wahrnehmbaren Repräsentationen erscheint, desto idealer im Sinne des ethischen Bildbegriffs wird dieser jemand von denen wahrgenommen werden, die darüber entscheiden, was dazu gehört, Idealmensch bzw. Person zu sein.[50] Das *Maß* und die *(Un-)Markiertheit*[51] visueller Körperrepräsentationen sind also nichts anderes als Repräsentationsformen der Personenhaftigkeit des idealen Menschen. Dies lässt sich anhand von Ausführungen belegen, die Thomas Gilroy un-

46 Neben der in Taf. 3a gezeigten zweidimensionalen Tänzerinnendarstellung mit Bes-Tätowierung auf der Leidener Fayenceschale finden sich weitere auf einer Hauswand aus Deir el-Medineh sowie im Grab des Amunnacht in Theben (TT 341). In dreidimensionalen Medien finden sich Repräsentationen von Bes-Tätowierungen auf drei Fruchtbarkeitsfiguren (vgl. G. Pinch, Votive Offerings, S. 207; 209), auf dem Griff eines hölzernen Salblöffels aus Moskau, zwei Elfenbeinstatuetten aus Philadelphia sowie auf dem figürlichen Griff eines Bronzespiegels aus dem Brooklynmuseum, vgl. J. Vandier d'Abbadie, Une fresque civile de Deir el-Médineh, in: RdÉ 3 (1938), S. 27ff.; Taf. 3, L. Keimer, Remarques, S. 40ff. u. Taf. 20–22 sowie Ägyptische Kunst aus dem Brooklynmuseum, (Katalog zur Sonderausstellung Berlin, 4. September bis 31. Oktober 1976), Berlin 1976, Nr. 47.

47 Vgl. nochmals L. Keimer, Remarques, S. 105 zur sozialen Stellung solcherart Tätowierter.

48 Vgl. für unseren Zusammenhang etwa L. Meskell, Private Life in New Kingdom Egypt, Princeton / Oxford 2002, S. 134ff.; G. Robins, Women in Ancient Egypt, London 1993, S. 92ff. s. a. G. Moers, Fingierte Welten, S. 211ff.

49 Ich sage *kann*, um anzuzeigen, dass es meiner Meinung nach eine grundsätzliche Kommunikationskonvention gegeben hat, die dies ermöglichte, ohne dass das bedeutet, dass in jedem Kommunikations- und Interaktionskontext so und nur so operiert werden musste. Die Gastmahlszenen des Neuen Reiches etwa belegen das Vorhandensein von Kontexten, in denen Frauen als gleichberechtigt relevant repräsentiert werden können. In der Tat erscheinen sie dort aber auch weniger markiert als zum Beispiel ihre weiblichen Bedienungen.

50 J. Assmann, Preservation and Presentation of Self in Ancient Egyptian Portraiture, in: P. Der Manuelian (Hg.), Studies in Honor of William Kelly Simpson. Vol. I, Boston 1996, S. 79.

51 »Unmarkiertheit« und »Markiertheit« sind hier die beiden nur gegeneinander bestimmbaren Seiten der Form *Markiertheit*. Weder kann die je eine Seite der Form ohne die je andere bestimmt werden, noch gibt es ein jenseits dieser Form angesiedeltes absolutes Maß zur Bestimmung von Markiertheit. Zum hier verwendeten Formbegriff vgl. in aller Kürze N. Luhmann, in: Soziale Welt 42 (1991), S. 166f.

ter Rückgriff auf eine Masse älterer Beobachtungen in einem jüngst publizierten Aufsatz formuliert gebracht hat.[52]

Tafel 3b aus dem Grab des Haremhab in Memphis zeigt den idealen Oberschicht-Ägypter in maßvoller Bewegung und mit mehr oder weniger bewegungslosem Gesichtsausdruck. Bereits die in Tafel 4a wiedergegebenen Soldaten aus demselben Grab tragen sowohl bezüglich ihrer Bewegungen als auch bezüglich ihres Gesichtsausdrucks deutlich expressivere, realistischere oder individuellere Züge – wie immer man das nennen will – als die Noblen aus Tafel 3b.

Dass realistisch oder individuell nun keinesfalls heißen soll, dass es sich um eine porträthaft-realistische Repräsentation von Individuen handelt, sei hier vorsichtshalber vermerkt.[53] Menschenbilder dieser Art sind genauso typisiert wie die der Noblen und die der gefangenen Fremden, die von den genannten Soldaten bewacht werden. Die Körper dieser Fremden aber sind nun nicht nur ausschließlich durch die Repräsentation ethnischer Zugehörigkeit besonders markiert – das würde im Prinzip auch schon ausreichen, um ihre mangelnde Personenhaftigkeit (s. o.) und geringere kommunikative Relevanz zu repräsentieren –, sondern durch eine gegenüber den Soldaten nochmals gesteigerte Form der Expressivität von Gesichts- und Bewegungsausdruck. In Tafel 4b schließlich drohen sie in der Maß-Losigkeit ihrer Bewegung geradezu die Konturen zu verlieren und lösen sich zu einer nahezu amorphen Masse auf.

Nun weiß man, dass es nicht nur im Rahmen von Fremdvölkerdarstellungen zu besonderen Betonungen beziehungsweise zu markierten Repräsentationen von Körperlichkeit kommt, sondern dass Gleiches ebenso für Repräsentationen von Ägyptern gilt, in denen Ägyptologen normalerweise Unterschichtenangehörige erkennen. Nacktheit (Taf. 5a), unkontrollierter Haarwuchs oder Glatzenbildung (Taf. 5b u. 6b), offener Mund und ein dümmlicher Gesichtsausdruck (Taf. 6a u. 6b), all diese Dinge gelten ägyptologisch als typisierte Repräsentationsformen der »déformations professionelles« dieser Schichten.[54]

Wenn ich Recht habe und die Codierung von Personenhaftigkeit und damit kommunikativer Relevanz in materiellen wie in sprachlichen Bildern wohl unter anderem auch durch eine spezifische Repräsentation von Körperlichkeit geregelt wird, dann stellen solche Bilder in der ägyptischen Kultur eine Möglichkeit dar, die in ihnen besonders markierten Menschen – Unterschichtenangehörige und Fremde – in Relation zu dem Kommunikationssystem, aus dem diese Codierung stammt, als vergleichsweise irrelevante Unpersonen wahrzunehmen.[55] Ich möchte also versuchsweise behaupten, dass das eigentliche Problem, welches die Dame im oben zitierten Liebeslied aus dem »pChester Beatty I« (Ex. 2) plagte, ihr Wissen um das ideale Menschen- bzw. Körperbild ist, an welches ihr Person-Sein-Können in der Wahrnehmung ihrer Umwelt gekoppelt ist. Dies wird durch ein weiteres Liebeslied aus dem zweiten Zyklus des »pHarris 500« bestätigt, in dem eine liebeskranke Frau beschreibt, dass sie sich trotz mangelhafter Toilette in die Öffentlichkeit begibt, um ihren Angebeteten zu suchen:

52 T. D. Gilroy, Outlandish Outlanders. Foreigners and Caricature in Egyptian Art, in: GM 191 (2002), S. 35ff.

53 Ägyptologische Positionen zur Porträtfrage bei J. Assmann, Ikonologie der Identität: Vier Stilkategorien der altägyptischen Bildniskunst, in: M. Kraatz (Hg.), Das Bildnis in der Kunst des Alten Orients, Abhandlungen für die Kunde des Morgenlandes 50,1, Stuttgart 1990, S. 17ff. und F. Junge, Hem-iunu, Anch-ha-ef und die sog. »Ersatzköpfe« in: Kunst des Alten Reiches. Symposium im Deutschen Archäologischen Institut Kairo am 29. und 30. Oktober 1991, SDAIK 28, Mainz 1995, S. 103ff.

54 J. Assmann, Preservation and Presentation, S. 69f.; P. F. Houlihan, Wit and Humour in Ancient Egypt, London 2001, S. 52ff.

55 Vgl. nochmals G. Moers, Auch der Feind war nur ein Mensch, Kap. 3.

Ex. 6 Mein Herz erinnerte sich Deiner Liebe und nur ein Teil meines Schläfenhaares war geflochten.
Eilends bin ich herbeigekommen auf der Suche nach Dir und habe meine Fris[ur] vernachläs-
sigt. Ich hörte auf und löste meine Zöpfe, um für jede Gelegenheit bereit zu sein.[56]

Beide Frauen thematisieren ihre abweichende Körperlichkeit deshalb,[57] weil sie wissen, dass
ihr Liebesrausch ihnen einen Körper beschert hat, der sie zur Unperson machen würde, denn
niemandem, der sie so gesehen hätte – also genau die idealen *rmṯ.w*, von denen die Dame in
Ex. 2 sich wünscht, dass sie sie so nicht sehen mögen –, hätte verborgen bleiben können, dass
sie weniger wie ideale Damen aussehen als vielmehr wie die nicht nur bezüglich ihrer Haar-
tracht derangierten Erscheinungen aus dem erotischen »pTurin 55001« (Taf. 7a).[58] Im Übri-
gen hat man auch hier alles beisammen, was gängigerweise zur Repräsentation von Men-
schen des Exklusionsbereichs dient – Nacktheit, unkontrollierter Bart- und Haarwuchs,
zerzaustes Haar sowie ein offener Mund und Fratzenhaftigkeit.

Nun teilen Unterschichtägypter und Fremde das vornehmlich über ihren Körper Wahrge-
nommenwerden nicht nur im Rahmen visueller Medien, wie Taf. 7b verdeutlicht:

Auch in der so genannten Literatur findet sich mit der Gattung *Charakteristik* ein analoges
Medium zur Repräsentation der geringeren kommunikativen Relevanz beider Gruppen.[59]
Nicht umsonst tauchen Fremden- und Berufscharakteristiken etwa zur selben Zeit auf. Diese
Texte schreiben sowohl den Angehörigen der ägyptischen Unterschicht als auch den Fremden
einen aufs physische Leid reduzierten Erfahrungshorizont zu. So lässt sich etwa das materiel-
le Bild des nackten Schilfarbeiters aus TT 82 (Taf. 5a) mit dem analogen Sprachbild der fol-
genden Passage aus der »Lehre des Cheti« in Bezug setzen.

56 pHarris 500 (pBM 10060) rto. 5,12–6,2; Text bei B. Mathieu, Poesie amoureuse, Taf. 12,12–13,2. Die hier
vorgelegte Übersetzung basiert im Wesentlichen auf der Auffassung der Stelle bei E. Graefe, *wnḫ* ›lösen‹ (zu
pHarris 500, 5.12–6.2 und pD'Orb. 5.1–2), in: SAK 7 (1979), S. 53ff.

57 Man wird sich natürlich fragen müssen, ob es tatsächlich Frauen sind, die hier mit einer Frauenstimme reden
und ihre Normabweichungen thematisieren. Vieles deutet darauf hin, dass die ägyptischen Liebeslieder nicht
nur von Männern gemacht sind, sondern auch ausschließlich von Männern vorgetragen oder aufgeführt wur-
den, es sich also um vollständig männliche Projektionen von Weiblichkeit handelt, vgl. G. Moers / H.-H.
Münch, Kursorisches zur Konstruktion liebender Körper im pharaonischen Ägypten, in: A. Hagedorn (Hg.),
Perspectives on the Song of Songs – Perspektiven der Hoheliedauslegung, Beihefte zur Zeitschrift für alt-
testamentliche Wissenschaft, Berlin / New York 2005, S. 136–149. Aus dieser Perspektive würden abwei-
chende Frauenkörper in den Liebesliedern von Männern ebenso zur Schau gestellt wie die abweichenden
Körper von Unterschichtenangehörigen in visuellen Medien. Nichtsdestoweniger unterschieden sich diese
Frauen z.B. von nackten Dienerinnen in typischen Bankettszenen dadurch, dass sie auch noch in den männ-
lichen (Wunsch-) Vorstellungen von derangierter weiblicher Körperlichkeit fähig bleiben, selbst auf diese ab-
weichende Körperlichkeit zu reflektieren.

58 J. A. Omlin, Der Papyrus 55001 und seine satirisch-erotischen Zeichnungen und Inschriften. Catalogo del
Museo Egizio di Torino. Serie Prima – Monumenti e Testi III, Turin 1973.

59 P. Seibert, Die Charakteristik. Untersuchungen zu einer altägyptischen Sprechsitte und ihren Ausprägungen
in Folklore und Literatur. Teil 1: Philologische Bearbeitung der Bezeugungen, ÄA 17, Wiesbaden 1967. Vgl.
G. Moers, Unter den Sohlen Pharaos. Fremdheit und Alterität im pharaonischen Ägypten, in: F. Lauterbach /
F. Paul / U.-C. Sander (Hg.), Abgrenzung – Eingrenzung. Komparatistische Studien zur Dialektik kultureller
Identitätsbildung, Abhandlungen der Akademie der Wissenschaften zu Göttingen. Philologisch-Historische
Klasse, Dritte Folge, Nr. 264, Göttingen 2004, S. 130ff.

Ex. 7 Der Schilfrohrschneider fährt flussabwärts in die Deltasümpfe, um sich Schäfte zu holen. Kaum beginnt er seine Arbeit, bringen ihn schon die Mücken um. Die Gnitzen schlachten ihn, so dass er Beulen bekommt.[60]

Und auch in der wohlbekannten Asiatencharakteristik aus der »Lehre für Merikare« geht es zunächst um das körperliche Leid des Fremden, was ihn dann in ägyptischer Wahrnehmung allerdings auch zu dem macht, was er ist – einem unberechenbaren Barbaren:

Ex. 8 Vom Bogenmann wird nun wieder erzählt: Der elendige Asiat *ist* die Beschwerlichkeit des Ortes, an dem er lebt – knapp an Wasser, unzugänglich trotz der Menge an vorhandenen Wegen, und schlimm wegen der Berge. Er hat sich nicht an einem Platz niedergelassen, denn der Hunger wird immer seine Füße vorantreiben. Seit der Zeit des Horus ist *er am Kämpfen*, ohne dass er siegen könnte, aber auch ohne dass man ihn besiegt hätte, denn er kündigt den Tag des Kampfes nicht an, wie ein Räuber, den die Gemeinschaft ausgestoßen hat. [...] Kümmere Dich nicht um ihn. Der Asiat ist ein Krokodil auf seinem Ufer. Es schnappt zwar vom vereinsamten Weg, raubt in der Regel aber nicht von einem belebten Kai.[61]

Wenn man sich die sprachlich codierten Fremdenbilder ein wenig genauer anschaut, dann fällt gegenüber der Darstellung von Unterschichtenägyptern auf, dass es nicht bei der im Prinzip stigmatisierenden Zuschreibung körperlicher Deformationen bleibt. Vielmehr werden dem Fremden Formen von Körperlichkeit zugeschrieben, die jenseits des physisch Menschlichen angesiedelt sind. In einer Geschichte der Monstrositäten hätte folgendes Körper-Bild aus dem »pAnastasi I« sicherlich einen prominenten Platz als eines der frühesten Beispiele dafür, wie »zunächst isolierte körperliche Merkmale in eine psychophysische Gesamtbeschreibung des Körpers umgeformt werden und dann im nächsten Schritt in eine soziale Charakteristik einer Population«[62] münden: Immerhin messen die beschriebenen Beduinen vom Fuß bis zur Nase zwischen 2.10 und 2.62 Meter.

Ex. 9 Der Engpass ist gefährlich mit Schasu-Beduinen, die sich unter den Büschen verstecken. Einige sind vier oder fünf Ellen groß von ihrer Nase bis zu den Füßen und haben wild verzerrte Gesichter. Sie sind unfreundlich gesinnt und unempfänglich für schmeichelnde Worte.[63]

Vor allem aber Tiermetaphern wie die vom *Krokodil* in der »Lehre für Merikare« (s. o.), den asiatischen Hunden in der »Geschichte des Sinuhe« oder in der »Lehre des Amenemhet« sowie die einfallenden Vögel in der »Prophezeiung des Neferti« sind es, die mentale Bilder vom Körper des Fremden evozieren, welche die Betroffenen auf der Menschlichkeitsskala eindeutig herabstufen. Brutalisierungen dieser Art verdanken sich dem Versuch, die zwangsläufig wahrnehmbare und damit auch unhintergehbare Menschlichkeit des Fremden eben

60 Text und Kommentar bei S. Jäger, Altägyptische Berufstypologien. Lingua Aegyptia. Studia Monographica 4, Göttingen 2004, S. 136f.; S. XXXIIff.; vgl. ferner P. Seibert, Charakteristik, S. 125ff.

61 A. Merikare E 91–98; Text bei J. F. Quack, Merikare, S. 183ff.

62 R. Stichweh, Der Körper des Fremden, in: M. Hagner (Hg.), Der falsche Körper. Beiträge zu einer Geschichte der Monstrositäten, Göttingen 1995, S. 182.

63 pAnastasi I 23,7–8; Text bei H.-W. Fischer-Elfert, Die satirische Streitschrift des Papyrus Anastasi I: Textzusammenstellung, KÄT, Wiesbaden 1983, S. 139f.

doch zu hintergehen.[64] Denn obwohl der Ägypter im Gegensatz zu anders lautenden ägypto-
logischen Behauptungen den Fremden durchaus immer schon als Menschen wahrgenommen
hat, besteht aufgrund der Weltbildopposition zwischen dem Inklusionsbereich (Ägypten) und
dem Exklusionsbereich (fremde Umwelt) die Notwendigkeit, die Exklusion des Fremden
darüber zu motivieren, dass man ihn mit Hilfe solcher Brutalisierungen zumindest als Men-
schen anderer Art auszeichnen kann.[65]

Man könnte im Anschluss daran überlegen, ob sich nicht auch diverse Anspielungen auf
die tierische Körperlichkeit der Arbeiter aus der »Lehre des Cheti« ähnlich interpretieren las-
sen. Der Kupferschmied hat Krokodilsfinger und stinkt wie ein Fisch,[66] der Töpfer wühlt im
Schlamm wie ein Schwein,[67] der Bauer schnattert lauter als die Vögel,[68] der Köhler lebt zwar
noch, stinkt aber schon wie ein Toter[69] und der Schuster gleicht dem Tier, dessen Haut er ver-
arbeitet.[70] Die Tiermetaphern schließlich, die die »Miscellanies« für den lernunwilligen
Schüler bereithalten, verdanken sich dem spiegelbildlichen Versuch des Lehrers, dem inklusi-
onsunwilligen Subjekt über den Vergleich mit dem brutalisierten Fremden vor Augen zu füh-
ren, wo er sich sozial wiederfindet, wenn er sich nicht in die Schreiberschicht inkludieren
lässt.[71] Ein zusammenfassender Blick auf die im Rahmen des ethischen Bildbegriffs besproch-
chenen Körperbilder verschiedenster medialer Qualität, die Personalität und damit verbunden
die Differenz zwischen Inklusion und Exklusion repräsentierten, scheint jedenfalls zu zeigen,
dass Unten und Draußen aus elitekultureller Perspektive im Rahmen der vorgestellten Medi-
en als identisch vorgestellt und wahrgenommen werden *können*.[72]

4. Zusammenschau

Nun sollte es hier ja eigentlich weniger um spezifische Fragen der Selbst- und Fremdwahrneh-
mung oder um die Analyse der Repräsentationsstrategien von Schichtungsphänomenen der
ägyptischen Gesellschaft in verschiedenen Medien gehen – das wäre vor dem Hintergrund des
präsentierten Materials ja so neu nicht –, sondern vornehmlich um die bildtheoretischen Impli-
kationen dieses Materials und den Perspektivenwechsel, der sich aus der hier gewählten termi-
nologischen Ansprache solcher durch den ethischen Bildbegriff zusammengehaltenen Bilder
ergibt. Ich bin nämlich nicht der Meinung, dass es von vorderster Relevanz ist, ob es sich, wie
immer wieder behauptet, bei den Sprachbildern um Satiren und den visuellen Bildern um Ka-
rikaturen handelt, und sie sich aufgrund dieser Eigenschaften einer vorgängigen Wirklichkeit
verdanken müssen, die sodann aus diesen Bildern zu destillieren wäre. Ich würde vielmehr da-
für plädieren, dass man die in ägyptischen Körper-, Bild- und Textmedien codierten Körper-
bilder – auch der durch Tätowierung zugerichtete echte menschliche Körper ist ein Körper-

64 Belege und Argumentation bei G. Moers, Unter den Sohlen Pharaos, S. 134ff. sowie G. Moers, Auch der
 Feind war nur ein Mensch, Kap. 3.
65 G. Moers, Auch der Feind war nur ein Mensch.
66 pSallier II 4,8; S. Jäger, Berufstypologien, S. 132f.; XXIII.
67 pSallier II 5,7; S. Jäger, Berufstypologien, S. 136f.; XXXV.
68 pSallier II 6,8; S. Jäger, Berufstypologien, S. 140f.; XLVII.
69 pSallier II 7,9; S. Jäger, Berufstypologien, S. 144f.; LXI.
70 pSallier II 8,2; S. Jäger, Berufstypologien, S. 146f. u. S. LXIII.
71 Belege und Argumentation bei G. Moers, Auch der Feind war nur ein Mensch, Kap. 2.4.
72 Vgl. Fußn. 54 zum Vorhandensein einer generellen Kommunikationskonvention, die dies erlaubt, ohne dass
 sie es zwingend vorschreiben würde.

Bild, »steht pars pro toto für die Verwandlung [des] eigenen Körpers in ein Bild«[73] – zunächst erst einmal als Belege dafür ansehen sollte, dass Bilder des menschlichen Körpers in Ägypten *selbst* die primäre Projektionsfläche zur Auszeichnung von Differenzen in Menschenbildfragen sind.[74] Dieses Menschenbild kann dann umgekehrt in verschiedenen Repräsentationsmedien – Körper, Bild, Text – auch wieder verschieden codiert sein. Von ägyptologischer Seite kann es aus dieser Perspektive zur Zeit also gar keine eineindeutige Antworten darauf geben, welche Differenzen die Körper-Bilder verschiedener medialer Qualität jenseits der Regeln ihrer eigenen medialen Codierung im einzelnen repräsentieren und in welchem Verhältnis die Repräsentierbarkeit von Differenzen zum jeweiligen Repräsentationsmedium stehen. So möchte ich denn, obwohl ich alle drei Bildmedien (Körper, Bild, Text) miteinander kontextualisiert und in gängiger Manier auch auf soziale Schichtung abgebildet habe, eigentlich nichts über das Verhältnis dieser Medien zueinander oder zu vorgängigen Wirklichkeiten gesagt haben, die man dann nur zu leicht als soziale Realitäten missverstehen könnte. Mit Blick auf die Frage nach der Wirklichkeit dieser Bilder implizieren obige Ausführungen vielmehr, dass der reale menschliche Körper sowie die text- und bildgestützten Körperbilder drei ebenso gleichberechtigte wie zunächst voneinander unabhängige Repräsentationsmedien eines Menschenbildes sind, welches jenseits dieser Repräsentationen überhaupt keine andere Wirklichkeit gehabt haben muss. Vielmehr wird über die objektbildende Eigenschaft der Bilder aller drei Medien Wirklichkeit generiert und konturiert. Das kann dann für den Ägyptologen entgegen gängiger Ansicht auch heißen, dass aus der Bilderwelt eben nicht direkt auf *die* Lebenswelt der pharaonischen Ägypter zurückgeschlossen werden kann,[75] denn »auch in historischen Kulturen standen die Bilder für eine Evidenz ein […], die man nur in Bildern fand – und für die man Bilder erfand«.[76] Vielmehr spricht einiges dafür, dass es sich bei diesen Bildern um Teile von *Sozialmetaphern* oder von *Deutungsschemata* handelt, um Wahrnehmungsformen sozialer Wirklichkeit also, die mit dieser keinesfalls identisch sind.[77] Wenn man also die Begriffe Bild und Wirklichkeit miteinander in Bezug setzen will, dann kann es dabei nur entweder um die Wirklichkeit der materiellen Existenz der Bilder im Sinne ihres Mediums gehen oder aber um die Wirklichkeit der wahrscheinlich immer auch medienabhängigen objektbildenden Funktion, die die Bilder für den Wahrnehmenden im Rahmen der Wahrnehmung der Wirklichkeit haben. Was an sozialer Realität im Rahmen von Interaktio-

73 H. Belting, Bild-Anthropologie, S. 34.

74 Dazu grundsätzlich H. Belting, Bild-Anthropologie, S. 87ff.

75 Vgl. dazu nochmals die eingangs zitierten Ausführungen von S. Schoske / D. Wildung, Gott und Götter, S. 3.

76 So H. Belting, Bild-Anthropologie, S. 18 bzgl. der angeblichen »Krise der Repräsentation« in der Moderne, die laut Belting insofern falsch diagnostiziert ist, als man für die Vormoderne davon ausging, dass es zwangsläufig etwas den Bildern Vorgängiges gegeben haben muss.

77 Vgl. dazu O. G. Oexle, Deutungsschemata der sozialen Wirklichkeit im frühen und hohen Mittelalter. Ein Beitrag zur Geschichte des Wissens, in: F. Graus (Hg.), Mentalitäten im Mittelalter. Methodische und inhaltliche Probleme, Vorträge und Forschungen XXXV, Sigmaringen 1987, S. 65ff. Die von Oexle für das Mittelalter herausgearbeiteten Forschungsprämissen sind ohne Abstriche auf das pharaonische Ägypten übertragbar: »Es sind also drei Ebenen der Reflexion im Spiel: die soziale Wirklichkeit mittelalterlicher Gesellschaft, ihre Wahrnehmung und Deutung bei den Menschen jener vergangenen Jahrhunderte und schließlich unsere Wahrnehmungen und Deutungen jener Wirklichkeit und jener Deutungen. Es muß hier klar ausgesprochen werden, dass diese Frage mit den einfachen Antworten idealistischer, materialistischer oder positivistischer Herkunft, nämlich mit den dichotomischen Gegenüberstellungen von »Basis« und »Überbau« oder von »Wirklichkeit« und »Ideal« nicht zu klären sind« (Graus, S. 68f.). Ich danke Hubertus Münch für diesen Literaturhinweis.

nen dann sonst noch stattfinden konnte, bleibt aus dieser Perspektive zunächst komplett entzogen.[78]

5. Ausblick

Wenn obige Schlussfolgerungen zutreffend sind und nicht nur unter methodisch unkontrollierter Zuhilfenahme bildwissenschaftlicher Terminologie alte Hüte[79] aufgedampft wurden, dann wäre die Anwendung bildwissenschaftlicher Strukturvorgaben tatsächlich auch in diesem Fall ein Gewinn. Auch unabhängig davon sollte der Perspektivenreichtum eines spezifisch bildwissenschaftlichen ägyptologischen Programms jedoch außer Frage stehen. Dies auch und gerade vor dem Hintergrund der stetig anhängigen Relevanzfrage unseres Faches und einer sich zunehmend unerquicklich zeigenden hochschulpolitischen Gegenwart. Wenn man etwa in einer kulturwissenschaftlichen Einführung bezüglich der Bildwissenschaft nachlesen kann, dass die modernen Massenmedien Erben älterer Formen des Bildgebrauchs sind und Wirkungsmechanismen fortsetzen, die aus der Kunstgeschichte zwar längst bekannt sind, aber viel älteren Epochen zugeschrieben werden können, wenn ebenda zu lesen ist, dass in Werbung, Design und neuen visuellen Medien Techniken praktiziert werden, die in der wissenschaftlichen Beschäftigung mit der Vormoderne eine wichtige Rolle spielen,[80] dann sollte der relevanzfragenantwortsuchende Ägyptologe aufhorchen. Könnte es sein, dass man dazu auch etwas zu sagen hätte? Man könnte etwa fragen nach der Intermedialität zwischen Text und Bild in Text-Bild-Kombinationen bei Tempelpylonen, Gräbern oder Papyri. Für die in den Kognitionswissenschaften durchaus noch anhängige Frage nach der doppelten Codierung innerer mentaler Bilder könnte die Normalität dieser Praxis in Ägypten durchaus von Bedeutung sein. Grundsätzlicher kann man sich fragen, ob nicht die zweite Medienrevolution mit ihrer Bilderflut einen rettenden Strohhalm darstellen könnte für unser Fach, wenn wir uns in die Lage versetzten, den modernen Bild- und damit auch Medienwissenschaften inhaltsreiche Angebote zu machen. Aber beeilen müssen wir uns schon, denn wenn man zum Beispiel das Kapitel »Bild und Tod – Verkörperung in frühen Kulturen« aus Hans Beltings »Bild-Anthropologie« zur Hand nimmt, dann stellt man fest, dass wir ganz offensichtlich nicht mehr wirklich gebraucht werden. Belting erzählt uns nämlich interessante Dinge über unser Ägypten, die wir uns als Ägyptologen so nicht hätten erzählen können.[81]

78 Deswegen auch meine wiederholte Wahl modaler Formulierungen in diesen Zusammenhängen, s. o. Fußn. 49 u. 72.

79 G. Moers, Unter den Sohlen Pharaos; G. Moers, Auch der Feind war nur ein Mensch.

80 M. Fauser, Einführung, S. 97.

81 H. Belting, Bild-Anthropologie, S. 143ff., bes. S. 160ff.

Maya Müller

Die Königsplastik des Mittleren Reiches und ihre Schöpfer: Reden über Statuen – Wenn Statuen reden

Einleitung

Die vorliegende Untersuchung zur Königsplastik des Mittleren Reiches geht von der theoretischen Voraussetzung aus, dass jedes Kunstwerk für jemanden gemacht ist. Es gehört zu den Existenzbedingungen eines Werks, dass es einen Betrachter gibt. Der Betrachter wiederum impliziert, dass die Statue von einem Auftraggeber bestellt und von einem Künstler oder einer Werkstatt ausgeführt wird. Sie ist Trägerin einer Aussage oder Botschaft, die sie einem Empfänger (dem Rezipienten) mitteilen soll. Die Betrachter konnten die Statue in einem ganz bestimmten Gebäude an einem ganz bestimmten Standort unter ganz bestimmten Umständen wahrnehmen. Dieser ursprüngliche Kontext im umfassenden Sinn, den wir auch als die »einstige Rezeptionsrealität« bezeichnen können, ist seit der Entstehung zu einem kleineren oder meist größeren Teil verloren gegangen, ja die Königs- und Götterstatuen des Mittleren Reichs mitsamt den Tempel- und Grabanlagen, für die sie einst geschaffen worden waren, sind mit niederschmetternder Gründlichkeit zerstört worden. Diese einstige Rezeptionsrealität ist mit größtmöglicher Sorgfalt zu rekonstruieren. Insofern handelt es sich um einen rezeptionsästhetischen Ansatz[1]. Aufschlüsse dazu können wir zum einen von einigen – meist königlichen – Schriftquellen des Mittleren Reichs erwarten, in denen von Kunst gesprochen wird, und zum anderen von den Statuen selbst, die auf ihre Ausdrucksfähigkeit hin zu analysieren sind.

Für die Rekonstruktion der ursprünglichen Rezeptionsrealität sind folgende vier Fragen von besonderem Belang, von denen sich die ersten drei an die Schriftquellen richten, und die letzte an die Statuen selbst:

Punkt 1: Wer bestimmt über Aussehen und Aussage oder Botschaft einer Statue? Es sind der Auftraggeber (Punkt 1a) und der Künstler (Punkt 1b), die in Frage kommen; ihre Rolle ist anhand der schriftlichen Quellen, die zu diesem Thema allerdings sehr spärlich fließen, zu definieren.

Punkt 2: Wer ist der Betrachter der Statue bzw. der Empfänger der Botschaft? Es wird sich in vielen Fällen nicht um Einzelne, sondern um Kollektive oder Gruppen von Personen handeln. Auch diese Rolle ist zu untersuchen. Die Schriftquellen sind wiederum sehr knapp. Bildquellen, das heißt Reliefzyklen, welche die Teilnehmer an Prozessionen oder anderen Ritualen in Tempeln mit Bauplastik zeigen und mit Beischriften versehen sind, sind aus dem Mittleren Reich so gut wie gar nicht vorhanden, im Neuen Reich aber recht reichlich.

1 Vgl. A. Verbovsek, »Imago aegyptia«. Wirkungsstrukturen der altägyptischen Bildsprache und ihre Rezeption, im vorliegenden Band; W. Kemp, Kunstwissenschaft und Rezeptionsästhetik, in: W. Kemp (Hg.), Der Betrachter ist im Bild. Kunstwissenschaft und Rezeptionsästhetik, Köln 1985, bes. S. 22–24.

Punkt 3: Welches ist die Aussage oder Botschaft der Statue gemäss den schriftlichen Quellen? Wir fragen nach bewussten Mitteilungen des Auftraggebers über die Aussage oder Wirkung, die eine Statue erzielen soll. Daran knüpft sich die Überlegung, ob die Aussage an der entsprechenden Statue sichtbar Gestalt annehmen muss, oder ob es genügt, sie schriftlich festzuhalten.

Punkt 4: Welches sind die sinntragenden Eigenschaften einer Statue und was leisten sie zur Frage nach dem Ausdruck?

Um den verlorenen Kontext einer Statue wiederzugewinnen, sind alle Eigenschaften aufzusuchen, die Sinnträger sein können und zusammen den Ausdruck der Statue konstituieren. Wir können auch von den Mitteln sprechen, welche auf den Betrachter einwirken, oder von den ikonographischen Elementen, aus denen sich die Figur zusammensetzt, oder von den Parametern, nach denen sie analysiert wird. Bei der Königsplastik des Mittleren Reiches können wir zwei Gruppen davon unterscheiden, die wir als die objektiven und die subjektiven bezeichnen wollen, oder vielleicht besser als die materiellen und die mimischen. Die objektiven oder materiellen Eigenschaften sind diejenigen, die messbar und eindeutig beschreibbar sind. Es sind im wesentlichen die folgenden: Körperhaltung; Gesten; Tracht und Insignien; Objekte, die in den Händen gehalten werden; Materialfarben; Bemalung; Reliefs auf dem Sockel oder anderen Flächen; die relative Größe einer Figur im Verhältnis zur Lebensgröße des Menschen; Inschrift(en); bei Gruppenstatuen: Partnerstatue(n); Zugehörigkeit zu einem Paar oder einer Serie von Statuen; der Standort im Gebäude, für den die Statue konzipiert worden war. Als subjektiv oder mimisch können die physiognomischen Eigenschaften des Gesichts und des Körpers einer Statue bezeichnet werden, und zwar darum, weil ihre Beschreibung von der subjektiven Wahrnehmung zuerst des Bildhauers und dann des Betrachters abhängt.

Die materiellen und die mimischen Eigenschaften der Statue sprechen den Betrachter auf zwei ganz verschiedenen Ebenen an, die einen vorwiegend auf der rationalen, die anderen auf der emotionalen. Sie sprechen somit verschiedene Sprachen. Dadurch wird die Frage aufgeworfen, ob ihre Botschaften konvergent oder auch widersprüchlich sein können und ob zu den materiellen bzw. mimischen Eigenschaften je eine spezifische Art von Aussagen gehört. Es ist anzunehmen, dass die materiellen Eigenschaften von Statuen religiöse und politische Aussagen, insbesondere über die Beziehung des Herrschers zur Götterwelt, machen können, während die mimischen in der Lage sind, etwas über die innere, die psychische Befindlichkeit des Dargestellten nach außen dringen zu lassen.

Die Punkte 1 bis 3 werden im I. Teil des vorliegenden Aufsatzes behandelt, in welchem die »Kunstschaffenden« des Mittleren Reichs zu Wort kommen. Es werden diejenigen Schriftquellen der 11. bis 13. Dynastie einbezogen, die das Thema Kunst in irgendeiner Form ansprechen.

Punkt 4 ist Gegenstand des II. Teils, wo die Statuen selbst zum Sprechen gebracht werden sollen, indem die mimischen Eigenschaften der Rundplastik Mentuhoteps II., III. und Sesostris' I. analysiert werden. Der sich daraus ergebende Ausdruck der Persönlichkeit dieser Herrscher wird verglichen mit dem Bild, das das zeitgenössische Schrifttum von ihnen zeichnete. (Der materielle Aspekt der Königsplastik und die mimischen Eigenschaften der Herrscher der zweiten Hälfte der 12. Dynastie müssen aus Platzgründen späteren Publikationen vorbehalten bleiben.)

I. Reden über Statuen: Schriftquellen des Mittleren Reichs zum Thema Kunst

Im Folgenden ist zu diskutieren, was die Schriftquellen des Mittleren Reiches über die Punkte 1 bis 3 aussagen. Es gibt eine ganze Reihe von Quellen, meist in Form von Statueninschriften, die wenigstens den Namen des königlichen Auftraggebers nennen (Punkt 1a). Ergiebiger sind aber politische oder literarische Texte, die auf anderen Schriftträgern stehen. Zur Rolle des Künstlers (Punkt 1b) schweigen sich die Quellen weitgehend aus; das Thema kommt nur auf einer Stele eines Künstlers vor. Der/die EmpfängerIn (Punkt 2) der Botschaft wird immerhin recht oft genannt, besonders im Falle von Widmungsinschriften auf Statuen, die den Namen einer Gottheit anführen. Die Botschaft oder Wirkung einer Statue (Punkt 3) wird sehr selten angesprochen in den königlichen Inschriften des Mittleren Reiches. Immerhin gibt es vereinzelte Fälle, wo es doch geschieht, und zwar wiederum in politisch-literarischen Texten.

I. 1 Zu Punkt 1a: Zur Rolle des Auftraggebers

Auftraggeber von Königs- und Götterstatuen ist grundsätzlich der Herrscher allein. Er hat aber einen Hofstaat, einen Kreis von »Räten« um sich, die die Träger der höchsten Ehrentitel und zuweilen auch Amtstitel sind. Es sind drei Texte aus dem Mittleren Reich erhalten, die wichtige Aufschlüsse bieten über die Rolle des Auftraggebers: die so genannte *Berliner Lederhandschrift Sesostris' I.*, die von der Neugründung des Re-Harachtetempels in Heliopolis handelt; die *Stele Ichernofrets aus Abydos*, der dort als Stellvertreter Sesostris' III. die Erneuerungsarbeiten an Kultstatuen beziehungsweise -geräten sowie die Festrituale des Osiris leitete, und die *Stele König Neferhoteps I. aus Abydos*, die das gleiche Thema behandelt wie diejenige Ichernofrets.

Die *Pergamenturkunde Sesostris' I. (Papyrus Berlin 3029)* beschreibt mit einiger Ausführlichkeit, wie der Herrscher vorging bei der Gründung des neuen Tempels, den er für Atum in Heliopolis zu errichten gedachte.[2] Der Vorgang zerfällt in zwei Akte: Zunächst findet eine feierliche Sitzung im Thronsaal statt, zu welcher der Herrscher mit der Doppelkrone erscheint, dem Hofstaat den Zweck seines Plans auseinandersetzt und den obersten Schatzmeister als ausführenden Bauleiter einsetzt. Sodann schreitet Sesostris I. zum Gründungsritual, dem »Spannen des Stricks«, nunmehr angetan mit der Federkrone. Für unseren Zusammenhang interessiert vor allem, wie der König seine Rolle als Auftraggeber auffasst und in welcher Weise er den Hof einbezieht. Am Anfang heißt es (in der Übersetzung von Miriam Lichtheim):

> »A sitting took place in the audience hall; a consultation with his followers, the companions of the palace, the officials of the private appartment. Command was uttered for them to hear; counsel was given for them to learn.«

Wir erfahren, dass die vornehmsten Männer, der innerste Kreis, der dem Thron am nächsten stand, zur Sitzung eingeladen war. Trotz dieser Qualifikation verlangt aber der König keinen Rat von den Räten, im Gegenteil, er allein ist es, der einen Rat oder vielmehr Befehl erteilt, den die Höflinge anzunehmen haben. Diese Einleitung spielt sich auf der Ebene der alltägli-

2 M. Lichtheim, Ancient Egyptian Literature I. The Old and Middle Kingdoms, Berkeley / Los Angeles / London 1973, S. 115–118.

chen, irdischen Realität ab. Darauf folgt ein Dialog mit den Höflingen, der mit einer langen Ansprache des Königs beginnt. In diesem Gespräch eröffnet sich uns eine abgehobene Phantasiewelt, in welcher sich Sesostris I. selbst als den Gott Horus vorstellt und seinen Vater als Atum. Die Höflinge behandeln ihn in ihrer Antwort dementsprechend als Gott. Die Rede des Königs hebt mit einem Preishymnus auf sich selbst an, der in sieben Doppelversen schildert, wie der Gott ihn zeugte, schuf, erwählte und »schon im Ei« als Herrscher bestimmte. Sieben weitere Doppelverse beschreiben den unfassbaren, himmelweiten Umfang der Herrscherlichkeit Sesostris' I., die ihn zum wahren Spiegelbild des göttlichen Weltenherrschers macht. Das Thema ist die Legitimation des Herrschers als Erwählter des Schöpfergottes bereits im Augenblick seiner Zeugung.

Im Anschluss an den Hymnus umreißt Sesostris I. seine Idee eines Werks, das der Großartigkeit seines göttlichen Vaters und seiner eigenen gerecht werden soll, wie folgt:

> »Having come as Horus, I have taken thought. Having established the offerings of the gods, I will construct a great house for my father Atum. He will enrich himself inasmuch as he made me conquer. I will supply his altars on earth. I will build my house in his neighborhood. My excellence will be remembered in his house: the shrine is my name, the lake my memorial. To do what profits is eternity.«

Sobald er König geworden war, richtete er seine Gedanken darauf, und er wusste spontan, was er tun muss und wie das Werk aussehen soll. Ein wichtiges Ziel wird gleich zu Anfang betont: Die Erbauung des Tempels geschieht zum gegenseitigen Nutzen des Gottes und des Königs.

Der überraschendste und aufschlussreichste Teil der ganzen Schrift ist die Antwort der Räte an ihren Herrn, den sie als Gott bezeichnen, wenn sie ihn als Initiator des zu erbauenden Tempels charakterisieren:

> »Then spoke the royal companions in answer to their god: Hu is (in) your mouth, Sia is behind you, O King! What you plan comes about: the King's appearance at the Uniting-of-the-Two-Lands, to stretch [the cord] in your temple. … The people cannot succeed (km) without you. Your Majesty is everyone's eyes.«

Wenn die Räte den König als »Sia« und »Hu« anreden, das heißt als »Erkennen« und »Ausspruch«, umreißen sie damit seine urzeitliche Schöpferrolle, wie sie etwa in den Sargtexten (CT VI, 268) beschrieben ist:

> »I am He who is south of his wall [Ptah], monarch of the gods; I am king of the sky, Nehebkau who rules the two lands … I am Nehebkau, and their [Götter und Menschen] lives are at my hand, when I wish, I act and they live … because I am Hu who is on my mouth and Sia who is in my body«.[3]

Wie bei Ptah tritt das, was Sesostris I. denkt oder ausspricht, sogleich in Erscheinung – (»wenn ich will, mache ich und sie leben«) – nach dem Prinzip der Schöpfung durch das Wort. Als Träger von Hu und Sia tritt er selbst in der Rolle des Schöpfergottes auf. Demgegenüber gibt uns der Text die ganz andere Bedingtheit der gewöhnlichen Sterblichen zu ver-

3 R. O. Faulkner, The Ancient Egyptian Coffin Texts II. Spells 355–787, Warminster 1977, S. 222 (Spell 647).

stehen, wenn es heißt, dass niemandem etwas gelingen kann ohne Pharao und dass er jedermanns Augen sei. Die Höflinge und alle anderen Leute können nicht selbständig denken, urteilen oder handeln, sondern sie sehen die Welt und insbesondere das Werk des Königs nur mit seinen Augen.

Wenn wir nun von der abgehobenen Phantasiewelt der Götterrolle zur Ebene der alltäglichen Realität hinüber wechseln, so heißt dies, dass bei Sesostris I. die Kommunikation nur in eine Richtung geht. Der Gott-König geht absolut autoritär vor, er hört niemanden an, denn er ist der einzige Autor, der fähig ist, ein Werk zu schaffen, und er weiß intuitiv, wie das Werk beschaffen sein soll. Der Rest der Menschheit befindet sich, da der König ihm seine Augen leiht, in vollkommener Übereinstimmung mit ihm. Für unseren Zusammenhang bedeutet dies vor allem, dass der König die Rezeption des Werks vollständig vorgibt. Eine andere Auffassung als die von ihm beabsichtigte ist gar nicht möglich.

Die Höflinge beschließen ihre Antwort mit dem Hinweis auf Sinn und Zweck des neuen Tempelkomplexes:

> »When your temple is built, it will provide for the altar. It will give service to your image. It will befriend your statues in all eternity.«

Die Höflinge formulieren die Absicht des ganzen monumentalen Unternehmens im Hinblick auf die Bauplastik: Der Tempel mit seinem elaborierten Versorgungssystem wird gleichsam als ein lebendiger Organismus beschrieben, in dessen Blutkreislauf der König in Gestalt seiner Statuen integriert ist. Das oberste Ziel ist, die Beziehung zum göttlichen Vater aufrecht zu erhalten, und es wird durch die Symbiose der Königsstatuen mit der Kultstatue des Gottes erreicht. Durch seine Statuen stellt Sesostris I. sich auf Erden in seiner wahren Gestalt als Gott dar.

Auf den Dialog zwischen König und Hofstaat folgt ein Abschnitt, der wiederum auf der Ebene der alltäglichen Realität spielt, denn Sesostris I. überträgt einem hohen Beamten die Leitung der Bauarbeiten. Es ist der oberste Schatzmeister, der für die Finanzierung und die Organisation der Arbeiten zuständig ist. Die Berufung des Bauleiters beschließt die Thronsitzung, und nun wird das Gründungsritual durchgeführt:

> »The king appeared in the plumed crown, with all the people following him. The chief lector-priest and scribe of the divine books stretched the cord. The rope was released, laid in the ground, made to be this temple. His Majesty ordered to proceed; the king turned round before the people. Joined together were Upper and Lower Egypt.« … [Ende verloren].

Das Ritual beginnt mit dem Auftritt des Königs als Sonnengott vor großem Publikum. Die für unseren Zusammenhang hoch interessante Information des Textes ist aber der Auftritt des zweiten Akteurs, dessen Name nicht genannt wird. Die Titel »oberster Vorlesepriester« und »Schreiber der Gottesbücher« kennzeichnen ihn als Gelehrten von höchstem Rang. Ihm war es vorbehalten, den symbolischen Strick zu spannen, der die Fluchtlinie des Tempels andeutet. Der folgende Satz über das Lösen des Stricks ist vermutlich so zu verstehen, dass der Strick auf den sandigen Boden gelegt wurde und der Abdruck den Grundriss des Tempels wenigstens in den Hauptlinien sichtbar werden ließ. Das Zusammenwirken des Königs und des Gelehrten ist es, so verstehe ich die Schilderung, was den Bau sogleich virtuell entstehen lässt, sie stampfen ihn sozusagen aus dem Boden. Ägypten ist neu gegründet, so heißt es, in einem Kraftakt wurde die Schöpfung neu vollzogen.

Dem Gelehrten kommt ein entscheidender Anteil an der Gründung zu, der aber ausschließlich auf der symbolischen Ebene behandelt wird. Ich denke, die Aussage sei auf die reale Ebene übersetzbar und dahingehend zu deuten, dass der oberste Vorlesepriester Einfluss hatte auf die Gestaltung des Gebäudes, ja dass er das mythische und vielleicht auch das technische Fachwissen beibrachte, das zur Planung nötig war. Zur Rolle des Gelehrten wird weiter unten in Zusammenhang mit den Stelen Ichernofrets und Neferhoteps I. mehr zu sagen sein. Hier sei aber bereits an die »Wundergeschichten am Hofe des Königs Cheops«[4] erinnert, genauer an die Tatsache, dass die Protagonisten dort, die obersten Vorlesepriester und Bücherschreiber, zugleich die größten Magier sind. Der exzentrischste von ihnen, der halbgottartige Djedi, wird vom Prinzen Djedefhor eingeführt, und zwar weil er Cheops eine seit langem gesuchte Information über die »Naoi des Thot« geben kann, die der Herrscher dringend benötigt, um sich das gleiche für seine Pyramidenanlage machen zu lassen. Zwar bleibt es – wegen der Seltenheit der entscheidenden Wörter – im Dunkeln, ob diese »Naoi« Gebäude oder Mobiliar sind, und was der König insbesondere wissen möchte, die Anzahl oder eher die Ausmaße. Aber es ist für unseren Zusammenhang bedeutsam, dass es zwei hochrangige Gelehrte und Magier braucht, den gargantuesken Djedi und einen Hohepriester des Re von Heliopolis, um diese für die Vollendung der königlichen Grabanlage unentbehrliche Information zu beschaffen, die, wie es heißt, in einem Archivraum von Heliopolis gelagert ist.

Der zweite, für die Rolle des Auftraggebers von Statuen relevante Text ist die *Stele Berlin 1204*, die vom obersten Schatzmeister und Siegelbewahrer Sesostris' III., *Ichernofret*, in Abydos errichtet worden war.[5] Die Inschrift berichtet, wie Ichernofret im Auftrag des Königs die »geheime« Prozessionsstatue des Osiris mit ihrem tragbaren Schrein, drei verschiedene Prozessionsbarken und die Statuen und Schreine der übrigen Gottheiten von Abydos neu macht, und wie der König das Gold, das er auf seinem neuesten Nubien-Feldzug erbeutete, dazu hergibt; anschließend leitet Ichernofret die große Prozession, die er als dramatische Aufführung einer »Seeschlacht« auf dem Tempelteich beschreibt. Der sehr knapp gefasste Text lässt eine relativ komplexe Folge von Handlungen erkennen, die als Festspiel bezeichnet werden kann. Wir erfahren von den Vorgängen aus der Perspektive des hohen Beamten und zugleich aus derjenigen des Herrschers, dessen, wie wir annehmen dürfen, authentische Legitimationsurkunde auf der Stele wiedergegeben ist. Ganz ungewöhnlich und interessant ist die Art, wie Sesostris III. den Mann beschreibt, den er als seinen Stellvertreter nach Abydos sandte:

> »You will surely do this in the best manner of acting for the benefit of my father Osiris. For my majesty sends you with my heart relying on your doing everything to the heart's content of my majesty. For you were brought up as a pupil of my majesty. You have grown up as foster child of my majesty, the sole pupil of my palace. My majesty made you a Companion when you were a youth of twenty-six years. My majesty did this because I saw you as one of excellent conduct, keen of tongue, who had come from the womb as one wise.«

Im Text Ichernofrets fehlt die Audienz im Thronsaal, bei welcher der Herrscher seinen Plan proklamiert. Er fängt mit dem Auftrag an den Durchführenden an. Dabei ist aber ein wichtiger Unterschied gegenüber der Lederhandschrift Sesostris' I. festzustellen, in welcher der

4 E. Brunner-Traut, Altägyptische Märchen, Mythen und andere volkstümliche Erzählungen, München 1989, S. 48; 50 (Papyrus Westcar).

5 M. Lichtheim, Ancient Egyptian Literature I, S. 123–125.

König einen zwar sehr hochrangigen Beamten als Bauleiter bestellt, der aber doch zur Kategorie derjenigen zählt, die nur mit den Augen ihres Herrn sehen können. Demgegenüber beruht die ungemein achtungs- und vertrauensvolle Beziehung Sesostris' III. zu seinem Abgesandten darauf, dass Ichernofret der Pflegsohn des Königs war und vom König erzogen, für gut befunden und erwählt wurde. (Diese Charakterisierung steht übrigens in auffallendem Gegensatz zu derjenigen, die Sesostris III. auf der Semna-Stele von seinen leiblichen Söhnen gibt, aber diese konnte selbst der Pharao nicht auswählen.) Ichernofret ist, wie es heißt, »als Pflegsohn Meiner Majestät, als einziger Schüler meines Palastes« aufgewachsen und daher traut und gesteht Sesostris III. ihm selbständiges Handeln zu (er macht den Schrein, er belehrt die Priester über die Rituale etc.), er ist dem Herrscher – zumindest im Rahmen eines solchen Auftrags – gleichgestellt und somit ein wahres Alter Ego. Wir erfahren auch, was ihn besonders dafür qualifiziert: Er zeichnet sich durch untadeliges Wesen und verständige Rede aus, und er war vom Mutterleib an gescheit. Diese Wendungen sind zwar nicht originell, die letztgenannte ist vor allem aus der Lehre für König Merikare bekannt. Es ist aber ungewohnt, dass ein König sie auf einen Höfling anwendet, während sie sonst nur in Selbstzeugnissen von Beamten vorkommen. Vermutlich verstand man unter »verständiger Rede« auch etwas ähnliches wie das, was heute als »politisch korrekte« Ausdrucksweise bezeichnet wird. Außerdem darf erwogen werden, ob Ichernofret doch ein leiblicher Sohn Sesostris' III. war, jedoch von einer Nebenfrau, also das, was man in der neueren europäischen Geschichte unter einem »königlichen Bastard« verstand.

Ichernofret leitet den Bericht über seine Tätigkeit in Abydos mit der Feststellung ein, dass er als »sein geliebter Sohn« für Osiris gehandelt habe. Er tritt also in die Götterrolle des Horus ein, sobald er sich ans Werk macht, das zwei Teile hat. Im ersten macht er die große Barke und den tragbaren Schrein, die Statuen der Götter von Abydos und deren Naoi neu aus allerlei kostbaren Materialien. Dann belehrt er die Priester über die Rituale und leitet die Arbeit an der Neschmet-Barke. In seiner Eigenschaft als »Leiter der Geheimnisse« (bzw. »Geheimrat«) schmückt er Osiris mit Kronen, Insignien und Schmuckstücken aus Gold und Edelsteinen. Im zweiten Teil gestaltet Ichernofret das Festspiel, das mit dem Auszug Upuauts beginnt. Es folgt der Große Auszug des Osiris zu Schiff. Der Hergang wird als ein urzeitliches Götterdrama erzählt, das sich hier und jetzt realisiert. Es wird zugleich als ein von Menschen inszeniertes Schauspiel gekennzeichnet, und zwar dadurch, dass Ichernofret in der Ich-Form redet und ununterbrochen seine Protagonistenrolle herausstreicht. Er ist es, der das Geschehen vorantreibt und zum guten Ende führt: Er ist immer noch Horus, der Sohn und Rächer des Osiris. Die Zeitebenen gehen ineinander auf.

Zwei Bemerkungen der Stele bringen Ichernofrets Fachwissen ins Spiel. Die erste, die sich mit den Ritualen befasst, lautet:

> »Ich ließ die Stundenpriester[6] ihre Aufgabe [erfüllen]; ich belehrte sie über das ›Tägliche Ritual‹ und die ›Feste der Zeitläufte‹.«

Das Tägliche Ritual ist die Basis, das Paradigma des Gottesdienstes überhaupt; die Feste der Zeitläufte sind an bestimmte Daten gebundene Feste bestimmter Gottheiten, die über das Kalenderjahr verteilt sind, und dazu gehörte vermutlich auch das Festspiel des Osiris von Abydos. Es ist unwahrscheinlich, dass Ichernofret den Priestern von Abydos elementaren Unter-

6 Hier wohl auf die Tagesstunden bezogen, wie in den Sonnenhymnen des Neuen Reiches? (J. Assmann, Ägyptische Hymnen und Gebete, Zürich / München 1975, S. 97–112, Nr. 1–12).

richt erteilt hat in einer Materie, die sie längst beherrschen mussten, um überhaupt an diesem wichtigen Heiligtum zu amtieren. Die Anspielung dürfte viel eher so zu verstehen sein, dass Ichernofret als Experte aus der Residenz auftritt, der über außerordentliche Kompetenzen verfügt – dafür spricht auch sein Titel »Leiter der Geheimnisse«, das heißt Gelehrter, der wenig weiter unten im Text genannt wird. Ihm dürfte die Kontrolle über die Ritualtexte zugekommen sein. Dabei gibt es zwei Möglichkeiten: Er könnte entweder die Einhaltung der Tradition überwachen oder im Gegenteil eine neue Version einführen. Das letztere dürfte wohl zutreffen. Es sind mir allerdings sonst keine Zeugnisse zu einem solchen Vorgang bekannt. Aber die Ritualtexte mussten ohnehin von Zeit zu Zeit abgeschrieben und neu redigiert werden, und zwar dürfte sich dies grundsätzlich in jeder Regierungszeit wiederholt haben, so wie der König die Tempel neu baut und die Opfer der Götter neu festsetzt. Die beiden letztgenannten Erneuerungen werden in königlichen Inschriften immer wieder angesprochen, die Erneuerung der Rituale aber kaum, was aber nicht heißen muss, dass sie nicht stattfand. Die Quellen schweigen auch über eine andere Erneuerung, die mit Sicherheit am Anfang jeder Regierung stattfand, aber nie schriftlich erwähnt wird, nämlich die »Erfindung« des aktuellen königlichen Porträttyps.

Die wichtigste der selten erhaltenen Ritualhandschriften ist sicher der so genannte dramatische Ramesseumpapyrus, der ein schwer definierbares, mit dem Regierungsantritt verbundenes Königsritual enthält und die Kartusche Sesostris' I.[7] trägt. Es handelt sich zweifellos um eine vom König bestellte Neuredaktion. Dieser Papyrus wurde auf dem Grund eines Grabschachts unter den Magazinräumen des Ramesseums gefunden, und zwar in einem Bücherkasten, der einem Gelehrten und Magier der 13. Dynastie gehört haben dürfte. Der Kasten enthielt eine einmalige Zusammenstellung religiöser, literarischer, magischer und administrativer Texte des Mittleren Reiches von unschätzbarer Qualität[8] nebst etlichen magischen Geräten und Figuren. Dieser einmalige Fund zeigt immerhin, dass sich auch so wichtige Papyri wie der Ritualtext Sesostris' I. im privaten Besitz eines Gelehrten befinden konnten. Es lässt sich daraus schließen, dass er als Meisterwerk eines großen Gelehrten seiner Zeit galt, ein Muster und Vorbild für die Späteren. Im übrigen wissen wir aus literarischen Texten von den privaten Büchern der Gelehrten. Den schon erwähnten »Wundergeschichten am Hofe des Königs Cheops« ist zu entnehmen, dass der große Magier Djedi für seine Reise zur Residenz zwei zusätzliche Schiffe braucht für seine Bücher und seine Sekretäre, und in dem ptolemäisch-römischen Setna-Zyklus ist es Prinz Setna-Chaemwase, der sich in einer lebensgefährlichen Lage seine magischen Bücher von zu Hause bringen lässt. Jedenfalls ist Ichernofret ein Gelehrter, und dies ist in Ägypten gleichbedeutend mit dem Magier, der über das geheime Wissen seiner Zeit verfügt. Seine Kompetenz in Sachen Rituale dürfte sich übrigens nicht nur auf die Texte, sondern auch auf die Regie, die Aufführungspraxis des Festspiels, bezogen haben. Die zweite Bemerkung über das Fachwissen Ichernofrets lautet:

7 K. Sethe, Dramatische Texte zu altägyptischen Mysterienspielen II. Der dramatische Ramesseumpapyrus. Ein Spiel zur Thronbesteigung des Königs, UGAÄ 10.2, Leipzig 1928, S. 81–264.

8 Gefunden von Quibell 1896, vgl. J. E. Quibell, The Ramesseum, Egyptian Research Account 2, London 1898, S. 3; R. K. Ritner, The Mechanics of Ancient Egyptian Magical Practice, SAOC 54, Chicago 1993, S. 206 (Anm. 953); 222–233, (Anm. 1077: Diskussion der Frage, ob es sich um eine Beisetzung beschädigten sakralen Geräts handle oder um ehemaliges Tempelgut, das sich ein Magier zu privatem Gebrauch angeeignet hatte); N. Reeves, Ancient Egypt. The Great Discoveries, London 2000, S. 96.

»I decked the breast of the lord of Abydos with lapis lazuli and turquoise, fine gold, and all the costly stones which are the ornaments of a gods body. I clothed the god with his regalia in my rank of master of secrets, in my function of stolist.«

Als »Geheimnis« wird in Ägypten alles hochspezialisierte Fachwissen bezeichnet, das nur einer kleinen, auserwählten Elite zugänglich ist. Wir werden den Begriff weiter unten in Zusammenhang mit den Stelen Neferhoteps I. und des Künstlers Irtisen ausführlicher behandeln. Es ist sehr aufschlussreich, dass Ichernofret den Begriff in Zusammenhang mit den göttlichen Attributen des Götterbildes, das außerdem am Anfang der Stele als »geheim« bezeichnet wurde, verwendet. Er gehört offenbar zu den Auserwählten, die genaue Kenntnis vom Aussehen des Gottes haben. Was dem Text über die Botschaft der Statue des Osiris zu entnehmen ist, wird weiter unten unter Punkt 3 diskutiert (I.4, S. 45).

Auch die Stele Ichernofrets sagt scheinbar nicht direkt etwas darüber aus, wer über Aussehen und Botschaft des Werks bestimmte, jedenfalls nicht auf der realen Ebene. In der Berliner Lederhandschrift tritt Sesostris I. sowohl bei der Thronsitzung, an welcher er den Plan seines Werks verkündet, als auch bei der Gründungszeremonie in der Rolle des Schöpfergottes auf, dessen Wort Realität wird, und bei der Gründungszeremonie tritt der Gelehrte und Magier hinzu, der den Bau virtuell entstehen lässt. Im Vergleich damit sind bei Ichernofret charakteristische Unterschiede festzustellen. Ichernofret handelt zwar ebenfalls als Gott, er spielt aber die Rolle des Horus, des Sohnes des Osiris, der die Barken und Prozessionsstatuen macht, die Feinde des Osiris fällt und den göttlichen Vater im Triumph in seinen Palast zurückführt. Zugleich ist Ichernofret der Experte in Ritualen und Herr der Geheimnisse, also der Gelehrte und Magier, der über das mythische Wissen verfügt. Er füllt beide Rollen zugleich aus. Dank dem engen Vertrauensverhältnis zwischen ihm und Sesostris III. übernimmt er die königliche Schöpferrolle, die sich hier vermischt mit derjenigen des Heilsbringers, des Sohnes und Rächers des Osiris, der die Welt nach dem Einbruch der Macht des Todes wieder in Ordnung bringt. Auf die Ebene der Realität übertragen, können wir immerhin daraus ableiten, dass Ichernofret als Gelehrter und »Gestaltungsfachmann« galt, der angab, wie die Ikonographie, d. h. die Zeichnung und die Attribute der Statuen, Barken und Schreine sowie die Inschriften aussehen sollten, und ebenso die Texte und die Choreographie des Festspiels.

Auch der dritte Text zur Rolle des Auftraggebers steht auf einer *Stele*, die in Abydos aufgestellt war, und zwar von *Neferhotep I. Chasechemre aus der 13. Dynastie*. Der ausführliche Bericht behandelt dasselbe Thema wie derjenige Ichernofrets – es soll eine neue Prozessionsstatue des Osiris geschaffen werden – und er ist sehr ähnlich aufgebaut wie die beiden vorigen Texte, enthält aber mehrere überraschend neue Elemente. Der Text ist allerdings sehr problematisch, da er nur in einer Abschrift aus dem 19. Jahrhundert überliefert ist, die Max Pieper 1929 ediert hat[9]. Es scheint mir aber, dass einige wichtige Stellen gut genug erhalten sind, um eine Deutung im Rahmen dieser Untersuchung zu wagen. Der Gesamttext zerfällt in zwei etwa gleich lange Hälften mit ganz unterschiedlichem Inhalt. Die erste Hälfte ist wiederum in zwei Abschnitte aufgeteilt, deren erster eine Thronsitzung zum Inhalt hat, an welcher der Herrscher seine Absicht verkündet, eine neue Statue des Osiris als sein Denkmal in Abydos anzufertigen. Der zweite Abschnitt berichtet, wie der König selbst in Abydos das Festspiel des Osiris durchführt und die Götterstatue und andere kostbare Requisiten des Tempels machen lässt. In der zweiten Hälfte des Stelentexts legt der König nicht mehr praktisch Hand an, sondern es geht darum, das Ziel der ganzen Aktivitäten abzusichern: Er hat

9 M. Pieper, Die große Inschrift des Königs Neferhotep in Abydos, MVÄG 32.2, Leipzig 1929, passim.

»Denkmäler« in Abydos errichtet, damit er selbst auf ewig Teil habe an den Opfern, die im Tempel dargebracht werden.

Die Handlung beginnt mit der feierlichen Audienz im Thronsaal, an der nebst der üblichen hochrangigen Entourage auch die »wahren Schreiber der Gottesbücher« und »Leiter der Geheimnisse« (bzw. Geheimräte) teilnehmen, und dies mit gutem Grund, denn es ist das erklärte Ziel des Königs, die »Schriften der Urzeit des Atum« zu sehen und zu überprüfen, um die originale, urzeitliche Gestalt seines Vaters Osiris kennenzulernen und die neue Statue dementsprechend zu bilden (Zeilen 2–3). Der Hofstaat soll ihm die Schriften vorlegen und begleitet ihn in die Bibliothek, wo man sie gemeinsam öffnet:

> »Da fand Seine Majestät die Bücher vom Hause des Osiris. Da sagte Seine Majestät zu diesen Freunden: Meine Majestät ist der Beschützer meines Vaters Osiris. Ich will ihn bilden zusammen mit seiner Neunheit (?), wie es Meine Majestät gesehen hat in den Büchern. Sein Aussehen, wie er erschien als König von Ober- und Unterägypten, wie er hervorging aus dem Leib seiner Mutter Nut« (Zeilen 7–8).

Im Anschluss an diese Beschreibung der geplanten Statue hält Neferhotep I. fest, warum er als einziger qualifiziert sei, das Götterbild zu schaffen:

> »Ich bin ein trefflicher Sohn, der den bildet, der ihn gebildet hat« (Zeile 9 Ende).

Dies will besagen, dass nur ein Gott einen anderen Gott erzeugen kann.

Wir sind immer noch in der Bibliothek beziehungsweise an der Thronsitzung, und Neferhotep I. kommentiert weiterhin die Pläne, die er für Abydos hegt. Er spricht von dem Denkmal, das er für Osiris errichten will, von dessen segensreicher Wirkung auf das Land, und wie er selbst von den Göttern als König erschaffen worden sei (Zeilen 10–11): Es habe ihm sein Vater Re, der Herr dessen, was ist und was nicht ist, Gutes erwiesen, und es hätten ihm die Götter Gutes erwiesen schon im Mutterleib, bis er herausgekommen bzw. geboren worden sei, prächtig angetan als König von Ober- und Unterägypten, wobei sich die Weiße Krone auf seinem Haupt befunden habe.

Daraufhin sendet der König einen hochrangigen Boten nach Abydos, um seinen persönlichen Besuch anzukündigen, und nun begibt sich Neferhotep I. selbst nach Abydos, wo er zusammen mit Osiris das Festspiel durchführt (Zeilen 15–18). Der Text ist hier allerdings schlecht erhalten, aber es scheint sich Ähnliches abzuspielen wie das, was Ichernofret auf der Stele Berlin 1204 beschreibt. Erst am Ende des Festspiels wird die Statue des Gottes im Goldhaus gemäss der persönlichen Anweisung Neferhoteps neu gebildet (Zeilen 19–20):

> »Da ließ man die Majestät dieses Gottes sich in den Tempel begeben, dass er ruhe auf seinem Sitze im Goldhause, um zu bilden die Schönheit [Statue] Seiner Majestät zusammen mit seiner Neunheit. Auch Opfertische wurden hergestellt und geschmückt mit allen herrlichen Steinen des Götterlandes. Seine Majestät leitete die Arbeiten im Goldhause selbst.«

Zum Schluss dieses Absatzes wird bekräftigt, dass Seine Majestät allein die alten Schriften gefunden habe (Zeile 21):

> »Seine Majestät selbst hatte diese Bücher der Ewigkeit gefunden. Niemals hatte sie ein Schreiber aus dem Gefolge Seiner Majestät gefunden.«

Die ganze zweite Hälfte des vierzigzeiligen Stelentexts ist offenbar dem Thema des Opferbetriebs im Tempel von Abydos gewidmet. Es scheint, dass Neferhotep I. sein Verdienst um die Abwehr der Feinde seines Vaters Osiris wortreich hervorhebt und das Anrecht daraus ableitet, dass seine Königsstatuen ihren Anteil an den täglich im Tempel dargebrachten Opfern bekommen. Die Pylone des Tempels werden mit den Toren zum Iaru, dem Opfergefilde der Seligen, gleichgesetzt. Den Priestern, welche die Opfer getreulich darbringen werden, werden Privilegien versprochen. Im zweitletzten Abschnitt des Texts wird die Reaktion des Gottes Osiris auf die Taten seines Sohnes Neferhotep dargestellt (Zeile 35):

>>Der Gott hat mir meinen Wunsch erfüllt, Denkmäler für mich in seinem Tempel zu errichten, um die Verträge, die ich in seinem Haus abgeschlossen habe, zu erfüllen. Es liebt der Gott, was ich für ihn getan habe, er ist froh über das, was ich für ihn habe machen lassen.<<

Der letzte Abschnitt des Texts schließlich beweist, dass die ewige Teilnahme des Königs am Opferbetrieb wahrhaft lebenswichtig ist, denn sie muss durch eine ausführliche Fluchformel abgesichert werden. Zwei Faktoren werden genannt: Der König lebt nicht nur von den Opferspeisen, sondern ebenso sehr vom ewigen Lob seines Namens an jedem Fest des Tempels. Jeder, der sich dem Befehl des Königs widersetzen und versuchen sollte, den Lobpreis seines Namens und die Teilhabe an den Opfern zu hintertreiben, soll dem wirklichen Tod, der endgültigen Vernichtung anheimfallen. Auch die oben behandelte Lederhandschrift Sesostris' I. hatte die ewige Symbiose des Königs und des Gottes in Gestalt ihrer Statuen, die im Tempel wohnen, als das eigentliche Ziel des vom König vollbrachten Werks dargestellt.

Der Text Neferhoteps I. ist der einzige, in dem die Gestalt der neuen Statue diskutiert wird. Es muss die Originalgestalt des Gottes sein, wie er am Anfang war. Um diese herauszufinden, beruft sich Neferhotep auf eine Autorität, die – wenigstens der Theorie nach – aus einer höheren Sphäre kommt und nichts mit Menschenwerk zu tun hat: Es sind die urzeitlichen Schriften des Atum und des Tempels des Osiris. Vermutlich galten sie als Offenbarung des Gottes selbst. Diese Vorstellung kennen wir ansonsten von drei Totenbuchsprüchen des Neuen Reichs, von denen es in der jeweiligen Nachschrift heißt, dass sie als Schrift des Gottes Thot selbst zu Füssen der Götterstatue im Tempel von Hermopolis gefunden worden seien (BD 30B, 64, 137A). Der Finder war Prinz Djedefhor, ein Sohn Chefrens, den man im Neuen Reich als hoch berühmten Gelehrten aus der Zeit des Mykerinos verehrte[10]. Die wunderbare Auffindung des Spruchs 137A wird in der Nachschrift wie folgt überliefert:

>>Der Königssohn Djedefhor war es, der ihn fand in einem geheimen Kasten, in der Handschrift des Gottes selbst, im Tempel der Unut, der Herrin von Hermopolis, als er stromauf fuhr, um Inspektionen vorzunehmen in den Tempeln, den Feldern und Hügeln der Götter.<<

Für Neferhotep ist der eigentliche kreative Akt das Auffinden der Schriften, um die Urgestalt des Gottes zu ermitteln, denn dies ist das Vorhaben, das er zuerst verkündet bei der Audienz im Thronsaal, und am Schluss, als die Statuen in Abydos geschaffen sind, rühmt er sich, dass niemals irgend ein (anderer) Gelehrter die Schriften gefunden (*gm*) habe. Außerdem begibt sich Neferhotep damit in die mythische Rolle des Prinzen Djedefhor, die zu seiner Zeit wohl bereits formuliert war. Die Rolle des gelehrten Magiers ist überhaupt etwas, das die Phantasie

10 E. Hornung, Das Totenbuch der Ägypter, Zürich / München 1979, S. 97; 139f.; 270; G. Posener, »Lehre des Djedefhor«, in: LÄ III (1980), Sp. 978–980.

der Ägypter besonders beflügelte. Der Papyrus Westcar mit den »Wundergeschichten am Hofe des Königs Cheops« ist ein einziges Preislied auf große Wundertäter, die die Naturgesetze aufheben können, und von denen uns wenigstens die drei Namen Ubaoner, Djadjaemanch und Djedi, der obersten Vorlesepriester und Bücherschreiber, erhalten sind.[11] Prinz Djedefhor tritt in der Erzählung als Bewunderer und wohl auch Schüler Djedis auf. Ansonsten war er durch die von ihm verfasste Lebenslehre schon bei seinen Zeitgenossen als Gelehrter berühmt, denn dies ist es, worauf die Totenbuchsprüche und andere Literaturwerke des Neuen Reiches Bezug nehmen. Sehr viel später, in ptolemäisch-römischer Zeit, ist der Zyklus der Erzählungen von Setna-Chaemwase[12] entstanden, wo die Prinzen Naneferkaptah und Chaemwase auf abenteuerlichste Weise das Buch des Gottes Thot selbst mit der »Weltformel«, die offenbar die Herrschaft über die Welt in sich birgt, erringen und das Wunderkind Siusire mit seinen hellseherischen Fähigkeiten einen Wettstreit zwischen den ägyptischen und den äthiopischen Magiern entscheidet. Der Setna-Zyklus setzt sich viel deutlicher als jeder ältere Text mit der Macht auseinander, die das magische Geheimwissen dem Gelehrten verleiht. Die im Buch enthaltene Formel des Schöpfergottes macht den Finder gottgleich und die Götter müssen ihn verderben, bevor er sich ihrer bemächtigt.

Wie die erwähnten literarischen Zeugnisse zeigen, bedarf es ganz außerordentlicher Qualitäten, um zum Fund eines Gottesbuches befähigt zu sein: Es braucht einen Gelehrten von höchstem Rang und wenn möglich von königlichem Geblüt, der berechtigt ist, in das Innerste des Tempels vorzudringen und dort Inspektionen durchzuführen. Ein großer Kenner der Schriften ist in erster Linie ein großer Magier, der über göttliche Schöpferkraft verfügt, weil er die Bücher des Thot nicht nur finden, sondern auch anwenden kann. Neferhotep verhält sich wie ein Gelehrter und Magier oder Prinz, und der Grund dafür liegt wohl in der Tatsache, dass er nicht ein Königssohn war, sondern nur von der Mutterseite her von der Königsfamilie abstammte. Als Gelehrter bringt er das für die Gestaltung der Statue notwendige mythische Wissen selbst bei.

Neferhoteps einzigartigem wissenschaftlichen Interesse ist es zu verdanken, dass in seinem Bericht das Aussehen der neuen Statue sogar beschrieben wird. Was der König in den Büchern der Götter sah, ist die Gestalt des Osiris bei seiner Entstehung in der Urzeit, wie er als König von Ober- und Unterägypten erschien, als er aus dem Leib seiner Mutter Nut hervorkam. Die Beschreibung ist überaus knapp und nennt nur ein einziges Merkmal. Auf die Beschaffenheit des Körpers brauchte er offenbar nicht einzugehen, das einzige, was zählte, waren die königlichen Insignien – man darf an Krone, Wedel und Krummstab und wohl auch Schmuckkragen und Pektoral denken. Dies stimmt mit Ichernofrets Beschreibung der neuen Götterstatue überein, die er mit den kostbarsten königlichen Attributen aus Gold und Edelsteinen versah. Die Insignien sind entscheidend als Beweis, dass Osiris der legitime und geborene Herrscher Ägyptens ist – und nicht sein neidischer Bruder Seth. Dass Osiris bei Neferhotep fixfertig als König aus dem Mutterleib kommt, erinnert stark an ein Motiv aus den schon mehrfach zitierten »Wundergeschichten am Hofe des Königs Cheops«. Dort wird geschildert, wie die Frau eines Priesters Drillinge gebiert, die Re selbst als künftige Könige gezeugt hat mit ihr: Die Neugeborenen kommen mit einem Königskopftuch aus Lapislazuli und einem Pektoral (?) aus Gold auf die Welt.[13] Noch wichtiger ist aber im Text Neferhoteps, dass

11 E. Brunner-Traut, Altägyptische Märchen, S. 43–55.

12 M. Lichtheim, Ancient Egyptian Literature III. The Late Period, Berkeley / Los Angeles / London 1980, S. 125–151.

13 E. Brunner-Traut, Altägyptische Märchen, S. 52.

er kurz danach seine eigene Geburt in Parallele setzt mit der Geburt des Osiris, wenn er beschreibt, wie sein Vater Re ihm im Mutterleib Gutes erwiesen habe, bis er als Pharao mit der Weißen Krone auf dem Haupt herausgekommen sei.

Die Entstehung der neuen Statue des Osiris wird, wie jeder schöpferische Akt, auf einer höheren, mythischen Ebene beschrieben, in einer Sprache der Symbole und Metaphern, die hier auf die urzeitliche Schöpfung Bezug nimmt. Die Herstellung der neuen Statue wird mit der Geburt des Gottes Osiris als urzeitlichem König Ägyptens gleichgesetzt, und diese wiederum mit der Geburt des aktuellen Herrschers Neferhotep als schon im Mutterleib gekröntem König. Die neue Statue des Osiris zu schaffen heißt, den Schöpfungsvorgang zu wiederholen. Dazu braucht es das mythische Wissen des gelehrten Magiers. Es geht aber nicht um ein triviales Nachschlagen der ikonographischen Elemente in den alten Papyri, sondern das Wissen um die Gestalt des Osiris wird Neferhotep neu offenbart vom göttlichen Autor der Schriften. Darum legt der König so großen Wert auf die Festellung, dass nur er die Schriftrolle gefunden habe. Die Gestalt der Statue ist also die ewig gleiche und doch immer neue. Jeder König, der sich als Schöpfergott erweisen will, muss Osiris neu schaffen, und damit schafft er auch sich selbst neu.

Versuchen wir, die Ereignisse, die auf der Ebene des phantasierten Götterlebens erzählt werden, auf der Ebene des faktischen Alltags zu verstehen. Neferhoteps Aussage, dass er selber bei der Geburt als König gleich ausgesehen habe wie Osiris bei der seinigen, in Verbindung mit der so nachdrücklich behaupteten Offenbarung der Gestalt, scheint mir in eine bestimmte Richtung zu deuten: Die Anspielung dürfte darauf hinauslaufen, dass die Osirisstatue Neferhoteps realiter wie die Person Neferhoteps aussieht, dass sie also seine Gesichtszüge trägt. Leider können wir das nicht an Statuen aus seiner Zeit nachprüfen, aber die bekannten Beispiele von Götterstatuen der 12. Dynastie, deren Physiognomie dem regierenden König entspricht, legen diesen Gedanken nahe; die Hauptbeispiele sind die Statuen Sesostris' II. und Amenemhets III. als der Nilgott Hapi und der Kopf des letzteren als Amun.[14]

Auf der Ebene des phantasierten Götterlebens ist auch die Aussage Neferhoteps angesiedelt, dass nur ein Gott einen (anderen) Gott erschaffen kann. Da die Gottheiten auf Erden in Gestalt ihrer Statuen leiblich präsent sind, ist der König kraft seiner Gottessohnschaft der Einzige, der eine Götterstatue machen kann, gemäss seiner Definition: »Ich bin ein trefflicher Sohn, der den schafft, der ihn schuf«. Auch der König ist auf Erden als Gott präsent in Gestalt seiner Statuen, die in den Tempeln stehen. Auf der Ebene des phantasierten Götterlebens wird das Bilden einer Götter- oder Königsstatue als Zeugung eines göttlichen, das heißt unsterblichen Lebewesens unter Göttern behandelt. Das erklärt, warum auf der realen Ebene nur der König den Befehl dazu geben konnte.

Neferhoteps Stele ist der einzige Text, der die Höflinge und unter ihnen insbesondere die Gelehrten, die »Schreiber der Gottesbücher« und »Leiter der Geheimnisse«, als Partner ernst nimmt, wenn es darum geht, über das Aussehen der neuen Götterstatue zu bestimmen. Wir haben die Geschichte des gemeinsamen Gangs in die Bibliothek, wo der Herrscher die Bücher des Osiris findet, auf der Ebene der metaphorischen Sprechweise kommentiert. Auf der Ebene der alltäglichen Realität heißt dies gewiss, dass Neferhotep eine Expertengruppe berief, die unter seiner persönlichen Leitung stand, da er sich selber als Gelehrten ansah. Paral-

14 Berlin, Ägyptisches Museum 9337 (H. G. Evers, Staat aus dem Stein. Denkmäler, Geschichte und Bedeutung der ägyptischen Plastik während des Mittleren Reichs I, München 1929, Taf. 70); Kairo, Ägyptisches Museum CG 392 (H. G. Evers, Staat aus dem Stein I, Taf. 129); Kairo, Ägyptisches Museum TR 13.4.22.9 (D. Wildung, Sesostris und Amenemhet. Ägypten im Mittleren Reich, Freiburg / München 1984, Abb. 61).

lelen dazu sind mir erst aus späterer Zeit bekannt. Zwei Inschriften aus der Regierungszeit Ramses' IV., die von Steinbruchexpeditionen im Wadi Hammamat berichten und auf der realen Ebene spielen, bieten eine gewisse Analogie (Couyat-Montet Nr. 240 und Nr. 12)[15]. Sobald dem König die richtige Stelle bekannt geworden war, an welcher die Steine für sein »großes Denkmal« in der Thebanischen Nekropole zu brechen seien, beauftragte er eine bedeutende Gruppe hochgestellter Höflinge, darunter auch Gelehrte, mit der Ausführung des Denkmals. In der zweiten Inschrift geht es um eine Vorabklärung, bevor die Steinbrucharbeit beginnt. Der König beauftragt einen Schreiber des Lebenshauses, einen königlichen Schreiber und einen Priester des Tempels des Min-Hor und der Isis von Koptos, alle früheren Bestellungen von Grauwacke für die Thebanische Nekropole aufzusuchen, da aus diesem hervorragend schönen Stein große und wundervolle Monumente entstanden seien. Es ist unklar, was der eigentliche Zweck dieser Untersuchung war, es erhebt sich aber der Verdacht, dass Ramses IV. an eine Liste usurpierbarer Objekte dachte. Klar ist immerhin, dass er technisch versierte Experten brauchte.

Im Fall Neferhoteps erfahren wir auch keine Einzelheiten darüber, was die Expertengruppe zu entscheiden hatte und wie die Entscheidungen getroffen wurden. Es ist aber anzunehmen, dass zu bestimmen war, welche Statuen und Objekte herzustellen waren, wer den Auftrag bekam, welche Materialien zu verwenden seien und welches die Form und Verzierung der Objekte und der Wortlaut der Inschriften sein solle.

I.2 Zu Punkt 1b: Zur Rolle des Künstlers

Was die Künstler angeht, so ist meines Wissens keine ägyptische Inschrift überliefert, die berichtet, dass ein König einem Bildhauer einen Auftrag erteilt habe. Immerhin ist ein bedeutender autobiographischer Text eines Vorstehers der Bildhauer und Malers der 11. Dynastie erhalten, die *Stele des Irtisen aus Abydos*[16], die in einzigartiger Weise die Fähigkeiten und Fertigkeiten des Inhabers beschreibt. Gerade wegen seiner Seltenheit ist der Text außerordentlich schwer verständlich. Es scheint aber, dass Irtisen die Techniken beschreibt, die er beherrscht, vornehmlich die Magie, das Zeichnen und die Herstellung von Farben und Werkstoffen. Die folgende Übersetzung ist dem Katalog »Ägypten 2000 v. Chr.« entnommen:

> »Ich kenne das Geheimnis der Hieroglyphen und den Aufbau der Rituale. Die Gesamtheit der Zauberformeln, ich beherrsche sie, nicht eine ist mir unbekannt.«

Damit will Irtisen zweifellos sagen, dass er über das Schulwissen seiner Zeit verfügt und dass er ein Magier und Gelehrter ist.

> »Ich kenne die *ru-bagu* (Proportionen?), ich vermag die Masse zu schätzen, zu korrigieren und anzupassen, bis ein Körper seine richtige Gestalt gefunden hat. Ich kenne das Schreiten einer Männerfigur und das Gehen einer Frauenfigur, die Haltung der elf Vögel, die Verzerrungen, das Schielen und den Ausdruck der Angst auf dem Gesicht der Feinde aus dem Süden, die Bewegung

15 A. H. Gardiner, The House of Life, in: JEA 24 (1938), 162f. (Nr. 15–16).

16 Paris, Musée du Louvre C 14 (D. Wildung [Hg.], Ägypten 2000 v. Chr. Die Geburt des Individuums [Sonderausstellungskatalog Würzburg, 10. Februar bis 21. Mai 2000], München 2000, S. 60–63, Nr. 10).

des Arms des Nilpferdjägers und die Bewegung der Beine des Läufers.[17] Ich verstehe es, Farben und Werkstoffe herzustellen, die schmelzen, ohne daß das Feuer sie verbrennt, ohne daß sie sich im Wasser auflösen.«

Bezeichnender Weise sind es die traditionellen Schemata der Zeichnung oder Komposition, die er nennt, und nicht etwa neue Bildmotive, die er selbst erfunden hätte. Wenigstens kann dem Text mit Sicherheit entnommen werden, dass von den Haltungen und Bewegungen bestimmter Figurentypen gesprochen wird. Bei den angstvollen Gesichtern der südlichen Feinde geht es wohl tatsächlich um den Gesichtsausdruck. Vermutlich spielt die Stelle auf Feindesgesichter in Frontalansicht an, wie sie zum traditionellen Motiv des Niederschlagens der Feinde gehören.

Von größter Wichtigkeit ist aber das Ende des Texts, denn hier sagt Irtisen, dass »der Gott«, das heißt der König, befohlen habe, seinen ältesten Sohn in das Geheimnis der Kunst einzuführen. Der entscheidende Satz sei nach Alan Gardiner[18] zitiert, und der Rest nach dem Katalog der Ausstellung »Ägypten 2000 v. Chr.«:

> »It was not revealed to anyone except to me alone and to my eldest son, whom the god commanded to be (?) one to whom (?) it was revealed«,
> »und ich habe seine Fähigkeit erkannt, Vorsteher der Arbeiten in allen kostbaren Materialien zu werden vom Silber über das Gold bis zum Elfenbein und Ebenholz.«

Der Abschnitt der Stele über den Befehl des Königs an den Meister und seinen Sohn ist die einzige Stelle vor dem Neuen Reich, wo ein König in Künstlerdinge eingreift. Das »es«, das dem Sohn enthüllt wird, bezieht sich zweifellos auf alles, was oben im Text genannt wird, das heißt des Meisters Kenntnis der Rituale und Zauberbücher, der Zeichenkunst und der Herstellung der Farben und Werkstoffe. Geheim sind nicht etwa nur die Farbrezepte und Ähnliches, woran man heute zuerst denken würde. Damals aber ging es zweifellos nicht um den Schutz vor Konkurrenz. Infolge der Knappheit der Aussage erfahren wir kaum etwas Konkretes über die Praxis der Tradierung in der Werkstatt. Vermutlich hat man laufend junge Leute ausgebildet, aber nur selten einen Meisterschüler, der Chef einer Werkstatt werden sollte. Wahrscheinlich soll mit der »Enthüllung« auch gesagt werden, dass der Sohn zum Nachfolger des Meisters als Werkstattchef bestimmt wird. Er wird allerdings nicht Bildhauer und Maler genannt wie der Vater, sondern Vorsteher der Arbeiten in Gold etc., was offen lässt, ob er einer anderen Werkstatt vorstehen sollte als derjenigen des Vaters.

Es ist bezeichnend, dass das Fachwissen der Werkstatt im künstlerischen und im technischen Bereich unter den Begriff des Geheimnisses beziehungsweise des Wissens, das enthüllt werden muss, fällt, unter einen Begriff also, der sonst insbesondere auf die Bücher des »Lebenshauses«, die das gesamte religiöse und technische Wissen der Gelehrten enthielten, angewandt wurde. Das Wissen kommt im Fall der Künstlerwerkstatt nicht (wie bei den Schriftrollen) direkt von einem Gott. Immerhin wird es aber vom Gottkönig überwacht, er selbst muss die Enthüllung oder Weitergabe befehlen. Damit wird dem Unterschied zwischen dem Schaffen mit den Händen und demjenigen mit Worten Rechnung getragen. Wesentlich ist aber, dass das Fachwissen der Künstler als äquivalent zum Wissen der Gelehrten angesehen wurde.

17 D. Wildung (Hg.), Ägypten 2000 v. Chr., S. 61 (Übersetzung von Bernadette Letellier).

18 A. H. Gardiner, The Tomb of Amenemhet, High-priest of Amon, in: ZÄS 47 (1910), S. 96 (zitiert die Stelle als Beispiel für den Ausdruck *pr ḥr*).

Wenn wir versuchen, dem Bericht eine Aussage in Klartext zu entnehmen, so lässt sich nur ganz allgemein feststellen, dass eine direkte Beziehung zwischen dem König und Irtisen, dem Meister einer königlichen Bildhauer- und Malerwerkstatt, besteht. Der König interessiert sich dafür, wem das künstlerische Know-how weitergegeben wird, er wacht persönlich darüber, dass es dem fähigsten Mann anvertraut wird, denn es ist ein Wissen, das als geheim qualifiziert wird, weil es mit Schöpferkraft verbunden ist. Mit anderen Worten: Der König entscheidet darüber, wer ein guter Künstler ist.

I.3 Zu Punkt 2: Zum Betrachter oder Empfänger der Botschaft einer Statue

Die Betrachter oder Empfänger der Botschaft einer Statue werden auf zwei gleich lautenden Stelen Sesostris' III. aus den nubischen Grenzfestungen Semna und Uronarti ausdrücklich genannt: Es sind die Söhne oder Nachfolger des Herrschers. Die Botschaft wird in einer politischen Erklärung begründet, die den Hauptinhalt des Stelentextes bildet, und sie besagt, dass der König seinen Söhnen die unbedingte Pflicht auferlegt, die Südgrenze des Reichs bei Semna zu verteidigen. Schließlich erfährt der Leser, dass die jeweils zur Stele gehörige Königsstatue die Trägerin und Garantin der Botschaft ist. Da der Stelentext in einmaliger Weise die Botschaft einer Statue formuliert, soll er unter Punkt 3, wo es um die Aussage oder Wirkung einer Statue geht, behandelt werden (I.4, S. 44f.).

Auch in anderen Situationen gab es Menschen, die Prozessions- und Tempelstatuen sehen konnten und als Empfänger ihrer Botschaften in Frage kamen. Ichernofret spricht auf seiner in Abydos aufgestellten Stele von den Bewohnern der beiden Wüsten, die jubeln, wenn das Prozessionsbild des Osiris in seiner Barke vorüberzieht.[19] Meist handelt es sich aber um einen kleineren Kreis von Personen rund um den Herrscher, die an Kulthandlungen teilnehmen konnten und deshalb Zutritt zum Inneren des Tempels hatten, wie sie auf Reliefzyklen von Götterfesten dargestellt sind. Aus dem Mittleren Reich sind nur kleine Bruchstücke solcher Bilder auf uns gekommen.[20] Aus dem Neuen Reich jedoch sind ganze Zyklen erhalten, wovon hier nur die Minfestdarstellungen Ramses' II. und III. im Ramesseum und in Medinet Habu auf dem thebanischen Westufer erwähnt seien. Im Zyklus des »Auszugs des Min zur Treppe« im zweiten Hof des Tempels von Medinet Habu treten als führende Einzeldarsteller nebst dem König der oberste Vorlesepriester und die Königin auf, als prominente Gruppen die Königssöhne, die Spitzen des Hofs und der Beamtenschaft wie die »Wedelträger« und die »königlichen Verwandten«, Priester, Militärs und die königlichen Ahnen in Gestalt ihrer Statuen.[21] Im Mittleren Reich entsprechen diesen Gruppen sicherlich diejenigen Würdenträger, die in den Thronszenen der Berliner Lederhandschrift Sesostris' I. und der Stele Neferhoteps I. aufgezählt sind.

Die Stele Neferhoteps aus Abydos nennt ausdrücklich den Gott Osiris als Adressaten des

19 M. Lichtheim, Ancient Egyptian Literature I, S. 125.

20 W. Kaiser / G. Dreyer / H. Jaritz / A. Krekeler / T. Schläger / M. Ziermann, Stadt und Tempel von Elephantine. 13./14. Grabungsbericht, in: MDAIK 43 (1987), S. 84–88, Abb. 4, Taf. 8 (Satettempel auf Elephantine); C. Vandersleyen, Das Alte Ägypten, Propyläen Kunstgeschichte 15, Berlin 1975, S. 301, Taf. 271 (Mintempel in Koptos).

21 B. Porter / R. Moss, Topographical Bibliography of Ancient Egyptian Hieroglyphic Texts, Reliefs, and Paintings II, Oxford 1972, S. 499f.; A. Roberts, Hathor Rising. The Serpent Power of Ancient Egypt, Totnes 1995, S. 82–90; H. Gauthier, Les fêtes du dieu Min. Recherches d'archéologie, de philologie et d'histoire 2, Kairo 1931, Taf. 2–14.

Werks, das er in Abydos vollbrachte und das nebst der neuen Götterstatue auch die Durchführung des Festspiels umfasste. Der Gott liebt das, was der König für ihn machte, und jubelt über die Anordnungen seines Sohnes. Das Werk festigt ihre Beziehung.

Aus dem Mittleren Reich sind nicht sehr viele Originalinschriften auf Statuen erhalten. Sie entsprechen meist der Formel »König NN (Titulatur), geliebt von Gottheit NN«, die sagen will, dass der König ein geliebtes Familienmitglied der Götter ist, nämlich der Sohn oder allenfalls der Gatte, der den ihm gebührenden Platz im gemeinsamen Haus einnimmt und von der Gottheit entsprechend wahrgenommen wird. Der König begibt sich in Gestalt seiner Statue in die physische Nähe der Gottheit, die ihm die emotionale Nähe bestätigt. Nur ausnahmsweise enthält eine Statue eine eigentliche Widmungsformel an eine Gottheit (»König NN machte es als sein Denkmal für seinen Vater Gott NN«), und auch die $ḏd$-mdw-Formel, »Worte sprechen seitens NN«, in welcher eine Gottheit gute Wünsche für den König ausdrückt, erscheint selten.

Eine Statue ist selten ein selbstständiges Werk, sie ist normaler Weise eine Komponente in einem komplexen Zusammenhang. Statuen werden als Bauplastik serien- oder paarweise an Aufwegen und Pylonen, in Höfen und Kapellen etc. aufgestellt, und demgemäss spricht die Inschrift nur einen Teilaspekt der Beziehung zwischen König und Gottheit an.

Eine seltene Variante zur Nennung von Göttern als Adressaten von Statueninschriften sind vergöttlichte Vorgänger des Herrschers. Als Beispiel sei die Granitstele Sesostris' III. im Tempel Mentuhoteps II. in Deir el-Bahari genannt, deren Betrachter Mentuhotep II. als Gott ist, wie die Inschrift und die Reliefdarstellung anzeigen.[22] In der Nähe der Stele hatte eine Serie von Beterstatuen Sesostris' III. ihren Platz,[23] deren Inschriften zwar verloren sind, die sich aber durch ihre ehrerbietige Geste eindeutig auf den göttlichen Ahnherrn im Sanktuar bezogen. Auch hier ist es klar, dass Sesostris III. als »Regisseur« und Träger der Doppelrolle des Auftraggebers und des Rezipienten die Botschaft und deren Wirkung kontrolliert.

Die Berliner Lederhandschrift Sesostris' I., die die Gründung des neuen Atumtempels von Heliopolis beschreibt, enthält einen wichtigen Hinweis auf die Wirkung, die die Königsstatuen im Tempelkomplex entfalten. Die Höflinge antworten dem König:

> »When your temple is built, it will provide for the altar. It will give service to your image. It will befriend your statues in all eternity.«[24]

Die Botschaft, die die Statuen dem Herrn des Tempels nahe bringen, ist nur indirekt angesprochen, aber da Atum ohnehin der Hauptrezipient des gesamten Bauwerks ist, ist es klar, dass sich der vergöttlichte König ihm gegenüber positionieren will. Der Tempelkomplex funktioniert als ein »echtes«, lebendiges Modell der ewigen Götterwelt. In Gestalt seiner Statuen lebt Sesostris I. dort im Schoß der Götterfamilie, die Symbiose ist auf der Ebene der Phantasiewelt beschrieben. Auf der praktischen Ebene mussten die Opfer gestiftet, beschafft und dargebracht werden.

Wenn wir die Ebene des in der Phantasie ausgelebten, direkten und persönlichen Umgangs zwischen Gottheit und König verlassen, so stellt sich die Lage wie folgt dar: In der Realität ist es der König, der die Götter- und Königsstatuen der Tempel machen lässt. Somit über-

22 B. Porter / R. Moss, Topographical Bibliography II, S. 391 (Kairo, Ägyptisches Museum JE 38655).

23 B. Porter / R. Moss, Topographical Bibliography II, S. 384 (Hauptfragmente: London, British Museum EA 684–686 und Kairo, Ägyptisches Museum TR 18.4.22.4).

24 M. Lichtheim, Ancient Egyptian Literature I, S. 117.

nimmt der Auftraggeber in der Phantasie auch die Rolle des Gottes, der die Statue wahr-nimmt, und die Botschaft der Statue kommt genau so an, wie er es will. Infolgedessen kann man behaupten, dass in der vorliegenden Konstellation der Auftraggeber praktisch identisch ist mit dem Adressaten.

I.4 Zu Punkt 3: Zur Aussage, Botschaft oder Wirkung einer Statue

Sehen wir zunächst den einmaligen Fall der Grenzstatuen Sesostris' III. am Anfang des 2. Ka-tarakts an, deren Botschaft und Funktion auf einem zugehörigen Stelentext erklärt wird. Seso-stris III. ließ in den Tempeln der beiden Festungen Uronarti und Semna am zweiten Katarakt Statuen aufstellen, die teilweise erhalten sind. In beiden Festungen wurden auch große Stelen dieses Königs mit nahezu gleichlautendem Text gefunden, und zwar ebenfalls in den Tempeln.

Auf der *Stele aus Semna (Berlin 1157)* steht der entscheidende Satz, der einem politischen Manifest gleichkommt, unmittelbar nach der Titulatur, nämlich dass der König seine Süd-grenze bei Heh (Semna) festgesetzt habe. Die anschließenden Zeilen erläutern und begrün-den die Nubien-Politik Sesostris' III. Darauf folgt eine Art Fluchformel, die jedem Sohn oder Nachfolger die Pflicht auferlegt, seine Südgrenze zu bewahren und zu verteidigen, andern-falls werde er verstoßen. Am Schluss heißt es, dass der König dort eine Statue seiner selbst errichtet habe, die als beständiges Mahnmal für die Nachfahren gedacht sei:

> »Jeder Nachfahr von mir, der diese Grenze, die Meine Majestät gesetzt hat, fest bewahren wird, der ist mein Sohn und Meiner Majestät geboren. Wer sie aber aufgeben und nicht für sie kämpfen wird, der ist nicht mein Sohn und mir nicht geboren. Meine Majestät hat eine Statue Meiner Ma-jestät auf dieser Grenze, die Meine Majestät gesetzt hat, machen lassen, damit ihr sie fest bewahrt und damit ihr für sie kämpft.«[25]

Wir müssen daraus schließen, dass Sesostris III. Misstrauen gegen seine Söhne hegte, die er für unverlässlich oder nicht unbedingt loyal hielt. Es fällt auf, dass diese Aussage das genaue Gegenteil derjenigen über Ichernofret, den absolut vertrauenswürdigen Schüler und Pflege-sohn, ist. Das Wort für Statue, *twt*, ist auf beiden Stelen mit dem mumienförmigen Standbild determiniert. Dies ist eines der geläufigsten Determinative für das Wort »Statue« überhaupt und sagt nichts darüber aus, welche Gestalt die reale Figur hatte.

In Semna haben sich wenige Spuren von der Kapelle des Mittleren Reiches erhalten, weil diese später neu gebaut wurde, namentlich von Thutmosis III. und Taharka. Beim Tempel Ta-harkas wurde eine Kniefigur Sesostris' III. gefunden, im Sanktuar eine Sitzfigur und im Raum C ein wohl demselben König zuschreibbarer Kopf (Khartum Museum 448 bzw. 447 und Boston Museum of Fine Arts 24.1764).[26] Die Dedikationsinschrift Thutmosis' III. be-zeugt ausdrücklich, dass er den Tempel, den Sesostris III. aus Lehmziegeln errichtete, erneu-ert habe. Es ist also anzunehmen, dass die bewusste Statue diejenige des Herrschers im Sank-tuar gewesen ist.

25 D. Wildung (Hg.), Ägypten 2000 v. Chr., S. 92.

26 Grenzstatuen Sesostris' III. aus Semna: Khartum Museum 448, 447 (B. Porter / R. Moss, Topographical Bi-bliography of Ancient Egyptian Hieroglyphic Texts, Reliefs, and Paintings VII, Oxford 1951, S. 150; 147) und Boston, Museum of Fine Arts 24.1764 (B. Porter / R. Moss, Topographical Bibliography VII, S. 150); D. Dunham / J. Janssen, Semna Kumma, Second Cataract Forts excavated by G. A. Reisner I, Boston 1960, S. 28, Taf. 125 (a–b).

Die Stele aus Uronarti berichtet am Anfang bezüglich der Festung, dass diese im Jahr 16 fertig gebaut worden sei. Der Text weicht nur an dieser Stelle ab von demjenigen der Semna-Stele. In oder bei der Kapelle wurde eine mittelgroße Sitzfigur Sesostris' III. gefunden (Khartum Museum 452). Sie gehörte offenbar in die Kultnische und darf als diejenige Statue gelten, von der der König auf seiner Stele spricht.[27]

Die Statue als Trägerin und Garantin einer politischen Idee braucht offenbar nicht einen besonderen ikonographischen Typus, ihre Funktion als Garantin der Grenze ergibt sich aus dem Standort, nicht aus einem entsprechenden Attribut o. Ä. Die Statue muss sich – in beiden Festungen – im Sanktuar des Tempels befunden und Sesostris III. als Gott von Nubien bezeichnet haben. Im Erneuerungsbau Thutmosis' III. in Semna wird Sesostris III. auf den Reliefs als Gott dargestellt und bezeichnet, nebst Dedwen, Chnum und anderen. Die Reliefs aus dem Mittleren Reich sind verloren.

In der *Lederhandschrift Sesostris' I.* wird im letzten Abschnitt das Gründungsritual für den neuen Tempel des Atum von Heliopolis vollzogen. Am Ende, nachdem der »Strick gespannt« und die verschiedenen rituellen Handlungen vollzogen sind, heißt es:

> »His Majesty ordered to proceed; the king turned round before the people. Joined together were Upper and Lower Egypt.«[28]

Dieser Abschluss bringt uns auf den Gedanken, dass die Ausführung des Tempelkomplexes mitsamt seinen Königs- und Götterstatuen eine unerwartete Nebenwirkung hat: Sie fördert die politische Integration des Landes.

Die oben in Zusammenhang mit der Rolle des Auftraggebers besprochene *Stele Ichernofrets aus Abydos* handelt von einer anderen Art von Statue und einer anderen Art von Botschaft oder Wirkung. Der Text evoziert die Ausstrahlung, die der neuen Prozessionsstatue des Osiris eigen ist. Die Aura manifestiert sich buchstäblich im Strahlen des Goldes und im Farbenglanz der Edelsteine, die vom Körperschmuck und besonders von den Herrschaftsinsignien des Gottes ausgehen.[29] Sein Erscheinen erweckt Jubel in den beiden Wüsten, womit zweifellos die lebenden und die verstorbenen Bewohner gemeint sind. Die »Schönheit« des Gottes ist der Beweis seiner Göttlichkeit; sie spricht den Sinn für Ästhetik an und wirkt beglückend auf die Teilnehmer der Prozession, die sie sehen.

Ein *Hymnus König Amenemhets*, wahrscheinlich Amenemhets III., gibt die Botschaft einer Götterstatue wenigstens andeutungsweise preis. Bezeichnender Weise handelt es sich um die Wirkung des Gesichts. Die bewusste Statue ist diejenige des Sobek (eigentlich: Sobek von Schedet, Horus, der in Schedet wohnt) im Tempel von Krokodilopolis (Fajjum), und die Stelle findet sich im Papyrus Ramesseum VI A, der am Ende des ersten Hymnus auf Sobek folgenden Stiftungsvermerk enthält:[30]

27 Grenzstatue Sesostris' III: Uronarti Khartum Museum 452 (B. Porter / R. Moss, Topographical Bibliography VII, S. 144); vgl. C. C. van Siclen III., The Chapel of Sesostris III at Uronarti, San Antonio 1982, S. 36–40.

28 M. Lichtheim, Ancient Egyptian Literature I, S. 118.

29 M. Lichtheim, Ancient Egyptian Literature I, S. 124f.

30 J. Assmann, ÄHG, S. 426 (Nr. 203A).

»König Amenemhet hat dieses dein schönes Antlitz gegeben,
Mit dem du auf deine Mutter Neith blickst,
Mit dem du den Göttern gnädig bist.
(Weihrauch auf die Flamme!)
Es ist für Sobek von Schedet, Horus, der in Schedet wohnt,
Der Herr von Myrrhen, gepriesen mit Weihrauch.
Mögest du dem König Amenemhet gnädig sein,
Möge dein Angesicht ›schön‹ sein durch ihn an diesem Tage!«

Die Stelle im Papyrus Ramesseum VI dürfte sich auf das Kultbild im Sanktuar, vor dem das tägliche Ritual zelebriert wird, beziehen. Dies ist die einzige literarische Erwähnung, die eine Aussage über Wesen und Funktion einer Figur enthält. Der Stifter war wohl Amenemhet III., da er eine besonders intensive Bautätigkeit im Fajjum entfaltet hat. Das Gesicht steht hier wohl einerseits als pars pro toto, als Vertreter für die ganze Person, etwa wie im Ausdruck »ḥr nb«, »jedermann«[31], und andererseits ist das Gesicht – vertreten durch die Augen – diejenige Stelle, von der die Wirkung oder die Ausstrahlung eines Menschen ausgeht. Die Fähigkeiten des Schauens und des Gnädigseins werden übrigens auch von anderen Texten dem Gesicht zugewiesen.[32]

Das Schauen auf Neith ist wohl nicht wörtlich zu verstehen in dem Sinne, dass die Figur auf eine andere blickte, sondern es ist als eine Anspielung auf die Beziehung des Gottes zu seiner Mutter zu erklären. Einen Hinweis darauf, was diese beinhaltete, kann uns eine Stelle aus den Pyramidentexten geben (Pyr. 308)[33]: Der verstorbene König begrüßt zunächst Horus, Seth, Iaru und »die beiden Versöhnten«, die ihn säugen, offenbar die Schwestern Isis und Nephthys, die sich nach der Affäre des Osiris mit seiner Schwägerin Nephthys wieder versöhnt haben. Auf die beiden Versöhnten schaut er, und dazu werden vier mythische Präzedenzfälle zitiert, wo jeweils ein Sohn auf seine Mutter schaut: Horus schaut auf Isis, Nehebkau auf Selkis, Sobek auf Neith, und Seth auf die beiden Versöhnten. Bei der Nennung der vier Gottesmütter, die zugleich die Beschützerinnen von Sarg und Kanopen sind, geht es um die in den Totentexten oft angesprochene Wiedergeburtssymbolik. Im Hymnus auf Sobek ist im Bild des »Schauens auf Neith« wohl derselbe Aspekt der Beziehung zur Mutter angesprochen, der die Fähigkeit des Gottes zu stetiger Verjüngung ausdrückt. Die zweite Fähigkeit der Statue des Sobek, die Abstrahlung von Gnade auf den König und die Götter, erweist den Krokodilsgott als den Herrn und Herrscher der Götterwelt. Es sind also zwei grundlegende Wesenszüge des Gottes andeutungsweise in die kurze Beschreibung der Statue aufgenommen worden.

Die Wirkensweise der Statue ist im Falle Sobeks ihre Ausstrahlung, vergleichbar der Prozessionsstatue des Osiris von Abydos, und vielleicht haben wir uns vorzustellen, dass das Mittel dazu der Gesichtsausdruck war.

I.5 Zusammenfassung zum Teil I

In den oben besprochenen Stelen und Papyri geht es um Werke und deren Gestalt, Wirkung oder Herstellungstechnik aus der Sicht des Auftraggebers oder Künstlers, insofern kann man

31 A. Erman / H. Grapow, Wörterbuch der ägyptischen Sprache II, Leipzig 1928, S. 130,4.
32 A. Erman / H. Grapow, Wörterbuch der ägyptischen Sprache III, Leipzig 1929, S. 125,8; 189,14.
33 R. O. Faulkner, The Ancient Egyptian Pyramid Texts translated into English, Warminster 1969, S. 96.

behaupten, dass diese Texte von Kunst reden. Es handelt sich aber um eine ganz andere Art des Redens von Kunst als die heutige. Hauptsächlich bediente man sich einer literarischen Technik des Beschreibens von Vorgängen auf einer höheren, nur der Phantasie zugänglichen Ebene, wo sich der König in seiner wahren Gestalt als unsterblicher Gott unter unsterblichen Gottheiten bewegt. Jedenfalls trifft dies auf größere Teile der Texte zu. Es ist eine hochgezüchtete, symbolische oder metaphorische Ausdrucksweise, die schwer zu deuten ist. Besonders schwierig ist es abzuschätzen, ob diesen Phantasien, die sich in einer abgehobenen Welt abspielen, zugleich ein Geschehen oder Zustand in der alltäglichen irdischen Realität entspricht, und wenn ja, worauf des Genaueren die Anspielung zielt.

I.5.1 Zwei Konzepte des Schöpferischen: Das Schöpferwort und das Geheimnis

In den Quellen des Mittleren Reiches fanden wir zwei Konzepte des Schöpferischen wirksam: Das erste ist das Konzept des intuitiven Schöpferworts, das nur dem König zukommt, weil er über Sia und Hu (»Erkennen« und »Ausspruch«) verfügt. Der König ist der göttliche Schöpfer, der ein Werk konzipiert. Nach neuzeitlicher Auffassung, die ihre Wurzeln in der Renaissance hat, ist die Schöpferkraft eine Qualität des Künstlers, nicht des Auftraggebers. Aus moderner Sicht wäre der Pharao der eigentliche Künstler.

Das zweite ist das Konzept des Geheimnisses, das heißt des gelehrten, magischen und mythischen Wissens, das es braucht, um die ikonographischen Elemente eines Werks festzulegen. Dieses fanden wir in erster Linie bei den Gelehrten und Magiern, die als Experten für das Design fungieren. Der König kann dieses Wissen auch haben, sofern er sich als Gelehrter empfindet. Der magischen Komponente, die unabdingbar allem ägyptischen Wissen innewohnt, kommt ein schöpferisches Potenzial zu, und es braucht Magie, um Wissen überhaupt auf irgend eine Weise in Anwendung zu bringen.

Eine zweite Variante des Konzepts des geheimen Wissens schält sich aus dem Text des Künstlers Irtisen heraus: Auch bei der Herstellung des Kunstwerks durch die Fachleute, namentlich die Bildhauer und Maler, ist das »geheime«, magische Wissen nötig. Der Künstler beherrscht die Schrift, die Zauberbücher, die Zeichenkunst und die Herstellungstechniken, und damit realisiert er das Kunstwerk auf eine ganz andere Weise als der König und der Gelehrte. Er braucht nicht göttliche Intuition und nicht mythisches Wissen, sondern hoch spezialisiertes, herstellungsbezogenes Fachwissen. Der Künstler ist der wissende Magier und Techniker.

Zur Rolle des Auftraggebers, der über Aussehen und Botschaft des Werks bestimmt, äußert sich die Berliner Lederhandschrift Sesostris' I. sehr dezidiert in der Weise, dass der König als Schöpfergott vorgestellt wird, dem die göttlichen Qualitäten »Sia« und »Hu«, »Erkennen« und »Ausspruch« eignen und der durch sein Wort das Werk ins Leben ruft. Er ist es, der das Werk konzipiert und initiiert und der daher nach moderner Auffassung der eigentliche Künstler ist. Die Schöpferrolle realisiert sich an der Thronsitzung, an welcher der Pharao gleichsam ex cathedra seinen Plan verkündet. Der König ist der einzig mögliche Auftraggeber für Götterstatuen, weil nur ein Gott einen Gott bilden kann, wie uns Neferhotep I. zu verstehen gibt.

Bei Sesostris I. bestimmte derjenige wichtige Gelehrte mit über das Aussehen des Werks, der am Gründungsritual für den neuen Atumtempel beteiligt war. Wir können aber nur ganz allgemein sagen, dass er Einfluss auf die Gestaltung des Baus nehmen konnte.

Ichernofret, der Pflegsohn und Stellvertreter Sesostris' III., übernimmt ein Stück weit die

königliche Schöpferrolle, indem er die Statue des Osiris von Abydos und seine Barken etc. macht und das Festspiel zu einem guten Ende führt. Bei ihm ist aber die Rolle des Schöpfergottes, der durch das Wort schafft, überlagert von derjenigen des Sohnes und Rächers des Osiris, der Heil und Rettung bringt. Auf der realen Ebene sehen wir Ichernofret als Gelehrten und Experten in Sachen Ritualtexte und Kultgerätdesign, er hatte sicherlich anzuordnen, wie diese Dinge gemacht werden sollten.

Neferhotep I. findet die Bücher des Gottes selbst, damit er die urzeitliche Gestalt des Osiris von Abydos in Erfahrung bringen und seine neue Statue bilden kann. Er will damit sagen, dass ihm die Gestalt vom göttlichen Autor neu offenbart wird. Der Bericht springt von einem realen Besuch in der Tempelbibliothek unversehens über auf die höhere Ebene des Götterdaseins. Auf der realen Ebene verhält er sich wie ein Gelehrter und Magier und bringt das nötige mythische Wissen selbst bei. Als Schöpfer und Auftraggeber produziert er nicht nur die allgemeine Inspiration für die neue Osirisstatue, sondern macht genaue Angaben, wie sie aussehen muss. Die Behauptung, dass Osiris bei seiner Geburt gleich ausgesehen habe wie Neferhotep I. bei der seinigen, lässt uns vermuten, dass die Statue, die der König machen ließ, seine eigenen Gesichtszüge trug. Neferhotep I. behandelt die Gelehrten und übrigen Höflinge als Partner, wenn es darum geht, den Auftrag für die Statue des Osiris im einzelnen zu formulieren. Man kann sagen, dass er eine Expertengruppe bestellt hat für die Herstellung seiner Denkmäler in Abydos.

Der Oberbildhauer Irtisen erklärt auf seiner Stele, dass König Mentuhotep II. selbst ihm befohlen habe, das Geheimwissen der Künstler an seinen Sohn weiterzugeben. Im Klartext heißt das zunächst sicherlich, dass der König in eigener Person entscheidet, wer den Chefposten an einer wichtigen Künstlerwerkstatt bekommt. Darüber hinaus bedeutet das Interesse des Herrschers aber vor allen Dingen, dass er persönlich darüber urteilt, wer die besten Künstler sind und was künstlerische Qualität ist.

Irtisen gibt auf seiner Stele eine auf der realen Ebene angesiedelte Beschreibung der Techniken, die er beherrscht. Es geht um die Zeichnung von statischen und bewegten Menschen- und Tierfiguren und um die Komposition von figürlichen Szenen. Daraus lässt sich ableiten, dass der Künstler für Zeichnung und Komposition eines Bildwerks zuständig war. Als Gelehrter mit dem fachtechnischen Wissen konnte er sagen, wie die Figuren, die ein Auftraggeber haben wollte, gemacht werden. Das »Wie« der Ausführung, das Sache des Künstlers war, lässt sich auch in den Begriff des Stils fassen.

In der Rolle der Rezipienten finden wir sowohl Menschen als auch Gottheiten. Menschliche Empfänger sind in einem besonderen Fall, nämlich demjenigen der Grenzstelen Sesostris' III. am zweiten Katarakt, die Söhne oder Nachfolger des Königs, die durch bestimmte Statuen des Vaters an die Erfüllung einer politischen Pflicht gemahnt werden. Menschen sind auch die Bewohner von Abydos, die beim Festspiel die Prozessionsstatue des Osiris erblicken. Durch den Anblick wird das Heil, das sie abstrahlt, auf sie übertragen. Unter den Göttern wird namentlich Osiris als Rezipient genannt, der sich freut über das, was der König für ihn machte. Die Inschriften vieler Statuen erwähnen die durch gegenseitige Liebe gekennzeichnete familiäre Beziehung zwischen dem König und der Gottheit, der die Statue zugedacht ist.

Sowohl bei den menschlichen als auch bei den göttlichen Rezipienten tritt aber der König als Schnittstelle dazwischen. In der Berliner Lederhandschrift Sesostris' I. besagen zwei wichtige Metaphern, dass niemandem etwas gelingen könne ohne den König und dass der König jedermanns »Augen« sei. Dies bedeutet, dass alle anderen Menschen nur eine Erweiterung seiner selbst sind. Das Werk, das er schafft, ist letztlich nur für die eigenen Augen bestimmt, er allein ist es, dem es gefallen muss.

Im Falle der Gottheiten, die gemäss den Inschriften in einer emotionalen Beziehung zum König stehen und mit Liebe oder Freude auf ein Werk reagieren, haben wir es mit virtuellen Personen zu tun. Es ist von vorn herein klar, dass sich die Göttinnen und Götter nur durch den König artikulieren können. Das will sagen, dass der König auch der Gottheit seine Augen leiht und in der Phantasie deren Rolle übernimmt. Insofern ist er zugleich Betrachter und Empfänger der Botschaft einer Statue. Der König ist somit in manchen Fällen Auftraggeber, Künstler und Betrachter in einem, die Rollen fallen weitgehend zusammen.

Die Aussage und Wirkung der Statue kann gemäss den untersuchten Texten auf zwei verschiedenen Ebenen liegen, zum einen auf der politischen und zum anderen auf der rituellen (eigentlich magischen). Im Falle der Grenzstelen Sesostris' III. vom zweiten Katarakt treten die Königsstatuen als Garantinnen eines politischen Ziels auf. Aus dem Bericht über den neuen Atumtempel Sesostris' I. in Heliopolis können wir ableiten, dass die Aktivität des Tempels mit seinem ganzen Kultbetrieb, der sich ausdrücklich und in erster Linie auf die Statuen bezieht, auch eine gesellschaftlich wichtige Wirkung hat: Er fördert die politische Integration der beiden Länder. Eine Kult- oder Prozessionsstatue eines Gottes hat eine physische Ausstrahlung, die das Heil auf den Rezipienten überträgt. So die Prozessionsstatue des Osiris von Abydos, die durch ihre Aura, ihre Ausstrahlung im wörtlichen Sinne, wirkt, denn sie erstrahlt von Gold und farbigen Steinen. Es ist eine ästhetische Qualität, die auf die Menschen, die sie sehen, beglückend und belebend wirkt. Ähnlich verhält es sich mit dem im Hymnus Amenemhets III. geschilderten Kultbild des Sobek von Schedet. Hier haben wir keinen Anhaltspunkt, aus welchem Material die Figur bestand und wie sie aussah, die Wirkung wird aber dem Gesicht zugeschrieben. Es heißt, dass es sein »schönes Gesicht« ist, also letztlich eine ästhetische Qualität, von der der Segen ausgeht.

II. Wenn Statuen reden: Die sinntragenden Eigenschaften der Statue und die Konstituierung des Ausdrucks

Wir kommen nun zur vierten der in der Einleitung genannten Fragen, die für die Rekonstruktion der ursprünglichen Rezeptionsrealität von Rundplastik belangvoll sind, nämlich derjenigen, die sich an die Statuen selbst richtet. Es sind zwei Arten von sinntragenden Eigenschaften von Königsstatuen des Mittleren Reiches zu unterscheiden, die objektiven (materiellen) und die subjektiven (mimischen). Die beiden Arten können separat behandelt werden wegen ihres völlig unterschiedlichen Charakters. Die materiellen Eigenschaften werden an anderer Stelle ausführlich besprochen.[34] Auf die mimischen möchten wir nun eingehen.

II.1 Zu Punkt 4: Gesichtsausdruck und Körpersprache der Könige der 11. und frühen 12. Dynastie

Die physiognomischen Eigenschaften des Gesichts und des Körpers sind persönlich oder sogar individuell (je nach Herrscher) und spielen daher eine ganz besondere Rolle. Sie sind ausdrucksvoll, ein Spiegel des Charakters, des inneren Empfindens. Darum sind sie auch extrem schwierig les- und deutbar. Wir möchten versuchen, ihre Botschaft zu entschlüsseln, auch wenn es keine direkt darauf bezüglichen Schriftquellen gibt. Die überaus individuell gestalte-

34 Manuskript abgeschlossen, Publikation in Planung.

ten Gesichter Sesostris' III. und Amenemhets III. stellen seit bald hundert Jahren eine stetige Herausforderung an die Wissenschaftler und Wissenschaftlerinnen dar, eine Deutung des Ausdrucks wurde schon viele Male versucht. Diese Fälle werden hier nicht einbezogen. Bei den übrigen Königen sind die spezifische Bildung und Aussagekraft von Gesicht und Körper viel weniger Gegenstand des Interesses gewesen. Diesen wollen wir uns nun zuwenden.

II.1.1 Mentuhotep II. Nebhepetre (ca. 2046–1995)

Aus der rund fünfzigjährigen Regierungszeit Mentuhoteps II. ist sehr wenig Rundplastik überliefert, die gut genug erhalten ist, um sich ein Urteil über Stil und Porträttypus zu bilden. Nebst einigen Tempeln in Oberägypten ist vor allem sein bedeutendstes Bauwerk, der bei der neuen Hauptstadt Theben errichtete Totentempel von Deir el-Bahari, als Standort von Statuen zu nennen. Für die Betrachtung des Körpers stehen uns eine Standfigur im futteralartigen Hebsedgewand, zwei sitzende Hebsedfiguren aus dem Hof seines Totentempels und die ebenfalls in den kurzen Hebsedmantel gehüllte Sitzfigur aus dem so genannten Bab el-Hosan, einem unter dem Vorhof des Totentempels in den Berg geschlagenen Scheingrab, zur Verfügung. Was die Köpfe angeht, so sind nur drei mehr oder weniger lebensgroße mit den Landeskronen aus dem Tempel von Deir el-Bahari erhalten. Zwei kleinere Köpfe unbekannter Herkunft mit dem Nemes-Kopftuch sind aufgrund der großen Ähnlichkeit der Gesichtszüge problemlos zuschreibbar. Dazu kommen noch eine Holz- und eine Steinstatuette von Gemahlinnen des Königs. Von der inneren Chronologie der Plastik können wir uns aufgrund des viel zu geringen Bestandes kein Bild machen. Wie die Normalstatuen dieses Herrschers ausgesehen haben, entzieht sich unserer Kenntnis.

Die Hebsedstatuen zeichnen sich alle durch die in der monumentalen Königsplastik einmalige Eigenschaft aus, dass sie keinen Rückenpfeiler haben. Stattdessen ist der Körper insgesamt pfeilerhaft konzipiert. Beim Standbild (New York, Metropolitan Museum of Art 26.3.29)[35] bildet der Körper in der Vorderansicht ein nahezu geschlossenes Hochrechteck, dessen Ecken und Kanten andeutungsweise abgerundet sind. Die seitlichen Umrisslinien laufen von den Schultern bis zu den Zehen ganz leicht zusammen, und zwar in drei Phasen, die durch die minimen Absätze an den Ellbogen und den Knien markiert werden. Die gesamte Körperoberfläche stellt sich als eine fast unbewegte Masse dar. Die Arme und Hände heben sich nur wenig ab, die Beine und Füße sind, fast wie bei einer mumiengestaltigen Figur, zu einer breiten, kaum artikulierten Stütze verschmolzen, aus der nur die rechteckigen Kniescheiben heraustreten. Für die seitliche Ansicht gilt Ähnliches wie für die vordere: Die Umrisslinien laufen von der breitesten Stelle, der Taille, an nach oben und unten kontinuierlich ganz leicht zusammen; die Fußgelenke sind nur wenig schmäler als die Taille.

Die sitzenden Hebsedstatuen (Kairo, JE 36195 und Deir el-Bahari, in situ)[36] sind genau gleich aufgebaut wie die stehenden. Erstaunlicherweise gilt auch hier, wo die Beine keine stützende Funktion haben, dieselbe Beobachtung wie für die Standbilder, dass nämlich die Unterschenkel-Fußpartie in Breite und Massigkeit stark an eine mumiengestaltige Figur erinnert. Die Schenkel sind zwar deutlich getrennt und die Knie und Zehen andeutungsweise modelliert; zwischen den Füssen befindet sich aber ein Füllstück, das ihrer Form angepasst ist

35 Di. Arnold, The Temple of Mentuhotep at Deir el-Bahari, New York 1979, S. 46–49, Taf. 23–25.

36 M. Saleh / H. Sourouzian, Die Hauptwerke im Ägyptischen Museum Kairo. Offizieller Katalog, Mainz 1986, Nr. 67 (JE 36195); Di. Arnold, The Temple of Mentuhotep, S. 49, Taf. 26–27 (die beiden Sitzfiguren in situ).

und sich unter den Sohlen fortsetzt, so dass die Füße mit einer seitlich und vorn senkrecht abgesetzten Platte verwachsen zu sein scheinen. Das Gesicht zeigt sowohl bei den drei Häuptern aus Deir el-Bahari (New York, Metropolitan Museum of Art 26.3.29A, Kairo, JE 36195, London, British Museum EA 720)[37] (Taf. 8a) als auch bei den beiden zugeschriebenen Köpfchen mit Nemes-Kopftuch (Edinburgh, Royal Museum of Scottland 1965.2, Bristol, City Museum H.5038)[38] den gleichen Typus. In der Vorderansicht entspricht die Höhe, vom Kronenrand bis zum Bartansatz gerechnet, etwa der mittleren Breite, der Umriss ist genau U-förmig, an den Schläfen ist kaum eine Einziehung zu bemerken. Auffallend ist auch hier die geschlossene Flächigkeit der Oberfläche, die nur minime Einbuchtungen und Wölbungen kennt. Vor allem sind die Augenräume so gut wie gar nicht vertieft, Braue, Augapfel, Wange und Kinn liegen nahezu in ein und derselben Ebene. Neben den Nasenflügeln ist ein in die Wange hineinlaufender Muskelstrang durch eine leichte Wölbung angedeutet. Augen, Brauen, Nase und Mund sind mit scharfen, zu spröder Geradheit neigenden Linien umrissen. Insbesondere verlaufen die Brauen und der Stirnansatz der Krone oder des Kopftuchs fast waagrecht, was einen Eindruck von unorganischer Härte ergibt. Was die Proportionen angeht, so sitzt die Augenpartie sehr weit oben; an den Köpfen mit Nemes ist gut zu erkennen, dass sie sich deutlich oberhalb der waagrechten Mittellinie befindet. Die Ohren sind im Normalbereich angebracht, nicht zu groß und nicht abstehend.

Was die Züge im einzelnen angeht, so ist das innere Ende der fast geradlinigen Brauen höchstens minim nach unten gebogen. Die Achse der Augen, das heißt die Linie, die den inneren mit dem äußeren Winkel verbindet, steht leicht schräg, der innere Winkel weist nach unten. Der untere Lidrand ist sehr wenig gebogen und verläuft im äußeren Drittel etwas nach oben. Der obere Lidrand steigt im inneren Drittel steil und weit nach oben an und beschreibt im Mittelteil einen so weiten Bogen, dass das Auge groß wirkt. Die Nase ist kurz, ihr Rücken bleibt fast bis zur Spitze gleichmäßig schmal, aber die Flügel greifen weit im Halbkreis aus. Der große Mund ist von einer Lippenleiste umzogen, die Spalte neigt zur V-Form, der Gesamtumriss zur Raute; die Linien der Spalte und des oberen und unteren Lippenrands treffen sich aber nicht im Mundwinkel, sondern verflüchtigen sich in einem Grübchen. Der Kinnwulst bildet ein großes, vorgewölbtes Oval.

Das Profil entwickelt sich auf einer etwa senkrechten Linie, über welche der gerade Nasenrücken leicht vortritt. Typisch sind die Kürze der Nase und die Länge des unteren Gesichtsteils, die dadurch zustande kommt, dass Lippen und Kinn sehr dick sind, genauer gesagt, dass Lippenrot und Kinnwulst eine bedeutende Höhenerstreckung haben, während die Hautober- und -unterlippe auffallend kurz sind. Die Kinnbasis fällt stark ab zum Hals hin.

Die Konturlinien der Kronen neigen stark zu einer Geradheit, die jenem Schwung, der in der 4. und 5. Dynastie gebräuchlich war, absagt. Beim Nemes-Kopftuch ist die Scheitelpartie niedrig und fast gerade, die Ecken der Flügel treten relativ wenig vor und der Hinterkopf ist abgeflacht; so entsteht sowohl in der Frontal- als auch in der Profilansicht ein Umriss von gedrungener Trapezform.

Das pfeilerhaft Aufragende und die Massigkeit der Hebsedstatuen wirken archaisierend, es stellt sich die Erinnerung an die Privatplastik der 3. Dynastie ein, wie die Sitzfiguren der bei-

37 Di. Arnold, The Temple of Mentuhotep, S. 46–49, Taf. 24; D. Wildung, Sesostris und Amenemhet, Taf. 39; T. G. H. James / W. V. Davies, Egyptian Sculpture, British Museum, London 1983, S. 25, Abb. 24.

38 C. Aldred, Some Royal Portraits of the Middle Kingdom in Ancient Egypt, in: MMJ 3 (1970), S. 33, Abb. 6–8.

den Anch (Leiden, Rijksmuseum van Oudheden AST 18/19)[39] und die großen Standbilder des Sepa und der Nesa (Paris, Louvre N 37 und 39)[40]. Die Statuen Mentuhoteps sind aber diszi- plinierter und regelmäßiger gegliedert als jene Figuren aus der formativen Phase der ägyp- tischen Großplastik, teils gemäss dem organischen Bau des Körpers, teils nach einem geo- metrisch-abstrakten System. Die natürliche Rundheit des Körpers ist ins Säulenhafte abgewandelt. Dies geschieht vor allem dadurch, dass die einzelnen Körperteile verbreitert und zu flächigen, kissenartig abgerundeten Elementen zusammengefasst werden. Es entsteht so, bei aller Strenge, zugleich eine gewisse sackartige Weichheit. Diese eigentümliche Art von Plastizität, die weder zur Klarheit abstrakter stereometrischer Formen, noch zu räumlich- organischer Modellierung findet, erzeugt einen Zwiespalt. Bei der Statue aus dem Bab el-Ho- san kommt die harte Kontrastwirkung der Farben hinzu.

Die Hebsedstatuen Mentuhoteps I. strahlen eine aggressive Dissonanz aus, die den Be- trachter gleichsam anspringt und die man in einem bestimmten Sinne auch als hässlich be- zeichnen kann. Zugleich ist jeder realitätsabbildende, individuelle Zug konsequent vermie- den. Das ganz außerordentliche Maß an Originalität, das uns hier entgegentritt, beruht nicht auf den persönlichen Zügen, sondern auf der für Mentuhotep II. entwickelten Ästhetik des Hässlichen. Unter Hässlichkeit verstehen wir hier die oben beschriebene Anwendung disso- nanter künstlerischer Mittel wie das Nebeneinanderstellen von stimmigen und unstimmigen Proportionen, das Ineinanderfügen von organischer und pseudo-organischer Modellierung, und die Verwendung von Konturlinien, die einerseits natürliche Körperformen bezeichnen, andererseits aber unentschieden dicht an der Grenze zur Abstraktion liegen. Ein klares Bei- spiel bietet auch die Holzstatuette der Königsgemahlin Aschait (Kairo, JE 47310)[41], deren Oberkörper und ausladende Becken-Oberschenkel-Partie mit feinem Fingerspitzengefühl und sinnlicher Anmut modelliert ist, während Kopf und Arme mit ihrer harten Geradlinigkeit und Flächigkeit einen frappanten Gegensatz dazu bilden. Diese Hässlichkeit stellt in der Art, wie sie hier vorliegt, ein neues Phänomen in der Geschichte der ägyptischen Kunst dar. In frühe- ren Epochen, besonders gegen Ende des Alten Reiches, ist stellenweise eine unschöne Dis- proportioniertheit von Statuen anzutreffen, die auf das Unvermögen der Künstler zurückzu- führen ist. Die Kunst Mentuhoteps II. hat aber nichts mit Unvermögen zu tun, sondern es geht hier, wie ich meine, um die Entdeckung und den bewussten Einsatz des Hässlichen als künstlerisches Mittel.

Von allen Reliefzyklen, die aus der Regierungzeit Mentuhoteps I. erhalten sind, ist es der- jenige aus dem Grab der Königin Nofru, das sich unter dem Totentempel ihres Gatten in Deir el-Bahari befindet, der den Statuen des Königs stilistisch am nächsten steht.[42] An den Figuren der Krugträgerinnen, der Tänzerinnen oder der Frisierszene ist eine starke Überlängung fest- zustellen. Die Körper, Hände und Perücken bilden eine streng geschlossene Gesamtsilhouet- te, sie sind mit kaum bewegten, hart begradigten Linien umrissen, die aber doch an allen Ge- lenkstellen leicht abgerundet sind. Zugleich haben die Figuren fast keine Binnenzeichnung, sie bilden großräumige, glatte Flächen. So vermittelt der Körper, gleich wie bei den Königs-

39 H. Schneider / M. Raven, De Egyptische Oudheid, Rijksmuseum van Oudheden te Leiden, 's-Gravenhage 1981, Nr. 22, 21.

40 C. Ziegler, Les statues égyptiennes de l'Ancien Empire, Paris 1997, Nr. 39, 31.

41 Do. Arnold, Amenemhat I and the Early Twelfth Dynasty at Thebes, in: MMJ 26 (1991), S. 27f., Abb. 36. Vgl. auch die Steinfigur Genf, Musée d'art et d'histoire 4766 (H. G. Evers, Staat aus dem Stein I, Taf. 11).

42 Krugträgerinnen: K. Simpson, The Face of Egypt, The Kathona Gallery, Kathona 1977, Nr. 13; Tänzerinnen: C. Aldred, Jewels of the Pharaohs, London 1971, Taf. 23; Frisierszene: J. S. Karig / K.-T. Zauzich (Hg.), Ägyptische Kunst aus dem Brooklyn Museum, Berlin 1976, Nr. 24–25.

statuen, jenen eigentümlichen Eindruck, aus leicht kissenartigen oder aufgeblasenen Elementen zu bestehen. Die Gesichter der Königin und ihrer Damen entsprechen genau demjenigen des Königs, welches an den Statuen und an bestimmten Reliefs aus Deir el-Bahari wie den Kopffragmenten in Genf und Cambridge vorgeprägt ist.[43] Die harte Sprödigkeit der aufs Notwendigste reduzierten Umrisse der Einzelzüge, die Begradigung der Profillinie und der Perückenränder, die das Gesicht beinahe zum Rechteck werden lassen, die ungefällige Proportion der raumgreifenden Lippen-Kinn-Partie und des sehr weit oben sitzenden Auges, das übergroße Ohr, all dies erzeugt eine charakteristische Hässlichkeit, die zur künstlerischen Kühnheit gesteigert ist.

Auch die Reliefs aus den Gräbern der Königsgemahlinnen, die in den vorderen Teil des königlichen Totentempels integriert sind, sind stilistisch nahe verwandt mit der Königsplastik. Gegenüber dem Grab der Nofru sind die Linien hier etwas gestrafft und manche Partien mit feiner Binnenzeichnung versehen. Die Gesichter der Frauen sind identisch mit demjenigen des Königs (Taf. 8b). Das System des Wechselspiels zwischen den großen, glatten Flächen der Körper und den eckig ausfahrenden Gesten der schmalen Glieder und Hände wird mit großer Meisterschaft gehandhabt. Zugleich machen die Körper stellenweise noch ein wenig den Eindruck einer kompakten, unartikulierten Masse. Eigenartiger Weise gibt es auf dem Sarkophag der Aschait keine Grundlinien; auf demjenigen der Kawit sind sie zwar vorhanden, die Figuren stehen aber nicht darauf, sondern schweben einige Millimeter oberhalb der Linie in der Luft. In solchen Eigentümlichkeiten manifestiert sich noch ein Rest der für die Erste Zwischenzeit charakteristischen Labilität.[44]

Es ist notwendig, sich an dieser Stelle Rechenschaft zu geben über die geistige Lage, aus der die neuen künstlerischen Konzepte der 11. Dynastie herausgewachsen sind und die gekennzeichnet war durch die Überwindung der politischen, sozialen und wirtschaftlichen Krise, die gegen Ende des Alten Reiches eingetreten war. Trotz der Dürftigkeit der Quellen aus der Ersten Zwischenzeit zeichnet sich ab, dass die zentrale Regierung und die Verwaltung zusammengebrochen waren und dass während geraumer Zeit ungehemmte individuelle Gewalttätigkeit, Bandenkriminalität und Hungersnöte herrschten. Eine wichtige Ursache der Notlage dürfte eine kurzfristige und einschneidende Klimaschwankung gewesen sein.[45]

Werfen wir zuerst einen Blick auf eines der wichtigsten Denkmäler jener Epoche, das Grab des Gaufürsten Anchtifi in Moalla, das in die 8. Dynastie zu datieren ist.[46] Es handelt sich um eine in den Fels geschlagene Pfeilerhalle, die nebst der Autobiographie des Grabherrn auch gemalte Darstellungen an Pfeilern und Wänden enthält. Bezeichnend ist zunächst der Strukturverlust in der Architektur: Der Grundriss und die Wände haben eine gänzlich unbestimmte Form, die Pfeiler sind unregelmäßig und verjüngen sich etwa kegelstumpfartig nach oben. Das große Wandbild mit der Schlachtungs- und den Bootsszenen ist weitgehend

43 Genf, Musée d'Art et d'Histoire 4587 (H. Schlögel [Hg.], Geschenk des Nils. Ägyptische Kunstwerke aus Schweizer Besitz, Eine Ausstellung des Ägyptologischen Seminars der Universität Basel, Basel 1978, Nr. 151); Cambridge, Fitzwilliam Museum EGA 3143.1943 (J. Bourriau, Pharaohs and Mortals. Egyptian Art in the Middle Kingdom, Fitzwilliam Museum Cambridge, Cambridge 1988, Nr. 2).

44 J. Bourriau, Pharaohs and Mortals, Nr. 3–4; M. Saleh / H. Sourouzian, Die Hauptwerke im Ägyptischen Museum Kairo, Nr. 68–69.

45 Zu neuen Ergebnissen der paläoklimatologischen Forschung vgl. J.-D. Stanley, M. D. Krom, R. A. Cliff, J. C. Woodward, Nile flow failure at the end of the Old Kingdom: Strontium isotopic and petrologic evidence, in: Geoarchaeology 18 (2003), S. 395–402.

46 J. Vandier, Mo'alla. La tombe d'Ankhtifi et la tombe de Sébekhotep, BdE 18, Kairo 1950, S. 134–147, Taf. 14; 40; D. Wildung, Sesostris und Amenemhet, S. 30, Abb. 24–25.

desorganisiert. Es werden keine Standlinien verwendet, die einzelnen Szenen, die teils auf dem Wasser und teils an Land spielen, sind willkürlich und ohne logische Anordnung über die Fläche gestreut oder ineinander geschachtelt, die Fische, die gespeert oder gefangen werden sollen, sind manchmal größer als die Fischer, und sie sind beliebig über die ganze Bildfläche verteilt. Die Fischer mit dem großen Schleppnetz benützen den Rand des Netzes als Standlinie. Die Figuren sind unproportioniert und meistens schwer verzeichnet. Die Papyrusboote bestehen aus einem dünnen, eckig geknickten Balken.

Offensichtlich sind die Orientierung an der waag- und senkrechten Achse und das Ordnungsprinzip der Symmetrie, die der Kunst des Alten Reiches zugrunde lagen, weitgehend verloren gegangen, die Welt ist aus den Fugen geraten. Nur ein einziges Ordnungskriterium hat sich gehalten: Der Grabherr ist riesenhaft groß dargestellt. Aber auch er ist labil, hat keinen festen Halt, kein Bezugssystem, keinen festen Boden unter den Füssen. Der autobiographische Text schildert den historischen Hintergrund dazu, den Verlust der Königsherrschaft und der Sozialordnung sowie die dadurch ausgelöste Not und Kriminalität. Der Hauptteil des Textes berichtet aber von der dank der Tatkraft Anchtifis gelungenen Rückkehr zu Ordnung und Wohlergehen. Die Bilder hingegen sind ein direkter Spiegel der durch den Verlust des Halts eingetretenen psychischen Regression, denn die Phantasie eines Künstlers arbeitet offenbar weniger kontrolliert beim Zeichnen von Bildern als diejenige eines Schreibers beim Verfassen eines Berichts; der Künstler schöpfte aus dem Unbewussten und schilderte daher mehr die Folgen des erlittenen Traumas als dessen Überwindung.

Die Befindlichkeit einer Epoche auf der sozialen Ebene des Hofes lässt sich am ehesten aus denjenigen Quellen erschließen, in denen das Verhältnis zwischen Gott und König und zwischen König und hohen Beamten zum Ausdruck kommt. Es sind dies vom späten Alten Reich bis in die 11. Dynastie hinein Grabtexte religiöser und autobiographischer Natur. Was das Verhältnis des Königs zu den Göttern im Alten Reich angeht, so geben hauptsächlich die Pyramidentexte Aufschluss darüber. Die Beziehung wird uns dort auf der psychischen Ebene als eine symbiotische geschildert, als eine gegenseitige Abhängigkeit und ein Ineinander-Aufgehen von König und Gottheit, was besonders deutlich zum Ausdruck kommt in stereotypen Wendungen wie derjenigen, dass alles, was dem König NN geschieht, auch dem Gott NN geschieht (»If I be cursed, then will Atum be cursed«), oder dass die Muttergöttinnen den König an ihrer Brust säugen und ihn in Ewigkeit nicht entwöhnen mögen (Pyr. 1107–1119);[47] auch die aggressiven Bemächtigungsphantasien, die schildern, wie der König sich die Gottheiten physisch einverleibt, gehören hierher, die so genannten Kannibalensprüche. (Im letztgenannten Fall berücksichtigen wir hier andere Leseebenen nicht, wie die metaphorische Beschreibung kosmischer Vorgänge). Im späteren Alten Reich hat auch die Beziehung zwischen den hohen Beamten und dem König etwas Symbiotisches, was insbesondere aus den in Privatgräbern der 6. Dynastie aufgezeichneten Königsbriefen hervorgeht. Der Beamte geht auf im Willen seines Herrn, sein ganzes Sinnen und Trachten ist darauf gerichtet, die Wünsche des Königs aufs Beste zu erfüllen, und in diesem liebenden Bemühen weiß er sich von der Liebe seines Herrn getragen: »[Meine] Majestät weiß, dass Du alles zu sagen liebst, was [meine] Majestät liebt. Oh Špss-rꜥw, ich sage Dir Millionen Male: Geliebter seines Herrn, Gelobter seines Herrn, der im Herzen seines Herrn ist …«[48]

In der Ersten Zwischenzeit hat der Zerfall des Gottkönigtums eine Destabilisierung nicht nur der Gesellschaftsordnung, sondern auch der Götterwelt bewirkt. Auf diesen Schock rea-

47 R. O. Faulkner, The Ancient Egyptian Pyramid Texts, S. 183f.

48 E. Eichler, Untersuchungen zu den Königsbriefen des Alten Reiches, in: SAK 18 (1991), S. 151.

gierten einige starke Persönlichkeiten mit der Herausbildung einer weitgehenden Autonomie, einer selbständigen Entschlussfähigkeit. Eines der wichtigsten Zeugnisse dazu ist die erwähnte Grabbiographie des Gaufürsten Anchtifi von Moalla, die der Nachwelt berichtet, wie es ihm gelang, ein mehrere Gaue Oberägyptens umfassendes Gebiet politisch und wirtschaftlich wieder zur Ordnung zurückzuführen. In seinem Handeln bezieht er sich weder auf den König noch auf die großen Götter, denn diese sind seiner Welt abhanden gekommen. Anchtifi ist der selbstgewisse Macher, dem die Lösung der selbstgestellten Aufgabe gelingt. Er bezeichnet sich immer wieder als einen Helden ohnegleichen, in Ewigkeit unerreichbar, und setzt sich mit Hapi, Sechathor, Nepri und Tait gleich, das heißt mit denjenigen Gottheiten, die die lebensnotwendigen Basismaterialien verkörpern wie Wasser, Viehherden, Korn und Textilien. Ähnlich selbstbewusst äußert sich der Gaufürst Cheti von Assiut,[49] der »Herr der Herren, die Saat der Urzeit, der Same des Thot«, der selber wie ein König handelt und z. B. einen Tempel baut. Er findet eine ganz neuartige und kühne Definition für sein Verhältnis zum Lokalkönig von Herakleopolis, indem er sich als »Herrscher, der an der Seite seines Herrn sitzt« bezeichnet. Außerdem legt er großen Wert auf die Beschreibung seiner guten Taten und seines guten Charakters. Letzteres trifft auch auf die Thebaner Heni, Tjetji und Rediuchnum aus der frühen 11. Dynastie zu.[50]

Das Thema des guten Charakters ist besonders bedeutungsvoll in der Lehre für Merikare, den Lokalkönig von Herakleopolis,[51] dessen Autor sich zwar König nennt, seine Rolle aber ganz nach Art der hohen Beamten begreift und das Königtum auch ausdrücklich als ein Amt bezeichnet. Die früher auf den König beschränkte Gleichsetzung mit den Göttern wird hier zu einer großen, kollektiven Gotteskindschaft ausgeweitet, indem alle guten Menschen das Abbild und leibliche Kind des Schöpfergottes sind und darum auch über dessen Bewirkensmacht verfügen, sind sie doch im Besitz der Magie. Merikares Vater verzichtet nicht nur weitgehend darauf, seine eigene Größe darzustellen, sondern er kann sogar einen Fehler, den er begangen hat, benennen und seine Gefühlsreaktionen ausdrücken, wenn er Bedauern empfindet über den Fehler oder Traurigkeit über die Invasion der Asiaten im Delta.

Die hohen Beamten und Lokalfürsten der Ersten Zwischenzeit gewinnen ein gesteigertes Bewusstsein ihrer eigenen Fähigkeiten, ja stellenweise sogar eine Wahrnehmung ihrer Emotionalität, wenn sie in immer neuen Wendungen ihre Leistungen und ihren Charakter schildern. Anstelle der verlorenen symbiotischen Identifizierung mit dem Gottkönig entwickeln sie jetzt erstmals Größen- und Allmachtsphantasien, die sich auf die eigene Einzigartigkeit und die Gleichsetzung mit Göttern gründet. Nach der Wiederherstellung des Einheitsreichs und des Gottkönigtums haben die hohen Beamten oder Fürsten ihre relativ starke Selbstwahrnehmung beibehalten und ihr Verhältnis zum König neu definiert. Dies gilt jedenfalls für eine kleine Gruppe führender Persönlichkeiten der 11. Dynastie, beginnend mit Antef, Sohn der Miit, dessen Stelen in der Zeit Mentuhotep II. Nebhepetres entstanden.[52] Die autobiographischen Texte dieser Gruppe zeichnen sich durch einen grandiosen Ton des Selbstpreises aus. Diesen Fürsten eignet eine übermenschliche Tatkraft und Vollkommenheit, die dadurch zustande kommt, dass sie sich mit eindrucksvoller Konsequenz die Fähigkeiten von Göttern

49 W. Schenkel, Memphis, Herakleopolis, Theben. Die epigraphischen Zeugnisse der 7.–11. Dynastie Ägyptens, ÄA 12, Wiesbaden 1965, S. 82–89.

50 Heni: W. Schenkel, Memphis, Herakleopolis, Theben, S. 101–103; Tjetji: W. Schenkel, Memphis, Herakleopolis, Theben, S. 103–107; Rediuchnum: W. Schenkel, Memphis, Herakleopolis, Theben, S. 112–115.

51 M. Lichtheim, Ancient Egyptian Literature I, S. 99–107; R. B. Parkinson, The Tale of Sinuhe and other ancient Egyptian poems 1940–1640 B. C., Oxford 1997, S. 216–227.

52 W. Schenkel, Memphis, Herakleopolis, Theben, S. 230–235.

und König leihen. So ist Antef, Sohn der Miit, ein dem Ptah Gleicher, der allen Meistern der Handwerker Anweisung gibt, ferner ein Thot und Hu. Die Vergleiche sind sehr hoch gegriffen, da es sich um den memphitischen Schöpfergott, den Gott des Wissens und der Magie sowie die Verkörperung des schöpferischen Ausspruchs handelt. Außerdem gebraucht er die außerordentlich aufschlussreiche Wendung »der wünscht und es geschieht«, die auch in der Inschrift Henenus, die dieser zur Zeit Mentuhotep III. Seanchkares im Wadi Hammamat anbringen ließ, wiederkehrt in der Variante »der spricht und es geschieht«.[53] Es handelt sich hier um die Formel der Schöpfung durch das Wort. Antef und Henenu wählen als Ausdruck für ihre Allmachtsphantasie die Rolle des Schöpfergottes und setzen somit den Satz aus der Lehre für König Merikare in die Praxis um, dass der Mensch im Besitz der Magie sei. Henenu betrachtet sich ferner als einen Gottgleichen, klüger als Thot, und als einen, unter dessen Händen der Nil von allem Guten überströmt.

Die Beziehung zum König wird in der bewussten Gruppe autobiographischer Texte auf eine neue, raffinierte Weise ins Spiel gebracht, indem die Herren sich mit einem Glied oder Organ Seiner Majestät gleichsetzen. Antef, Sohn der Miit, und Amenemhet, der Wesir Mentuhoteps IV. Nebtauire, gebrauchen das allgemeine Wort »Glied«, während Henenu die »Augen« seines Herrn ist und der Vorsteher der Steinhauerarbeit Cheti gar das »Herz«.[54] In der Metapher des Gliedes verselbständigt sich ein entscheidendes Organ des Königs und nimmt in einem Beamten Gestalt an; es lässt sich nicht mehr unterscheiden, ob das, was der Beamte in dieser Eigenschaft tut, vom König oder von ihm selbst gesteuert wird. Darin liegt wohl auch ein Potenzial an Spannung zwischen der eigenen Entscheidungsfreiheit des Beamten und der totalen Identifikation mit dem Willen des Königs.

Für die Frage nach dem Verhältnis des Königs zu den Göttern in der frühen und mittleren 11. Dynastie stehen nur der Götterhymnus Antefs II. und die rund- und flachbildlichen Königs- und Götterdarstellungen Mentuhoteps II. als Zeugnisse zur Verfügung. Der Hymnus Antefs II. an Re und Hathor geht über die Pyramidentexte, auf deren Phraseologie er basiert, weit hinaus, indem er einen viel persönlicheren Ton anschlägt.[55] Obwohl Antef II. nur ein thebanischer Lokalfürst war, herrscht wieder der Ton des Gottkönigs, da er sich unumwunden als Angehörigen der hohen Götter zu erkennen gibt. Er ist zunächst das Kind der Hathor, das täglich von ihr gesäugt wird. Dann gehört er aber auch zu den Göttern des Westhimmels, die die Göttin als Abendstern jubelnd bewundern, wobei er mit den Gesten seiner Hände, mit seinem ganzen Körper und seinem Gesang die Sehnsucht nach ihr ausdrückt, um sich schließlich in der Rolle des Horus mit ihr zu vereinen. Antef II. nimmt eine differenzierte und gefühlsbetonte Haltung gegenüber Hathor ein, indem er sich in die Rolle des Kindes, des Bewunderers und des Gatten phantasiert.

Auch Mentuhotep II. bringt sich selbst in seiner Eigenschaft als Herrscher viel stärker zur Geltung bei der Neugestaltung der Beziehungen zur Götterwelt, insbesondere fassbar bei Osiris, Hathor und Amun, die in seinem Tempelkomplex von Deir el-Bahari so prominent vertreten sind. Da eine eingehende Analyse dieses Themas hier allerdings zu weit führen würde, müssen wir es bei einer Andeutung des Sachverhalts bewenden lassen. Die Sitzstatue im Bab el-Hosan verkörpert die Identifizierung des Königs mit Osiris als dem König der Un-

53 W. Schenkel, Memphis, Herakleopolis, Theben, S. 253–258, bes. S. 255.

54 Antef, Sohn der Miit: W. Schenkel, Memphis, Herakleopolis, Theben, S. 233; Henenu: W. Schenkel, Memphis, Herakleopolis, Theben, S. 254; Wesir Ameni (Zeit Mentuhoteps IV.): W. Schenkel, Memphis, Herakleopolis, Theben, S. 266; Cheti: W. Schenkel, Memphis, Herakleopolis, Theben, S. 284.

55 J. Assmann, ÄHG, S. 421–423 (Nr. 201).

terwelt. Die Serie der Hebsedstatuen im Vorhof des Tempels deutet auf eine Neudefinition der osirianischen Königsrolle: Es geht um eine Ausweitung seiner Herrschaft auf die Oberwelt wegen der dem Hebsedmantel innewohnenden Regenerationssymbolik, die für alle Bereiche der Schöpfung gilt. Die fragmentarische Genfer Statuengruppe einer Königsgemahlin und die Statuette der Aschait gehören zum Komplex der königlich-hathorischen Symbolik der Erneuerung, die auf der Doppelrolle des Herrschers als Kind und als Gatte der Göttin beruht. Im Sanktuar und Speos des Tempels vollzieht sich die Überleitung zum Führungsanspruch des neuen Herrschergottes Amun, den Mentuhotep II. nach seinem eigenen Bild geschaffen hat.

II.1.2 Mentuhotep III. Seanchkare (ca. 1995–1983)

Für Mentuhotep III. ist trotz seiner kurzen Regierung ein relativ umfangreiches Tempelbauprogramm in Oberägypten nachweisbar, Statuen sind aber in geringer Zahl und meist sehr fragmentarisch auf uns gekommen. Vom Porträt Seanchkares können wir uns erst in jüngerer Zeit ein Bild machen. Er gehört zu denjenigen Königen des Mittleren Reiches, denen die moderne Kunstwissenschaft ihr Antlitz wiedergeben konnte. Ganz unbekannt sind immer noch die Gesichter der weniger bedeutenden Herrscher vom Ende der 11. und der 12. Dynastie, Mentuhoteps IV. Nebtauire, Amenemhets IV. und Nofrusobeks. Der Fall Seanchkares gestaltete sich dadurch so schwierig, dass es keine einzige Statue gibt, die durch Inschrift oder Fundort datiert ist. Einen Anhaltspunkt boten aber die wunderbar feinen Reliefblöcke aus dem Monthtempel von Tod, die Bisson de la Roque 1936 zutage gefördert hatte.[56] Als Cyril Aldred gegen 1970 den Königsköpfen der 11. und 12. Dynasie nachspürte, bemerkte er, dass zwei der Köpfe von den mumiengestaltigen Statuen aus Armant sowie die kleinen Köpfe mit Nemes-Kopftuch in Basel (Museum der Kulturen III 8397) und New York (Metropolitan Museum of Art 66.99.3) einander sehr ähnlich sähen und stilistisch alle zwischen Nebhepetre und Sesostris I. einzureihen seien. Aldred kam zu dem Schluss, dass sie wahrscheinlich Mentuhotep III. Seanchkare darstellten.[57] Das Grauwackeköpfchen mit den eingelegten Augen im Louvre (E.10299), das Aldred lieber noch mit Nebhepetre in Verbindung brachte, wurde 1992 von Wilfried Seipel Seanchkare zugewiesen.[58]

Die beiden einzigen vollständigen Statuen, die wir heute kennen, stammen aus der mumiengestaltigen Serie, die am Aufweg des Monthtempels von Armant stand und in Boston (Taf. 9a) und Luxor aufbewahrt werden (Boston, Museum of Fine Arts 38.1395 und Luxor Museum J.69).[59] Sie haben keinen Rückenpfeiler und erweisen sich dadurch als die direkten Nachfolger der stehenden Hebsedfiguren Mentuhoteps II. Nebhepetres, die im großen Vorhof seines Tempels von Deir el-Bahari aufgestellt waren. Auf der stilistischen Ebene ist aber inzwischen eine ganz erstaunliche Entwicklung eingetreten. Der auf gedrungenen Rechtecken basierende Umriss der älteren Figuren entfällt, die gesamte Statue ist nun sehr langgezogen und konisch stereometrisiert. Die Oberarme verlaufen von den Schultern bis zu den Ellbogen

56 D. Wildung, Sesostris und Amenemhet, S. 52–59, Abb. 47–52.

57 C. Aldred, in: MMJ 3 (1970), S. 35–37.

58 W. Seipel, Gott, Mensch, Pharao. Viertausend Jahre Menschenbild in der Skulptur des alten Ägypten, Wien 1992, Nr. 40.

59 R. Mond / O. Myers, Temples of Armant, A Preliminary Survey, EEF 43, London 1940, S. 16f.; 49f.; 59; 64; 188, Taf. 11; 16 (S. 102), 17 (links oben und Mitte rechts); The Luxor Museum of Ancient Egyptian Art. Catalogue, Kairo 1979, Nr. 19, Abb. 12–13.

schräg nach innen und die Beine sind in die Mumienhülle eingepackt, unter welcher sich aber die Wölbung der Schenkel, die Einziehung an den Gelenken und die abgerundeten Kniescheiben abzeichnen. Vorn sind die Unterschenkel durch eine Rinne getrennt und auf der Rückseite verläuft eine Mittelrinne von den Schultern bis zum Fuß. Der Bart, der bis zu den Handgelenken reicht, ist sehr lang und schmal. Der Kopf ist klein, wird aber von einer außerordentlich hohen und schlanken Weißen Krone überhöht. So verjüngt sich die Silhouette der Statue, von den Schultern an gerechnet, konsequent nach unten bis zum Fuß und nach oben bis zum Kronenknauf. Dank dem leichten Ein- und Ausbuchten der Umrisslinien wirkt der Körper andeutungsweise artikuliert.

Die drei unterlebensgroßen Köpfe mit Nemes-Kopftuch in Basel (Taf. 10a u. 10b), New York und Paris, die sich Mentuhotep III. Seanchkare zuschreiben lassen, weisen alle eine erhebliche Ähnlichkeit mit Mentuhotep II. auf. Sie sind aus hochwertigen Hartgesteinen in sorgfältiger Arbeit von beachtlicher technischer und künstlerischer Qualität hergestellt. In der Vorderansicht sind der U-förmige Gesichtsumriss, die Proportionen, das heißt vor allem die hochsitzende Augenpartie, und die Form der einzelnen Züge etwa die gleichen wie beim Vorgänger. Der deutlichste Unterschied macht sich beim Schnitt der Augen bemerkbar. Die Achse steht noch schräger, der untere Lidrand ist sehr flach gebogen, der obere steigt nur wenig in die Höhe. Beide Lidränder sind gegen die Winkel hin stark begradigt, besonders der äußere Augenwinkel sieht wie ein spitzes liegendes Dreieck aus, was zur Folge hat, dass das Auge fast schlitzartig wirkt. Die Brauen und die Scheitelpartie des Kopftuchs sind etwas stärker geschweift, der Kinnwulst ist ein wenig kleiner. Alle Linien sind fein und diszipliniert, und dasselbe gilt für die kompakten Wölbungen der Gesichts- und Kopftuchoberfläche.

An der Seitenansicht ist eine erste Eigentümlichkeit dieser Köpfe zu beobachten, die darin besteht, dass sie sich überdurchschnittlich weit in die Tiefe erstrecken. Der Kopftuchflügel sitzt so weit hinten, dass ein langer Abstand zwischen äußerem Augenwinkel und Ohr entsteht, und dieser ist extrem gesteigert beim Pariser Kopf, wo vor dem Ohr noch ein Rechteck, das das natürliche Haar andeutet, Platz beansprucht. Die Konturlinie der Scheitel- und Hinterkopfpartie des Kopftuchs ist beim Basler und Pariser Kopf gleichmäßig gewölbt, beim New Yorker Kopf eher begradigt. Des weiteren fällt bei allen der weit offene Winkel zwischen der stark abfallenden Kinnbasis und der Halslinie auf. Etwa parallel zur Kinnbasis, aber doch in unterschiedlicher Abweichung davon, verlaufen das Stirnband und die Scheitellinie des Kopftuchs; hingegen sind die Hals- und die Profillinie, die Außenkante des Kopftuchflügels und die Umrisslinie des Hinterhaupts der Senkrechten angenähert, stehen aber in unentschiedenen Schräglagen zueinander. Die Folge davon ist, dass die Köpfe deutlich aufwärts blicken, ohne dass sich aber genau entscheiden ließe, welches ihre ursprüngliche Lage war.

Die wenigen von Seanchkare erhaltenen Relieffragmente sind inschriftlich datiert und stammen aus Tod, Armant und Elephantine.[60] Sie bestätigen die Gesichtsbildung der Statuen und besonders die hochsitzenden, schlitzartigen Augen vollauf als diejenigen Mentuhoteps III. Statuen und Relieffiguren haben mehr Standfestigkeit gewonnen, weil das Liniengefüge, obwohl es im Grunde dasselbe blieb wie unter dem zweiten Reichseiniger, eine gewisse Elastizität und strenge Eleganz gewonnen hat. Der Stil Seanchkares ist eine direkte Fortsetzung desjenigen Mentuhoteps II. Es ist aber ein Wandel im Sinne einer erheblichen Verfeinerung eingetreten und die Werke strahlen nun etwas mehr innere Ausgeglichenheit aus.

60 Tod und Armant: D. Wildung, Sesostris und Amenemhet, S. 52–59, Abb. 47–52; Elephantine: C. Vandersleyen, Das Alte Ägypten, Taf. 268b.

Von Seanchkare sind keine Königsinschriften überliefert. Die Wandreliefs seines renovierten Monthtempels in Tod warten aber mit einer zweifellos eigenen und zukunftsträchtigen Bildidee auf: Die göttliche Geburt des Königs wird neu formuliert in der Weise, dass er als leibliches Götterkind auf dem Thron seines Vaters Month steht und von diesem umarmt wird, während seine Mutter Tjenenet daneben sitzt.[61] Es sieht aus wie eine komprimierte Fassung des im Neuen Reich breit ausgemalten Bilderzyklus von der Geburt des Gottkönigs. Ein hervorstechendes privates Schriftzeugnis aus der Regierungszeit Seanchkares ist die Inschrift des erfolgreichen Expeditionsleiters Henenu im Wadi Hammamat, die oben in Zusammenhang mit dem gesteigerten Selbstbewusstsein der leitenden Beamten der 11. Dynastie zitiert wurde. Henenu kann andere Beamte spielend überflügeln, indem er seine unermessliche Wahrnehmungsfähigkeit mit Ausdrücken beschreibt, die aus der religiösen Literatur entliehen sind: Er bezeichnet sich als einen, »der die Art dessen, was ist und was nicht ist, kennt, dem nichts entgeht«. Aus seiner Sicht ist es durchaus angemessen, sich göttliche Allwissenheit zuzuschreiben, denn er pflegt als Organ des Gottkönigs zu fungieren, genauer geagt als die »Augen seines Herrn«, wie aus der gleichen Inschrift zu erfahren ist.[62] Über diesen Herrn aber wissen wir zu wenig, um etwas über seinen Charakter zu sagen. Aber die Stilentwicklung, die an seinen Reliefs und Statuen ablesbar ist, und der Neubau des Monthtempels von Tod mit dem neu formulierten Bildthema der göttlichen Geburt des Königs weisen darauf hin, dass er über innovative Künstler und Gelehrte verfügte.

Der letzte König der 11. Dynastie, Mentuhotep IV. Nebtauire (ca. 1983–1976), kann hier nicht besprochen werden, da von ihm keine Statuen erhalten sind. Auch der Gründer der 12. Dynastie, Amenemhet I. Sehetepibre (ca. 1976–1947), muss unbehandelt bleiben, weil keine gut erhaltenen Figuren zur Verfügung stehen.

II.1.3 Sesostris I. Cheperkare (ca. 1947–1911/10)

An 15 Orten vom Delta bis Nubien sind Bauwerke Sesostris' I. durch archäologische Reste nachgewiesen, weitere werden inschriftlich erwähnt, und es sind über 60 Statuen und Statuenfragmente erhalten, deren Fundorte meistens bekannt sind. Aber nur im Fall der Pyramidenanlage in Lischt konnte der Grundriss wiedergewonnen und die Ausstattung mit Statuen stellenweise rekonstruiert werden. Sesostris I. ist der einzige Herrscher des Mittleren Reiches, von dem wir wohlerhaltene Monumentalplastik haben. Dies in erster Linie dank der Serie von 10 kolossalen Sitzfiguren, die in nahezu perfektem, vollständigem Zustand gefunden wurden, und zwar in einem Versteck in der königlichen Grabanlage in Lischt (Kairo, CG 411–420).[63] Auch die beiden kolossalen Granitstandbilder aus Karnak, Kairo (JE 38286–38287)[64] sind fast ganz erhalten, einschließlich der Gesichter. Alle genannten Figuren tragen den Schendjut-Schurz und gaben somit dem Bildhauer Gelegenheit, den Körper weitgehend nackt zu zeigen. Ansonsten kann man die Körpermodellierung noch an der Sitzstatue aus

61 Di. Arnold, Bemerkungen zu den frühen Tempeln von El-Tod, in: MDAIK 31 (1975), S. 182f., Taf. 54.

62 W. Schenkel, Memphis, Herakleopolis, Theben, S. 254.

63 F. W. von Bissing, Denkmäler Ägyptischer Skulptur I–III, München 1911–1914, Taf. 19–20; H. G. Evers, Staat aus dem Stein I, Taf. 26–29; K. Lange / M. Hirmer, Ägypten. Architektur, Plastik, Malerei in drei Jahrtausenden, München 1967, Taf. 87.

64 Kairo, Ägyptisches Museum JE 38286/87 (H. G. Evers, Staat aus dem Stein I, Taf. 34) und Kairo, Ägyptisches Museum JE 38286 (H. Sourouzian, Standing Royal Colossi of the Middle Kingdom reused by Ramesses II, in: MDAIK 44 [1988], S. 253, Taf. 74).

die eigene Kraft und Energie. Demgegenüber ist das Gesicht maskenhaft starr, unindividuell, unpersönlich; es wirkt nicht wie ein realistisches Porträt, sondern wie ein synthetischer Typus. Die Züge sollen zwar den seit Mentuhotep II. gängigen Familientypus evozieren, aber mit Sicherheit nichts von dem, was im Inneren vorgeht, vom Denken und Empfinden, verraten.

Der Wille zur realitätsnahen Modellierung bestätigt sich an den Reliefs. Aus der Pyramidenanlage des Königs in Lischt stammt ein Block, auf dem der obere Teil einer am Speisetisch sitzenden Figur des Herrschers erhalten ist.[69] Hier kommen die gut entwickelte Muskulatur sowie die leichte Übergröße der Arme und vor allem der Hände klar zur Geltung. An der Weißen Kapelle in Karnak, einer Barkenstation für das Prozessionsbild des Amun, findet sich eine ganze Reihe von Bildern Sesostris' I. von hervorragender künstlerischer Qualität und ausgezeichneter Erhaltung.[70] Die Arme, Hände und besonders die Beine sind eine Spur zu groß und breit im Verhältnis zu der etwas kurzen und schmalen Becken-, Taillen- und Brustpartie; die Beine sind ein wenig zu weit nach außen gesetzt, was übrigens auch auf die stehenden Kolossalstatuen aus Karnak zutrifft. Es zeigt sich, dass die Statur des Königs ganz leicht untersetzt war, und dies darf wohl als persönliches Merkmal gewertet werden.

Ein Block mit einer Kultlaufszene aus dem Mintempel von Koptos ist ein großes Meisterwerk.[71] Der König, der sich mit weit gespreizten Beinen auf die Götterfigur zu bewegt, erscheint in bisher unerreichter Spannkraft dank dem Spiel der Muskeln, das sich an Umriss und Modellierung der Figur entfaltet und sogar das Becken einbezieht. Hier bekommen wir ausnahmsweise die sonst immer unter dem Schurz verborgenen, kräftigen kurzen Oberschenkel zu sehen, die die Taille umso schmaler erscheinen lassen. Nicht minder erstaunlich ist der ithyphallische Min, dessen Körper in eine dünne, anschmiegsame »Haut« gehüllt ist, die sogar eine sanfte Modellierung des Körpers zulässt – dies kommt sonst bei der Mumienhülle nicht vor. Der lange, leicht gebogene Phallus erscheint praktisch nackt und mit klar abgesetzter Eichel. In dieser Szene stehen sich zwei kraftvoll schöne Persönlichkeiten gegenüber, die ihre Männlichkeit auf unterschiedliche Weise ins Spiel bringen.

Im Amuntempel von Karnak wurde ferner ein Pfeiler aus einem Tempel Sesostris' I. gefunden, auf dessen mit Reliefs bedeckten Seiten sich jeweils der König und ein Gott gegenüberstehen und sich umarmen (Kairo, Ägyptisches Museum JE 36809).[72] Auch diese Szenen haben eine Atmosphäre, die über die Neutralität der Ritualszenen an der Weißen Kapelle hinausgeht. Die Besonderheit ergibt sich daraus, dass die Körper der beiden Partner sehr nahe aneinander gerückt und ganz knapp in den schmalen Rahmen der Pfeilerseiten eingefügt sind. Auf derjenigen Seite, die dem urzeitlichen Schöpfergott Atum gehört, stehen sich zwei Männer gegenüber, die beide mit der Doppelkrone angetan sind und sich an Gesicht und Ge-

69 Di. Arnold, The Pyramid of Senwosret I. The South Cemeteries of Lisht I. The Metropolitan Museum of Art
 Egyptian Expedition, New York 1988, Taf. 49.

70 B. Porter / R. Moss, Topographical Bibliography II, S. 61–63; D. Wildung, Sesostris und Amenemhet, S. 64–
 67, Abb. 54–57, mit Hinweis auf die »bisweilen etwas gedrungenen Figuren« voll »strotzender Kraft«; K.
 Lange / M. Hirmer, Ägypten, Taf. 92; J. Yoyotte, Les trésors des pharaons, Genf 1968, Taf. 44; D. Valbelle /
 C. Bonnet, Le sanctuaire d'Hathor, maîtresse de la turquoise. Sérabit el-Khadim au Moyen Empire, Paris
 1996, Abb. 147 (die Proportionen der Figuren sind nur auf denjenigen Aufnahmen richtig sichtbar, wo die
 Kamera senkrecht auf das Relief gerichtet war, was aber wegen der engen Platzverhältnisse schwierig ist; bei
 schrägem Blickwinkel ergibt sich immer eine Verzerrung).

71 London, University College 14786 (C. Vandersleyen, Das Alte Ägypten, Taf. 271).

72 Kairo, Ägyptisches Museum JE 36809 (B. Porter / R. Moss, Topographical Bibliography II, S. 133; E. Drio-
 ton, Encyclopédie photographique de l'art. Le Musée du Caire, Paris 1949, Taf. 68 [König und Atum]; D.
 Wildung, Sesostris und Amenemhet, S. 67, Abb. 60 [König und Atum]; K. Lange, Sesostris. Ein ägyptischer
 König in Mythos, Geschichte und Kunst, München 1954, Abb. 4–5 [König und Ptah]; J. Vandier, La sculpture
 égyptienne, Paris 1951, Taf. 47 [König und Horus]; K. Lange / M. Hirmer, Ägypten, Taf. 93–97].

stalt wie eineiige Zwillinge gleichen. Ihre Schultern und Beine überschneiden sich. Die große rechte Hand des Gottes liegt am Nacken des Königs, während die linke seinen Oberarm packt; er hat den König fest im Griff. Aber Sesostris trägt eine Waffe, eine Keule, und seine kräftige Schulter und sein linkes Bein schieben sich vor den Körper des Gottes, der dadurch gleichsam »an die Wand gedrückt« wird. Dadurch wird eine minimale Dominanz des Königs suggeriert, oder zumindest halten sich die beiden Partner in Schach. Es entsteht eher der Eindruck von Konkurrenten, denn die Gesten haben nichts von familiärer Zärtlichkeit, sondern erinnern an den Handschlag zweier Athleten, etwa von Ringern, bevor der Kampf beginnt. Noch deutlicher spricht die Szene mit Ptah, denn der Gott ist viel kleiner als der König, weil er auf einem Sockel steht, und die Schulterpartie kann sich nicht in die Breite entwickeln, weil sie in echter Seitenansicht wiedergegeben ist (Taf. 12a). Zwar umfangen Ptahs Hände die Taille des Königs, aber dieser schiebt eine Schulter, einen riesigen, angewinkelten Arm und ein Bein vor den Körper des Gottes, dessen Rumpf an denjenigen des Königs angeschmiegt ist. So bilden die vordere Körperkontur des Königs zusammen mit seinem massigen, senkrecht an Rücken und Hinterkopf des Gottes angelegten Unterarm eine Klammer um Ptahs schmale Gestalt. Dazu kommt, dass sich die beiden Gesichter gefährlich nahe kommen. In diesem Falle kann man die Geste des Königs als bedrohlich oder beschützend empfinden, mit Sicherheit aber demonstriert er seine überlegene Kraft.

Schließlich sind die Reliefs an den Thronwangen der Serie von Sitzstatuen Sesostris' I. aus Lischt zu nennen, die die symbolische Vereinigung der beiden Länder darstellen, vollzogen von je einem Götterpaar.[73] Es sind entweder Horus und Seth oder zwei Nilgenien, die mit erstaunlichem Aufwand an Energie die Schnüre um das Symbol verknoten, mit angestemmten Füssen und weit ausgreifenden Armen, und noch viel erstaunlicher ist der Realismus ihrer Körperbildung. Noch nie sah man in der königlichen ägyptischen Kunst eine derart detailliert und differenziert geschilderte Muskulatur, und – im Falle der traditionell fettleibigen Nilgenien – einen derartigen Naturalismus in der Schilderung der herabhängenden Brüste, Speckfalten und Bäuche (Taf. 12b). Die Nilgottheiten der Thronreliefs zeigen übrigens eine starke Ähnlichkeit mit dem König in Gesichts- und Körperbildung, abgesehen natürlich von der Besonderheit ihres Rumpfs.

Der Körper wirkt jung, das Gesicht alterslos. Es ist ein Gegensatz zwischen Kopf und Körper angestrebt. Gegenüber der Königsplastik des Alten Reiches ist die Plastizität des Körpers leicht gesteigert; dort waren aber Körper und Kopf einheitlich gestaltet und in die Gesamterscheinung integriert. Bei Sesostris I. hingegen bleibt etwas unterschwellig Störendes, ja fast Bedrohliches, eine gewisse Zwiespältigkeit jedenfalls, denn die Gestalt wirkt attraktiv und abweisend zugleich.

Ein nahe liegender Grund für die Verschlossenheit des königlichen Antlitzes ist das Trauma, das Sesostris I. durch die Ermordung seines Vaters erlitten haben muss. Der Mord war offenbar ein Schlüsselerlebnis, das die ganze Regierungszeit prägte und einen Aspekt von Distanziertheit, Abschottung und Kälte in das Aussehen und Verhalten des Königs brachte, und der sich zum beschriebenen Aspekt der Stärke, der Tatkraft und des Erfolgs gesellt. Das schlimme Ereignis gab Anlass zur Entstehung oder fand zumindest seinen Niederschlag in fünf wichtigen Literaturwerken von sehr verschiedener Art. In zweien davon wird der Mord direkt oder andeutungsweise erwähnt: Das eine ist die *Lehre Amenemhets I.*«, eine politische Schrift, die vom König in Auftrag gegeben wurde, um seine Beziehung zum Vater auf-

73 K. Lange / M. Hirmer, Ägypten, Taf. 88–89; H. G. Evers, Staat aus dem Stein I, Taf. 40; D. Wildung, Die Kunst des alten Ägypten, Freiburg / Basel / Wien 1988, Abb. 39.

zuarbeiten, das andere die *Lebensbeschreibung des Sinuhe*, die eine weniger politische als vielmehr ganz persönliche Auseinandersetzung des Autors mit Sesostris I. enthält. Zwei weitere, die *Berliner Lederhandschrift* mit der Gründungsinschrift des Atumtempels von Heliopolis und der *dramatische Ramesseumpapyrus* mit einem Ritual zum Herrschaftsantritt, sind davon berührt, ohne es zu nennen, und es sind religiöse Schriften mit politischem Unterton. Das fünfte Stück, die *Grabbiographie Sarenputs I. von Elephantine*, ist, wenigstens was die darin geschilderte Beziehung zum König angeht, wiederum ein persönliches Zeugnis.

Es ist mir bewusst, dass es sehr schwierig ist, diesen Schriften Aussagen über den realen Menschen Sesostris abgewinnen zu wollen, und dies nicht zuletzt wegen der Formelhaftigkeit ägyptischer Schreibweise, die die heutige Leserschaft stets im Ungewissen lässt, ob eine Aussage konventionell oder individuell gemeint ist. Es ist hier nicht der Ort, die Literatur der frühen 12. Dynastie als historische Quellen zu diskutieren. Ohnehin scheint es mir ganz offensichtlich daraus hervorzugehen, dass Amenemhet I. einem Attentat zum Opfer fiel, während der Thronfolger fern von der Residenz auf einem Feldzug war. Was die Frage einer zehnjährigen Mitregentschaft zwischen Amenemhet I. und Sesostris I. angeht, welche heute noch von vielen für gegeben gehalten wird, so bin ich mit Claude Obsomer der Ansicht, dass sie nicht stattgefunden habe, weil einerseits keine Beweise dafür vorliegen und andererseits Indizien für deren »Erfindung« unter Sesostris I. sprechen.[74] Meine Frage an die Quellen lautet vielmehr, ob eine persönliche, eventuell auch emotionale Stellungnahme der Autoren oder der Auftraggeber der Schriftzeugnisse in Dingen, welche den König betreffen, fassbar ist, denn diese kann einen Reflex der Persönlichkeit des Königs enthalten, besonders wenn der Auftraggeber der König selbst ist. Das Risiko sich zu täuschen ist sehr hoch, aber in der seltenen Tatsache, dass fünf Schriften über den König vorliegen, die von ihm selbst (in drei Fällen) oder von besonders begabten Männern der Oberschicht (in zwei Fällen) veranlasst wurden, liegt doch eine Chance, individuelle Züge zu entdecken.[75]

Literarisch ist etwas von jenem Gefühl von Selbstvertrauen, Energie und Überlegenheit, das die Statuen und Reliefs ausstrahlen, im Hymnus auf Sesostris I. wahrzunehmen, der in der Erzählung des Sinuhe wiedergegeben ist. Sinuhe schildert ihn als kampflustigen Sieger, der seine Stärke zwar genießt, sie aber kühl und zielbewusst einsetzt:

74 Zu Amenemhet I. und Sesostris I. allgemein und zum Problem der Mitregentschaft vgl. W. K. Simpson, »Sesostris I.«, in: LÄ V (1984), Sp. 890–899; T. Schneider, Lexikon der Pharaonen. Die altägyptischen Könige von der Frühzeit bis zur Römerherrschaft, Düsseldorf / Zürich 1997, S. 52–54; 264–266; D. B. Redford (Hg.), The Oxford Encyclopedia of Ancient Egypt I, New York 2001, S. 68f. (Amenemhet I), 307–311 (coregency); D. B. Redford (Hg.), The Oxford Encyclopedia of Ancient Egypt III, New York 2001, S. 266–268 (Senwosret I); K. Jansen-Winkeln, Das Attentat auf Amenemhet I. und die erste ägyptische Koregentschaft, in: SAK 18 (1991), S. 241–264; C. Obsomer, Sésostris Ier. Etude chronologique du règne, o. O. 1995, passim; C. Obsomer, Sinouhé l'Egyptien et les raisons de son exil, in: Le Muséon 12 (1999), 207–271; C. Obsomer, Littérature et politique sous le règne de Sésostris Ier: l'Enseignement d'Amenemhat, l'Enseignement loyaliste et le Roman de Sinouhé, in: Egypte, Afrique et Orient 37 (2005), 33–64. Es ist in erster Linie Obsomer, der die historische Grundlage für die weitere Arbeit über die Zeit Sesostris' I. geschaffen hat.

75 Vgl. Simpsons Einschätzung Sesostris' I. bzw. der Quellen in W. K. Simpson, in: LÄ V (1984), Sp. 890–899.

»Eager at the sight of combat,
Joyful when he works his bow.
Clasping his shield he treads under foot,
No second blow needed to kill;
None can escape his arrow,
None turn aside his bow …
As he fights he plans the goal,
Unconcerned about all else.«[76]

Die Berliner Lederhandschrift, die die Gründungsurkunde des neuen Atumtempels von Heliopolis wiedergibt, enthält einen in Ich-Form gehaltenen Selbstpreishymnus Sesostris' I. Der König wird nicht müde zu versichern, dass Atum ihn schon »im Ei« zum Herrscher, Herrn und Sieger erwählt und bestimmt habe zu einem Ebenbürtigen, der dem Gott mindestens soviel zurückgibt, wie er bekommt:

»[Mine is the land], its length and breadth,
I was nursed to be a conqueror.
Mine is the land, I am its lord,
My power reaches heaven's height
I excel by acting for my maker,
Pleasing the god with what he gave.
[I am] his son and his protector,
He gave me to conquer what he conquered.«[77]

Je mächtiger und göttlicher Sesostris I. selber ist, desto mächtiger und göttlicher ist auch der Gott, der ihn geschaffen und erkoren hat, und umgekehrt, das ist die Botschaft, die der Hymnus vermitteln will. Diese Selbstgewissheit ist eine große Stärke des Königs, die zugleich sein Verhältnis zu den Göttern definiert.

Pharaonen erwähnen kaum je ihren leiblichen Vater, geschweige denn, dass sie ihre Beziehung zu ihm thematisieren. Genau das hat aber Sesostris I. getan, oder vielmehr tun lassen, in Form einer Schrift, die als die *Lehre Amenemhets I.* bezeichnet wird.[78] Der Text enthält eine genaue Beschreibung des Mordanschlags auf Amenemhet I., gefolgt von einem Überblick über seine Verdienste als Herrscher und sein geistiges Vermächtnis an seinen Sohn Sesostris. Der Ton ist, hört man genau hin, persönlich und emotional. Von den Schuldigen an dem Verbrechen ist nur andeutungsweise die Rede, man erfährt nicht, was mit ihnen geschah. Dafür wird gleich am Anfang die Gefühlsreaktion Sesostris' I. auf die Untat und den Verlust geschildert. Es geht somit um die Aufarbeitung des Traumas wegen des Mordes am Vater. Die Thematik ist derart unerhört in der ägyptischen Literatur, dass sie nur auf eine ganz persönliche Entscheidung des betroffenen Sohnes selbst zurückgehen kann. Das Lehrgedicht ist dem ermordeten Herrscher, der in Ich-Form spricht, in den Mund gelegt und besteht aus einer Ansprache des Vaters an den Sohn, wobei der Sohn nur als stummer Zuhörer auftritt. Die Rede

76 M. Lichtheim, Ancient Egyptian Literature I, S. 226. Hier und im folgenden zitiere ich meistens die Übersetzungen von Miriam Lichtheim; diejenigen von Richard Parkinson (1997) sind wohl oft näher am Original, aber Lichtheim dünkt mich verständlicher für eine nicht spezialisierte Leserschaft.

77 M. Lichtheim, Ancient Egyptian Literature I, S. 117.

78 M. Lichtheim, Ancient Egyptian Literature I, S. 135–139 ; R. B. Parkinson, The Tale of Sinuhe, S. 203–211 ; G. Posener, Littérature et politique dans l'Egypte de la XIIe dynastie, Paris 1956, S. 61–86.

enthält sicherlich das, was Sesostris sich vorstellte, dass sein Vater gesagt hätte. Dennoch wird sie aus der Perspektive des Sohnes gehalten, darum erfährt die Leserschaft aus dem Text letztlich mehr über den Sohn als über den Vater. Es handelt sich also um eine Art intrapsychischen Dialog, weil Sesostris als Autor oder Auftraggeber beide Rollen innehat, auch wenn er nur diejenige des Vaters ausgestaltet. Dies ist letztlich eine gewohnte Übung, weil ein Pharao in seinen Verlautbarungen wie besonders den Tempel- und Statueninschriften nebst seiner eigenen Rolle immer auch diejenigen der Gottheiten mit übernimmt.

In der Einleitung wird die Lehre als eine Enthüllung bezeichnet, die Amenemhet I. seinem göttlichen Sohn zugedacht hat. Gleich danach liest man die berühmten Zeilen:

> »Beware of subjects who are nobodies,
> Of whose plotting one is not aware.
> Trust not a brother, know not a friend,
> Make no intimates, it is worthless …
> He who ate my food raised opposition,
> He whom I gave my trust [lit. hands] used it to plot.«[79]

Der Text enthält keine expliziten Drohungen gegenüber potenziellen Verrätern, aber die Bitterkeit und die Enttäuschung darüber, dass gerade diejenigen, denen man vertraut und Wohltaten erwiesen hat, zum Verrat fähig sind, ist eindrucksvoller als Racheschwüre. Die Reaktion oder die Selbstschutzmassnahme des neuen Königs besteht vielmehr darin, dass er eine unüberbrückbare Distanz zwischen sich und die Menschen legt: »Traue keinem Bruder, kenne keinen Freund«. Anschließend ist die Rede von einer unerhörten Trauerkundgebung, die Amenemhet verdient habe, und von einem ebenso unerhörten Kampf. Dies scheint mir eine persönliche Aussage Sesostris' I. über die Intensität seiner Trauer zu sein, die eine starke Beziehung zum Verstorbenen impliziert. Eine Andeutung etwas weiter unten im Text weist darauf hin, dass die Untat von Frauen und Männern der eigenen Familie ausging, die die Gelegenheit wahrnahmen, als der Kronprinz Sesostris von der Residenz abwesend war und sich auf einem Feldzug befand. Vermutlich war es die Absicht der Verschwörer, einen Prätendenten aus einem anderen Zweig der Familie auf den Thron zu bringen.

Es folgt die Schilderung der Bluttat, die mit den Worten beginnt:

> »It was after supper, when darkness had fallen,
> And I had spent a happy time.
> I was lying on my bed, since I was tired,
> And my heart had begun to follow sleep.«[80]

Es heißt dann, dass Bewaffnete eindrangen, dass es ihm aber in der Schlaftrunkenheit und Dunkelheit nicht möglich war, sich zu wehren gegen den Angriff, und dass ihm niemand zu Hilfe kam. Die Szene spielt sich also am späteren Abend im Schlafzimmer des Königs ab. Richard Parkinson wies darauf hin, dass der Ausdruck »eine glückliche Stunde verbringen« wohl heißt, dass der König mit einer Frau geschlafen habe. Dies klingt sehr plausibel, denn dadurch wäre Amenemhet, ob diese Frau nun mit im Komplott war oder nicht, jedenfalls gründlich abgelenkt und eine leichte Beute für die Verschwörer gewesen.

79 M. Lichtheim, Ancient Egyptian Literature I, S. 136.
80 R. B. Parkinson, The Tale of Sinuhe, S. 207.

Die Schilderung des Tathergangs endet in der Feststellung, dass die Untat nur geschehen konnte, weil der König in Abwesenheit des Thronfolgers allein war.[81]

> »Thus bloodshed occured while I was without you; before the courtiers had heard I would hand over to you; before I had sat with you so as to advise you.«

Sesostris will damit sagen, dass sich die Mörder nicht an den Vater herangewagt hätten, wenn er, der starke Sohn, da gewesen wäre, und dass ihm auch ein Mittel eingefallen ist, um solche Intrigen um die Thronfolge in Zukunft zu verhindern: Der regierende König muss seinen Nachfolger beizeiten einsetzen und dem Hof präsentieren. Aus dieser Stelle höre ich jedenfalls heraus, dass Sesostris die Erfindung der Mitregentschaft zurückprojiziert in die Zeit seines Vaters. Was ihn dazu bewog, ist nicht durchschaubar, vielleicht geht es darum, die Autorität des Vaters und seine enge Bindung an ihn hervorzuheben. Auch wenn Sesostris I. seinen leiblichen Vater nicht retten konnte, so erklärt er sich doch (in anderen Schriftzeugnissen) umso mehr zum Schützer seiner göttlichen Väter. In der Berliner Lederhandschrift heißt es, dass er der Sohn und Schützer des Schöpfergottes sei.[82] Außerdem ließ er eine Reihe von Kolossalstatuen mit Dolch im Gürtel vor dem Ptahtempel von Memphis aufstellen.[83]

Danach wird Amenemhets exemplarische Regierung in wenigen prägnanten Formulierungen vergegenwärtigt. Die Lehre gipfelt in dem im letzten Teil festgehaltenen geistigen Vermächtnis an den Sohn, das schlecht erhalten und nur teilweise verständlich, dessen Tenor aber dennoch fassbar ist. Sehr eindrucksvoll ist der Anfang, wo Amenemhet seinem Sohn zuruft, dass seine Beine ihn nun zwar forttrügen, sein Herz aber bei ihm bleibe und seine Blicke auf ihm ruhten. Die letzte Strophe bringt zum Ausdruck, dass der Sohn das Werk des Vaters fortführen möge. (Was er darunter verstand, hatte er im dritten Teil der Lehre ausgeführt). Vor allem werde er, Amenemhet, die ganze Macht seines Wünschens und Wirkens als der Gott, zu dem er nun geworden sei, dafür einsetzen, dass sein geliebter Sohn Sesostris unangefochten und glücklich regiere.

Die Lehre Amenemhets I. ist so überraschend und einmalig, weil sie bestimmte Empfindungen und Erlebnisse der Könige Amenemhet und Sesostris auf der Ebene des realen, menschlichen Lebens behandelt, im Gegensatz zur Ebene des phantasierten Götterlebens des Herrschers, auf welcher königliche Texte meistens angesiedelt sind. Besonders in den Stellen über die große Trauer um den Vater und über die Art, wie Amenemhet seinen Sohn aus dem Jenseits mit seiner Liebe umfängt und begleitet, äußert sich eine respektvolle, ja bewundernde Gefühlsbeziehung, anders als das Verhältnis zu den Götter-Vätern, denen man Stärke beweisen muss, oder zu den Höflingen und Verwandten, die man auf Distanz halten muss. Es spielt dabei kaum eine Rolle, ob die Beziehung wirklich so war, wie Sesostris sie schildern lässt, wichtig ist nur, dass der Dichter das Bild malte, das er (Sesostris) für richtig hielt. Die Lehre ist auch ein politisches Manifest, dessen Adressaten die Angehörigen des Königs und die Spitzen der Verwaltung sind. Es sollte das geistige Vermächtnis, das Sesostris von seinem Vater bekommen haben will, festhalten, und den betroffenen Kreisen des Hofes und der hohen Beamtenschaft erklären, woran sie mit ihm seien und woran sie sich zu halten hätten. Das Lehrgedicht lehrt uns: Aus dem Schock, den Sesostris I. erlitt, entstand die Entfernung von den Menschen, besonders von den Nächsten; innere Nähe und gute Gefühle sind nur für

81 R. B. Parkinson, The Tale of Sinuhe, S. 207.
82 M. Lichtheim, Ancient Egyptian Literature I, S. 117.
83 H. Sourouzian, in: MDAIK 44 (1988), S. 248–254.

den toten Vater möglich. Damit geht aber auch das Bewusstsein einher, als regierender König der Allherr (der Schöpfergott), zu sein, der mächtig und unangreifbar ist.

Sesostris I. hat seiner Pietät gegenüber dem Vater auch in zwei Bildwerken Ausdruck verliehen. Das erste ist eine Gruppenstatue aus dem Hathortempel von Serabit el-Chadim im Sinai, die sich aus zwei Vater-Sohn-Paaren zusammensetzt, ein Unikum in der ägyptischen Plastik (Kairo, Ägyptisches Museum JE 38263).[84] Die Gruppe besteht aus vier in einer Reihe knienden Königen, die die Hände auf einen vor ihnen liegenden Block legen. Die vier Herrscher sind Sesostris I., Amenemhet I., Mentuhotep II. Nebhetepre und Mentuhotep III. Seanchkare. Es geht somit um ein aktuelles Vater-Sohn-Paar, das in Parallele gesetzt wird zu einem früheren: Die beiden Väter sind der zweite Reichseiniger, der das Land nach der chaotischen Ersten Zwischenzeit zurückeroberte, und der Gründer der 12. Dynastie, der dank seines erfolgreichen Kampfs gegen die ins Delta eingedrungenen Asiaten ebenfalls die Funktion eines Einigers hatte. Die beiden Söhne sind die tatkräftigen Erben, die das Werk der Väter fortführen. Das zweite pietätvolle Bildwerk ist ein Türsturz aus einer Kapelle in Lischt, die Sesostris I. im Pyramidenbezirk Amenemhets I. nach dem Tod des Vaters errichtet hatte. Das Relief zeigt die übliche, axialsymmetrische Opferszene. Der Gott, dem Sesostris gegenüber tritt, ist aber beide Male sein Vater Amenemhet I., umarmt von den beiden Kronengöttinnen Nechbet und Wadjet, der dem Sohn die Symbole der Herrschaft und des Lebens spendet.[85] Der Vergleich mit dem großen Mentuhotep im ersten Fall und die konsequente Vergöttlichung des Vaters im zweiten Fall sind eine Huldigung an Amenemhet I.

Aus der *Berliner Lederhandschrift*, die bereits im ersten Teil dieser Untersuchung zu behandeln war, erfahren wir, dass Sesostris I. ernst machte mit der in der Lehre Amenemhets I. erklärten Absicht, eine große Distanz zwischen sich und die hohen Beamten und Höflinge seiner Umgebung zu legen. Es heißt dort, dass der König im dritten Regierungsjahr seine Gefolgschaft zu einer Sitzung im Thronsaal einberuft, um seinen Plan eines neu zu bauenden Tempels für Atum von Heliopolis zu verkünden. Der autoritäre Kommunikationsstil des Herrschers wird schneidend klar aus der Art, wie er die Versammlung handhabt: »Command was uttered for them to hear, counsel was given for them to learn.«[86] Es handelt sich um eine reine Befehlsausgabe ohne die geringste Höflichkeitsformel. Auf diesen Satz folgt der oben auszugsweise zitierte Hymnus, in welchem der Herrscher seine Stärke als der geborene Eroberer und seine aufs höchste gesteigerte Göttlichkeit preist und damit den Zuhörern seine Abgehobenheit von den Menschen, die in weiter Ferne, weit unter ihm existieren, vor Augen führt. Die Berliner Lederhandschrift ist der erste Beleg für die literarische Gattung der Königsnovelle in ihrer eigentlichen Form, und wahrscheinlich wurde sie in dieser strengen, den Abstand des Gottkönigs von den Menschen betonenden Form für Sesostris I. entwickelt. Interessant ist der Unterschied gegenüber einem wenig älteren Vorläufertext, den für Amenemhet I. geschriebenen »Prophezeiungen des Neferti«,[87] bei welchen es sich auch um eine Art Königsnovelle handelt. Die Erzählung beginnt mit einer Audienzszene im Palast, wobei aber sowohl die Höflinge als auch der herbeigerufene Prophet vom Herrscher in direkter Rede und auf erstaunlich freundliche Weise angesprochen werden.

Des Weiteren ist hier der so genannte *dramatische Ramesseumpapyrus*, die wohl wichtig-

84 Kairo, Ägyptisches Museum JE 38263 (W. M. F. Petrie, Researches in Sinai, London 1906, S. 96; 123; A. H. Gardiner / T. Peet, The Inscriptions of Sinai I, London 1952, Taf. 22 [Nr. 70]).
85 C. Obsomer, Sésostris Ier, S. 93f., Abb. 14 (er deutet, mit Elke Blumenthal, den Türsturz als ein Werk Sesostris' I. nach dem Tod seines Vaters).
86 M. Lichtheim, Ancient Egyptian Literature I, S. 116.
87 M. Lichtheim, Ancient Egyptian Literature I, S. 140.

ste unter den selten erhaltenen königlichen Ritualhandschriften, zu nennen, obschon der Inhalt ganz anderen Charakters ist. Er enthält ein schwer definierbares, mit dem Regierungsantritt verbundenes Königsritual und trägt die Kartusche Sesostris' I.[88] Es handelt sich zweifellos um eine vom König bestellte Neuredaktion, die mindestens neue Akzente setzt.[89] Das Ritual setzt sich aus 46 kurzen Szenen zusammen, wobei stets die Handlung angegeben wird, begleitet von der zugehörigen mythologischen Bedeutung, dem Götterdialog und oft auch einer Illustration. Die Kernpunkte sind, (wenn wir Sethes Lesung zugrunde legen), das Aufrichten des Djedpfeilers, die Krönung des neuen Königs mit der Federkrone und die Himmelfahrt des zum Gott gewordenen verstorbenen Königs. Es fällt auf, dass das Ritual durchsetzt ist mit Anspielungen auf das Verbrechen des Seth an Osiris und die Rächerfunktion des Horus. Die Rache an Seth wird zunächst beim »Aufrichten des Djedpfeilers« in einer sublimierten Form vollzogen, denn der gefesselte Mörder wird offenbar identifiziert mit dem Schaft des Djedpfeilers, der dem auferstehenden Osiris als Stütze oder Skelett dient. Osiris eignet sich damit Seths Vitalität an (Szenen 13–15). Nach dem Aufsetzen der Krone umarmt und beweint Horus seinen getöteten Vater Osiris (Szenen 31–34). Eine drastische physische Vergeltung an Seth wird in Szenen 35 und 41 geschildert, wo Horus und Thot ihm die Beine ausreißen, damit der getötete König Osiris ungefährdet zum Himmel aufsteigen kann (Szenen 37–38). Da es weder ältere noch jüngere Ritualtexte ähnlicher Art gibt und auch die Sedfestdarstellungen des Alten und des Neuen Reiches nur sehr bedingt vergleichbar sind, kann nicht festgestellt werden, wie weit das Ritual Sesostris' I. neue, eigenständige Züge aufweist. Es darf aber vermutet werden, dass die Themen des Königsmords, der Trauer des Sohnes und seines Triumphs über den Mörder und dessen Bande, die so breiten Raum einnehmen, mit der besonderen Situation Sesostris' I. zu tun haben. Bei ihm, der sich nach der Ermordung seines königlichen Vaters als Thronfolger durchsetzen musste, liegt eine solche magische Absicherung seiner Herrschaft besonders nahe.

An literarischen Zeugnissen für die distanzierte Haltung des Königs, der niemanden an sich heranlässt, haben wir bereits die Lehre Amenemhets I. und die in der Berliner Lederhandschrift festgehaltene Audienzszene angeführt. Außerdem sind zwei ganz außerordentliche Zeugnisse relativ unabhängiger, selbstbestimmt handelnder Männer erhalten, die einen höchst aufschlussreichen Einblick in das Verhältnis solcher Ausnahmepersönlichkeiten zu ihrem autoritären Souverän vermitteln: die *autobiographischen Inschriften Sarenputs I.*, die er in seinem Grab in Assuan und im Heqaib-Heiligtum auf Elephantine anbringen ließ, und die berühmte *Erzählung des Sinuhe*. Beides sind Lebensberichte, der eine im Stil einer üblichen Grabbiographie gehalten, der andere eine fiktive, poetische Erzählung eines Abenteurers, der auf eine Beamtenkarriere verzichtete, eine im alten Ägypten wahrhaft unerhörte Idee. Die beiden so unterschiedlichen Werke weisen doch einige Gemeinsamkeiten auf, vor allem die insistente Befassung mit der Person des (abwesenden) Königs, und die größte Merkwürdigkeit besteht darin, dass in beiden Texten die Beziehung des Autors zum König in einem ekstatischen Erlebnis gipfelt.

Sarenput I. war »großes Oberhaupt« der Grenzprovinz zwischen Ägypten und Nubien, Ta-Seti. Er hinterließ mehrere ausführliche biographische Inschriften in seinem Felsgrab auf der Qubbet el-Hawa und im Tempel eines vergöttlichten Lokalfürsten namens Heqaib auf der Insel Elephantine. Detlef Franke hat diese Texte in seiner Monographie über das Heiligtum des Heqaib der Wissenschaft erschlossen und in seiner Analyse hervorgehoben, dass die wichtig-

88 K. Sethe, Dramatische Texte, S. 81–264.
89 H. Altenmüller, »Dramatischer Ramesseumspapyrus«, in: LÄ I (1975), Sp. 1132–1140.

ste Besonderheit der Autobiographie Sarenputs I. darin bestehe, die Beziehung des Autors zu König Sesostris I. zu beschreiben.[90] Das Oberhaupt von Ta-Seti war ein mächtiger und vermögender Mann, der den Güter- und Schiffsverkehr mit dem Sudan kontrollierte. Aus Nubien kamen seit alters Gold und andere Bodenschätze, Sklaven und weitere, aus dem Inneren Afrikas importierte hochwertige Produkte.[91] Sarenput I. verstand es offenbar, daraus sehr bedeutende Einnahmen für die Krone und für sich selbst zu generieren. Außerdem war er maßgeblich beteiligt an der magisch-rituellen Kontrolle desjenigen Reichtums Ägyptens, der aus der Überschwemmung des Nils entsteht, war er doch Vorsteher der Priester der Satet und des Chnum und spielte eine entscheidende Rolle beim »Großen Fest« im Tempel der Satet. Die Gottheiten des Katarakts waren die Herren/Herrinnen der Quellöcher des Nils, und das Hauptfest des Satettempels galt der Überschwemmung, bei deren Eintritt es gefeiert wurde. Dies ist der – leider sehr lückenhaft erhaltenen – Bauinschrift Sesostris' I. zu entnehmen, der den Satettempel neu erbauen ließ.[92]

Sarenput I. breitet in sechs sich inhaltlich teils ergänzenden, teils überschneidenden Texten seine Titel, seine Verdienste um seine Provinz, das Land und den König aus und zählt die zahlreichen und unerhört großzügigen Gunstbeweise auf, die er vom König bekam. Zwei Inschriften Sarenputs[93] aus dem Heiligtum des »Heiligen« Heqaib auf Elephantine beschreiben ausführlich den Verfallszustand und die schlechte Bauweise der alten Kapelle, die er abtragen und durch einen schöneren Neubau ersetzen liess. Er stellte darin eine Statue seiner selbst in einem Schrein auf und setzte die regelmäßigen Opfer für sie fest. Das Erbauen von Tempeln ist sonst königliches Privileg, aber Sarenput weiß es seinem Herrn gleichzutun als Bauherr. Eine weitere Inschrift[94] befasst sich zunächst mit dem gegenseitigen Nutzen, den der göttliche Heqaib und der Stifter aus dem Heiligtum ziehen, denn die Ka-Kapelle dient Heqaib als Götterwohnung und Sarenput als Totentempel, da sein Statuenkult darin angesiedelt ist. Danach geht die Inschrift auf das Thema König über mit der einleitenden Bemerkung, dass Sarenput in der Gunst seines Herrn stand, als er den Bau errichtete. Sein Rang wird erhöht über alle anderen hochgestellten Persönlichkeiten des Landes, indem er sich vor niemandem mehr prosternieren muss. Der König schickt ihm 300 Leute aus Unterägypten. Sein Grab wird von des Königs Handwerkern gebaut. Dass die letztgenannte Angabe stimmt, lässt sich noch heute an der wahrhaft königlichen Qualität der Reliefs des großzügigen Felsgrabs an der Qubbet el-Hawa konstatieren (Taf. 13a); zweifellos waren es dieselben Handwerker und Künstler, die den von Sesostris I. gestifteten Neubau des Satettempels ausführten. Außerdem ließ ihm der König zwei Schiffsladungen voll Ausstattungsstücke für das Jenseits schicken, namentlich einen Sarg, Mumienbinden, Goldkragen, Kleider und Salben. So ausgerüstet sitzt Sarenput, wie er in einer weiteren Inschrift wörtlich ausmalt, auf dem Thron des Osiris mit dem Zepter in der Hand und regiert die Bewohner des Totenreichs.[95]

90 D. Franke, Das Heiligtum des Heqaib auf Elephantine, SAGA 9, Heidelberg 1994, passim; die autobiographischen Texte: S. 192–215; Erörterung der Beziehung zwischen Sarenput I. und Sesostris I.: S. 8–29.

91 D. Franke, Das Heiligtum des Heqaib, S. 197f. Sarenput verwendet nur allgemeine Begriffe wie Abgaben, Produkte u. Ä.

92 W. Schenkel, Die Bauinschrift Sesostris' I. im Tempel von Elephantine, in: MDAIK 31 (1975), S. 109–125; W. Helck, Die Weihinschrift Sesostris' I. am Satet-Tempel von Elephantine, in: MDAIK 34 (1978), S. 69–78; Neubau Sesostris' I. und Reliefreste: W. Kaiser / G. Dreyer / H. Jaritz / A. Krekeler / T. Schläger / M. Ziermann, in: MDAIK 43 (1986), S. 84–88.

93 Inschriften an der Tür und auf Stele Nr. 9: D. Franke, Das Heiligtum des Heqaib, S. 190; 154–157.

94 Stele Nr. 10: D. Franke, Das Heiligtum des Heqaib, S. 176–178.

95 Inschrift auf Sarenputs Schrein Nr. 1 im Heqaib-Heiligtum: D. Franke, Das Heiligtum des Heqaib, S. 216.

Auch die kleine Autobiographie seines Grabes befasst sich mit der Gunst des Herrschers.[96] Zunächst erwähnt Sarenput I. einen aktuellen Nubienfeldzug Seiner Majestät, anlässlich dessen man ihm ein geopfertes Rind bringt. Überhaupt erhalte er bei allen religiösen Ereignissen in Elephantine Fleischzuteilungen – solche sind übrigens auch in der oben erwähnten königlichen Bauinschrift des Satettempels aufgezählt. Eine Reihe von Titeln und Epitheta[97] umschreibt seine Beliebtheit bei König und Hof, kein Wunder, ist er doch (wie) Ptah, (wie) das Winkelmass des Thot, und weise von Geburt an.

Die große Autobiographie[98] ist das Hauptstück, in welchem seine Karriere als großes Oberhaupt der Grenzprovinz konkretisiert wird. Sie besteht aus drei Reden, deren erste die Leistungsbiographie des Grabherrn darstellt, und die dritte die Idealbiographie. Die zweite und längste Rede befasst sich insbesondere mit Sarenputs Beziehung zu Sesostris I., die auf ganz unerhörte Weise Gestalt annahm, und zwar nachdem oder indem er durch die Gunst des Königs sein Grab gebaut hatte und vom König über alle anderen Oberhäupter der Provinzen erhöht worden war. Sarenputs Leben erreicht seinen Kulminationspunkt in einem Ereignis, dessen Schilderung einmalig ist in der ägyptischen Literatur. Er umschreibt es mit den Worten, dass der König ihn den Himmel erreichen ließ. Dies ist zunächst eine Metapher, die, wie Detlef Franke vorschlägt, für Sarenputs kometenhaften Aufstieg steht. Sarenput nimmt den Ausdruck aber wörtlich und malt aus, wie dies vor sich ging:

> »Ich gab sehr stark Verehrung
> und Zuneigung, bis es der Kehle an Luft mangelte,
> indem ich jubelte, als man [d. h. der König] mich den Himmel erreichen ließ,
> mein Kopf erreichte das Firmament,
> ich kratzte die Körper der Sterne und ließ es donnern,
> indem ich leuchtete wie ein Stern
> und tanzte wie die Gestirne des Himmels. –
> Meine Stadt war im Fest,
> meine jungen Leute jubelten,
> als man hörte? …
> ich tanzte? …
> … … …
> … alte Leute mit den Kindern,
> alt und jung war voll Jubel. –
> Die Götter, die hinter Elephantine stehen,
> mögen sie dauern lassen für mich Seine Majestät als König
> und gebären für mich Seine Majestät ganz neu,
> dass er für mich wiederholt Millionen von Sedfesten,
> mögen sie ihm geben eine Unendlichkeit als König,
> dass er sich niederlässt auf den Horusthronen ganz wirklich,
> so wie ich es wünsche.«

96 Im Vorhof des Grabes: D. Franke, Das Heiligtum des Heqaib, S. 204.

97 An Grabfassade, Pfeilern und Schrein Nr. 1 im Heqaib-Heiligtum: D. Franke, Das Heiligtum des Heqaib, S. 205f.

98 D. Franke, Das Heiligtum des Heqaib, S. 23–25; 192–203.

Sarenputs Erlebnis entspricht, gemäss Frankes überzeugender Deutung, einer Ekstase. Die Beschreibung seiner Vision oder eher der gänzlich veränderten Wahrnehmung seiner selbst in der ersten Strophe ist eindeutig.[99] Es ist aber zu bedenken, dass Ekstase oder Trance im alten Ägypten keine geläufige religiöse Technik war, daher sprechen die Quellen kaum davon und nennen keine Bezeichnung dafür. Überdies wirken ägyptische Texte meist völlig unemotional. Aber Erfahrungen wie Trance oder Ekstase sind etwas zutiefst Emotionales, und wenn in einem emotionslosen Ton davon berichtet wird, sind sie für die heutigen Wissenschaftler und Wissenschaftlerinnen schwierig zu identifizieren. Im alten Ägypten gab es dennoch einzelne Individuen, die eine besondere Fähigkeit dazu hatten, und im Fall Sarenputs brach sich diese Bahn bei einer offenbar zutiefst aufregenden Gelegenheit. Der zweiten Strophe seines Berichts, die sehr schlecht erhalten ist, ist wenigstens zu entnehmen, dass ein Fest gefeiert wurde, an dem die ganze Stadt Elephantine teilnahm. Der Grund dafür muss in der Einleitung zum eigentlichen Bericht genannt sein: Es war wohl die Vollendung des vom König gestifteten Grabs, oder eher die Ankunft der vom König gesandten Grabausstattung, verbunden mit der Erhöhung Sarenputs über alle anderen Provinzoberhäupter. Es gibt keinen Hinweis darauf, dass der König anwesend war.

Sarenput sagt in der Beschreibung seines Erlebnisses, dass er laut und anhaltend Jubelschreie oder -worte ausstieß und dass er tanzte, und es fällt auch das Stichwort »Fest«, das Musik impliziert. Dies sind Anzeichen eines heftigen Gefühlsausbruchs, und mehr noch, es sind altbekannte Techniken zur Einleitung einer Trance oder ekstatischen Bewusstseinserweiterung von der Antike bis heute. So berichtet beispielsweise Plutarch von den Priestern beim Begräbniszug des Apis, dass ihre Schreie und sprunghaften Bewegungen den ekstatischen Zelebranten dionysischer Orgien in nichts nachstanden.[100] In seiner Ekstase nimmt Sarenput kosmische Dimensionen an, wenn sein Haupt an den Himmel stößt und die Sterne kratzt; im Donner demonstriert er seine Macht, im Leuchten und in der Tanzbewegung wird er selbst zum Stern und vereinigt sich mit dem ewigen Kreislauf der Gestirne. Franke deutet Sarenputs Erlebnis als einen Aufstieg zum Himmel, wie er in den Pyramidentexten vielfach beschrieben wird, wo der verstorbene König beispielsweise als Falke zum Himmel auffliegt, oder das Erscheinen des neuen Gottes unter den unvergänglichen Sternen von Erdbeben und Donner begleitet sein kann (Pyr. 1120–22).[101] Eine Assoziation mit dem König liegt auch im Bild des Anstoßens oder Kratzens am Himmel vor, denn es geht gewiss auf einen Horusnamen Mentuhoteps II. zurück, der lautet: »der mit seinen beiden Federn den Himmel kratzt«.[102] Die Identifikation Sarenputs mit dem König als kosmische Gottheit scheint auch mir gegeben, ich möchte aber weniger an einen Aufstieg denken, als vielmehr an ein Anwachsen, eine Erweiterung, wie in einer hymnischen Beschreibung eines Tempels in Abydos impliziert, der als Wolkenkratzer bezeichnet wird: »Die Mauern kratzen/durchstoßen den Himmel«.[103]

Sarenput lässt in seinen ganzen autobiographischen Inschriften offen, welches seine reale Beziehung zum König war. Manche Epitheta beschreiben seine Beliebtheit beim König und wie sehr ihn dieser schätzte, aber alle beruflichen Funktionen, die er nennt, beziehen sich auf

99 D. Franke, Das Heiligtum des Heqaib, S. 23f.; zu Ekstase und Trance vgl. J. Hastings (Hg.), Encyclopaedia of Religion and Ethics V, Edinburgh 1912, S. 157–159; B. Streck (Hg.), Wörterbuch der Ethnologie, Köln 1987, S. 37–40.

100 De Iside et Osiride, 35.

101 R. O. Faulkner, The Ancient Egyptian Pyramid Texts, S. 184.

102 D. Franke, Das Heiligtum des Heqaib, S. 200 (Anm. 14).

103 M. Lichtheim, Ancient Egyptian Autobiographies Chiefly of the Middle Kingdom, OBO 84, Freiburg / Göttingen 1988, S. 86 (Stele des Meri, der ein Heiligtum in Abydos im Auftrag Sesostris' I. baute).

seine Provinz. Er hatte eine Schlüsselposition inne, die für die Wirtschaft des ganzen Landes von Bedeutung war, und er wusste sie zu nutzen und die Krone reich zu machen; in der Realität war sicher dieses sein Verdienst. Bei den außerordentlichen Gunsterweisen des Königs geht es immer um Sarenputs Grab, dessen Bau und Ausstattung vom König gestiftet wurden, wie es auf der Stele Nr. 10 im Heiligtum des Heqaib und in der zweiten Rede der großen autobiographischen Inschrift im Grab selbst ausführlich zu lesen steht. In der Einleitung dieser zweiten Rede, die dem ekstatischen Erlebnis unmittelbar vorangeht, stellt Sarenput einen direkten Kausalzusammenhang her zwischen dem Grab, der Rangerhöhung und der Ekstase. Er erklärt, dass er das Grab durch die Gunst des Königs gebaut habe, nachdem ihn Seine Majestät über die Herrscher der Provinzen erhoben hatte, dass er über die Gebräuche der alten Zeit [hinausgegangen sei?][104] und dass man ihn den Himmel erreichen ließ. Diese Erhöhung über alle anderen Menschen drückte sich vermutlich konkret in den königlichen Privilegien aus, die seinem Grab zugestanden wurden. Heute noch fassbar sind einige Reliefs an den Pfeilern, die den Grabherrn in direktem Verkehr mit einer Gottheit zeigen,[105] wie es sonst nur in den vom König erbauten Göttertempeln üblich ist. Königliches Verhalten legte Sarenput auch an den Tag, als er sich in Gestalt des Heqaib-Heiligtums eine Art Totentempel baute.

Dies bringt uns zur Schlussstrophe der zweiten Rede mit dem Appell Sarenputs an die Götter von Elephantine, dass sie den König stets neu gebären und neu inthronisieren mögen für ihn, dass er Millionen von Sedfesten feiern möge für ihn, gefolgt von zwei weiteren ähnlichen Wünschen nach ewiger Dauer des Königs zugunsten von Sarenput. Diese Wünsche beziehen sich auf das Nachleben des Königs als Gott im Jenseits, wie aus der Nennung von Millionen von Sedfesten und erneuter Geburt klar wird. In seinem ekstatischen Erlebnis empfand sich Sarenput als ein unendliches kosmisches Wesen, ganz jenseits seiner Physis. Wahrscheinlich zielt diese seine psychische Fähigkeit, sich mit dem als Gott auferstehenden König in eins zu setzen, in Verbindung mit seinem Anspruch auf das ewige Leben des Königs, auf eine Art unio mystica mit Sesostris I., und zwar in Vorwegnahme einer unendlich wiederholbaren Vereinigung oder gemeinsamen Neugeburt in Ewigkeit. Die Vorstellung klingt an das Motiv der vereinigten Ba-Seelen des Re und des Osiris an, von denen es in den Sargtexten heisst, dass sie sich in Djed (Mendes) finden und umarmen (CT IV, 276).[106]

Die Frage, was Sarenputs Bericht über die reale Person Sesostris' I. aussagt, ist nicht leicht zu beantworten, weil Sarenput nicht bewusst zwischen dem König als Mensch und als Gott unterschied. Aus den berufsbezogenen Mitteilungen der autobiographischen Texte geht hervor, dass die reale Beziehung zum Herrscher sehr formell gewesen sein muss. Der König kommt nur ganz unpersönlich als Adressat von Leistungen und Absender von Gunstbezeugungen vor. Hingegen ist Sarenputs Rede über das ekstatische Erlebnis Ausdruck seines Wunsches nach einer emotionalen Beziehung, und vor allem nahm er es ernst als das wichtigste Ereignis seines irdischen Lebens im Hinblick auf die Absicherung seines ewigen Lebens. Dies wird aus der Tatsache ersichtlich, dass der Bericht darüber den Hauptplatz in seiner Autobiographie einnimmt, handelt es sich doch um eine Einschaltung von mehr als doppelter Länge zwischen der Leistungs- und der Idealbiographie. Eine Gefühlsbeziehung zwischen dem realen, irdischen König Sesostris und dem Bürgermeister von Elephantine Sarenput war nicht denkbar, wohl aber zwischen den jenseitigen Göttern Osiris-Sarenput und

104 A. H. Gardiner, Inscriptions from the tomb of Si-renpowet I., Prince of Elephantine, in: ZÄS 45 (1908), S. 125; D. Wildung, Sesostris und Amenemhet, S. 141.

105 D. Franke, Das Heiligtum des Heqaib, S. 25; H. W. Müller, Die Felsengräber der Fürsten von Elephantine aus der Zeit des Mittleren Reiches, ÄF 9, Glückstadt / Hamburg / New York 1940, S. 44–46, Abb. 9; 21–22.

106 R. O. Faulkner, The Ancient Egyptian Coffin Texts I. Spells 1–354, Warminster 1973, S. 264.

Re-Sesostris. Mittelbar war es dennoch der reale König, der Anlass gab für Sarenputs eindrucksvolle Phantasie. Sie scheint über Sesostris I. auszusagen, dass ihm eine Ausstrahlung von unerreichbarer Hoheit eignete, darum wurde eine persönliche, emotionale Nähe nur in Form des ekstatischen Einswerdens möglich.

Die berühmte *Lebensbeschreibung des Sinuhe*[107] hat einige wichtige Züge mit den autobiographischen Inschriften Sarenputs I. gemeinsam. Sie setzt sich in fast obsessiver Weise mit der Person Sesostris' I. auseinander, und am Schluss kommt es zu einer persönlichen Begegnung mit dem König, die Sinuhe mit unmissverständlichen Worten als ekstatisches Erlebnis beschreibt, nachdem er schon am Anfang in einen außergewöhnlichen Bewusstseinszustand geraten war, den wir vielleicht als lang andauernde Trance bezeichnen können. Gemäss lang etabliertem Konsens der Ägyptologie ist der »Sinuhe« ein Dichtwerk von hohem Rang, das sich der Form der Autobiographie als Rahmen bedient, dessen Autor aber nicht identisch ist mit dem Ich-Erzähler. Die Geschichte beginnt mit einem Feldzug des Kronprinzen Sesostris nach Libyen, an welchem Sinuhe teilnimmt. Er hört zufällig den Bericht eines Boten aus der Residenz, dass König Amenemhet gewaltsam zu Tode gekommen sei, und erschrickt so tief darüber, dass er nach Syrien flieht. Dort wird er vom Fürsten von Retjenu mit offenen Armen empfangen, der ihn mit seiner Tochter verheiratet und ihm ein fruchtbares Land zuweist. Sinuhe regiert sein blühendes Land während vieler Jahre mit großem wirtschaftlichem und militärischem Erfolg, zwar als treuer Vasall des Fürsten von Retjenu, aber als weitgehend unabhängiger Stammesfürst oder Beduinenscheich. Trotz seiner erfolgreichen Integration in Vorderasien bleibt sein eigentlicher König stets präsent in seiner Phantasie. Schon kurz nach seiner Ankunft in Syrien schildert er einem syrischen Gesprächspartner das heldenhafte Wesen Sesostris' I. in einem begeisterten Hymnus. Danach wird die syrische Karriere auf knappem Raum abgehandelt und es folgt ein langer Teil, der ausschließlich mit Sesostris I. befasst ist. Er beginnt damit, dass Sinuhe alt geworden ist und Sehnsucht nach Ägypten hat, denn er möchte unbedingt in der alten Heimat sterben und begraben werden. Es werden ein Brief des Königs, der Sinuhe freundlich nachhause einlädt, und der enthusiastische Antwortbrief zitiert, und schließlich werden Sinuhes Rückkehr nach Ägypten, seine überwältigende Audienz beim König und die unvorstellbaren Gunsterweise des Herrschers geschildert, der seinem Günstling einen Palast und ein Grab mit der reichlichsten Ausstattung errichten lässt.

Die Geschichte des Sinuhe ist als Autobiographie formuliert, eine wohlbekannte Kategorie, die der Selbstdarstellung verdienter Beamter des Königs im Grabe diente. Bei Sinuhe entbehrt dieser Rahmen nicht der Ironie, weil er ein völlig unübliches, selbstbestimmtes Leben schildert, das nichts gemein hatte mit einer ägyptischen Beamtenkarriere. Seine am Anfang genannten Titel sind, wie Georges Posener es nannte, eine retroaktive Sanktionierung seiner Tätigkeit im Ausland durch den König.[108] Der Autor des Werks bleibt für uns vollkommen im Dunkeln. Aus dem Werk lässt sich nur schließen, dass er ein Zeitgenosse Sesostris' I. und von ihm fasziniert war; vermutlich kannte er den König relativ gut, wohl auch persönlich. Da die Erzählung fiktiv ist, ist es der Autor, der in einer Art intrapsychischem Dialog beide Hauptrollen spielt, diejenige Sinuhes und diejenige des Königs. Im letzten Teil des

107 M. Lichtheim, Ancient Egyptian Literature I, S. 222–235; R. Koch, Die Erzählung des Sinuhe, BAe 17, Brüssel 1990, passim; R. B. Parkinson, The Tale of Sinuhe, S. 21–53; G. Posener, Littérature et politique, S. 87–116; J. Baines, Interpreting Sinuhe, in: JEA 68 (1982), S. 31–44; C. Obsomer, in: Le Muséon 12 (1999), 207–271; C. Obsomer, in: Egypte, Afrique et Orient 37 (2005) 33–64. Angesichts der umfangreichen Literatur über Sinuhe kann ich hier nur die für meinen Zusammenhang wesentlichsten Übersetzungen und Kommentare nennen.

108 G. Posener, Littérature et politique, S. 113.

Werks wird die unerhörte Wertschätzung breit dargestellt, die Sesostris I. dem aus der Fremde zurückkehrenden Sinuhe entgegenbringt, aber seltsamer Weise wird überhaupt kein Grund dafür genannt. Die Wertschätzung des Königs beruht sonst immer auf den Verdiensten eines Mannes als Beamten, eine Motivation, die hier jedoch entfällt. Der Grund, warum Sinuhe vom König so hoch geschätzt wird, kann deshalb nur sein dichterisches Werk sein – eine Probe davon ist ja in die Erzählung eingeschaltet in Form des langen, formvollendeten Preislieds auf Sesostris I. Das bedeutet, dass der Autor seine fiktive Figur Sinuhe und seine reale Person nicht ganz klar getrennt hat, dass sich die beiden stellenweise vermischen. Dieser Verdacht drängt sich auch auf, wenn Sinuhe sehr gut Bescheid weiß über Wesen und Wirken des Königs, obschon er ihn als junger Mann verlassen und Jahrzehnte im Ausland verbracht hat: An solchen Stellen greift Sinuhe auf das Wissen des Autors zurück. Wie wir uns den Auftritt eines geschätzten Dichters bei Hofe vorzustellen haben, ist uns übrigens in den »Prophezeiungen des Neferti« überliefert, einer von Amenemhet I. bestellten Schrift, in welcher der berühmte Gast Neferti als begabter Schriftsteller und Gelehrter begrüsst wird, der schöne Worte und erlesene Verse zu sprechen weiß.[109]

Der faszinierendste Zug seines Wesens ist Sinuhes ekstatische Fähigkeit. Am Anfang und am Ende seines Werks schildert er mit großer Genauigkeit je ein Erlebnis veränderten Bewusstseins, wovon das erste, die Flucht aus Ägypten, eher als Trance bezeichnet werden kann. Er nennt die Symptome, die ihn befielen, als er die Nachricht vom gewaltsamen Tod Amenemhets I. hörte: Sein Herz steht still, ein Zittern befällt seinen ganzen Körper, er läuft davon in Sprüngen und sucht Deckung, mehrere Tage lang tragen ihn seine Füsse automatisch nach Nordosten, wobei er jede Begegnung mit Menschen meidet, bis er vor Austrocknung wie tot liegen bleibt. Da findet ihn ein Syrer und gibt ihm Wasser. Weiter unten im Text kommt Sinuhe zweimal auf diese Flucht zurück und versucht, sich selbst und einem Gesprächspartner zu erklären, warum er geflohen sei, obschon ihn keinerlei Schuld traf. Zum Fürsten von Retjenu sagt er, dass sein Herz ihn forttrug, er wisse nicht, was ihn nach Syrien brachte, es sei wie der Willkürakt eines Gottes, der ihn ver-rückte. Im Brief an Sesostris I. wiederholt Sinuhe, dass er die Flucht nicht geplant und nicht gewollt habe, es sei wie ein Traum gewesen, er habe sich plötzlich am Ende der Welt wiedergefunden; ihn habe ein Schauder ergriffen, seine Füße und sein Herz hätten ihn fortgetragen, ein Gott habe ihn fortgeschleppt.

Plutarch berichtet, dass man bei der Initiation in eine Mysterienreligion durch Schrecken, Schaudern, Zittern und Schwitzen hindurch müsse, bis man das Licht und die reinen Gefilde und Wiesen erreiche.[110] Mehr noch fühlt man sich an Schamanen und Besessenheitspriester erinnert, bei denen eine große Erregung der in Trance vollzogenen Reise vorangeht.[111] Bei Sinuhe handelt es sich allerdings nicht um eine willkürlich herbeigeführte Trance. Seine Schilderung klingt ganz so, als habe die ungeheure Erregung, in die ihn die Nachricht vom Tod des Königs versetzte, bei ihm einen psychischen Ausnahmezustand ausgelöst, eine Art Trance oder Besessenheit, (hat doch ein Gott von ihm Besitz ergriffen), die solange anhielt, bis er in Syrien vom Tod durch Verdursten errettet wurde und dadurch ins normale Bewusstsein zurückkehrte. Offenbar war er sich seiner Fähigkeit zu solchen Zuständen vorher nicht bewusst. Sinuhes Fähigkeit, Trancen oder Ekstasen zu erleben und zu beschreiben, macht aber seine Außenseiter- oder Ausnahmestellung im Leben plausibel. Ich meine, es sei ange-

109 R. B. Parkinson, The Tale of Sinuhe, S. 134.
110 G. Mylonas, Eleusis and the Eleusinian Mysteries, Princeton 1961, S. 246.
111 B. Streck (Hg.), Wörterbuch der Ethnologie, S. 37–41.

zeigt, Sinuhes Erklärung seiner Flucht wörtlich und ernst zu nehmen. Sein Problem entsteht eben daraus, dass er sie selber nicht verstand, und die Geschichte bezieht ihre Spannung aus der stets erneuten Auseinandersetzung Sinuhes mit dem Schockerlebnis.

Weiter unten im Text wird die ekstatische Wiedervereinigung mit Heimat und König, in der die ganze Geschichte gipfelt, vorbereitet durch den Brief, mit dem er Sesostris I. für seine Einladung, nach Ägypten zurückzukehren, dankt. Man findet darin eine ausführliche Erklärung seiner Flucht als Traum, als Verrückung durch einen Gott, als unwillkürlichen Akt seines Herzens und seiner Füße – sie wurde oben zitiert. Dann folgen poetisch-prophetische Preisungen des Königs:

> »Whether I am at the residence, whether I am in this place, it is you who covers this horizon. The sun rises at your pleasure. The water in the river is drunk when you wish. The air of heaven is breathed at your bidding … This servant has been sent for. Your Majesty will do as he wishes!«[112]

Sinuhe steigert sich hier in eine erregte Schilderung der Allgegenwart und Allmacht Sesostris' I. als Gott hinein, um sich schließlich ganz seinem Willen anheimzugeben.

Das zweite Erlebnis ist die am Ende der Erzählung geschilderte Audienz beim König, wo Sinuhe bei seiner Rückkehr nach Ägypten dem ersehnten Gott endlich von Angesicht zu Angesicht gegenübertritt. Die Symptome des psychischen Ausnahmezustands sind aufschlussreich. Er wird in den Thronsaal geführt, findet seine Majestät auf dem großen Thron und wirft sich auf den Bauch vor ihm. »Und da«, so sagt er, »kannte ich mich selbst nicht mehr in seiner Gegenwart. Dieser Gott sprach mich freundlich an, aber ich war von Finsternis befallen, meine Seele war gegangen, mein Leib zitterte, mein Herz war nicht mehr im Körper, lebte ich oder war ich tot?«[113] Als Sinuhe den König sagen hört, er möge nun endlich antworten, bekommt er Angst und entschuldigt sich mit dem Hinweis, dass ihm jetzt das gleiche geschehe wie damals bei seinem ersten ekstatischen Erlebnis: »Es ist der Schreck, der in meinem Leib sitzt, wie derjenige, der meine schicksalshafte Flucht verursachte. Sieh mich hier vor dir, du bist das Leben, möge deine Majestät tun (mit mir) was er will!«[114] Der Schreck und die Erregung, in die ihn das Erscheinen des Gottes versetzt, überwältigen Sinuhe. Sein normales Ich-Bewusstsein ist vergangen, die Seele hat sich getrennt vom Körper, er ist in der Finsternis des Todes. Dass Sinuhe eine Art unio mystica mit dem König erlebt, wird nicht bewusst in Worte gefasst. Er deutet es aber mit dem Zuruf an, dass er sich seinem Gott, dem Herrn über Leben und Tod, vollständig preisgegeben habe. Sinuhe selbst nennt ja am Anfang seiner Erzählung ein Beispiel mystischer Vereinigung, wenn er vom Tod Amenemhets I. spricht: »The king of Upper and Lower Egypt, Sehetepibre, flew to heaven and united with the sun-disk, the divine body merging with its maker.«[115] Eine solche Vorstellung wird hinter seiner eigenen mystischen Erfahrung spürbar.

Obschon die von Sinuhe berichteten ekstatischen Erlebnisse anders klingen als spätere Zeugnisse, sind doch gewisse Parallelen mit antiken Autoren festzustellen, etwa einem Gedicht der Sappho, das sich auf den Kult des Dionysos bezieht:

112 M. Lichtheim, Ancient Egyptian Literature I, S. 231.
113 Nach M. Lichtheim, Ancient Egyptian Literature I, S. 231.
114 Nach M. Lichtheim, Ancient Egyptian Literature I, S. 232.
115 M. Lichtheim, Ancient Egyptian Literature I, S. 223.

»I see nothing with my eyes, my ears hum / sweat pours from me, a trembling seizes me all over / I am greener than grass / and it seems to me / that I am little short of dying.«

Abstrakter sind die Berichte der Neuplatoniker oder der mittelalterlichen Mystiker über ihre Vereinigung mit Gott.[116]

Sarenputs und Sinuhes Berichte über ekstatische Erlebnisse sind sehr ungewöhnlich und sehr persönlich. Sie sagen aber mehr aus über die Persönlichkeit des Subjekts des Erlebnisses als über diejenige des Objekts, des Königs, weil seine reale Person kaum eine Rolle spielte dabei. Die reale Beziehung dieser beiden Männer zu Sesostris I. dürfte im wesentlichen darin bestanden haben, dass der eine den König reich machte und der andere ihn besang. In ihrer Phantasie aber erleben sie Sesostris I. als allwissenden, unermesslichen und unerreichbaren Gott: Sinuhe verbringt sein Leben bezeichnenderweise weit weg von ihm im Ausland, und selbst zu Sarenput I., dem realen Oberhaupt der südlichen Grenzprovinz, kommen die königlichen Gaben stets mit Schiffen aus der fernen Residenz. Als Kontrapunkt dazu kommt aber bei beiden ein starker Wunsch nach einer emotionalen Teilhabe an Sesostris I. zum Ausdruck, die nicht am realen König, sondern nur am Gott ausgelebt werden kann. Die reale Unzugänglichkeit Sesostris' I. konnte offenbar nur auf diese Weise durchbrochen oder aufgehoben werden – dies ist jedenfalls eine denkbare Deutung der Tatsache, dass nur zu seiner Zeit Ekstase vorkommt.

II.2 Zusammenfassung zum Teil II

II.2.1 Mentuhotep II.

Die Statuen und Reliefs aus dem Tempel von Deir el Bahari sind Denkmäler eines Pharaos, der nach der Krise der Ersten Zwischenzeit als erster wieder den Anspruch auf die Herrschaft über das gesamte Reich durchsetzt und dem die Erschaffung eines neuen, ganz eigenen Stils gelingt. Nach dem Gefühl der Selbstgewissheit und des Einklangs mit sich selbst und der Welt, den die königlichen Denkmäler der 4. und 5. Dynastie ausgestrahlt hatten, waren der Zerfall des Herrschafts- und Sozialgefüges im späten Alten Reich und in der Ersten Zwischenzeit und der dadurch bewirkte künstlerische Absturz umso empfindlicher. Unter Mentuhotep II. wird die psychische Regression, die an der Kunst der Ersten Zwischenzeit zum Ausdruck kommt, überwunden. Die neuen künstlerischen Mittel sprechen eine deutliche Sprache: Die schwankende Unsicherheit in der Zeichnung der menschlichen Figur wurde abgelöst von einem klaren, zielbewussten Darstellungssystem, das auf kühne Weise gefällige und ungefällige Elemente in sich aufzunehmen vermochte. Wir haben von einer Ästhetik des Hässlichen gesprochen, die die Kunst Mentuhoteps II. auszeichnet. Dieses überraschende Konzept verbindet Harmonie und Dissonanz. Seinen Schöpfern saß, so lässt sich die Erscheinung deuten, die Erschütterung über den Zerfall der Ordnung noch in den Knochen, aber sie haben den Schrecken in ein neues, festes Gerüst integriert. König Mentuhotep II. legt ein starkes Selbstbewusstsein als neuer Reichseiniger und Organisator des Landes an den Tag, wenn er die Beziehung zu den Göttern in der Weise neu definiert, dass er ihren Gestalten seine eigene Vorstellung von Herrscherlichkeit aufprägt.

116 J. Hastings (Hg.), Encyclopaedia, S. 157–159.

II.2.2 Sesostris I.

Auch dem Sohn des Gründers der 12. Dynastie ist die Herrschaft über die beiden Länder nicht in den Schoß gefallen, auch er musste sie sich erobern, jedoch aufgrund ganz anderer Voraussetzungen als der zweite Reichseiniger. Auf Sesostris als Kronprinz wirkte einerseits die Stärke des Vaters, Amenemhets I., prägend, der sich als neuer Pharao durchsetzte und das Delta befriedete. Dazu gesellte sich die Erfahrung der eigenen Kraft, des Mutes und des Durchsetzungsvermögens, seiner persönlichen Stärken also, die ihm zur Verfügung standen, um sich die durch das Attentat auf den Vater gefährdete Herrschaft dauerhaft zu sichern. Andererseits hinterließ das Trauma, das er durch den Mord am Vater erlitt, seine Spuren in seinem Verhalten, indem es ihn zwang, den Menschen zu misstrauen und sie auf Distanz zu halten. Der Schock des Königsmords und die Notwendigkeit, seine Stärke als Gott zur Geltung zu bringen, lösten die Entstehung mehrerer sehr ungewöhnlicher literarischer Werke aus, die teils vom König selbst und teils von hochgestellten Privatleuten veranlasst wurden und die dadurch so einzigartig sind, dass sie sogar beim König gewisse Gefühlsreaktionen auf der Ebene der menschlichen Realität reflektieren. Die Werke beschreiben in verschiedener Weise einerseits die Kraft, Energie, Sieghaftigkeit und Effizienz Sesostris' I., die wirksam waren bei der Absicherung der Göttlichkeit und der Herrschaft, und andererseits die unüberbrückbare Distanz zwischen dem König und den Menschen. Ja, Sarenput I. und Sinuhe erleben den Gottkönig als derart fern und hoch, dass der Zugang zu ihm nur in der Ekstase möglich war, nur sie erlaubte die Aufhebung des Abstands und die Identifikation als Gefühl des Aufgehens in ihm.

Die beiden Schlüsselerfahrungen des Königs schlugen sich in einem dualen ästhetischen Konzept nieder, einem Konzept des »ja, aber …«, das grundsätzlich weltbejahend ist, aber einen wesentlichen Vorbehalt einschließt. Dieses Konzept ist an den Statuen und Reliefs Sesostris' I. realisiert in Gestalt eines schönen, kraftvollen männlichen Körpers, auf welchem ein maskenhaft starres Haupt mit streng geometrisierten Zügen ruht. Beim organisch modellierten Körper, der leicht untersetzt ist, besteht eine gewisse Wahrscheinlichkeit, dass er dem realen Aussehen entspricht. Beim Gesicht hingegen ist dies sehr unwahrscheinlich, weil es sich bei den Zügen um einen Nachklang derjenigen Mentuhoteps II., des (ideellen) Ahnen, handelt. Der Realitätsgehalt ist auch nicht von großer Bedeutung, weil die Bilder vom Wesen des Königs sprechen, unabhängig davon, ob sich Wille und Wirklichkeit des Aussehens deckten. Der Körper spricht eine deutliche, positive Sprache, denn er ist extravertiert und wirkt attraktiv und stark; auch das Gesicht spricht eine deutliche Sprache, aber mit negativem Vorzeichen, denn es ist introvertiert und darf nichts vom Denken und Empfinden des Inneren nach außen dringen lassen. Sesostris I. hat das Prinzip der Distanz und der Dominanz mit größter Konsequenz zur Anwendung gebracht, und dies sogar den Göttern gegenüber, war er doch der erste Herrscher, der die Tempel des ganzen Landes systematisch mit Statuen ausstattete, die ihn selbst in seiner Göttlichkeit und Größe zur Geltung brachten. Der König bleibt fern und undurchschaubar, und zugleich ist er wirkensmächtig und präsent.

Karol Myśliwiec

Reading a Statue of a Statue:
A Testimony of three-dimensional Cryptography

Dedicated to the Memory of Hans Wolfgang Müller

Unusual in its iconography, and remarkable in its style, a »statue of Amenhotep III« (Taf. 14a, 15a, 15b), found among other sculptures of the late 18th Dynasty in the sculpture cachette unearthed in the solar court of the Luxor temple in 1989, has been published and analysed several times[1]. Still, its unique artistic conception seems far from being fully understood.

Made of dark red quartzite, a material emphasizing the statue's solar connotations[2], it is 2.49 m high, its base being 1.06 m long and 0.55 m wide. Some parts of the statue, such as the king's crown, his broad collar, armlets, bracelets and sandals were originally overlaid with gold leaf, remains of which were still visible upon discovery[3]. It is presumed that the statue originally stood on the west side of a processional way so that the hieroglyphic text carved on its back support was facing the interior of the temple, or constituted one element of a symmetrical pair of statues, as the layout of this long text would suggest[4]. This statue, which was probably the focus of the cult of the deified Amenhotep III in the Luxor temple[5], is now in the Luxor Museum of Art (J 838).

First of all the label given by Egyptologists to this masterpiece of Egyptian sculpture, »a statue of Amenhotep III«, is misleading. This denomination appears correct but only in respect to chronological aspects of the object, clearly indicated by its inscriptions and style. Its iconography shows, however, that the sculpture is by no means just a statue of Amenhotep III. What is actually standing on the base of the monolithic sculpture is another, smaller stat-

1 M. El-Saghir, The Discovery of the Statuary Cachette of Luxor Temple, SDAIK 26, Mainz 1991, pp. 21–27; B. M. Bryan, La statuaire divine et royale, in: Aménophis III, Le pharaon-soleil, Galeries Nationales du Grand Palais, Paris, 2 mars – 31 mai 1993, pp. 106–110; R. Tefnin, Aménophis III sur son traîneau: mise en abyme et/ou cryptogramme?, in: GM 138 (1994), pp. 71–80; W. R. Johnson, Monuments and Monumental Art under Amenhotep III. Evolution and Meaning, in: D. O'Connor / E. H. Cline (Ed.), Amenhotep III. Perspectives on His Reign, Ann Arbor 2001, p. 68, n. 28, fig. 3.5; W. R. Johnson, Amenhotep III and Amarna: Some New Considerations, in: JEA 82 (1996), p. 69; C. Spiesser, Iconographie composite et pouvoir royal durant la 18e dynastie, in: CdE 79 (2004), p. 9, n. 22; F. J. Giles, The Amarna Age: Egypt, ACE-Stud. 6, Warminster 2001, p. 86.
2 B. M. Bryan, La statuaire divine et royale, p. 106.
3 M. El-Saghir, Statuary Cachette, p. 21.
4 B. M. Bryan, La statuaire divine et royale, p. 109.
5 As suggested by W. R. Johnson, Monuments and Monumental Art, p. 89, n. 146; W. R. Johnson, The Deified Amenhotep III as the Living Re-Horakhty: Stylistic and Iconographic Considerations, in: G. M. Zaccone / T. R. di Netro (Ed.), Sesto Congresso internazionale di egittologia. Atti. Volume II, Turin 1993, p. 236, n. 22.

ue representing the king, placed on a sledge[6]. In other words, it is primarily a statue of the sledge supporting another statue.

This effect of »theatre in theatre« reminds one of a classic dramaturgical trick attested since antiquity, and probably best known from Shakespeare's »Hamlet«, in which the »internal play« receives a secondary, metaphoric meaning in the context of the main play. In the case of this statue, the »internal play«, being the actual cult object, is the group composed of the sledge and the statue standing on it. That these two elements together form one coherent symbol is clearly indicated by the fact that the back support, in the form of a round-topped stela, couples the effigy of the king with the sledge, but does not extend further down to the lower base, i.e. the base of the whole statue[7]. Another attempt to link the effigy with the sledge into one inseparable entity is discernible in the profile view of the statue: the lateral surfaces of the stela and those of the two runners form a genuine rectangular frame delineating the group comprised of the two elements (Taf. 15a, 15b).

Why has a popular means of transportation, in this case the sledge[8], been honoured so much by becoming part of a cult object? Various sources, mainly representations in reliefs and paintings found in tombs and temples, but also genuine sledges from pharaonic times (e.g. the one from Dahshur in the Cairo Museum, CG 4928)[9] testify to the use of the sledge for transporting large heavy objects, such as building blocks, statues or boats, across the sand since the early periods of Egyptian history[10]. But besides this practical function, the sledge form must have played a decorative or mysterious ritual function, for it occurs in many surviving objects, which were not supposed to be dragged this way along the ground. A variety of small objects mounted on a sledge come from the tomb of Tutankhamen, such as the heavily gilded canopic shrine[11] and a game box[12]. Funerary scenes on the walls of Tutankhamen's burial chamber depict the royal mummy lying on a bier and being pulled on a sledge[13]. Outer coffins from New Kingdom tombs, e.g. those of Yuya, Thuya and Maiherpri, have sledges incorporated into their designs, although these items seem rather to have been carried, if necessary, by using wooden poles passed beneath them, which certainly was also the case with shrines containing images of the gods or kings used in processions[14].

Belonging to the latter category was doubtless a statue of Amenhotep III, represented twice in the reliefs decorating the southeastern gate of the w3d3yt-room in Karnak[15]. They show the statue standing on a sledge, which also supports a double-shrine veiling the figure of the king[16]. This transportable statue was certainly made of wood, as was probably the effi-

6 The idea of the »statue of a statue« was first proposed by M. El-Saghir, Statuary Cachette, p. 21; cf. R. Tefnin, in: GM 138 (1994), pp. 72, 77.

7 As already noticed by R. Tefnin, in: GM 138 (1994), pp. 74, 76, 78.

8 R. Partridge, Transport in Ancient Egypt, London 1996, pp. 223–234.

9 R. Partridge, Transport, p. 132.

10 R. Partridge, Transport, p. 131; B. M. Bryan, La statuaire divine et royale, p. 106, n. 27; R. Tefnin, in: GM 138 (1994), pp. 71–72.

11 R. Partridge, Transport, pp. 136–137.

12 Cairo Museum JE 61490: H. G. Fischer, L'écriture et l'art de l'Ancienne Egypte. Quatre leçons sur la paléographie et l'épigraphie pharaoniques, Paris 1986, p. 200, pl. 103; F. Tiradritti (Ed.), The Treasures of the Egyptian Museum, Cairo 2000, p. 212; R. Partridge, Transport, p. 136.

13 R. Partridge, Transport, p. 134.

14 R. Partridge, Transport, pp. 134–135.

15 C. Loeben, La porte sud-est de la salle-w3d3yt, in: Cahiers de Karnak VIII (1982–1985), Paris 1987, pp. 207–219; R. Tefnin, in: GM 138 (1994), p. 72, n. 2; p. 75, n. 2; p. 76.

16 C. Loeben, La porte sud-est, p. 215, fig. 1; p. 219, pl. 2.

gy standing on the sledge portrayed in the Luxor statue. Iconographically the figure of the king represented in Karnak is different from that found in Luxor, (the former wears a wig surmounted by a composite crown, and the latter the double crown), but some specific features of the Karnak figure, such as the presence of a panther's head at the top of the king's sporran[17] and the shape of the uraeus framing the latter[18], seem to indicate that chronologically the two statues were close to each other. Even the short inscription accompanying the scene in Karnak confirms their affinity[19]. Emphasizing the king's solar aspect with the epithet »son of Re from his body«, it connects him with the Theban demiurge Amon-Ra.

Both the style and the inscriptions of the statue found in Luxor imply that it dates to the last decade of Amenhotep III's long reign, i.e. after his first jubilee in year 30. In the four-phase chronological framework proposed by W. R. Johnson for the king's monument decoration throughout Egypt, which is observable in the relief[20] as well as in the sculpture in the round[21], the Luxor statue evidently belongs to phase 4[22]. It is visible in its proportions, in the style of its facial features, and in iconographic details of the king's garment[23]. In relation to Amenhotep III's representations from the three earlier decades, his legs are lengthened, and his waist is shorter and thicker. Overemphasized youthfulness can be read in his facial features, oversized almond-shaped eyes dominating the face, enlarged and slightly protruding lips, but smaller ears and nose. His rich accoutrements are comprised of the double crown on the head, an elaborate pleated kilt festooned with disc-crowned cobras, falcon-tail sporran, and looped sash at the belt line, as well as a broad collar, armlets and bracelets. The surface of the crown, collar, armlets, bracelets and sandals is roughened for the application of gilded gesso[24]. With respect to royal iconography, this effigy of Amenhotep III looks very like a three-dimensional version of his figures depicted on the 3rd pylon in Karnak[25].

Dramatic changes in royal iconography and style that occurred after his first jubilee in year 30 were accompanied by important changes in »political theology« during the years following that event, when the deified old Amenhotep III progressively ceded the Egyptian throne to his son and successor, Amenhotep IV, the future Akhenaten[26]. The status of both the father and his son had changed: the »rejuvenated« Amenhotep III seems to have become

17 W. R. Johnson, Images of Amenhotep III in Thebes: Styles and Intentions, in: L. M. Berman (Ed.), The Art of Amenhotep III: Art Historical Analysis. Papers presented at the International Symposium held at the Cleveland Museum of Art, Cleveland, Ohio, 20–21 November 1987, Cleveland 1990, p. 35.

18 C. Loeben, La porte sud-est, p. 210.

19 C. Loeben, La porte sud-est, p. 215, fig. 1.

20 W. R. Johnson, Monuments and Monumental Art, pp. 80–85; W. R. Johnson, The Deified Amenhotep III, pp. 231–234; F. J. Giles, The Amarna Age, pp. 84–91.

21 F. J. Giles, The Amarna Age, p. 86.

22 W. R. Johnson, Monuments and Monumental Art, pp. 83–85; W. R. Johnson, The Deified Amenhotep III, 231–232; R. Tefnin, in: GM 138 (1994), pp. 72–73; F. J. Giles, The Amarna Age, p. 85. This phase corresponds to Phase III (Final, Baroque Phase), proposed previously by the same author (W. R. Johnson, Images of Amenhotep III, pp. 34–36), and to groups 4–7, observed earlier by the present author: K. Myśliwiec, Le portrait royal dans le bas-relief du Nouvel Empire, Warsaw 1976, pp. 71–74.

23 W. R. Johnson, The Deified Amenhotep III, 236, n. 22; W. R. Johnson, Monuments and Monumental Art, p. 68, n. 28; p. 89, n. 146.

24 W. R. Johnson, Monuments and Monumental Art, p. 68.

25 W. R. Johnson, Monuments and Monumental Art, p. 85, fig. 3.24, 3.25, n. 119.

26 W. J. Murnane, Observations on pre-Amarna theology during the earliest reign of Amenhotep IV, in: E. Teeter / J. A. Larson (Ed.), Gold of Praise. Studies on Ancient Egypt in Honor of Edward F. Wente, Chicago 1999, p. 303.

more a living god than a ruler, identified with various, possibly all, Egyptian gods, but particularly with different emanations of the Heliopolitan sun god, especially Re-Horakhty.[27]

Among these emanations there was the solar disc Aten. It is in the inscriptions dating from this period that the old father is sometimes called »the dazzling Aten«[28]. One of these inscriptions is the long text carved on the outer side of the round-topped back support of the sledge-statue from Luxor[29]. It describes Amenhotep III as the »dazzling Aten of all lands, whose uraeus illuminates the two banks«. Identified with Aten, the father would then have become the sun disc worshipped by his son and the latter's family during the Amarna Period. Considered to be children of this demiurge, Akhenaten and his wife Nefertiti would have naturally been associated and identified with the first pair of gods, Shu and Tefnut[30].

However, apart from this unusual epithet identifying Amenhotep III with Aten, all the other inscriptions carved on the sledge-statue seem to be very »orthodox« in their devotion to the Theban demiurge Amun, whose names on the statue were later erased by Atenist iconoclasts[31]. Even so, the epithets of both the god and the king stress their double nature (Lord of the Two Lands, King of Upper and Lower Egypt, Lord of the Thrones of the Two Lands etc.) on the one hand, and their solar aspect (Amun-Re, … lord of heaven; son of Re Amenhotep) on the other. These two groups of denominations are reminiscent of the Heliopolitan demiurge Atum, who was a »Lord of the Two Lands« and a solar deity *par excellence*. One almost feels the »lord of Heliopolis« behind the »ruler of Thebes« in this text, although Atum himself is not mentioned at all.

This kind of dichotomy typical of the last years of Amenhotep III and the first years of Amenhotep IV, is expressed even more explicitly in the decoration of the tomb of Kheruef, which is close in date to the Luxor statue. In the antithetical double-scene sculpted on the lintel of the tomb's façade, the counterpart of Re-Horakhty is Atum, and not Amun, although the latter is evoked in the first columns of the parallel texts decorating the jambs[32]. W. Murnane calls it »the first cautious step toward Aten's replacing of Amun-Ra«, through a »mediation« of Atum, but it could also probably be considered as a sign of a specific theological schizophrenia convulsing those turbulent years, a religious current that found another expression in the Luxor sledge-statue of Amenhotep III.

An iconographic link between this representation of the king and the god Atum has already been observed by B. M. Bryan[33]. This is his double crown of Upper and Lower Egypt, a classical headdress of a »Lord of the Two Lands«, whether it be Atum or a king. Every statue representing a king wearing this crown could possibly be viewed as an effigy of Atum, for

27 A. Radwan, Einige Aspekte der Vergöttlichung des ägyptischen Königs, in: Ägypten und Wandel. Symposium anläßlich des 75jährigen Bestehens des Deutschen Archäologischen Instituts Kairo am 10. und 11. Oktober 1982, Mainz 1985, pp. 100–104; W. R. Johnson, Monuments and Monumental Art, pp. 70, 74, 75, 80, 86–88, 90.

28 W. R. Johnson, Images of Amenhotep III, pp. 38–39, fig. 5; W. R. Johnson, Monuments and Monumental Art, pp. 88–90.

29 M. El-Saghir, Statuary Cachette, p. 26, n. 7; B. M. Bryan, La statuaire divine et royale, p. 109; W. R. Johnson, Monuments and Monumental Art, pp. 88–89, n. 146; R. Tefnin, in GM 138 (1994), pp. 78–79.

30 A. Radwan, Einige Aspekte der Vergöttlichung, pp. 60–61, n. 36; W. R. Johnson, Images of Amenhotep III, p. 44; W. R. Johnson, The Deified Amenhotep III, p. 232; W. R. Johnson, Monuments and Monumental Art, pp. 91–92; cf. W. J. Murnane, Observations, p. 303, n. 3.

31 M. El-Saghir, Statuary Cachette, pp. 24–26; B. M. Bryan, La statuaire divine et royale, pp. 108–109.

32 W. J. Murnane, Observations, p. 311; The Epigraphical Survey, The Tomb of Kheruef – Theban Tomb 192, OIP 102, Chicago 1980, pl. 8–10, text: pp. 32–33.

33 B. M. Bryan, La statuaire divine et royale, p. 106.

in this case the only iconographic difference between them consists in the shape of the beard, rectangular in the representations of the king, and curved forward in those of the god[34]. This close association may be one of the reasons why statues of Atum himself are so rare, much less numerous than those of other important Egyptian gods[35]. Atum belonged to the solar gods with whom Amenhotep III was identified, particularly in the last phase of his reign[36].

In Egyptian religious texts, the affinity, if not identity of Atum with the king is attested as early as the Old Kingdom in the Pyramid Texts (end of the 5th Dynasty)[37]. During the thousand years preceding the Amarna Period, the god's name was usually written with the hieroglyphic sign representing a sledge (Gardiner list U15). This sign is the only constant element in the visual form of the name Atum, most frequently with the addition of a phonetic complement placed on or above this stem[38]. Worth noting in particular are two writings, ☉ and ⌂ both attested already in the Old Kingdom (Pyramid Texts). The first one, representing a solar disc on a sledge, is found in the pyramid of Unas[39] and thus belongs to the earliest notations of the god's name. Its composition looks like a simple prototype of the Luxor statue, where the king standing on the sledge is called »dazzling Aten (i.e. solar disc) of all lands«. If this ancient writing was indeed a source of inspiration, even if not a direct one, for the composition of the Luxor statue, it would only corroborate the supposition of W. R. Johnson concerning possible direct influences of the 5th Dynasty solar religion on religious concepts of Amenhotep III, which he bases on the architectural shape of the, unfortunately unfinished, sun temple of Amenhotep III at Kom el-Abd[40].

The sledge-statue of Amenhotep III may, therefore, have been conceived as a cryptographic writing of the god's name, uniting the god with the king in one entity, and thus emphasizing the latter's solar aspect which is only tentatively mentioned in the long text carved on the statue's back support[41]. Representing the god, the sledge bears the prenomen of the king, Neb-Maat-Re, carved on the front of both runners that are curved upwards[42].

This kind of rebus writing became popular in the last phase of Amenhotep III's reign[43]. Used frequently for notation of the king's name and solar titulary, it is even found in private statuary of this period, e.g. the statue of Kheruef in Berlin (No. 2293), unfortunately de-

34 K. Myśliwiec, Studien zum Gott Atum II: Name – Epitheta – Ikonographie, HÄB 8, Hildesheim 1979, pp. 210–211; K. Myśliwiec, Herr Beider Länder. Ägypten im 1. Jahrtausend v. Chr., Mainz 1999, p. 18.

35 J. Popielska-Grzybowska, Atum in the Pyramid Texts, in: J. Popielska-Grzybowska (Ed.), Proceedings of the First Central European Conference of Young Egyptologists, Egypt 1999: Perspectives of Research, Warsaw 7–9 June 1999, Warsaw 2001, p. 123; K. Myśliwiec, Atum II, p. 211.

36 B. Birkstam, Reflections on the association between the sun-god and divine kingship in the 18th Dynasty, in: G. Englund / M. Hamrén / L. Troy (Ed.), Sundries in honour of T. Säve-Söderbergh, Uppsala 1984, p. 36 (no. 9); W. R. Johnson, Monuments and Monumental Art, pp. 88, 92.

37 J. Popielska-Grzybowska, Atum in the Pyramid Texts, pp. 115–124; J. Popielska-Grzybowska, Some preliminary remarks on Atum and jackal in the Pyramid Texts, in: GM 173 (1999), pp. 143–153; W. R. Johnson, Monuments and Monumental Art, p. 87.

38 C. Leitz (Ed.), Lexikon der Ägyptischen Götter und Götterbezeichnungen VII (š-ḏ), Leuven / Paris / Dudley 2002, 411 (Nos. 1 u. 44); Myśliwiec, Atum II, p. 5 sq. For the various writings of the god's name in the Pyramid Texts, J. Popielska-Grzybowska, Atum in the Pyramid Texts, pp. 125–129.

39 C. Leitz (Ed.), LGG VII, 411 (no. 44); K. Myśliwiec, Atum II, p. 5.

40 W. R. Johnson, Images of Amenhotep III, p. 45; W. R. Johnson, Monuments and Monumental Art, pp. 77–78.

41 R. Tefnin, in: GM 138 (1994), pp. 77–79.

42 M. El-Saghir, Statuary Cachette, p. 24.

43 W. R. Johnson, Images of Amenhotep III, pp. 38–39; W. R. Johnson, The Deified Amenhotep III, p. 232, n. 20; W. R. Johnson, Monuments and Monumental Art, p. 88, n. 143–146.

stroyed during World War II[44]. Three-dimensional cryptography in the form of statues with unusual iconographic elements rendering a royal name visibly inspired kings of later periods for instance Ramesses II, the great emulator of Amenhotep III,[45] in matters of self-deification (cf. the statue of Ramesses as a child from Tanis, now in Cairo Museum J. 64735)[46] and Nectanebo II (cf. the statue from Heliopolis in the Metropolitan Museum of Art, New York Acc.no. 34.2.1)[47].

The unique composition of the sledge-statue from Luxor makes its meaning so universal that it may be read not only as a form of the god's name, but also as one of the numerous epithets of Egyptian kings relating them to Atum, for instance:

»Living statue of Atum…« (Thutmosis III)[48]
»Emanation of Re, egg of Atum …« (Ramesses IV)[49]
»Holy emanation of Atum« (Roman Period)[50].

The second example is particularly interesting for it is found on a statue showing Ramses IV in the company of an anthropomorphic god, doubtless Atum, walking behind him[51]. Although the torsos of both figures are missing, the preserved lower part of the king's garment looks almost like a copy of Amenhotep III's accoutrement from the Luxor statue. In spite of iconographic differences between these statues, both seem to express the same idea of the king as Atum's *alter ego*, the god being once represented by the object rendering the spelling of his name, and once by his anthropomorphic effigy.

However, the identification of a pharaoh with a solar deity was by no means an invention of Amenhotep III. Its origins are to be looked for in the 5th Dynasty at the latest, it reappears in the Middle Kingdom (particularly in the deification of Mentuhotep Nebhepetre),[52] and occurs frequently in royal titulary from the very beginning of the 18th Dynasty[53].

The practice of a royal cult statue seems to have begun at the latest under Thutmosis IV[54]. Some specific details in this king's iconography suggest that the father of Amenhotep III was on the way to developing religious concepts analogous to those that found full expression on-

44 W. R. Johnson, Images of Amenhotep III, pp. 39–40, fig. 6–7; W. R. Johnson, The Deified Amenhotep III, p. 235, n. 21; W. R. Johnson, Monuments and Monumental Art, p. 88, n. 144.

45 W. R. Johnson, The Deified Amenhotep III, p. 235, n. 19; W. R. Johnson, Monuments and Monumental Art, p. 90, n. 149.

46 H. G. Fischer, L'écriture, p. 138, pl. 38; H. W. Müller, Ägyptische Kunst, Frankfurt a. Main 1970, p. 43, no. 153; M. Saleh / H. Sourouzian, The Egyptian Museum Cairo. Official Catalogue, Mainz 1987, no. 203; F. Tiradritti, The Treasures, pp. 258–259.

47 H. G. Fischer, L'écriture, p. 43, pl. 4, n. 59; K. Myśliwiec, Royal Portraiture of the Dynasties XXI–XXX, Mainz 1988, p. 73 (statuary, no. 1), pl. 86d; K. Myśliwiec, Herr Beider Länder, pp. 213, 232, fig. 79; K. Myśliwiec, The Twilight of Ancient Egypt. First Millenium B.C.E., Ithaca / London 2000, pp. 176–177, fig. 52.

48 Urk. IV, 600, 6–7; B. Birkstam, Reflections, p. 36, no. 14.

49 Statue from Tell el Faraoun, now in Zagazig, Museum Orabi, Reg. no. 1399: K. Myśliwiec, Une statue-groupe en haut-relief de Ramsès IV, in: J. Osing / E. K. Nielsen (Ed.), The Heritage of Ancient Egypt. Studies in honour of Erik Iversen, Copenhagen 1992, pp. 90–91, fig. 1.

50 F. Daumas, Les Mammisis de Dendara, Cairo 1959, 259, third column (in the text of Hathor [6]); C. Leitz, LGG VII, pp. 366–367.

51 K. Myśliwiec, Une statue-groupe, pp. 89–91, fig. 1–2.

52 W. R. Johnson, Monuments and Monumental Art, p. 90, n. 149.

53 B. Birkstam, Reflections, pp. 35–36 (Nos. 8–16), p. 38.

54 B. Birkstam, Reflections, p. 39.

ly thirty years later, in the fourth and final decade of his son's rule[55]. It may be supposed that Thutmosis IV's premature death put an end to those ambitions. Such an evolution of religious ideas was paralleled by a development of artistic phenomena that culminated in the art of Amenhotep III / Amenhotep IV[56]. Imitated later by the Ramessides, particularly Ramesses II, the innovations of Amenhotep III appear, therefore, as an important link in the long development of solar theology during the New Kingdom – a link that precedes and introduces the most dramatic episode of the evolution, the Amarna Period.

In this context, the cult sledge-statue from Luxor cryptographically uniting Amenhotep III with Atum into one solar being, may be interpreted as a *signum temporis,* an important witness of the years when political power progressively passed from the old Amenhotep III to his young son, which on the level of »political theology« was paralleled by the transition from the cult of Amun to that of Aten, the latter being identified with the deified father. Heliopolitan gods, particularly Re-Horakhty and Atum, evidently played an intermediate role in this process.[57]

The Author wishes to thank Dr. Jocelyn Gohary for the revision of the article's English.

55 W. R. Johnson, The *nfrw*-collar reconsidered, in: E. Teeter / J. A. Larson (Ed.), Gold of Praise. Studies on Ancient Egypt in honour of Edward F. Wente, Chicago 1999, p. 232; M. Hartwig, Divine Kingship and personal Piety in the Mid-eighteenth Dynasty, in: IXᵉ Congrès International des Égyptologues, 6–12 Septembre 2004, Grenoble. Résumés des Communications, p. 57.

56 K. Myśliwiec, The Art of Amenhotep III. The Link in a Continuous Evolution, in: L. M. Berman (Ed.), The Art of Amenhotep III. Art Historical Analysis, Papers Presented at the International Symposium Held at the Cleveland Museum of Art, Cleveland, Ohio, 20–21 November 1987, Cleveland 1990, pp. 16–25.

57 B. Birkstam, Reflections, p. 40; W. J. Murnane, Observations, 311; K. Myśliwiec, Amon, Atum and Aton: The Evolution of Heliopolitan Influences in Thebes, in: L'Égyptologie en 1979. Axes prioritaires de recherches II, Paris 1982, pp. 285–289; E. Cruz-Uribe, Atum, Shu, and the Gods during the Amarna Period, in: JSSEA 25 (1995), pp. 15–22.

Silvia Rabehl

Eine Gruppe von Asiaten im Grab Chnumhoteps II. (BH 3)

Tradierung eines Bildmotivs in den Felsgräbern des Mittleren Reiches von Beni Hassan[1]

1. Eine Gruppe von Asiaten

Die Galeriegräber von Beni Hassan, die in der ersten Hälfte des Mittleren Reiches vor allem als Grabstätten für die lokalen Fürsten des 16. oberägyptischen Gaus angelegt wurden, sind durch ihren hinsichtlich anderer Gräber aus gleicher Zeit vergleichsweise sehr guten Erhaltungszustand von großer Bedeutung.[2] Diese Tatsache nämlich prädestiniert sie zum idealen Forschungsobjekt, was die Entwicklung der Grabdekoration in einem lokal und zeitlich begrenzten Mikrokosmos, in diesem Fall dem einer lokalen Fürstengruppe aus der Frühzeit des Mittleren Reiches, betrifft.

Die besondere Bedeutung der Dekoration der Grabanlagen liegt nicht nur in ihrem guten Erhaltungszustand,[3] sondern in der Vielfalt der einmaligen und vielfach nur aus Beni Hassan bekannten Bildmotive, aus denen sie sich zusammensetzt.[4] Unter all diesen Bildmotiven hat die Darstellung einer Gruppe von Asiaten auf der Nordwand der Grabanlage BH 3 von *Ḥnm-ḥtp II.*, dem spätesten Inhaber einer großen, dekorierten Grabanlage in Beni Hassan, stets besonders großes Interesse hervorgerufen. Das mag an der bis ins Detail sehr realistisch wirkenden Wiedergabe dieser Gruppe von Männern, Frauen und Kindern liegen, die durch ihre ungewöhnliche Kleidung, Haartracht und Ausrüstung eindeutig als Asiaten identifizierbar sind (vgl. Taf. 16a). Diese naturgetreue Darstellung beschäftigte im 19. Jahrhundert bereits Bibelwissenschaftler, welche hier ein Abbild des Einzugs der Israeliten in Ägypten vermuteten.[5] Im Gegensatz zu diesen interessierte spätere Forscher vielmehr der Zusammenhang zwi-

1 Nummerierung und Kurzbezeichnungen für die Gräber entsprechen der von Percy E. Newberry eingeführten Kategorisierung. Dazu P. E. Newberry, Beni Hasan, ASE 1, London 1893 und P. E. Newberry, Beni Hasan, ASE 2, London 1894.

2 A. G. Shedid, Die Felsgräber von Beni Hassan in Mittelägypten, Mainz 1994.

3 Von dem ich mich selbst im Frühjahr 2002 während eines Aufenthalts in Beni Hassan überzeugen konnte, welcher der Vorbereitung meiner inzwischen abgeschlossenen Dissertation über die Grabanlage des Amenemhet (BH 2) diente.

4 Vgl. J. G. Wilkinson, The Ancient Egyptians. Their Life and Customs. A Popular Account of the Ancient Egyptians, Revised and Abridged from his Larger Work, New York 1989, der für seine Illustrationen zum großen Teil Bildmotive aus Beni Hassan verwendete.

5 Vgl. O. Keel, Die Rezeption ägyptischer Bilder als Dokumente der biblischen Ereignisgeschichte (Historie) im 19. Jahrhundert, in: E. Staehelin / B. Jaeger (Hg.), Ägypten-Bilder. Akten des »Symposions zur Ägypten-Rezeption«, Augst bei Basel, vom 9.–11. September 1993, OBO 150, Fribourg / Göttingen 1997, S. 51ff.; zum Problem vgl. M. Görg, Zur Rezeptionsgeschichte der Asiaten-Szene von Beni-Hassan, in: Biblische Notizen 88 (1997), S. 9ff.

schen der Abbildung und ihren Beischriften, und sie betrachteten die Szene schließlich im Gesamtkontext der Abbildungen auf der Nordwand von BH 3.[6]

Die bisherigen Beobachtungen trugen dazu bei, die Besonderheit der Szene und ihre Einmaligkeit innerhalb der Grabdekoration der Gräbergruppe von Beni Hassan hervorzuheben. Doch gerade die Thematisierung der »Besonderheit« steht im Gegensatz zur Tradition der Gräber, innerhalb deren Grabdekoration sich durchaus eine chronologische Weiterentwicklung der dargestellten Themen und Bildmotive feststellen lässt. Ziel des Artikels ist es zu zeigen, dass auch und gerade die »Asiatenkarawane« nicht etwa ein völlig neues Motiv wiedergibt, das einzig die Erinnerung an ein bedeutendes Ereignis festhält, sondern dass sich ihre Ursprünge in der Grabdekoration früherer Gräber aus Beni Hassan wiederfinden lassen. Außerdem soll die mögliche Motivation des Grabherrn für die Wahl gerade dieses »Bildes« dargelegt werden.

2. Bildmotiv und Interpretation der Szene

Bei den in Grab BH 3 des *Ḫnm-ḥtp II.* in Beni Hassan dargestellten Asiaten handelt es sich um eine Gruppe von acht Männern, vier Frauen und drei Kindern, die sich zu Fuß, angetan mit bunter Tracht und Sandalen und begleitet von Packeseln, in offenbar friedlicher Absicht auf den großformatig abgebildeten Grabbesitzer am östlichen Ende der Nordwand zubewegen. Lässt man zunächst den begleitenden Text zur Szene außer Acht und betrachtet einzig die Abbildung, erkennt man: Mehrere der Männer sind mit Bögen oder Axt bewaffnet, ohne jedoch bedrohlich zu wirken. Die Szene muss im Gesamtkontext der Abbildungen dieser Wand, der Nordwand des Grabes, gesehen werden, welche die Jagd in der Wüste und das Zählen des Viehbestandes des Grabherrn zeigen. Unter den Waffen, die die Asiaten mit sich führen, ist die früheste Wiedergabe einer so genannten »duckbill«-Axt anzutreffen. Hierbei handelt es sich eindeutig um eine asiatische Waffe und damit um ein weiteres Detail, das neben der Kleidung der Typisierung der Gruppe dient.[7]

Die Darstellung der Asiaten wird von drei verschiedenen Beischriften textlich begleitet. Die erste Beischrift ist über dem Beginn der Asiatengruppe vor *Ḫnm-ḥtp II.* angebracht.[8] Sie lautet: *jjt ḥr jnt msḏmt jn.n.f ꜥ3mw* 37 / »Kommen mit dem Bringen der Augenschminke, nachdem er 37 Asiaten geholt hat.« Bei der Person, welche die Asiaten »geholt hat«, handelt es sich um den Sohn des Grabherrn, dessen Name ebenfalls *Ḫnm-ḥtp* lautet.[9] Dies geht aus der zweiten Beischrift hervor. Sie ist auf einer bildlich wiedergegebenen Schreibtafel angebracht, welche dem großformatig abgebildeten Grabherrn vom *sš ꜥn nsw Nfr-ḥtp*[10] präsentiert

6 Vgl. H. Goedicke, Abi-Sha(i)'s Representation in Beni Hasan, in: JARCE 21 (1984), S. 203ff.; D. Kessler, Die Asiatenkarawane von Beni Hassan, in: SAK 14 (1987), S. 147ff.; J. Kamrin, The Cosmos of Khnumhotep II. at Beni Hasan, Studies in Egyptology, London / New York 1999, S. 93ff.

7 M. Bietak, Relative and Absolute Chronology of the Middle Bronze Age. Comments on the Present State of Research, in: The Middle Bronze Age in the Levant, Proceedings of an International Conference on MB IIA Ceramic Material, Vienna 24–26th January 2001, Contributions to the Chronology of the Eastern Mediterranean 3, DÖAWW 26, Wien 2002, S. 39ff.

8 P. E. Newberry, Beni Hasan I, Taf. 30.

9 Für kritische Anmerkungen zur Übersetzung der folgenden Stellen danke ich Martina Ullmann. Zu weiteren Übersetzungen vgl. P. Vernus, Sur deux inscriptions du Moyen Empire, in: BSEG 13 (1989), S. 173ff.; H. Goedicke, in: JARCE 21 (1984), S. 203ff.; D. Kessler, in: SAK 14 (1987), S. 147ff.

10 Zu diesem Titel vgl. W. A. Ward, The Nomarch Khnumhotep at Pelusium, in: JEA 55 (1969), S. 158, Nr. 1360.

wird (vgl. Taf. 17a). Darauf steht zu lesen: *rnpt-sp 6 ḥr ḥm n Ḥr Sšm-tꜣwj nsw-bjtj Ḫꜥ-ḫpr-Rꜥ rḫt n ꜥꜣmw jn.n sꜣ ḥꜣtj-ꜥ Ḫnm-ḥtp ḥr msḏmt ꜥꜣm n Šw rḫt-jrj 37 /* »Regierungsjahr 6 unter der Majestät des Horus *Sšm-tꜣwj*, des Königs von Ober- und Unterägypten *Ḫꜥ-ḫpr-Rꜥ* (Sesostris II.). Liste der Asiaten, die gebracht hat der Sohn des Fürsten *Ḫnm-ḥtp* wegen der Augenschminke. Asiaten aus *Šw*, zugehörige Anzahl 37«. Dieser Sohn *Ḫnm-ḥtp* des Grabbesitzers gehörte zum Hofstaat des Königs und stieg vom einfachen Expeditionsleiter zum *r-ꜥꜣ ḫꜣswt*[11] auf. Er war folglich für die Zulieferung von ausländischen Produkten an den Königshof zuständig – und pflegte demnach ständigen Umgang mit Fremdvölkern. Sein fulminanter Aufstieg[12] ermöglichte es ihm wahrscheinlich, seine letzte Ruhestätte in Dahschur im Grabbezirk Sesostris' III. zu errichten und nicht mehr in Beni Hassan wie sein Vater.[13]

Eine letzte, direkt die Asiatenszene betreffende Beischrift widmet sich konkret der Person des Anführers der kleinen Gruppe. Er wird als *ḥqꜣ ḫꜣswt*, fremdländischer Herrscher, mit Namen *Jbš ꜥꜣ* benannt.[14] Diese Beischrift bedeutet eine weitere Spezifizierung der bereits durch viele ikonographische Details eindeutig als fremdländisch charakterisierten Truppe von Männern, Frauen und Kindern. Gleichzeitig mit der Literatur zeigt sich hier auch in der bildlichen Darstellung der individualisierte Ausländer. Wie Antonio Loprieno dargelegt hat, handelt es sich um das »Aufkommen der ›Du-Einstellung‹ zur Ausländerfigur«.[15] Darunter versteht er das sich während des frühen Mittleren Reiches »allmählich … [entwickelnde] … ägyptische Bewußtsein der menschlichen Vielfalt«, das nicht nur in der bildlichen und rundplastischen Darstellung zum Ausdruck kommt, sondern gerade durch die zeitgenössische Literatur wie etwa die Sinuhe-Erzählung auf eindringliche Weise präsent ist.[16]

Im Gegensatz zu dieser letzten, spezifizierenden Beischrift handelt es sich bei den beiden zuvor gegebenen Beischriften um zur Darstellung in gewissem Sinne komplementäre Informationen, welche aus der rein optischen Betrachtung der abgebildeten Asiatengruppe nicht ohne weiteres hervorgehen. Etwa, dass es sich um eine Gruppe von 37 Asiaten handelt. Gemäß der Abbildung werden hier, Frauen und Kinder mit eingeschlossen, lediglich 15 Personen gezeigt. Auch bringen sie Tiere und andere Habseligkeiten mit und sehen keinesfalls wie eine zu allem bereite Truppe von Beduinen aus, die mit einer mühsamen und beschwerlichen Wüstenexpedition in Verbindung gebracht werden kann. Eher scheint es sich um Viehhirten mit ihren Familien zu handeln, die in der Gegend ansässig sind oder zu sein planen. Diese Diskrepanz zwischen Bildmotiv und begleitendem Text hat immer wieder Diskussionen hervorgerufen.[17] Schließlich ist es erst die gemeinsame »Lesung« von Text und Bild, welche eine Einheit erzeugt, die wiederum den Eindruck eines singulären Ereignisses hervorruft. Die-

11 Zu diesem seltenen Titel vgl. D. M. Doxey, Egyptian Non-Royal Epithets in the Middle Kingdom. A Social and Historical Analysis, PÄ 12, Leiden 1998, S. 331.

12 D. Franke, The Career of Khnumhotep III. of Beni Hasan and the so-called »Decline of the Nomarchs«, in: S. Quirke (Hg.), Middle Kingdom Studies, New Malden 1991, S. 51ff.

13 D. Arnold, Middle Kingdom Mastabas at Dahshur, in: EA 21 (2002), S. 38ff; D. Arnold, Die letzte Ruhestätte ägyptischer Beamter: Ein Mastaba-Feld des Mittleren Reiches in Dahschur, Ägypten, in: AW 33/6 (2002), S. 624ff.

14 M. Görg, Zum Personennamen *Jbš ꜥꜣ*, in: Biblische Notizen 73 (1994), S. 9ff.

15 A. Loprieno, Topos und Mimesis. Zum Ausländer in der Ägyptischen Literatur, ÄA 48, Wiesbaden 1988, S. 44ff.

16 A. Loprieno, Topos und Mimesis, S. 44ff. und speziell S. 46f.: »Die Kunst und die Literatur unterliegen also ähnlichen kulturgeschichtlichen Entwicklungslinien, so daß vielleicht in Ägypten erst mit dem Aufkommen der individuellen Identitätsfrage, also mit der Ersten Zwischenzeit bzw. den Anfängen des Mittleren Reiches, nicht nur von einer *Literatur*, sondern auch von einer *Kunst* im engeren Sinne die Rede sein dürfte.«

17 H. Goedicke, in JARCE 21 (1984), S. 203ff.; D. Kessler, in: SAK 14 (1987), S. 147ff.

ses auf den ersten Blick singuläre Ereignis scheint es wert zu sein, eine herausragende Position in der Grabdekoration *Ḫnm-ḥtp*'s *II.* einzunehmen.

Unter Berücksichtigung der bereits erwähnten Tatsache, dass gerade spektakuläre Bildmotive – wie beispielsweise die Ringerszenen oder auch die Greifendarstellungen – in mehreren der Grabanlagen von Beni Hassan wiederaufgenommen worden sind, soll hier nun die Einmaligkeit des Bildmotivs einer friedlichen Gruppe von Ausländern – Asiaten – in den Gräbern von Beni Hassan überprüft werden. Dazu ist es zunächst notwendig, die Historie von Asiatendarstellungen in Privatgräbern bis in die Zeit des frühen Mittleren Reiches näher zu betrachten.

3. Darstellungen von Ausländern

3.1 Darstellungen von Asiaten außerhalb des Kontextes von Beni Hassan

Darstellungen von Asiaten sind in Ägypten lange vor dem Mittleren Reich nachzuweisen. Zwei Belege aus Privatgräbern lassen sich bereits für die frühe 6. Dynastie ermitteln. Der erste stammt aus dem Grab des *Jntj* in der Nekropole des oberägyptischen Deschasche.[18] Dort wird die Einnahme einer asiatischen Festung durch Ägypter gezeigt.[19] Eine weitere solche Belagerungsszene findet sich im Grab des *Kʒj-m-ḥs.wt*.[20] Die Asiaten sind in beiden Kampfdarstellungen mit Frauen und Kindern abgebildet. Ihre Identifizierung als Asiaten ist allerdings nur anhand ihrer Tracht möglich. In der Ikonographie des Alten Reiches unterscheiden sie sich von den Ägyptern hauptsächlich durch ihre langen, spitz zulaufenden Bärte und die Langhaartracht.[21] Im Gegensatz zur Abbildung des Asiatenzuges im Grabe *Ḫnm-ḥtp*'s *II.* fehlt hier jegliche Beischrift, die eine Identifizierung beziehungsweise ethnographische Lokalisierung der abgebildeten Feinde über die bildliche Manifestation hinaus ermöglichen würde.[22]

Die nächste bekannte Abbildung von Asiaten in einem Privatgrab außerhalb von Beni Hassan findet sich erst im frühen Mittleren Reich. Es handelt sich dabei um das im Asasif gelegene Grab TT 386 des *Jnj-jtj.f*, der als General unter Mentuhotep II. diente.[23] Und wie bereits zuvor ist auch hier eine Schlachtendarstellung zwischen Ägyptern und Asiaten das Thema.

18 W. M. F. Petrie, Deshasheh 1897, EEF 15, London 1898; N. Kanawati, Re-excavating and Recording Deshasha, in: BACE 5 (1994), S. 43ff.

19 W. M. F. Petrie, Deshasheh; N. Kanawati, in: BACE 5 (1994), S. 47ff. mit Abb. 2; P. Saretta, Egyptian Perceptions of West-Semites in Art and Literature During the Middle Kingdom. (An Archaeological, Art Historical, and Textual Survey), Ann Arbor 1997, S. 79f.

20 J. E. Quibell / A. G. K. Hayter, Teti Pyramid, North Side, SAE/Excavations at Saqqara, Kairo 1927; S. Clarke / R. Engelbach, Ancient Egyptian Masonry, Oxford 1930.

21 P. Saretta, Egyptian Perceptions of West-Semites, S. 86.

22 Für eine genaue Schilderung und Analyse der beiden Belagerungsszenen vgl. R. Schulz, Der Sturm auf die Festung. Gedanken zu einigen Aspekten des Kampfbildes im Alten Ägypten vor dem Neuen Reich, in: M. Bietak / M. Schwarz (Hg.), Krieg und Sieg. Narrative Wanddarstellungen von Altägypten bis ins Mittelalter, Internationales Kolloquium vom 29. bis 30. Juli 1997 in Schloss Haindorf, Langenlois, UÖAW 20, Wien 2002, S. 25ff.

23 D. Arnold / J. Settgast, Erster Vorbericht über die vom Deutschen Archäologischen Institut in Kairo im Asasif unternommenen Arbeiten (1. und 2. Kampagne), in: MDAIK 20 (1965), S. 47ff.; B. Jaroš-Deckert, Das Grab des *Jnj-jtj.f*. Die Wandmalereien der XI. Dynastie nach Vorarbeiten von Dieter Arnold und Jürgen Settgast, AV 12, Mainz 1984.

Ähnliche Szenen sind gleichfalls auf Reliefblöcken aus dem Totentempel Mentuhoteps' II. aus Deir el-Bahri wiedergegeben.[24] Auf Grund der zeitlichen Kongruenz handelt es sich bei den in *Jnj-jtj.f*'s Grab gezeigten Szenen höchstwahrscheinlich um eine Beschreibung derselben Ereignisse, da er als General unter Mentuhotep II. eine herausragende Rolle bei solchen Kämpfen innehatte.

Außerhalb der Gräber von Beni Hassan ist demnach eine Gruppe offensichtlich in friedlicher Absicht nach Ägypten kommender Asiaten für die Zeit des Mittleren Reiches oder früher, soweit bisher bekannt, nicht belegt. Die einzige Ausnahme einer Darstellung von nicht nachweisbar in Kampfhandlungen verwickelten Asiaten datiert wesentlich früher und stammt aus königlichem Kontext, genauer gesagt aus dem Pyramidentempel von König Sahure in Abusir.[25] Unter den vom Aufweg des Tempels erhaltenen Darstellungen finden sich Szenen von acht Booten mit Ausländern. Es handelt sich bei den Insassen um Männer mit Schurzen und Vollbärten, deren lange Haare von einem Netz zusammengehalten werden, sowie Frauen und Kinder. Die einander gegenüberliegend angeordneten Szenen schildern jeweils die An- und Abreise dieser Gruppe.[26] Möglicherweise ist hier eine syrisch-asiatische Handelsmission in Ägypten dargestellt.[27] Da eine Beischrift zu diesen Darstellungen fehlt, ist eine endgültige Interpretation der Szene jedoch nicht möglich.[28]

3.2 Dekorierte Grabanlagen in Beni Hassan

Für Hinweise auf eventuelle Vorgängermodelle des Bildmotivs der Asiatenszene aus BH 3 bleiben demnach nur die Anlagen von Beni Hassan selbst. Der unterschiedliche Grad der Fertigstellung sowie der Erhaltungszustand der Gräber erschweren dabei zwar eine endgültige Aussage, doch ist die noch vorhandene Grabdekoration durchaus hilfreich zum besseren Verständnis der Darstellung. Da BH 3, das Grab *Ḫnm-ḥtp*'s *II.*, das späteste dekorierte Grab darstellt, sollen die früheren Gräber hier in chronologischer Reihenfolge auf Abbildungen von Asiaten untersucht werden.

Bei den drei frühesten, in den Ausgang der 11. Dynastie zu datierenden Gräbern,[29] namentlich BH 29 (*Bȝḳt I.*), BH 33 (*Bȝḳt II.*) und BH 27 (*Rȝmwšntj*) finden sich unter den Abbildungen keine in irgendeiner Weise durch ikonographische Merkmale oder eine Beischrift als Asiaten zu identifizierende Personen.[30]

Die beiden zeitlich folgenden Grabanlagen, BH 15 (*Bȝḳt III.*) und BH 17 (*Ḫtj*), bei denen es sich architektonisch und stilistisch um einander ähnliche Gräber mit einer möglichen Datierung gegen Ende der 11. bis zum Beginn der 12. Dynastie handelt, weisen an der Ostwand

24 I. Shaw, Battle in Ancient Egypt: The Triumph of Horus or the Cutting Edge of the Temple Economy?, in: A. B. Lloyd (Hg.), Battle in Antiquity, London 1996, S. 239ff. Zu Gemeinsamkeiten und Unterschieden vgl. R. Schulz, Der Sturm auf die Festung, S. 25ff.

25 L. Borchardt, Das Grabdenkmal des Königs Sahure, WVDOG 14 u. 26, Leipzig / Berlin 1910 u. 1913, Taf. 11–12, 40.

26 P. Saretta, Egyptian Perceptions of West-Semites, S. 81ff.; G. A. Gaballa, Narrative in Egyptian Art, Mainz 1976, S. 33ff.

27 P. Saretta, Egyptian Perceptions of West-Semites, S. 83.

28 P. Saretta, Egyptian Perceptions of West-Semites, S. 82, Anm. 206.

29 Für einen guten Überblick zur zeitlichen Zuordnung vgl. A. G. Shedid, Beni Hassan, S. 22, Abb. 25.

30 Für eine Kurzbeschreibung dieser Grabanlagen vgl. A. G. Shedid, Beni Hassan, S. 23ff.; ansonsten vgl. P. E. Newberry, Beni Hasan II.

erstmals die einzig für Beni Hassan belegten Ringerszenen in Kombination mit Festungsdarstellung und Schlachtgeschehen auf.[31] Diese Schlachtenszenen im unteren bis mittleren Teil der Ostwand sind so aufgeteilt, dass im nördlichen Wandabschnitt die Erstürmung einer Festung wiedergegeben ist, während im südlichen Wandabschnitt, sozusagen von Süden nach Norden hin ausgerichtet, der Kampf auf dem Schlachtfeld dargestellt ist. Dabei sind die jeweiligen Gegner ikonographisch nicht durch Tracht, Frisur oder sonstige äußere Merkmale voneinander unterschieden. Die Szene erweckt daher eher den Eindruck, als handelte es sich um Ägypter, die hier gegeneinander kämpfen.[32] Doch sind unter den Truppen, welche auf die Festung zumarschieren, deutlich mehrere Soldaten mit bunten Schurzen zu erkennen, wie sie für Asiaten typisch sind.[33] Außer den bunt gewebten Schurzen deutet weiter nichts auf die Herkunft der Männer aus Asien. Mit üblicher Haartracht und ohne Bart dargestellt, unterscheiden sie sich nicht weiter von Bildern ägyptischer Soldaten. Möglicherweise handelt es sich um ausländische Söldner.

Ein sehr ähnliches Bild bietet sich auf der Ostwand von BH 17 (*Ḫtj*). Auch hier sind beim Ansturm auf die Festung Soldaten in bunt gewebten Schurzen dargestellt. Und auch hier findet sich außer den bunten Schurzen kein weiterer Hinweis darauf, dass es sich bei diesen Soldaten um Asiaten handelt.[34]

In BH 14 (*Ḫnm-ḥtp I.*), dem ersten anhand der Nennung Amenemhets I. sicher in die 12. Dynastie datierbaren Grab, befinden sich – wieder auf der Ostwand – unter den Truppen beim Ansturm auf die Festung ebenfalls asiatische Soldaten. Das gesamte Grab ist heute dringend restaurierungsbedürftig und in einem sehr schlechten Erhaltungszustand, so dass von den Darstellungen auf der Ostwand nicht mehr viel zu erkennen ist. Einzig verlässliche Quelle bleibt somit die Abbildung bei Newberry.[35] Die hier dargestellten Asiaten unterscheiden sich nicht nur durch ihre bunten Schurze, sondern auch durch ihre Haartracht und ihren Spitzbart von den übrigen Soldaten (vgl. Taf. 17b, oben links). Die kappenartige Frisur nimmt bereits den Pilzkopfschnitt[36] der Asiaten auf der Nordwand von BH 3 vorweg.[37] Im Unterschied zu den zeitlich etwa gleich beziehungsweise etwas früher anzusetzenden Gräbern BH 15 und BH 17 lassen sich die in BH 14 auf der Ostwand dargestellten Ausländer durch ihre Tracht auch ohne erläuternde Beischrift zweifelsfrei als Asiaten klassifizieren.[38]

BH 21, das Grab des *Nḫt*, des Sohnes und Nachfolgers im Amt von *Ḫnm-ḥtp I.*, wurde nie fertig gestellt und weist nur an der Südwand Spuren von Malerei auf.[39] Eine Aussage zum Dekorationsprogramm des Grabes lässt sich folglich nicht treffen.

Auch BH 23 wurde nie fertig gestellt, und der Grabschacht ist bis heute nicht ausgehoben

31 A. G. Shedid, Beni Hassan, S. 70ff.

32 I. Shaw, Battle in Ancient Egypt, S. 245. Er ist der Meinung, dass »… the Beni Hassan scenes appear to document civil war between rival factions of Egyptians«.

33 P. E. Newberry, Beni Hasan II, Taf. 4 (3. Reihe von unten); P. Saretta, Egyptian Perceptions of West-Semites, S. 104.

34 P. E. Newberry, Beni Hasan II, Taf. 15 (3. Reihe von unten).

35 P. E. Newberry, Beni Hasan I, Taf. 47.

36 P. Saretta, Egyptian Perceptions of West-Semites, S. 114ff.

37 Für Gemeinsamkeiten und Unterschiede der Asiatendarstellungen von BH 14 und BH 3 vgl. P. Saretta, Egyptian Perceptions of West-Semites, S. 108ff.

38 Möglicherweise handelt es sich hier um eine den *ꜥꜣmw* aus BH 3 nahe stehende Gruppe. Dazu P. Saretta, Egyptian Perceptions of West-Semites, S. 109f., Anm. 278, 279.

39 P. E. Newberry, Beni Hasan II, S. 26.

worden.[40] Die nachträglich von *Ḫnm-ḥtp II.* an der Ostwand der Grabanlage angebrachten In-schriften ordnen das Grab dem *Nṯr-nḫt*, einem Vorfahren *Ḫnm-ḥtp*'s *II.*, zu.[41] Außer Familien-angehörigen und Opferszenen finden sich keinerlei Darstellungen.

Im letzten der zeitlich vor BH 3 liegenden Gräber, BH 2, welches sich auf Grund der im Türrahmen eingemeißelten biographischen Inschrift seines Inhabers *Jmnjj* eindeutig in die Zeit Sesostris' I. datieren lässt,[42] sind – wiederum an der Ostwand – Darstellungen von Asia-ten angebracht.[43]

Architektonisch hebt sich diese Grabanlage von den vorherigen durch eine klare West-Ost-Ausrichtung ab, die besonders durch einen in die Ostwand eingearbeiteten Schrein be-tont wird. Dieser mittels eines Durchgangs in der Ostwand zugängliche Schrein unterteilt die Ostwand des Grabes optisch in zwei Hälften.[44] Dieser architektonischen Neuerung setzt die Wanddekoration nochmals die Thematik der Vorgänger entgegen. Auf einem Großteil der Wand finden sich die bereits bekannten Ringerdarstellungen, an welche sich im unteren Be-reich wieder Festungs- und Schlachtenszenen anfügen.[45] Wie bereits zuvor werden auch in diesem Grab die Kampfhandlungen auf dem Schlachtfeld im unteren südlichen Teil der Ost-wand geschildert. Ganz unten im südöstlichen Wandeck ist eine Formation von drei asiati-schen Söldnern abgebildet.[46] Sie sind gemäß ihrer Tracht und Ausrüstung mit den Asiaten in BH 14 nahezu identisch,[47] soweit Newberrys Abbildungen der Ostwand von BH 14 dem nicht mehr verifizierbaren Original entsprechen. Möglicherweise orientierte sich der Künstler bei der Ausgestaltung von BH 2 an diesem Vorbild. Eine Beischrift, die eine genauere Aussage zu Funktion und Herkunft dieser Personen ermöglichen würde, fehlt.

Darstellungen von Asiaten lassen sich in den Gräbern von Beni Hassan vor *Ḫnm-ḥtp II.* al-so durchaus feststellen. Doch im Gegensatz zu der Gruppe von *ꜥꜣmw*-Asiaten in BH 3, die mit Frauen, Kindern und Vieh offenbar in friedlicher Absicht unter dem Auge des Fürsten auftreten, handelt es sich bei der Abbildung von Asiaten (BH 14, BH 2) – oder an ihrem bun-ten Schurz möglicherweise als Asiaten klassifizierbaren Ausländern (BH 15, BH 17) – in den früheren Gräbern wohl stets um Söldner. Aus den Darstellungen in den Gräbern von Beni Hassan wird nicht deutlich, ob sie dabei mit freundlichen oder feindlichen Truppen kooperie-ren, doch ist der Kontext stets kriegerischer Natur.

3.3 Weitere Ausländerdarstellungen

Die Asiaten sind nicht die einzige Ausländergruppe, welche bei näherer Untersuchung der Grabdekoration ins Auge fällt. BH 14, Grab *Ḫnm-ḥtp*'s *I.*, des Großvaters von *Ḫnm-ḥtp II.*, zeigt auf der Ostwand nicht nur asiatische Söldner, sondern außerdem eine Gruppe von Liby-

40 P. E. Newberry, Beni Hasan II, S. 77. Wegen der Tiefe der Grabschächte war es den damaligen Ausgräbern nicht möglich, alle Gräber auszuheben, so dass nicht in jedem Fall Aussagen zu den Bestatteten getroffen werden können.

41 P. E. Newberry, Beni Hasan II, S. 27ff.

42 P. E. Newberry, Beni Hasan I, Taf. 8; A. G. Shedid, Beni Hassan, S. 44f. mit Abb. 74 u. 75.

43 P. E. Newberry, Beni Hasan I, Taf. 16.

44 P. E. Newberry, Beni Hasan I, Taf. 14–16.

45 P. E. Newberry, Beni Hasan I, Taf. 14, 16.

46 P. E. Newberry, Beni Hasan I, Taf. 16; für eine farbige Abbildung vgl. A. G. Shedid, Beni Hassan, S. 69 mit Abb. 116.

47 P. E. Newberry, Beni Hasan I, Taf. 47.

ern.[48] Bemerkenswerterweise bewegt sich dieser von einem Ägypter angeführte Zug von Norden nach Süden, also weg vom Kampfgeschehen (vgl. Taf. 17b). Zu dieser Gruppe gehören Frauen mit hochgebundenen Haaren, gelblicher Hautfarbe und langen, fransigen Röcken, die ihre Kinder auf den Rücken gebunden tragen. Die dazugehörigen Männer sind vollbärtig, von rötlicher Hautfarbe, mit Straußenfedern in der rechten Hand und im Haar abgebildet. In der linken, zur Brust geführten Hand tragen sie jeweils eine Steinschleuder.[49] Diese Wiedergabe von Libyern ist in der ägyptischen Ikonographie charakteristisch von den ersten bekannten Darstellungen bis hin zum ausgehenden Alten Reich.[50] Zu den Libyern in BH 14 gehört außerdem eine Herde Ziegen. Es handelt sich hier dem Augenschein nach um Libyer, die als Viehhirten in friedlicher Absicht nach Ägypten gekommen sind. Vielleicht haben sie tatsächlich Beni Hassan erreicht, um hier sesshaft zu werden.

Die heute nicht mehr lesbare Biographie des Grabherrn,[51] die auf der Westwand von BH 14 angebracht war, wurde, soweit noch erhalten, durch Newberry dokumentiert.[52] Ihr Inhalt lässt darauf schließen, dass *Ḫnm-ḥtp I.* sich seine Ämter in Beni Hassan durch die ruhmreiche Teilnahme an mehreren Feldzügen unter Amenemhet I. erworben hat.[53] *Ḫnm-ḥtp I.*, über dessen Erfolge sein Enkel *Ḫnm-ḥtp II.* in seiner eigenen biographischen Inschrift stolz berichtet,[54] ist unter Amenemhet I. weit herumgekommen. Den Angaben seiner Biographie nach erreichte der Grabinhaber auf den Feldzügen, welche er mit seinem Herrscher unternahm, unter anderem auch Pelusium.[55] Da wäre es durchaus denkbar, dass er gleichfalls zu den Teilnehmern des Feldzugs gegen die Temehu-Libyer gehörte, der in der Erzählung des Sinuhe geschildert wird.[56] Ob es sich bei den auf der Ostwand von BH 14 dargestellten Libyern um tatsächlich nach Beni Hassan immigrierte Libyer handelt oder nur um die Wiedergabe einer Begegnung, die möglicherweise aus den Erfahrungen von der Teilnahme *Ḫnm-ḥtp's I.* am Libyenfeldzug resultiert, kann nicht mit Sicherheit festgelegt werden, da erläuternde Beischriften zu dieser Szene fehlen.[57] Rolf Gundlach hat die These aufgestellt, dass die durch die Kämpfe während der Machtübernahme Amenemhets I. eingetretenen Zerstörungen und die damit verbundenen Verluste von Mensch und Tier nur wieder ausgeglichen werden konnten, indem ausländische Bevölkerungsgruppen mitsamt der dabei erbeuteten Viehherden nach Ägypten zwangsumgesiedelt wurden.[58] Möglicherweise handelt es sich bei den hier abgebildeten Libyern um eine solche Gruppe.

Erwähnenswert ist in diesem Zusammenhang der Fund einer hölzernen Statuette durch

48 P. E. Newberry, Beni Hasan I, Taf. 45, 47 (mittlere Reihe).

49 Zur Tracht der Libyer vgl. O. Bates, The Eastern Libyans. An Essay, London 1914, S. 118ff., Taf. 5; W. Hölscher, Libyer und Ägypter. Beiträge zur Ethnologie und Geschichte libyscher Völkerschaften nach den altägyptischen Quellen, ÄF 4, Glückstadt 1955, S. 26f.

50 J. Osing, »Libyen, Libyer«, in: LÄ III (1980), Sp. 1018.

51 Bei meinem Besuch des Grabes im März 2002 konnte ich keine Spuren der Inschrift mehr erkennen.

52 P. E. Newberry, Beni Hasan I, Taf. 44.

53 L. M. Berman, Amenemhet I., Ann Arbor 1986, S. 147ff.

54 L. M. Berman, Amenemhet I., S. 151ff.

55 W. A. Ward, in: JEA 55 (1969), S. 215f.

56 Vgl. Sinuhe R 11–16; außerdem E. Meyer, Geschichte des Altertums II.1. Die Zeit der Ägyptischen Großmacht, Basel 1953, S. 423f.

57 W. Hölscher, Libyer und Ägypter, S. 27, spricht sich deutlich gegen Libyeransiedlungen in Beni Hassan aus.

58 R. Gundlach, Die Zwangsumsiedlung auswärtiger Bevölkerung als Mittel ägyptischer Politik bis zum Ende des Mittleren Reiches, in: H. Bellen (Hg.), Forschungen zur antiken Sklaverei 26, Stuttgart 1994, S. 168ff.

John Garstang.[59] Sie befand sich in einem der Schachtgräber von Beni Hassan aus dem Mittleren Reich, welche am Hang unterhalb der Felsgalerie liegen. Die Statuette, welche heute im Royal Scottish Museum in Edinburgh ausgestellt ist, zeigt eine Frau mit kugeliger, vielleicht hochgebundener Haartracht, bekleidet mit einem langen Rock, die ein Kind auf den Rücken gebunden trägt, ganz ähnlich den Libyerinnen auf der Ostwand von BH 14.[60]

Noch einmal treten die Libyer in den Gräbern von Beni Hassan in Erscheinung, nämlich in der Grabanlage des *Jmnjj* in BH 2. Sie werden nun nicht mehr zwischen den Schlachtenszenen auf der Ostwand gezeigt, sondern sind auf die Nordwand gewechselt. Sie stehen in BH 2 im selben Kontext wie die Wüstenjagd, die Zählung des Viehs und die Kornspeicherung. Genau dort, im linken unteren Wandteil, zwischen der Kornkammerdarstellung und den Büros der Schreiber, befindet sich eine kleine – heute mit bloßem Auge kaum noch auszumachende – Gruppe von Libyern mit Ziegen.[61] Es handelt sich hier um die komprimierte Version der Libyerszene aus BH 14. Trotz schlechten Erhaltungszustands sind zwei Männer mit Federn im Haar, gefolgt von zwei Frauen, zu erkennen, die vor sich her eine Herde von Ziegen treiben.

Wieder scheint es sich um eine friedliche Gruppe von Ausländern, genauer um Libyer, zu handeln. Vielleicht sind es dieselben Libyer, oder ihre Nachfahren, welche mit *Ḫnm-ḥtp I.* infolge der Umsiedlungspolitik unter Amenemhet I. nach Beni Hassan gekommen waren.[62]

4. Zusammenfassung

4.1 Der Ursprung des Bildmotivs innerhalb der Asiatendarstellungen

Abbildungen von Ausländern, bei denen es sich um Asiaten oder Libyer handelt, die durch ihre äußeren Merkmale sowie durch eventuell vorhandene Beischriften klar als solche identifizierbar sind, lassen sich in Beni Hassan konkret nur für drei Gräber belegen. Alle drei Gräber, BH 14, BH 2 und BH 3, sind anhand der genannten Königsnamen und der biographischen Inschriften sicher in die 12. Dynastie datierbar. Alle drei Grabinhaber sind, wie in ihren biographischen Inschriften berichtet, vom jeweiligen König in ihr Amt als Gaufürst des 16. oberägyptischen Gaues beziehungsweise als Bürgermeister von *Mnꜥt-Ḫwfw* eingesetzt worden.[63]

Bei der Suche nach einem Bildmotiv mit Vorbildfunktion für die Asiatengruppe *Ḫnm-ḥtp's II.* innerhalb der Galeriegräber von Beni Hassan können die Asiatendarstellungen als direkte Vorlage für diese Szene ausgeschlossen werden: In den Gräbern BH 14 und BH 2 figurieren sie einzig als Söldner innerhalb der an der Schlacht um die Festung beteiligten Truppen.

59 J. Garstang, The Burial Customs of Ancient Egypt as illustrated by Tombs of the Middle Kingdom. Being a Report of Excavations made in the Necropolis of Beni Hasan during 1902-3-4, London 1907, S. 139f., Abb. 138.

60 Für eine gute Abbildung vgl. W. S. Smith, The Art and Architecture of Ancient Egypt, revised by William Kelly Simpson, Yale 1998, S. 112, Abb. 201.

61 P. E. Newberry, Beni Hasan I, Taf. 13.

62 R. Gundlach, Die Zwangsumsiedlung, S. 168f.

63 W. Helck, Zur Verwaltung des Mittleren und Neuen Reiches, Leiden / Köln 1958, S. 208ff. Weitere Informationsquellen zu den einzelnen Persönlichkeiten: Zu *Ḫnm-ḥtp I.* vgl. L. M. Berman, Amenemhet I., S. 147ff.; zu *Jmnjj* vgl. M. Lichtheim, Ancient Egyptian Autobiographies Chiefly of the Middle Kingdom. A Study and an Anthology, OBO 84, Fribourg / Göttingen 1988, S. 137ff.; zu *Ḫnm-ḥtp II.* vgl. A. B. Lloyd, The Great Inscription of Khnumhotpe II at Beni Hasan, in: A. B. Lloyd (Hg.), Studies in Pharaonic Religion and Society in Honour of J. Gwyn Griffiths, EES 8, London 1992, S. 21ff.

Auch in Darstellungen außerhalb der Gräber von Beni Hassan sind Asiaten, mit Ausnahme eines aus dem Alten Reich stammenden Reliefs aus königlichem Kontext vom Aufweg des Pyramidentempels von Sahure in Abusir,[64] üblicherweise in Kampfszenen zu sehen.

4.2 Der Ursprung des Bildmotivs innerhalb der Libyerdarstellungen

Dagegen eignet sich der friedliche Zug von libyschen Viehhirten mit ihren Frauen und Kindern in BH 14 durchaus als Wegbereiter für die berühmte Szene aus BH 3. Zu dem starken familiären Bezug, den *Ḫnm-ḥtp II.* bereits in seiner biographischen Inschrift zwischen sich und seinem Großvater mütterlicherseits herstellt,[65] würde eine Übernahme bedeutungsintensiver Bildmotive aus dem Grab des hoch geschätzten Vorfahren durchaus passen.

Denn auch für *Ḫnm-ḥtp I.* mag bereits die Darstellung einer Gruppe in friedlicher Absicht kommender Viehhirten von großer Bedeutung gewesen sein: Hinter der Darstellung libyscher Viehhirten mit ihren Frauen und Kindern sowie einer Herde von Ziegen auf der Ostwand von BH 14 (vgl. Taf. 17b) verbirgt sich unter Umständen die Tatsache, dass *Ḫnm-ḥtp I.* im Rahmen der von Gundlach thematisierten Zwangsumsiedlung von Ausländern und ihrem Viehbestand »zum Zwecke der Wiedererschließung von Landstrichen, die möglicherweise während der Nachfolgekämpfe nach der Machtübernahme durch Amenemhet I. verwüstet worden sind …«,[66] tatsächlich eine Gruppe von Libyern nach Beni Hassan gebracht hat. Wie die Ringer- und Kampfszenen der zeitgleich bzw. etwas früher als BH 14 entstandenen Grabanlagen der Gaufürsten *Bꜣḳt III.* (BH 15) und *Ḫtj* (BH 17) zeigen, haben sich unter Umständen auch in Beni Hassan schwere Kampfhandlungen ereignet. Verluste unter der Bevölkerung sowie Versorgungslücken in der Land- und Viehwirtschaft sind daher nicht unwahrscheinlich. Die mitgebrachten Libyer dienten dem vom König zunächst als *ḥꜣtj-ꜥ n Mnꜥt-Ḫwfw* und außerdem als *mr smjwt jꜣbtwt*[67] eingesetzten *Ḫnm-ḥtp I.* vielleicht zunächst zur Festigung seiner eigenen Position neben jener der einheimischen Gaufürsten des 16. oberägyptischen Gaues.

Die Anlage BH 14 weist sowohl stilistisch als auch von der Auswahl und Ausführung des Dekorationsprogramms her große Nähe zu BH 15 auf,[68] was allein schon eine zeitlich nahe Datierung der beiden Anlagen notwendig erscheinen lässt. Sie ist in ihren Proportionen jedoch erheblich kleiner als BH 15 und als die nachfolgende Anlage BH 17. Bei den beiden letztgenannten Anlagen sprechen sowohl das Dekorationsprogramm, die Architektur und die Ausmaße wie auch die Titulatur der beiden Gaufürsten dafür, dass es sich um nahe aufeinander folgende, in ihren Rängen gleichwertige und mit ziemlicher Sicherheit eng verwandte lokale Machtinhaber gehandelt haben muss. So kann davon ausgegangen werden, dass *Ḫnm-ḥtp I.* bei seiner Ankunft in Beni Hassan vielleicht noch *Bꜣḳt III.*, sicherlich aber dessen Nachfolger *Ḫtj* als Regenten über den *Mꜣ-ḥḏ*-Gau antraf, der sich vor allem auf der westlichen Nilseite erstreckte.[69] *Ḫnm-ḥtp I.* selbst wurde von Amenemhet I. erst nachträglich –

64 P. Saretta, Egyptian Perceptions of West-Semites, S. 82, Anm. 206.

65 D. Franke, Altägyptische Verwandtschaftsbezeichnungen im Mittleren Reich, HÄS 3, Hamburg 1983, S. 335ff., zur Hervorhebung dieser Verwandtschaftsbeziehung durch *Ḫnm-ḥtp II.*

66 R. Gundlach, Die Zwangsumsiedlung, S. 169.

67 W. A. Ward, in: JEA 55 (1969), S. 44, Nr. 340. Er übersetzt »Overseer of the Desert«.

68 Vor Ort fand ich diese Aussage besonders durch die verwendeten Farben und die Darstellungsweise der Festungsszenen in den beiden Gräbern belegt.

69 D. Kessler, Historische Topographie der Region zwischen Mallawi und Salamut, TAVO 30, Wiesbaden 1981, S. 129ff.

eventuell nach dem Ableben des lokalen Gaufürsten – in den Stand eines *ḫrj-tp ꜥꜣ n Mꜣ-ḥḏ* erhoben, wie aus seiner biographischen Inschrift hervorgeht.[70]

Bei *Ḫnm-ḥtp I.* verbirgt sich hinter der Abbildung von friedlichen Libyern an so prominenter Stelle in seinem Grab möglicherweise der Wunsch nach Legitimation an der Seite der lokalen Herrscher des *Mꜣ-ḥḏ*-Gaus. Die Darstellung erweist sich als wichtige Ergänzung seiner biographischen Inschrift an der Westwand. Sein hoher militärischer Rang und seine militärischen Erfolge werden vielleicht noch dadurch unterstrichen, dass er von seinen Eroberungszügen Ausländer mitbringen kann. Ob dieses Ereignis auch in seiner biographischen Inschrift Erwähnung fand, lässt sich auf Grund des besonders schlechten Erhaltungszustands der Westwand des Grabes heute nicht mehr sagen.[71] Andererseits war dieser Umstand des Mitbringens von Siedlern und Vieh, der auf praktische Weise *Ḫnm-ḥtp's I.* Position als vom neuen König eingesetzter Beamter zwischen lokalen Herrschern untermauerte, es ihm unbedingt wert, in bleibender (bildlicher) Form erinnert zu werden.

4.3 Ursache für die Wahl des Bildmotivs

Was für die Darstellung einer Gruppe von Libyern im Grab des Großvaters gegolten haben mag, ist erst recht für das Grab des Enkels aussagekräftig. Das Motiv einer Gruppe von friedlichen Ausländern im Grabe *Ḫnm-ḥtp's II.*, bei denen es sich, dem aktuellen Zeitgeschehen entsprechend, um Asiaten handelt, ist daher sowohl als Legitimation wie auch als bildmotivliche Ergänzung zu seiner biographischen Inschrift zu verstehen.[72] Bereits aus den Beischriften zur Szene ergibt sich ein biographischer Kontext, der gleichzeitig den – wohl ältesten[73] – Sohn des Grabherrn involviert. Dieser ebenfalls *Ḫnm-ḥtp* genannte Sohn machte am Königshof erst unter Sesostris II. und dann unter Sesostris III. eine große Karriere.[74] In militärischer Funktion war er sehr viel mit Auslandsmissionen befasst, und unter Sesostris III. gelang ihm ein beachtlicher Aufstieg, so dass er sich schließlich seine eigene Mastaba in unmittelbarer Nähe der Grabanlage dieses Königs in Dahschur errichten durfte.[75] Die Darstellung betont darüber hinaus die Nähe und Verbundenheit der Familie *Ḫnm-ḥtp's II.* zum Königshaus der 12. Dynastie, auf dessen Aufstieg und Macht der Erfolg seines eigenen Familiengeschlechts beruht.[76] Diese Nähe und Loyalität zum Königshaus wird bereits in der biographischen Inschrift konkret. Aber auch die tatsächliche Erwähnung des herrschenden Königs auf der Nordwand (vgl. Taf. 17a) und die Darstellung von dem Königshof nahe stehenden Personen betonen noch einmal diese Verbindung. In erster Linie handelt es sich dabei um den Sohn des

70 L. M. Berman, Amenemhet I., S. 151ff.

71 An dieser Stelle sei noch einmal auf den schlechten Erhaltungszustand der biographischen Inschrift hingewiesen. Bereits Newberrys Dokumentation weist hier große Lücken auf. Vgl. P. E. Newberry, Beni Hasan I, Taf. 44.

72 A. V. Baines, The Function of Iconography as Autobiographical Narration in the Tomb of Khnemhotep at Beni Hasan (Tomb 3), in: JNSL 21/2 (1995), S. 1ff.

73 Vgl. dazu P. E. Newberry, Beni Hasan I, Taf. 30; die Beischrift zur Großdarstellung des Grabherrn auf derselben Wand. In der letzten Kolumne wird sein Sohn genannt als »Sohn des Fürsten, großer Sohn, den der König befördert hat«; zur Übersetzung vgl. im Zettelarchiv des Wörterbuchs DZA 29485960.

74 D. Franke, The Career of Khnumhotep III., S. 51ff.

75 Vgl. dazu besonders die neuesten Funde bei D. Arnold, in: EA 21 (2002); D. Arnold, in: AW 33/6 (2002).

76 Eine Tatsache, die er in seiner biographischen Inschrift gar nicht oft genug betonen kann. Dazu G. Dantong, The Inscription of Khnumhotpe II. A New Study, in: JACiv 10 (1995), S. 55ff.; ebenso die Übersetzung von A. B. Lloyd, The Great Inscription, S. 21ff.

Grabherrn, *Ḫnm-ḥtp*. Aber auch der *sš ꜥn nsw Nfr-ḥtp*, der königliche Urkundenschreiber, der stets den Bezug zum Königshof verdeutlicht, weist durch sein Amt darauf hin, dass die bild-lich-inschriftlichen Zusammenhänge der Nordwand nicht nur auf einen eng begrenzten loka-len Bereich Bezug nehmen, sondern durchaus übergeordnet zu verstehen sind.[77] Wie bereits sein Großvater, welcher dem Großvater des jetzigen Herrschers Sesostris II. so viel zu ver-danken hatte, hält in Beni Hassan nun *Ḫnm-ḥtp II.*, der Enkel des unter Amenemhet I. so er-folgreichen *Ḫnm-ḥtp I.*, die Familientradition aufrecht.

Die Wahl des Bildmotivs einer friedlichen Ausländergruppe – aus aktuellem Zusammen-hang in BH 3 als Gruppe von Asiaten wiedergegeben – stellt somit einen bildlichen Rückgriff auf den erfolgreichen Großvater mütterlicherseits, *Ḫnm-ḥtp I.*, dar. Sie legitimiert den Enkel *Ḫnm-ḥtp II.* in seinem Amt in Beni Hassan, indem sie auf die bereits vom seinem Großvater an diesem Ort ausgeübte Herrschaft verweist und somit die Tradition betont, in welcher *Ḫnm-ḥtp II.* steht. Gleichzeitig dokumentiert *Ḫnm-ḥtp II.* mittels dieser Darstellung wie auch im Gesamtkontext der Nordwanddekoration des Grabes die Nähe seiner Familie zum Königshaus der 12. Dynastie. Es handelt sich um eine Tradition, die von seinem ältesten Sohn *Ḫnm-ḥtp* bereits erfolgreich weitergeführt wird. Durch diese raffinierte bildmotivliche Retrospektive werden die Leitlinien der biographischen Inschrift *Ḫnm-ḥtp*'s *II.* hier auf spektakuläre Weise nochmals subsumiert.

77 So auch D. Kessler, in: SAK 14 (1987), S. 152f.

Regine Schulz

Musikanten und Brettspieler

Gedanken zur Bild- und Textanalyse eines bekannten Reliefs

In der Ägyptischen Abteilung des Walters Art Museums befinden sich mehrere spätzeitliche Relieffragmente, die aus einem bislang noch nicht lokalisierten Grab des ꜥnḫ=f-n-Sḫm.t stammen. Diese Fragmente gehören mit einer Ausnahme[1] zu einem Türsturz, der hier näher betrachtet werden soll (Taf. 18a). Obwohl die Szenen dieses Reliefs wegen ihrer attraktiven Darstellungen von Musikanten und Brettspielern, und wegen des Rückgriffs auf Ikone und Motive des Alten Reiches schon häufiger angesprochen wurden, sollen sie hier noch einmal genauer behandelt werden. Grund dafür ist, dass bislang keine zusammenhängende Bild- und Textanalyse vorliegt,[2] und einige der bislang angestellten Überlegungen überdacht werden müssen. Folgende Fragen stellen sich: Wer war ꜥnḫ=f-n-Sḫm.t? Wann und wo wurde das Relief hergestellt, und wann die Sekundärbeischriften? Warum wurden Bilder und Motive des Alten Reiches verwendet, und warum war es notwendig, sie zu modifizieren? Warum wurden die Motive auf einem Türsturz und nicht wie sonst üblich auf einer Grabwand angebracht? Welche Idee steht hinter dieser bislang einmaligen Konzeption?

Im Rahmen der folgenden Analyse wird deutlich zwischen der Interpretation von Bild/Text, von vermitteltem Thema und übergreifendem Programm unterschieden. Die Bedeutung von Bild und Thema kann, muss aber nicht in allen Aspekten deckungsgleich sein. Als Bedeutungsträger werden nicht nur die Bild- und Textikone sondern auch die Komposition verstanden, das heißt nicht nur die Anordnung von Bild- und Textelementen, sondern auch die Trennung oder Verbindung von Szenen auf direkte oder indirekte Weise. Weiterhin werden Begriffe wie »Bildelement« und »Szene« in Zusammenhang mit der formalen Bestimmung des Bildes verwendet, »Ikon« und »Motiv« dagegen in Verbindung mit den Bedeutungsebenen.

1. Objektinformationen

1.1 Standort

Baltimore, Walters Art Museum 22.152 (Fragmente I–III, vgl. Abb. 1); I ehemals Seattle Art Museum Eg. 11.6.); 22.153 (Fragmente IV–VI, vgl. Abb. 1; bei Ankunft im Museum 1931 wurde die Nummer 22.88 vergeben, und 1934 nach der Zusammenführung mit 22.152 in 22.153 geändert).

1 Das Wandfragment 22.38.

2 Eine ausführlichere Analyse findet sich in der hervorragenden Dissertation von Lisa Montagno Leahy »Private Tomb Reliefs of the Late Period from Lower Egypt« von 1988, Queen's College, Oxford, deren bildformalistische Zielsetzung sich jedoch von der hier vorgenommenen unterscheidet.

Die Erwerbungsgeschichte stellt sich folgendermaßen dar: Die Fragmente 22.152 (II–III) und 22.153 wurden 1930 und 1931 für Henry Walters durch den Kunsthändler Dikran Kelekian von dem ägyptischen Kunsthändler Khawam in Kairo erworben. Das Reliefbruchstück 22.152 (I) ging zunächst ans Seattle Art Museum (Eg. 11.6) und wurde 1957 nach Entdeckung der Zusammengehörigkeit der Fragmente der Walters Art Gallery[3] übergeben.

1.2 Material

Sehr feiner, heller Kalkstein mit kleineren Farbunregelmäßigkeiten; es haben sich wenige Spuren roter und schwarzer Farbpigmente erhalten.

1.3 Technik

Erhabenes, sehr flach gearbeitetes Relief, ursprünglich bemalt; die später hinzugefügten Sekundärbeischriften wurden eingetieft.

1.4 Maße

22.152 rechts (I):	H. 21 cm, Br. 31 cm.
22.152 links (II–III):	H. 23 cm, Br. 110 cm.
22.153 (IV–VI):	H. 18,5 cm, Br. 142 cm.
Umlaufende Rahmung:	H. oben: min. 3,5 cm;
	Br. Seiten: max. 5,2 cm.
Rekonstruierte Maße:	H. ca. 48 cm, Br. ca. 144 cm (Verhältnis 1:3);
	ohne Rahmung H. ca. 6 Handbreit, Br. 18 Handbreit.

1.5 Herkunft

Der Türsturz und das zu demselben Grab gehörige, heute ebenfalls in Baltimore befindliche Wandfragment 22.38 stammen höchst wahrscheinlich aus dem memphitischen Raum. Grund für diese Annahme sind sowohl die mit Sachmet und Ptah verbundenen Priestertitel des Grabherrn, als auch des *P3-ḥm-nṯr* (Vater/Großvater der in den Sekundärbeischriften genannten Personen). Darüber hinaus stammen weitere Familienmitglieder des *ꜥnḫ=f-n-Sḫm.t*, die auf anderen Denkmälern genannt sind, ebenfalls aus Memphis (s. Datierung).

1.6 Datierung

Spätzeit, 26. Dynastie, Zeit des Amasis bis Psammetichs III., um 550–525 v. Chr.; Sekundärbeischriften 27. Dynastie, Zeit Darius' I.–Artaxerxes' I., um 500–450 v. Chr.

3 Der Name der Institution wurde 2001 in Walters Art Museum geändert.

Die Datierung des Reliefs basiert nicht nur auf stilistischen Kriterien,[4] sondern auch auf möglichen familiären Beziehungen zu Personen, die auf anderen Objekten, vor allem einem sicher datierten Denkmal erwähnt werden:[5]

– Baltimore 22.152/22.153 nennt den *ḥm nṯr Sḫm.t n.t tꜣ šnḏ.t* namens *ꜥnḫ⸗f-n-Sḫm.t*.
– Baltimore 22.28 (Wandfragment) gehört dem gleichen *ꜥnḫ⸗f-n-Sḫm.t*, der hier aber eine ausführlichere Titulatur besitzt: *ḥm nṯr Ptḥ ḥm nṯr Sḫm.t n.t tꜣ šnḏ.t*. Genannt werden außerdem seine Frau *Ḥw.t-Ḥr-m-ḥꜣ.t* und seine Tochter *Tꜣ(-n.t)-Nfr-tm*.
– Paris, Louvre IM 4111 (Serapeumsstele aus dem Jahr 34 Darius' I. = 488 v. Chr.) verzeichnet als Stifter einen *jt nṯr sm ḥrj sštꜣ n Rꜥ-stꜣ.w wꜥb m ḥw.wt nṯr.w Jnb-ḥḏ ꜥnḫ⸗f-n-Sḫm.t* und nennt auch dessen Vater *sꜣ ḥm nṯr sš mḥꜣ.t n pr Ptḥ sš ḫtm.w nṯr jmj-rꜣ wꜥb Sḫm.t n pr Ptḥ m ḥw.wt nṯr.w Jnb-ḥḏ ... Nfr-sšm-Psmṯk*, dessen Mutter *Tꜣ(-n.t)-Nfr-tm*, sowie den Vater der Mutter, den *jt nṯr ḥm nṯr Sḫm.t n.t tꜣ šnḏ.t* namens *ꜥnḫ⸗f-n-Sḫm.t*.
– Rom, Museo Nazionale d'Arte Orientale 115259 (Statue) verzeichnet als Inhaber den *jt nṯr wꜥb (n) ḥw.wt nṯr.w Jnb-ḥḏ ḥrj sštꜣ n pr Ptḥ Nfr-sšm-Psmṯk* und nennt auch dessen Sohn *ꜥnḫ⸗f-n-Sḫm.t*, einen *jrj pꜥ.t jt nṯr mrj nṯr sm wꜥb n ḥw.wt nṯr.w Jnb-ḥḏ ḥrj sštꜣ n pr Ptḥ sm ḥm Ptḥ*.

Daraus könnte sich die folgende Konstellation ergeben:

Nfr-sšm-Psmṯk (I.)[6] hatte einen Sohn namens *ꜥnḫ⸗f-n-Sḫm.t* (I.), dessen Tochter *Tꜣ-(n.t)-Nfr-tm* mit einem weiteren *Nfr-sšm-Psmṯk* (II.)[7] verheiratet war. Der Sohn der beiden wurde nach dem Großvater *ꜥnḫ⸗f-n-Sḫm.t* benannt. Dieser *ꜥnḫ⸗f-n-Sḫm.t* (II.) lebte zur Zeit Darius' I. (ca. 500–475 v. Chr.), seine Eltern am Ende der 26. und zu Beginn der 27. Dynastie (ca. 525–500 v. Chr.) und sein Großvater *ꜥnḫ⸗f-n-Sḫm.t* (I.) zur Zeit der 26. Dynastie, wohl unter Amasis (ca. 550–525 v. Chr.).

Betrachtet man die Sekundärbeischriften genauer und geht davon aus, dass die dort genannten Personen in einem verwandtschaftlichen Verhältnis zu *ꜥnḫ⸗f-n-Sḫm.t* (I.) standen, worauf zumindest die Beischrift des Mannes mit der Lotosblüte verweist, die ihn als »Enkel« bezeichnet, so ließe sich zumindest hypothetisch auch die Genealogie der jüngeren Generation rekonstruieren: *ꜥnḫ⸗f-n-Sḫm.t* (I.) könnte der Vater des *Pꜣ-ḥm-nṯr* gewesen sein, und der Großvater von *ꜥnḫ⸗f-n-Sḫm.t* (II.) und *Ptḥ-nfr* (Sohn des *Pꜣ-ḥm-nṯr*) sowie einer Enkelin *Sꜣ.t-Nbw* (Tochter des *Pꜣ-ḥm-nṯr*). Die Enkelin *Sꜣ.t-Nbw* ist mit *Jrj-ḥkꜣ-ꜥꜣ* verheiratet und hat einen Sohn namens *ꜥnḫ-wn-nfr*, der somit der Urenkel von *ꜥnḫ⸗f-n-Sḫm.t* (I.) wäre. Demzufolge würden die Sekundärbeischriften folgende Personen benennen: Mann mit Lotosblüte: der Enkel *ꜥnḫ⸗f-n-Sḫm.t* (II.); Mann am *mdw*-Stab: der Sohn *Pꜣ-ḥm-nṯr*; der linke *sn.t*-Spieler: der Urenkel *ꜥnḫ-wn-nfr*; der rechte *sn.t*-Spieler: *Ptḥ-nfr* (Sohn des *Pꜣ-ḥm-nṯr* und Onkel von *ꜥnḫ-*

4 B. V. Bothmer (Hg.), Egyptian Sculpture of the Late Period 700 B. C. to A. D. 100, Brooklyn 1960, S. 110 datiert die Reliefs auf Grund stilistischer Erwägungen in die Mitte der 27. Dynastie. Zur Problematik der stilistischen Datierung von Reliefs der 27. Dynastie vgl. L. Montagno Leahy, Private Tomb Reliefs, S. 51ff.

5 Zur Diskussion und zu weiter greifenden familiären Beziehungen vgl. J. Malek, Imset (I) and Hepi (H) canopic-jars of Neferseshem-psammethek, in: JEA 64 (1978), S. 138ff. und L. Montagno Leahy, Private Tomb Reliefs, S. 39ff.; zu Paris, Louvre IM 4111 vgl. F. von Känel, Les prêtres-wouâb de Sekhmet et les conjurateurs de Serket, BEHE 87, Paris 1984, S. 138ff.; zu Rom, Museo Nazionale d'Arte Orientale 115259 vgl. L. Limme, Un nouveau document memphite, in: F. Geus / F. Thill (Hg.), Mélanges offerts à Jean Vercoutter, Paris 1985, S. 205ff.

6 Bei J. Malek, in: JEA 64 (1978), S. 138ff.; L. Montagno Leahy, Private Tomb Reliefs, S. 39ff. als *Nfr-sšm-Psmṯk* B des weiter greifenden Familienverbundes bezeichnet.

7 Bei J. Malek, in: JEA 64 (1978), S. 138ff.; L. Montagno Leahy, Private Tomb Reliefs, S. 39ff. als *Nfr-sšm-Psmṯk* C verzeichnet.

wn-nfr). *Pꜣ-ḥm-nṯr* wäre gleichzeitig anzusetzen wie *Nfr-sšm-Psmṯk* (II.) und *Šsmt.t*, d. h. Ende der 26./Anfang der 27. Dynastie (ca. 525–500 v. Chr.), *Ꜥnḫ=f-n-Sḫm.t* (II.), *Ptḥ-nfr* und *Sꜣ.t-Nbw* zur Zeit Darius' I. (ca. 500–475 v. Chr.) und *Ꜥnḫ-wn-nfr* zur Zeit Xerxes' I. – Artaxerxes' I. (ca. 475–450 v. Chr.)

Der ältere *Ꜥnḫ=f-n-Sḫm.t* (I.) wäre somit der Inhaber des Grabes zu dem die Blöcke im Walters Art Museum gehören und das Grab wäre in der Zeit des Amasis zwischen 550–525 v. Chr. entstanden. Sein Enkel, der jüngere *Ꜥnḫ=f-n-Sḫm.t* (II.), könnte demzufolge für die Sekundärbeischriften verantwortlich sein, die dann in der Zeit zwischen 500–475 v. Chr. entstanden wären, oder sein Urenkel *Ꜥnḫ-wn-nfr* zwischen 475–450 v. Chr.

1.7 Erhaltungszustand

Das Relief, das in ein Haupt- und zwei Unterregister unterteilt ist, besteht heute aus sechs Fragmenten; oben: I, II–III und unten: VI–V–IV (Abb. 1). Während die Fragmente II–III sowie IV–VI passende Bruchkanten aufwiesen und direkt aneinander gefügt werden konnten, befinden sich zwischen I und II, sowie zwischen dem gesamten oberen (22.152) und unteren Teil (22.153) des Bildfelds breite Fehlstellen. Diese massiven Brüche, die weite Teile des Bildfeldes zerstört haben, dürften durch den Versuch entstanden sein, einzelne Szenen aus der Wandverbund herauszuschneiden. Kleinere Risse und Beschädigungen der Oberfläche sind auf allen Fragmenten zu vermerken. Darüber hinaus sind vor und während der ersten Zusammensetzungsarbeiten auch einige Kleinfragmente an den Rändern verloren gegangen oder mit Füllmasse überdeckt worden. Die ehemalige Bemalung ist weitgehend geschwunden. Wenige Partikel roter und schwarzer Farbe sind nur noch unter dem Mikroskop zu erkennen. Die Fragmente II und III mussten wegen starker Salzausblühungen vor dem Zusammensetzen im Walters Art Museum gewässert werden, was die Oberflächenstruktur stark beeinträchtigt hat (Taf. 18, 19).[8] Der umlaufende Steg wurde nach der Entfernung aus dem Grab, wohl wegen zahlreicher Beschädigungen, geglättet und zurechtgeschnitten. Wenige leicht vorkragende Stellen im oberen Bruchkantenverlauf der Fragmente II und III verweisen darauf, dass sich über dem Block ursprünglich ein Rundstab befunden hat.[9]

Abbildung 1: Die Fragmente des Reliefs 22.152/153 im Walters Art Museum, Baltimore

8 Ein Archivfoto, das vor 1934 im Walters Art Museum gemacht wurde, zeigt insbesondere bei den Musikantenszenen noch zahlreiche Details, die später der Wässerung zum Opfer fielen (Taf. 19a).

9 Hierauf hat schon D. Kent Hill, Notes on some Neo-Memphite Reliefs, in: JWAG 19–20 (1956/57), S. 39f. verwiesen.

1.8 Restaurierungen

Um 1932/33 Entsalzung der Fragmente II und III durch Wässerung; nach 1934 Zusammensetzung von II–III und IV–VI sowie Auffüllung der Fehlstellen unter Anleitung von Jean Capart;[10] nach 1957 Hinzufügung des zusätzlichen Fragments ex Seattle Eg. 11.6; 1967 verbesserte Auffüllung der Fehlstellen; 2001 Reinigung und Farbangleichung der aufgefüllten Stellen (vgl. Taf. 18 und 19).

1.9 Veröffentlichungen und Erwähnungen

Jacques Pirenne, Histoire des institutions et du droit privé de l'Ancienne Égypte, Bd. 3, Brüssel 1935, Taf. 48; Jean Capart, A Neo-memphite Bas-relief, in: JWAG 1 (1938), S. 15–17; Stephen Luce, in: AJA 44 (1940), S. 363; Georg Steindorff, Catalogue of the Egyptian Sculpture in the Walters Art Gallery, Baltimore 1946, S. 80–81, Nr. 274, Taf. LIV; Handbook. Seattle Art Museum, 1951, S. 9 mit Abb.; Dorothy Kent Hill, The Egyptian Game of Senaït, in: BWAG 3/5 (Feb. 1951), S. 4; Pierre Montet, Le jeu du serpent, in: CdE 30 (1955), S. 192–193, Abb. 6; Dorothy Kent Hill, Notes on Some Neo-Memphite Reliefs, in: JWAG 19–20 (1956/57), S. 35–41; Dorothy Kent Hill, Chairs and Tables ot the Ancient Egyptians, in: Archaeology 11 (1958), S. 278; Bernhard V. Bothmer (Hg.), Egyptian Sculpture of the Late Period 700 B. C. to A. D. 100, Brooklyn 1960, S. 110, 112, 114; Jacques Vandier, Manuel d'archéologie égyptienne, Bd. IV, Paris 1964, 489, Abb. 262; Lisa Montagno Leahy, A Saïte Lintel Reunited, in: JEA 71 (1985), S. 126, no. 22; Peter Munro, Review: Bothmer. Egyptian Scupture of the Late Period, in: BiOr 27, 3/4 (1970), S. 203; Lise Manniche, Ancient Egyptian Musical Instruments, MÄS 34, München 1975, 45; Edgar B. Pusch, Das Senet-Brettspiel im Alten Ägypten, Teil 1, MÄS 38, München 1979, S. 141–144; Lisa Montagno Leahy, Private Tomb Reliefs of the Late Period from Lower Egypt, Dissertation, Oxford, Queen's College 1988, S. 598–606; Wolfgang Deckers und Michael Herb, Bildatlas zum Sport im Alten Ägypten, HdO 1, Abt. Bd. 14, Leiden / New York / Köln 1994, S. 637f., Q 1.10, Taf. CCCLVII und S. 661f., Q 3.48; Christian Leitz, Lexikon der Ägyptischen Götter und Götterbezeichnungen, Bd. VI, OLA 115, Leuven / Paris / Dudley 2002, S. 567.

2. Szenenüberblick

Die sechs Großfragmente gehören zu einem abgeschlossenen Bildfeld, das von einem breiten, erhabenen Steg umschlossen wird, der unten und an den Seiten etwas breiter, oben etwas schmaler gestaltet ist. Den oberen Abschluss bildete wahrscheinlich der bereits erwähnte Rundstab und eine darüber liegende Hohlkehle.[11]

Auf der rechten Seite ist der auf einem Stuhl sitzende, nach links orientierte Grabherr dar-

10 Jean Capart war es bei einem Besuch in der Walters Art Gallery als Erstem gelungen, die Zusammengehörigkeit von 22.252 und ehemals 22.88 festzustellen.

11 Ein gutes Beispiel für ein Grabrelief, das eine vergleichbar breite Rahmung besitzt und einen oberen Abschluss mit Rundstab und Hohlkehle, ist das des *Pꜣ-dj-[Wsjr///]*, Walters Art Museum 22.97 aus der Mitte des 4. Jh. v. Chr. (vgl. B. V. Bothmer [Hg.], Egyptian Sculpture, S. 109f., Taf. 82–3; L. Montagno Leahy, Private Tomb Reliefs, S. 706ff.).

gestellt und vor ihm, in zwei Unterregistern, Musikanten (oben) und Brettspieler (unten). Unmittelbar vor dem Grabherrn ist zu Beginn jedes der beiden Unterregister eine weitere Figur abgebildet, die in direktem Kontakt zum Grabherrn steht.

Das Bildfeld lässt sich in einzelne Szenen mit verschiedenen Personengruppen unterteilen, die durch Bild- und/oder Textelemente voneinander getrennt sind. Trotzdem bilden diese Szenen übergreifende Einheiten, die in der Platzierung und Ausrichtung, der Haltung und den Gesten der Figuren zum Ausdruck kommt. Die Abfolge der Szenen ist im oberen Register von rechts nach links, im unteren von links nach rechts angelegt, und muss wahrscheinlich als zweidimensionale Umsetzung einer räumlichen Anordnung aufgefasst werden (Abb. 2). Dabei würden die Instrumentalisten rechts, die Sänger/Cheironomen und *sn.t*-Spieler gegenüber und die *tз.w*-Spieler mit dem *mḥn*-Spielbrett links vom Grabherrn sitzen. Bei einer solchen Verteilung wären jeweils fünf Personen an jeder Seite platziert, wobei es sich um je zwei Paare und eine Einzelperson handeln würde. Diesen Einzelpersonen (Figuren 2, 3 und 8) käme somit eine besondere Rolle zu, die bei den Figuren 2 und 3 wegen ihrer direkten Kontaktaufnahme zum Grabherrn offenkundig ist, bei Figur 8 aber nur aus ihrer Platzierung, Ausrichtung und ihrem Kontext entnommen werden kann. Alle übrigen Figuren sind einander paarweise zugeordnet, wobei es sich um drei Musiker/Cheironomenpaare und um drei Spielerpaare handelt.

(Orientierung des Körpers: –>; abweichende Blickrichtung: >
abweichende Armhaltung: =>; Figuren: **Zahlen** (standard)
Themen: **Großbuchstaben mit und ohne Zahlen** (fett)
Nebenthemen: **Kleinbuchstaben**)

Abbildung 2: Szenenverteilung im imaginären Raumgefüge mit Ausrichtung der Figuren

3. Themen, Motive und Ikone der einzelnen Szenen und Bildelemente

3.1 Thema A

Themenbestimmung: Regenerationswunsch und Ritualgarantie für den Grabherrn.
Bildliche Umsetzung: Zwei Ritualisten agieren vor dem sitzenden Grabherrn.
Lokalisierung: Fragmente I und IV; Hauptregister und Anfang der beiden Subregister.
Die Hauptfigur in dieser Doppelszene, die zwei aus dem Alten Reich gut bekannte Motive miteinander kombiniert, ist der sitzende Grabherr, dessen thronartiger Stuhl auf einem Podest steht. Sein Bild füllt das gesamte Hauptregister, die beiden anderen Figuren befinden sich in den Subregistern davor.

Im oberen der beiden Motive geht es um den Regenerationswunsch für den Verstorbenen, der bildlich durch das Überreichen einer Lotosblüte zum Ausdruck gebracht wird.[12]

Das untere Motiv beinhaltet die Ritualgarantie für den Verstorbenen durch seinen Nachfolger. Die bildliche Umsetzung zeigt den Grabherrn mit *mdw*-Stab in der Hand und im unteren Register davor seinen in kleinerem Maßstab dargestellten Sohn, der das untere Ende des Stabes umfasst.[13] Keine der beiden vor dem Grabherrn befindlichen Figuren scheint ursprünglich durch eine Inschrift individualisiert worden zu sein, da bei Rekonstruktion aller zerstörten Bild- und Textelemente kein Platz für zusätzliche Beischriften im Maßstab der übrigen Primärinschriften verbleibt. Die kanonische Bildtradition weist diese Personen jedoch als Angehörige des Grabherrn aus. Während die obere Szene als gut bekanntes Standardmotiv des Alten Reiches gewertet werden kann, zeigt die untere eine seltene Motivvariante, in welcher der auf dem Boden hockende Sohn seinen Oberkörper zurück zum Grabherrn wendet.[14]

3.1.1. Figur 1: Der Grabinhaber (Fragmente I und IV, Hauptregister)

– Erhaltungszustand: Nur Oberkörper und Unterschenkel erhalten; zahlreiche kleinere Beschädigungen im gesamten Bildfeld; der zentrale Bruch trennt Fragment I und IV.
– Haltung: Aufrecht sitzend, nach links orientiert; rechter Fuß leicht vorgeschoben; Arme angewinkelt, rechte Hand erhoben, linke ruht auf der Seitenlehne des Stuhles.
– Tracht: Schulterlange, ungeteilte Perücke mit freien Ohren; Halskragen.
– Attribute: *mdw*-Stab in der rechten Hand, dessen unteres Ende vor den Füßen des Grabherrn aufgestützt ist.
– Zusätzliche Bildelemente: Stuhl mit »Rinderbeinen« und hoher Seitenlehne[15] auf einem niedrigen Podest.
– Inschrift: Einzeilig, rechtsläufig in erhabenem Relief; erstreckt sich wie eine Überschrift über das gesamte Bildfeld der Fragmente I–III.
 (→) *m33 shm-jb m hs.t n k3=k rᶜ nb m hᶜb mhn m sn.t m t3.w [hm ntr] Shm.t n.t t3 šnd.t.*[16]

12 Zur Kombination diese Motivs mit Musikanten- und/oder Brettspielszenen in Gräbern des Alten Reiches z. B. Giza G 6010 und G 6020 (vgl. K. R. Weeks, Mastabas of Cemetery G 600, Giza Mastabas 5, Boston 1994, Taf. 20 und 43), G 2086 und G 2091 (vgl. A. M. Roth, A Cemetery of Palace Attendants, Giza Mastabas 6, Boston 1995, Taf. 140 und 163), G 4761, G 5170, G 5340 (vgl. R. Pérez Arroyo, Music in the Age of the Pyramids, Madrid 2003, S. 278, 281und 286).

13 In fast allen Belegen aus dem Alten Reich handelt es sich um die Darstellung des Sohnes des Verstorbenen, nur ganz wenige Beispiele zeigen die Tochter, z. B. in G 2150 (vgl. G. A. Reisner, A History of the Giza Necropolis 1, Cambridge 1942, Abb. 258).

14 In den meisten vergleichbaren Szenen orientiert sich die Ausrichtung des Sohnes an der des Vaters, oder der Sohn tritt auf den Vater zu; die hier gewählte Variante verbindet beide Möglichkeiten miteinander.

15 Der Typus des Stuhles mit hoher Seitenlehne entspricht Vorbildern aus dem Alten Reich. Diese zeigen jedoch außerdem eine hohe Rückenlehne, die hier nicht abgebildet ist und wahrscheinlich als vom Kopf und Rücken des Grabherrn verdeckt verstanden wurde; z. B. in Giza, G 4561 (vgl. N. Kanawati, Tombs at Giza 1, ACER 16, Warminster 2001, Taf. 32 und 33), in G 5340, G 4761 und G 5170 (vgl. R. Pérez Arroyo, Music, S. 278, 281 und 286). Alle genannten Beispiele zeigen Musiker- und/oder Brettspielszenen vor dem Grabherrn. Im Unterschied zu den Beispielen aus dem Alten Reich hält ᶜnh=f-n-Shm.t hier keinen Wedel in der Hand; seine linke ruht ohne zusätzliches Attribut auf der Lehne des Stuhles, dafür hält seine rechte den *mdw*-Stab.

16 Erwähnt bei C. Leitz (Hg.), Lexikon der Ägyptischen Götter und Götterbezeichnungen VI (X-s), OLA 115, Leuven / Paris / Dudley 2002, S. 567.

»Sieh und erfreue (Dich) am Gesang für Deinen Ka täglich, (sowie) am *mḥn*-Brettspiel, am *sn.t*-Brettspiel (und) am *ṯ3.w*-Spiel, (Du) [Priester[17] der Sa]chmet (von) der Dornakazie *ᶜnḫ=f-n-Sḫm.t*.«

3.1.2. Figur 2: Männlicher Verwandter des Grabherrn mit Lotosblüte
 (Fragment I, oberes Subregister).

– Erhaltungszustand: Der größte Teil des Körpers ist zerstört, nur Gesicht, linke Schulter und rechter Arm erhalten. Der untere Teil der Sekundärbeischrift ist verloren.
– Haltung: Stehend;[18] nach rechts orientiert; rechter, leicht angewinkelter Arm zum Gesicht des Grabherrn vorgestreckt, die Hand umfasst den Stiel einer Lotospflanze[19] unterhalb der Blüte, die linke Hand umfasste wahrscheinlich das Ende des Pflanzenstiels.[20]
– Tracht: Kurzhaarfrisur.
– Attribute: Lotospflanze.
– Sekundärbeischrift: Die Schriftzeichen wurden später hinzugefügt; sie sind kleiner als die übrigen Inschriften und vertieft ausgeführt. Sie befinden sich vor Gesicht und Oberkörper der Figur.
 (←) *s3 n s3=f smsw* (↓) ⸢*mrj*⸣ *[=f]* ///
 »Sohn seines ältesten, [seines] geliebten Sohnes ///.« Wahrscheinlich ist hier der Name des *ᶜnḫ=f-n-Sḫm.t* (II.) zu ergänzen (s. u.).

3.1.3. Figur 3: Der Sohn (?) des Grabherrn umfasst dessen *mdw*-Stab
 (Fragment V, unteres Subregister).

– Erhaltungszustand: Partielle Zerstörung des linken Unterarmes; zahlreiche kleine Beschädigungen im gesamten Körperbereich.[21] Sekundärbeischrift weitgehend verloren.
– Haltung: Ungleichmäßige Hockhaltung mit aufgestelltem rechten Knie; Unterkörper nach links orientiert, Oberkörper frontal, Kopf nach rechts zum Grabherrn zurückgewandt; Gesicht leicht erhoben; beide Arme angewinkelt, die rechte Hand ruht auf dem linken Knie, die linke umfasst den Stab des Grabherrn.
– Tracht: Kurzschurz;[22] Kurzhaarfrisur.

17 Die Fehlstelle zwischen den Fragmenten I und II weist genügend Platz für den zu ergänzenden Priestertitel auf.

18 Im Vergleich zu den Darstellungen der am Boden hockenden Musikanten, deren Körper die Hälfte der rekonstruierten Registerhöhe einnehmen, kann für die Figur dieses Mannes, die zwei Drittel des Registers ausgefüllt haben muss, nur eine Standhaltung ergänzt werden.

19 Zu Beispielen aus dem Alten Reich vgl. R. Pérez Arroyo, Music, S. 278, 281 und 286.

20 Auf dem bereits angesprochenen Archivfoto, das die Fragmente II und III zeigt (Taf. 19a), sind vor dem Gefäß **a** noch wenige Bildreste zu erkennen, die zur Darstellung des Mannes mit der Lotosblüte gehört haben könnten. Möglicherweise handelt es sich um seine zur Faust geballte linke Hand mit dem Ende des Lotosblütenstengels.

21 Auf einem weiteren Archivfoto, das ebenfalls vor den Restaurierungsmaßnahmen Anfang der 30er Jahre aufgenommen wurde, sind noch größere Teile des Unterarmes erhalten (Taf. 19b).

22 Der Kurzschurz aller hockenden Figuren ist gleich dargestellt; er wird durch vertiefte Linien über den Hüften und Knien definiert. Die obere Schurzkante ist im Rücken weit hochgezogen, vorne dagegen unter den leicht vortretenden Bauch geschoben, wodurch ein steiler Anstiegswinkel an den Seiten entsteht.

– Sekundärbeischrift: Auch hier wurde später eine Inschriftkolumne hinzugefügt, die heute aber weitgehend zerstört ist (vgl. Taf. 19b).

(\downarrow) ⌐n=¬ f [23]

3.1.4 Objekt a (Nebenthema)

Themenbestimmung: Versorgung des Grabherrn mit Öl/Salbe und Stoffen (?).
Bildliche Umsetzung: Alabastergefäß und Stoffstreifen.
Lokalisierung: Fragment II, oberes Subregister.
Hinter der Darstellung des Ritualisten mit Lotosblüte ist das Oberteil eines hohen Gefäßes mit flachem Deckel erkennbar, von dem rechts und links Teile eines Stoffes herabhängen. [24] Hierbei handelt es sich um keines der gängigen Ikone für Gefäße oder Opfergaben, so dass Funktion und Bedeutung fraglich bleiben. Zu erwägen ist jedoch, ob es sich hier um ein hohes Alabastergefäß handeln könnte, das mit einem Stofftuch kombiniert wurde. Das Gefäß könnte Salbe bzw. Öl enthalten haben und das Tuch zum Durchseihen oder Auftragen gedacht gewesen sein. Es ist aber auch möglich, das Tuch als weitere kostbare Gabe zu verstehen. [25]

3.2 Themen B1 und B2

Themenbestimmung: Erfreuen des Grabherrn und magisch-rituelle Regenerationssicherung.
Bildliche Umsetzung: Zwei auf den Grabherrn ausgerichtete Musikerpaare: Harfner und Flötist sowie Harfner und Klarinettist.
Lokalisierung: Fragment II, oberes Subregister.
Die in beiden Szene verwendeten Ikone sind im Alten Reich und später gut belegt. Es handelt sich um die Bilder eines auf dem Boden hockenden Harfners [26], eines ebenfalls hockenden

23 Diese Inschriftreste sind heute nicht mehr zu erkennen; auf dem bereits erwähnten Archivfoto vom Anfang der 1930er Jahre (s. Taf. 19b) sind zwei Zeichen jedoch noch zu lesen. Das kleine dreieckige Fragment mit diesen Beischriftresten und Teilen des Unterarms ging noch vor den Zusammensetzungsarbeiten verloren; vgl. hierzu D. Kent Hill, in: JWAG 19–20 (1956/57), S. 39f., Abb. 4. Die Inschriftreste müssten zum Namen gehört haben.

24 D. Kent Hill, in: JWAG 19–20 (1956/57), S. 3 beschreibt diesen Gegenstand als ein Gefäß mit »lug handles on sloping sides and a horizontal line setting off the cover« und L. Montagno Leahy, Private Tomb Reliefs, S. 600, als »the base of an upended pot, possibly with a cloth draped over its base«. Der Deckel des Gefäßes ist aber deutlich durch eine Ritzlinie markiert, so dass es aufrecht gestanden haben muss.

25 Eine solche Kombination könnte analog zur traditionellen Aufzählung von Stoffen und Alabastergefäßen in Opferlisten und Opferformeln zu verstehen sein.

26 Zum Harfenspiel im Alten Ägypten vgl. H. Hickmann, Le harpes de l'Égypte pharaonique. Essai d'une nouvelle classification, in: BIE 35 (1954), S. 309ff.; C. Ziegler, Les instruments de musique égyptiens au Musée du Louvre, Paris 1979, S. 99ff.; L. Manniche, Ancient Egyptian Musical Instruments, MÄS 34, München 1975, S. 36ff.; K. Krah, Die Harfe im pharaonischen Ägypten. Ihre Entwicklung und Funktion, Orbis Musicarum 7, Göttingen 1991; R. Pérez Arroyo, Music, S. 193ff. und 249ff.

Flötisten[27] sowie eines Klarinettisten[28]. Diese Ikone wurden der Bildtradition des Alten Reiches zufolge vor dem Grabherrn dargestellt und mit anderen Musikanten- und/oder Tanzszenen kombiniert. Eine direkte Vorlage aus dem Alten Reich, in der ein Harfner und ein Flötist sowie ein Harfner und ein Klarinettist zu je einem eigenständigen Duo kombiniert wurden, ist mir bislang nicht bekannt.[29] In den meisten Fällen sind zwischen diesen Musikern Cheironomen/Sänger abgebildet, oder Harfner, Flötist und Klarinettist sind in eine größere Gruppe eingebunden.[30] In einem solchen Zusammenhang scheint es sich zumeist um den von Instrumentalisten begleiteten Lobgesang (ḥs.t) für den Grabherrn gehandelt zu haben. Dass das Harfen- und Flöten/Klarinettenspiel darüber hinaus nicht nur eine unterhaltsame Funktion, sondern auch eine sexuelle und damit regenerative Konnotation besaß ist offenkundig, und dürfte im funerären Kontext eines solchen Grabreliefs eine wichtige Rolle gespielt haben.[31]

3.2.1 Figur 4: Harfner

– Erhaltungszustand: Unterkörper zerstört; Oberkörper über der Taille, Arme und Oberteil der Bogenharfe erhalten. Zahlreiche kleinere Beschädigungen finden sich auf der gesamten Oberfläche, ein größerer Ausbruch betrifft die äußeren Enden der mittleren Saiten der Harfe.
– Haltung: Wohl ungleichmäßige Hockhaltung mit aufgestelltem linken Knie; Oberkörper aufgerichtet, nach rechts orientiert; die linke Schulter, welche die Harfe stützt, ist frontal, die rechte Schulter von der Seite abgebildet. Die Arme sind angewinkelt; die Finger der linken Hand (als hinter den Saiten befindlich dargestellt) scheinen die fünfte und sechste Saite abzugreifen, während Zeige- und Mittelfinger und ursprünglich wohl auch der jetzt zerstörte Daumen der rechten (vor den Saiten dargestellt) dieselben Saiten anschlagen;[32] der Ringfinger und der kleine Finger sind zur Handfläche hin angewinkelt.
– Tracht: Glatzköpfig[33] oder Kurzhaarfrisur.

27 Zum Flötenspiel vgl. H. Hickmann, Classement et classification des flûtes, clarinettes et hautbois de l'Égypte ancienne, in: CdE 51 (1951), S. 17ff.; C. Ziegler, Les instruments de musique, S. 79ff.; L. Manniche, Ancient Egyptian Musical Instruments, S. 12ff.; R. Pérez Arroyo, Music, S. 165ff. und 249.

28 Zum Klarinettenspiel H. Hickmann, ›Klarinette‹, in: Die Musik in Geschichte und Gegenwart, Basel 1958, Sp. 993ff.; vgl. R. Pérez Arroyo, Music, S. 181ff.

29 Duos sind im Alten Reich in der Regel nur für Harfner belegt, z. B. im Grabe des Nfr und Kȝ-ḥȝj in Saqqara, vgl. R. Pérez Arroyo, Music, S. 295.

30 Z. B. im Grab des Nfr in Giza (G 4761); vgl. R. Pérez Arroyo, Music, S. 281.

31 Vgl. hierzu W. Westendorf, Harfenspiel und Sexualität, in: K. Krah, Die Harfe im pharaonischen Ägypten, S. 221ff.; L. Manniche, Music and Musicians in Ancient Egypt, London 1991, S. 115f. Es ist auffällig, dass im Alten Reich häufig Harfenduos oder zwei Harfen in einer größeren Musikergruppe dargestellt sind. Einer der Gründe dafür dürfte darin zu sehen sein, dass der Dual bn.tj »die beiden Harfen« gleich lautend ist wie der Begriff für die »weiblichen Brüste« und somit den sexuellen/regenerativen Aspekt verstärkt.

32 Zur Fingerhaltung vgl. K. Krah, Die Harfe im pharaonischen Ägypten, S. 31f. sowie R. Pérez Arroyo, Music, S. 207.

33 Da die Bemalung völlig verschwunden und die Oberflächenstruktur des Kopfes stark beeinträchtigt ist, kann nicht entschieden werden, ob eine Kurzhaarfrisur oder Kahlköpfigkeit gemeint war. Jedoch ist bei allen Figuren des unteren Registers eine eingeschnittene Abgrenzungslinie zu vermerken, und auf dem Archivfoto der Fragmente II und III (Taf. 19a) sind solche Linien auch für die Figuren 6–8 nachweisbar. Bei allen Figuren ohne diese Linien ist die Oberflächenstruktur stärker beschädigt, so dass auch für diese eine Kurzhaarfrisur in Frage kommen könnte.

- Attribute: Bogenharfe mit neun Haltepflöcken und neun Saiten.[34]
- Beischrift: Linksläufige Zeile vor der Harfe mit kurzer Kolumne darunter, die Gefäß **a** und Szene **B** trennt; die Harfe dient als Trennelement zwischen den Beischriften des Harfners und der folgenden Figur.
 (←) *sqr bn.t* (↓) *pr-ꜥꜣ*
 »Spielen der Königsharfe.«[35]

3.2.2 Figur 5: Flötist

- Erhaltungszustand: Unterkörper und Hände zerstört; Oberkörper über der Taille, Arme und linkes Knie erhalten. Tiefe Kratzer verlaufen quer über Brust- und Schulterbereich, kleinere Beschädigungen betreffen die gesamte Oberfläche.
- Haltung: Ungleichmäßige Hockhaltung mit aufgestelltem linken Knie; nach rechts orientiert; der frontal dargestellte Oberkörper ist leicht nach vorne gelehnt. Arme leicht angewinkelt nach unten gestreckt, um die Grifflöcher der Flöte zu erreichen. Die Flöte wird schräg-vertikal vor den Oberkörper gehalten und das obere Ende an den Mund geführt.
- Tracht: Glatzköpfig oder Kurzhaarfrisur.
- Attribute: Pharaonische Längsflöte[36]; die Anzahl der Grifflöcher ist nicht zu ermitteln, da der unterste Teil des Instruments zerstört ist.
- Beischrift: Linksläufige Zeile über der Figur des Flötisten und Kolumne vor dem Oberkörper. Diese Inschrift wird von der links folgenden Beischrift zu Figur 6 in Szene **B2** mittels eines senkrechten Trennstrichs abgegrenzt.
 (←) *sbꜣ m* (↓) *mꜣ(.t)*
 »Blasen des Schilfrohrblasinstruments.«[37]

34 L. Montagno Leahy, Private Tomb Reliefs, S. 600 vermerkt sieben Halteplflöcke, auf dem Archivfoto (Taf. 19a) sind jedoch noch neun Pflöcke zu erkennen.

35 Es stellt sich die Frage, ob der Zusatz *pr-ꜥꜣ* als Hinweis darauf zu verstehen ist, dass diese Harfe zu den Musikinstrumenten des königlichen Palastes gehörte, oder ob es sich um ein ganz besonders qualitätvolles oder spezielles Instrument handelte, das denen des königlichen Orchesters entsprach. Die Darstellung selbst weist keinerlei Besonderheiten auf.

36 Zur Definition der verschiedenen Flöten vgl. H. Hickmann, in: CdE 51 (1951), S. 17f., R. Pérez Arroyo, Music, S. 169.

37 Der Begriff *mꜣ.t*, der normaler Weise mit »Flöte« übersetzt wird, findet sich auch in Szene **B2** in der Beischrift zu Figur 7, eines Mannes, der ein kurzes Blasinstrument vor sich hält (zur bisherigen Diskussion vgl. L. Montagno Leahy, Private Tomb Reliefs, S. 154f.). Somit stellt sich die Frage, ob dessen Instrument nicht wie bislang angenommen als eine Klarinette verstanden werden kann, die normalerweise als *mm.t* bezeichnet wird, sondern um eine Flöte. Da es sich bei der Darstellung des Blasinstrumentalisten in **B2** aber um ein gut belegtes Abbild für einen Klarinettisten handelt (zu Beispielen vgl. R. Pérez Arroyo, Music, S. 268, 272 und 275), muss eher davon ausgegangen werden, dass das Begriffsfeld für *mꜣ.t* weiter greifen kann. Da hier in beiden Fällen *mꜣ.t* mit einem Determinativ versehen ist (Aa 26), das auch für das Material Holz oder Schilfrohr stehen kann, und Flöten wie Klarinetten in der Regel aus Schilf (Arundo donax) hergestellt wurden, kann *mꜣ.t* im übergreifenden Gebrauch wohl als »Schilfrohrblasinstrument« aufgefasst werden.

3.2.3 Objekt b (Nebenthema)

Themenbestimmung: Versorgung des Grabherrn mit kostbarer Essenz.
Bildliche Umsetzung: Metallgefäß.
Lokalisierung: Fragment II, oberes Subregister.
Zwischen dem Flötisten der Szene **B1** und dem Harfner der Szene **B2** befindet sich ein hohes
Gefäß. Es besitzt einen schlanken Hals, eine schmale Lippe, sowie einen kleinen Deckel mit
zentralem Knauf. Der untere Teil des Gefäßes ist zerstört, trotzdem lässt sich vermuten, dass
ein Standfuß oder Gefäßständer zu ergänzen ist.[38] Die Gestalt des Gefäßes und des Deckels
verweisen auf ein Metallgefäß. Solche Gefäße wurden für kostbare Flüssigkeiten verwendet,
wie Duftessenzen oder -öle.

3.2.4 Figur 6: Harfner

– Erhaltungszustand: Unterkörper zerstört; Oberkörper ab der Taille, Arme und oberer Teil
 der Harfe erhalten. Kleinere Beschädigungen betreffen die gesamte Oberfläche.[39]
– Haltung: Wohl ungleichmäßige Hockhaltung mit aufgestelltem linken Knie; Oberkörper
 aufgerichtet, nach rechts orientiert. Die linke Schulter, welche die Harfe stützt, ist frontal,
 die rechte Schulter von der Seite abgebildet. Die Arme sind angewinkelt, die linke Hand-
 fläche (als hinter den Saiten befindlich dargestellt) berührt die Saiten 4–7, der Zeige- und
 Mittelfinger der rechten Hand sowie der Daumen schlagen die 5. und 6. Saite an, Ring-
 und kleiner Finger sind zur Handfläche hin abgewinkelt.
– Tracht: Kurzhaarfrisur.
– Attribute: Bogenharfe mit neun Haltepflöcke und acht Saiten.
– Beischrift: Linksläufige Zeile vor der Harfe mit Kolumne darunter, die Gefäß **a** und Szene
 B trennt; die Harfe dient als Trennelement zwischen den Beischriften des Harfners und der
 folgenden Figur.
 (←) *sqr [b]n* (↓) *[.t pr-ꜥꜣ]* [40]
 »Spielen der [Königsharfe].«

3.2.5 Figur 7: Klarinettist

– Erhaltungszustand: Unterkörper zerstört; Oberkörper über der Taille, die Spitze des linken
 Knies und die Hände erhalten. Vor dem linken Ellenbogen sind beim Herstellungsprozess
 versehentlich Reste des ursprünglichen Materialstegs stehen geblieben.
– Haltung: Wohl ungleichmäßige Hockhaltung mit aufgestelltem linken Knie; Oberkörper

38 Zu vergleichbaren Gefäßformen vgl. J. Vandier, Manuel d'archéologie égyptienne IV, Paris 1964, S. 151,
 Abb. 50 (72); als Beispiel aus dem Alten Reich s. G 4561 (vgl. N. Kanawati, Tombs at Giza, Bd. I, Taf. 35).

39 Das Archivfoto (Taf. 19a) zeigt noch ein weiteres Bruchstück mit Harfensaiten, das unmittelbar an die aufge-
 füllte Fehlstelle grenzt, und bei den späteren Restaurierungsmaßnahmen verloren ging.

40 Eine breite Fehlstelle befindet sich vor dem Körper des Harfners. An dieser Stelle dürfte sich analog zur vor-
 hergehenden Harfnerdarstellung eine weitere Inschriftkolumne befunden haben. Die Schreibung des Begriffs
 bn.t scheint hier zu variieren, da das *t* nicht unter dem *n* erscheint, und unter dem zerstörten *b* zu rekonstru-
 ieren ist. Eine kleinster Rest der linken oberen Ecke eines rechteckigen Zeichens kann auf den Zusatz *pr-ꜥꜣ* ver-
 weisen.

aufgerichtet, nach rechts orientiert; die linke Schulter ist frontal, die rechte in Seitenansicht dargestellt. Die Arme sind vor dem Oberkörper angewinkelt, der linke Ellenbogen stützt sich gegen das linke Knie. Die Klarinette wird mit den Händen schräg-horizontal vor den Körper gehalten, und das Mundstück an die Lippen geführt; die beiden Zeigefinger schließen je eines der Grifflöcher.

- Tracht: Kurzhaarfrisur.
- Attribute: Doppelklarinette[41]; die Anzahl der Grifflöcher ist nicht zu ermitteln.
- Beischrift: Linksläufige Zeile über dem Instrumentalisten und kurze Kolumne vor dem Oberkörper der Figur. Diese Inschrift wird von der links folgenden Beischrift zu Figur 8 in Szene **D** mittels eines senkrechten Trennstriches abgegrenzt.

 (←) *sbȝ m* (↓) *mȝ.t*

 »Blasen des Schilfrohrblasinstruments.«[42]

3.2.6 Objekt c (Nebenthema)

Themenbestimmung: Versorgung des Grabherrn mit Bier.
Bildliche Umsetzung: Biergefäß.[43]
Lokalisierung: Fragment III, oberes Subregister.
Zwischen den Klarinettisten der Szene **B2** und dem Sänger/Cheironom der Szene **C** befindet sich ein weiteres Gefäß mit spitzkonischem Deckel,[44] das wahrscheinlich auf einen Gefäßständer gesetzt war. Die Form ist charakteristisch für Biergefäße aus Keramik.

3.3 Thema C

Themenbestimmung: Lobpreis und Ehrbezeugung für den Grabherrn.
Bildliche Umsetzung: Sänger auf Grabherrn ausgerichtet und antithetisches Cheironomenpaar.
Lokalisierung: Fragment III, oberes Subregister.
Die Szenenverbindung besteht aus einem Motiv, das zwei einander gegenübersitzende Cheironomen zeigt, und aus einem zusätzlichen Ikon eines weiteren Sängers oder Cheironomen. Letzterer spielt eine besondere Rolle, da er als einziger von allen Musikern und Spielern allein dargestellt ist und somit analog zu den Figuren 2 und 3 aufgefasst werden muss. Seine Platzierung, Ausrichtung und besondere Gestik stellen die Verbindung zum Grabherrn her.

41 Aus dem alten Ägypten sind nur Doppelklarinetten belegt. In Abbildungen können diese Instrumente entweder in Seitenansicht erscheinen, wobei nur eines der Blasrohre sichtbar ist, oder in Aufsicht mit beiden Rohren. Zu Beispielen in Seitenansicht: vgl. R. Pérez Arroyo, Music, S. 272 und 307 und in Aufsicht: S. 190, 296 und 303.

42 Auffällig ist auch die Zeichenfolge für *mȝ.t*, wobei das Determinativ des Begriffs an das Ende der linksläufigen Zeile hinter die Präposition *m* gesetzt wurde und nicht ans Ende des Begriffes unterhalb der Flötendarstellung. Dass auf dieses Determinativ nicht einfach verzichtet wurde, mag damit in Zusammenhang gestanden haben, dass der Begriff hier übergreifend für die Gruppe der Schilfrohrblasinstrumente verwendet wurde.

43 Zur Gefäßform vgl. J. Vandier, Manuel IV, S. 151, Abb. 50 (56); vgl. auch D. Faltings, Die Keramik der Lebensmittelproduktion im Alten Reich, SAGA 14, Heidelberg (1998), 204ff.

44 Ein vergleichbares Gefäß, das innerhalb einer Gruppe von sieben Harfnern aufgestellt war, ist im Grab des *Jbj* in Deir el-Gebrawi (6. Dynastie) abgebildet (vgl. N. de Garis Davis, The Rock Tombs of Deir el Gebrâwi I, ASE 11, London 1902, Taf. 8; K. Krah, Die Harfe im pharaonischen Ägypten, S. 86f., Abb. 13).

Die Gesten der abgebildeten Personen dienen der zusätzlichen Interpretation[45] des Gesangs/ der Rezitation und sind typisch für die 5. und 6. Dynastie. Die Beischriften zu allen drei Figuren bezeichnen die Aktion der Personen als ḥs.t »Gesang«, analog zur Bedeutung der Vorbilder aus dem Alten Reich könnte es sich um den/die Lobgesang/-rezitation für den Grabherrn gehandelt haben.

3.3.1 Figur 8: Sänger/Cheironom

- Erhaltungszustand: Unterkörper zerstört; Oberkörper ab der Taille, Arme, linkes Knie und Teil des zugehörigen Oberschenkels erhalten. Mehrere Ausbrüche und Risse beeinträchtigen heute die Oberflächenstruktur der Figur und haben das Gesicht stark zerstört.
- Haltung: Wohl ungleichmäßige Hockhaltung mit aufgestelltem linken Knie; Oberkörper aufgerichtet, nach rechts orientiert; die linke Schulter ist frontal, die rechte in Seitenansicht dargestellt. Der rechte Arm ist stark angewinkelt, die geöffnete Hand seitlich ans Ohr gelegt, die Handfläche weist nach vorne; der linke leicht angewinkelte Arm ist vorgestreckt, die geöffnete Handfläche weist nach oben, der linke Ellenbogen stützt sich gegen das linken Knie.[46]
- Tracht: Kurzhaarfrisur.
- Beischrift: Linksläufige Zeile über und kurze Kolumne vor der Figur. Diese Inschrift wird von der links folgenden Beischrift zu Figur 9 mittels eines senkrechten Trennstriches abgegrenzt.
 (←) ḥs.t nfr.t (←↓) n kȝ=k r[ꜥ nb]
 »Vollkommener Gesang[47] für Deinen Ka [täglich].«[48]

3.3.2 Figur 9: Cheironom

- Erhaltungszustand: Unterkörper und linker Unteram zerstört; Oberkörper über der Taille, rechtes Knie und rechter Arm erhalten; zahlreiche Ausbrüche und Beschädigungen beeinträchtigen die Oberflächenstrukturen; der Kopf ist heute stark zerstört, ein tiefer Riss läuft parallel zur Scheitellinie.

45 Zur Cheironomie vgl. H. Hickmann, La chironomie dans l'Egypte pharaonique, in: ZÄS 83 (1958), S. 96ff.; E. Hickmann, »Cheironomie«, in: LÄ I (1975), Sp. 914f.; R. Pérez Arroyo, Music, S. 119ff.

46 Die Haltungs- und Gestenverbindung ist vergleichbar mit dem Klassifikationscode Q-A1 (Gesang) / Q-A2 (Rezitation) für Cheironomen nach R. Pérez Arroyo, Music, S. 125, Abb. 8. Abweichend von diesen beiden Varianten ist der linke Arm weniger stark angewinkelt, außerdem weist die rechte Handfläche nach vorne, was für das Alte Reich nicht belegt ist. Demzufolge kann an den Gesten nicht abgelesen werden, ob die abgebildete Person singend oder rezitierend dargestellt ist.

47 Hier erhebt sich allerdings die Frage, ob auch im Grab des ꜥnḫ=f-n-Sḫm.t der Begriff ḥs.t als »Lobgesang« für den Verstorbenen aufzufassen ist, oder ob er wie später üblich ganz allgemein als »Gesang« verstanden wurde. Zwar ist nicht generell davon auszugehen, dass die Übernahme von Alten Reichs-Motiven und Textformeln zwangsläufig auch deren Inhalte transferiert, trotzdem scheint die für die Konzeption verantwortliche Person über genaue Kenntnisse verfügt zu haben, die ein Verständnis der Cheironomenabbildungen durchaus wahrscheinlich macht. Ohne solche Kenntnisse wäre eine Neukonzeption, wie sie hier vorliegt, kaum möglich gewesen.

48 Der halbrunde Bogen unterhalb der Hand des Sängers könnte analog zur übergreifenden Inschrift als rꜥ nb zu ergänzen sein, vgl. hierzu auch L. Montagno Leahy, Private Tomb Reliefs, S. 601f., Anm. i.

– Haltung: Wohl ungleichmäßige Hockhaltung mit aufgestelltem rechten Knie; nach links orientiert, Oberkörper frontal. Der rechte Arm ist stark angewinkelt, der Ellenbogen gegen das Knie gelehnt, die Hand erhoben und weist mit geöffneter Handfläche nach vorne; die linke Hand ruhte ursprünglich wohl ausgestreckt oder geballt auf dem linken Oberschenkel.[49]
– Tracht: Kurzhaarig oder glatzköpfig (?).
– Beischrift: Rechtsläufig ohne Trennstrich zur Beischrift der Figur 10, wohl weil die Kolumne zwischen beiden Figuren mit beiden Beischriften zu verbinden ist.
 (←) ḥs.t (↓) n kȝ=k r[ꜥ nb]
 »Gesang für Deinen Ka [täglich].«[50]

3.3.3 Figur 10: Cheironom

– Erhaltungszustand: Unterkörper und rechter Unterarm zerstört; Oberkörper ab der Taille, linkes Knie und linker Arm erhalten; größerer Ausbruch am Hinterkopf- und Schläfenbereich; zahlreiche kleinere Beschädigungen beeinträchtigen die Oberfläche.
– Haltung: Wohl ungleichmäßige Hockhaltung mit aufgestelltem linken Knie; nach rechts orientiert, Oberkörper frontal. Der linke Arm ist stark angewinkelt, der Ellenbogen stützt sich gegen das linke Knie; die Handhaltung führt Daumen und Zeigefinger zusammen, der Mittelfinger ist ausgestreckt, Ring- und kleiner Finger sind angewinkelt.[51] Die rechte Hand ruhte wohl ausgestreckt oder geballt auf dem rechten Oberschenkel.
– Tracht: Kurzhaarig oder glatzköpfig (?).
– Beischrift: Linksläufig ohne Trennstrich zur Beischrift der Figur 9.
 (←) ḥs.t nfr.t (↓) n kȝ=k r[ꜥ nb]
 »Vollkommener Gesang für Deinen Ka [täglich]«. Die Kolumne n kȝ=k r[ꜥ nb] ist sowohl Bestandteil der Beischrift zu Cheironom 9 als auch zu 10.

3.4 Thema D

Themenbestimmung: Erfreuen des Grabherrn und Hilfsmittel auf dem Weg zur Gotteshalle.
Bildliche Umsetzung: Zwei einander am sn.t-Spieltisch gegenüber sitzende Spieler.
Lokalisierung: Fragment VI, unteres Subregister.
Die Szene zeigt ein seit dem Alten Reich gut bekanntes Motiv: Zwei Personen hocken einander am Brettspieltisch gegenüber und spielen sn.t.[52] Die beiden hier beteiligten Personen ho-

49 Wohl vergleichbar mit Haltung Q-C3 nach R. Pérez Arroyo, Music, S. 125, Abb. 8.

50 Ähnlich wie bei Figur 8 ist unter dem Schriftzeichen k der obere Rand einer Hieroglyphe mit Rundung erhalten, der ebenfalls als rꜥ der Verbindung rꜥ nb aufzufassen sein könnte.

51 Dieses Handzeichen ist selten belegt, und nur bedingt vergleichbar mit Q-S8 nach R. Pérez Arroyo, Music, S. 127, Abb. 9 und S. 129, Abb. 10 (Saqqara, Grab des Ptḥ-ḥtp II.), da dort eine Kombination mit erhobener und vorgestreckter rechter Hand dargestellt ist, die hier nicht vorgelegen haben kann, weil der rechte Unterarm auf oder neben dem rechten Unterschenkel gelegen haben muss.

52 Zum sn.t-Spiel vgl. E. B. Pusch, Das Senet-Brettspiel im Alten Ägypten, Teil 1, MÄS 38, München 1979; T. Kendall, Passing through the Netherworld: the Meaning and Play of Senet, an Ancient Egyptian Funerary Game, Belmot 1978; P. A. Piccione, The Historical Development of the Game of Senet and its Significance for Egyptian Religion, Dissertation University of Chicago, Chicago 1990.

cken auf dem Boden und blicken einander an. Jeder von ihnen hat einen Spielstein ergriffen, so dass das Spiel im Gange zu sein scheint.[53] Häufig wird der Grabherr selber beim Spiel gezeigt, oder der Spieltisch unter bzw. vor seinem Stuhl abgebildet.[54] Die herausragende Bedeutung, die man diesem Spiel im Grabkontext zugemessen hat, erklärt sich nicht allein aus dem Wunsch nach Vergnügen. Das Spiel hat eine rituelle Funktion und wurde als Hilfsmittel auf dem Weg vom Dies- ins Jenseits[55] und zur Gotteshalle (= Totengericht)[56] verstanden und somit als magische Initiationshilfe.[57]

3.4.1 Figur 11: Linker *sn.t*-Spieler

– Erhaltungszustand: Die Figur ist vollständig erhalten, und weist nur wenige kleinere Oberflächenbeschädigungen auf. Die Zeichen der Primärbeischrift sind im oberen Viertel weggebrochen. Ein heute von der linken oberen Ecke des Fragments bis zum Beginn der Sekundärbeischrift der linken Figur schräg herabreichender, bei der Restaurierung wieder aufgefüllter Riss betrifft den obersten Teil einiger der Schriftzeichen im Titel des abgebildeten Mannes.
– Haltung: Ungleichmäßige Hockhaltung mit aufgestelltem linken Knie; Körper nach rechts orientiert, Oberkörper aufgerichtet und frontal abgebildet. Der rechte Arm des Mannes ist vorgestreckt, die Hand fasst mit Daumen und Zeigefinger den ersten Spielstein auf seiner Spieltischseite. Die Hand des linken, leicht angewinkelten Armes umfasst das vordere Bein des Spieltisches unterhalb der Querverstrebung.
– Tracht: Kurzer Schurz, Kurzhaarfrisur.
– Attribute: Konischer Spielstein in der rechten Hand.
– Primärbeischrift: Linksläufige Zeile ohne Trennstrich zur Beischrift der Spielerpartners; jedoch übernimmt die Kolumnenschreibung des ersten Wortes, in der das *k* unterhalb des unteren Zeilenniveaus platziert wurde, eine vergleichbare Trennfunktion.
 (↓) ⌐m⌐ *k* (←) *nn* ⌐prj.n⌐ (=j) *n(=k)*
 »Siehe diesen (= Spielzug), den ich gewonnen habe gegen dich.«[58]
– Sekundärbeischrift: Die Schriftzeichen wurden später hinzugefügt; sie sind kleiner als die übrigen Inschriften und vertieft ausgeführt. Die linksläufige Beischrift erstreckt sich zwi-

53 Zu dieser Szene vgl. E. B. Pusch, Das Senet-Brettspiel, S. 141ff., Taf. 37b; W. Deckers / M. Herb, Bildatlas zum Sport im Alten Ägypten, HdO 1,14, Leiden / New York / Köln 1994, S. 661 (Q 3.48), Taf. 357.

54 Vgl. E. B. Pusch, Das Senet-Brettspiel; P. A. Piccione, The Historical Development of the Game of Senet.

55 Vgl. hierzu M. Pieper, Ein Text über das Ägyptische Brettspiel, in: ZÄS 66 (1931), S. 16ff.

56 Der Begriff *sn.t* »vorbeigehen, überschreiten, hindurchgehen« umschreibt einen Prozess, d. h. eine Übergangsphase, die besondere Gefahren in sich birgt, weshalb man sich zusätzlicher Schutzmittel bediente.

57 Eine solche Bedeutung ergibt sich nicht nur aus der Erwähnung des Spiels in CT V, 210a–c sowie der Darstellung in den Vignetten zu Tb17 (vgl. hierzu H. Milde, It is All in the Game. The Development of an Ancient Egyptian Illusion, in: J. H. Kamstra / H. Milde / K. Wagtendonk [Hg.], Funerary Symbols and Religion. Essays dedicated to Professor M. S. H. G. Heerma van Voss, Kampen 1988, S. 89ff.), sondern vor allem aus dem großen Brettspieltext (vgl. P. A. Piccione, The Historical Development of the Game of Senet, S. 191ff.).

58 Eine erste Rekonstruktion des Textes findet sich in der Umzeichnung von J. Capart, A Neo-Memphite Bas-relief, in: JWAG 1 (1938), S. 14, Abb. 3. Der Begriff *prj* »herauskommen« kann hier wohl als »gewinnen, siegen« aufgefasst werden, *ßj* »hochheben« in der Beischrift des Spielpartners dagegen als »einen Spielzug machen«. E. B. Pusch, Das Senet-Brettspiel, S. 143 möchte über den beiden *n* am Ende der Phrase noch ein weiteres flaches Zeichen ergänzen, was aber unwahrscheinlich ist, da das erhaltene und das zum Teil zu ergänzende *n* harmonisch in die Zeilengestaltung eingepasst sind.

schen dem *k*-Zeichen der Primärbeischrift und dem Gesicht des Spielers und setzt sich hinter seinem Körper als Kolumne fort. Die Angabe mit dem Namen der Mutter wurde ausgehackt und überschrieben und ist schwer zu rekonstruieren. Im Gegensatz zur Primärbeischrift dient diese Beischrift der Individualisierung.

(←) *jt nṯr ⸢sḥḏ*[59] *ḥm.w-kȝ⸣ n.w wdn.w(?) ꜥnḫ-wn-nfr sȝ*

(↓) *Jrj-ḥkȝ-ꜥȝ*[60] *⸢jrj n Sȝ.t-Nbw*[61]*, sȝ.t⸣ jt nṯr ḥm (nṯr) Sḫm.t Pȝ(-ḥm-nṯr)*

»Gottesvater, Untervorsteher der Totenpriester der Weihopfer[62] *ꜥnḫ-wn-nfr*, Sohn des *Jrj-ḥkȝ-ꜥȝ*, erzeugt von[63] *Sȝ.t-Nbw(.t)* Tochter des Gottesvaters (und) Gottesdieners der Sachmet *Pȝ(-ḥm-nṯr)*.«

3.4.2 Objekt d: Spieltisch

Der längsrechteckige Spieltisch besteht aus einem rechteckigen Rahmen, der aus Quarthölzern, tief angesetzten Querverstrebungen und einer Spielbrettauflage zusammengesetzt ist. Die zehn konischen Spielsteine besetzten in gleichmäßigem Abstand die Spielfelder. Zur Bedeutung s. o.

3.4.3 Figur 12: Rechter *sn.t*-Spieler

– Erhaltungszustand: Die Figur ist vollständig erhalten, kleinere Ausbrüche betreffen das Gesicht, den linken Unteram und die linke Hüfte.
– Haltung: Ungleichmäßige Hockhaltung mit aufgestelltem rechten Knie; Körper nach links orientiert; Oberkörper aufgerichtet und frontal dargestellt. Der rechte Arm ist vorgestreckt, die Hand des Mannes fasst mit Daumen und Zeigefinger den zweiten Spielstein auf seiner Spieltischseite. Der linke Unterarm ruht mit ausgestreckter Hand auf dem linken Oberschenkel.
– Tracht: Kurzer Schurz, Kurzhaarfrisur.
– Attribute: Spielstein in der Hand.
– Primärbeischrift: Rechtsläufig ohne Trennstrich zur Beischrift der Figur 11, aber mit Trennstrich zur Figur 13 in Szene E1.

(→) *jw nfr ⸢fȝ(.t)⸣*[64]

59 Der obere Teil des *sḥḏ* ist beschädigt, was nur schwer zu erkennen ist, da die Fehlstellen wieder aufgefüllt wurden. Das *ḥḏ*-Zeichen ist sehr breit geschrieben, in der phonetischen Komplementierung mit *ḏ* aber verifizierbar.

60 Ein *Jrj-ḥkȝ-ꜥȝ* aus dem 34. Jahr Darius' I. ist auf einer Apis-Stele belegt (Paris, Louvre S.N.72). Auffällig ist, dass im gleichen Jahr *ꜥnḫ=f-n-Sḫm.t* (II.) ebenfalls eine solche Stele gestiftet hat (s. o. unter Datierung). Zu erwägen ist, ob es sich bei unserem *Jrj-ḥkȝ-ꜥȝ* um die gleiche Person handelt, die auf der Apisstele genannt wird.

61 Der Name ist schwer zu entziffern, wahrscheinlich handelt es sich um den Namen *Sȝ.t-Nbw.(t)* »Tochter der Goldenen«, wobei die Bezeichnung »Goldene« als Beiname der Hathor aufzufassen wäre.

62 Die Lesung ist unsicher, es könnte sich auch um eine sehr verkürzte Schreibung von *wḏb-jḥ.t* »Umlaufopfer« handeln.

63 Statt *msj n* wurde hier *jrj n* verwendet.

64 Zur Rekonstruktion der Schreibung für *fȝj* mit Mann mit Schlange (A11a) statt Mann mit Korb auf dem Kopf (A9), vgl. E. B. Pusch, Das Senet-Brettspiel, S. 143. Die Schwanzspitze der Schlange ist noch erhalten.

»Der Spielzug ist gut.«[65]

– Sekundärbeischrift: Die Schriftzeichen wurden später hinzugefügt; sie sind kleiner als die übrigen Inschriften und vertieft ausgeführt. Die Beischrift befindet sich zwischen dem *k*-Zeichen der Primärbeischrift zu Figur 11 über dem Spieltisch und dem Gesicht von Figur 12; sie ist rechtsläufig angelegt und nur der Name am Schluss wurde aus Platzgründen als Kolumne geschrieben.

(→) *sn=f hrj wdb (n) nb ʒ.t Ptḥ-nfr sʒ ḥm-nṯr Sḫm.t* (↓) *Pʒ-ḥm-nṯr*

»Sein Onkel (?)[66], der Oberste der Lebensmittelverteilung (des) Herrn der Stärke,[67] *Ptḥ-nfr*, Sohn des Priesters der Sachmet *Pʒ-ḥm-nṯr*.«

3.5 Themen E1 und E2

Themenbestimmung: Erfreuen des Grabherrn, Hilfestellung in der Gotteshalle und Regenerationsgarantie.

Bildliche Umsetzung: Zwei in sich antithetisch ausgerichtete Spielerpaare beim Kügelchenspiel rechts und links vom *mḥn*-Spielbrett.

Lokalisierung: Fragment V und VI, unteres Subregister.

Dargestellt sind zwei Spielerpaare, die rechts und links vom runden *mḥn*-Spielbrett auf dem Boden hocken. Auffällig ist, dass anders als bei den üblichen Darstellungen des *mḥn*-Spiels aus dem Alten Reich,[68] sich keiner der Spieler dem Brett zuwendet oder Spielzüge auf ihm vornimmt. Nur im Grab des *Jbj* aus der 26. Dynastie ist eine vergleichbare Szenerie dargestellt.[69] Die Bündel mit aufgereihten Kügelchen/Steinperlen in den Händen der Spieler scheinen dagegen eher auf das in der Überschrift genannte *tʒ.w*-Spiel zu verweisen.[70] Da dort aber *mḥn*, *sn.t* und *tʒ.w* gleich berechtigt nebeneinander genannt werden, erscheint es zunächst verwunderlich, dass, falls beide Spielerpaare mit Kugelbündeln als *tʒ.w*-Spieler aufzu-

65 *fʒj* »hochheben, aufheben« ist hier sicherlich als »hochheben des Spielsteines« und damit als »Spielzug« zu verstehen.

66 *sn* kann hier nicht als Bruder aufgefasst werden, da *Ptḥ-nfr* und *ʿnḫ-wn-nfr* nicht den gleichen Vater besitzen. Auffällig ist jedoch, dass der Vater des *Ptḥ-nfr* und der Großvater des *ʿnḫ-wn-nfr* den gleichen Titel und Namen führen. Demzufolge ist entweder zu Beginn der Phrase für *Ptḥ-nfr* der Zusatz *jt* für *sn jt=f* »sein Onkel« ausgefallen, oder es ist ein anderer männlicher Verwandter gemeint.

67 Obwohl die Lesung sicher scheint, stellt sich doch die Frage ob wirklich das *ʒ.t*-Zeichen gemeint ist, oder ob es sich um eine etwas verunglückte Schreibung von *jmʒḫ* handelt, so dass dann zu übersetzen wäre »der Ehrwürdige …«.

68 Z. B. im Grab des *Rʿ-špss* in Saqqara sowie in den Gräbern des *Kʒj-m-ʿnḫ* und *Jdw* in Giza (vgl. W. Deckers / M. Herb, Atlas zum Sport im Alten Ägypten, 14, S. 634ff., Q 1.3, Q 1.6, Q. 1.7). Nur bei dem Beispiel aus Saqqara sind vier Personen am Spiel beteiligt, sonst ist jeweils nur ein Paar dargestellt.

69 Vgl. K. P. Kuhlmann / W. Schenkel, Das Grab des Ibi, Obergutsverwalter der Gottesgemahlin des Amun, AV 15, Mainz 1983, S. 81ff., bes. Anm. 340, Taf. 28.

70 Vgl. W. Deckers / M. Herb, Atlas zum Sport im Alten Ägypten,14, S. 638; K. P. Kuhlmann / W. Schenkel, Das Grab des Ibi, S. 83, Anm. 340, hier auch zur weiteren Diskussion des *tʒ.w*-Spieles durch Vandier, Birch und Ranke.

fassen sind, keine *mḥn*-Spieler abgebildet wären.[71] Möglicherweise muss die Darstellung des *ṯ̣.w*-Spiels als ein Zusatz der Spätzeit aufgefasst werden, der notwendig war, um den Aussagewert des *mḥn*-Spiels zu verdeutlichen oder zu modifizieren. Beim Kügelchenspiel selbst scheint es sich um eine Art von Glücks- oder Vorhersagespiel zu handeln. Derjenige, der die Kügelchen vorstreckt, wendet seinen Kopf ab, während der andere ihm das Ergebnis mitteilt. Das Spiel könnte auf der religiösen Ebene für die Totengerichtssituation in der Gotteshalle stehen, wo sich das weitere Schicksal des Verstorbenen entscheidet. Die Bezeichnung *ṯ̣.w* könnte dabei nicht nur die Form der Kugeln bezeichnen, sondern in Bezug zu *ṯ̣* »Küken« auch den Erneuerungsaspekt beinhalten. Das *mḥn*-Spielbrett zwischen den Spielerpaaren stand im Alten Reich für den Transformationsprozess der zur Regeneration führte, und somit für die Initiation ins Totenreich. Später stand *mḥn* aber auch für den Schutz und die Wiedergeburt des Sonnengottes,[72] so dass es in der Spätzeit möglicherweise nicht mehr als adäquat galt, das Spielen auf dem *mḥn*-Spielbrett darzustellen. Das Spielbrett selber wurde zwar abgebildet und sein Name genannt, der Spielprozess selbst aber durch das Spiel mit dem Kugeln ersetzt/ergänzt, das neben dem Spielbrett stattfand. Folgerichtig drehen die Spieler dem Spielbrett den Rücken zu.

3.5.1 Figur 13: Linker Spieler der linken Gruppe

- Erhaltungszustand: Die Figur ist vollständig erhalten, wenige kleinere Oberflächenbeschädigungen. Das obere Viertel der Beischrift ist zerstört.
- Haltung: Ungleichmäßige Hockhaltung mit aufgestelltem linken Knie; Körper nach rechts orientiert, Oberkörper aufgerichtet und frontal dargestellt, Kopf nach links zurückgewandt. Der rechte Arm ist vorgestreckt, der linke angewinkelt. Mit der zur Faust geballten rechten Hand umfasst der Spieler ein Bündel, das aus mehreren Strängen mit aufgezogenen Kügelchen, vielleicht Steinperlen, besteht, und das er über der linken offenen Hand hält.
- Tracht: Kurzer Schurz, Kurzhaarfrisur.
- Attribute: Steinperlenbündel.
- Beischrift: Linksläufig mit Trennstrichen zu den Beischriften der Figuren 12 und 14.

71 Die von K. P. Kuhlmann / W. Schenkel, Das Grab des Ibi, S. 83, Anm. 340 erwogene Lösung für die Darstellung im Grab des *Jbj*, dass es sich bei den Kugelbündeln um »Spielsteine« für beide Spiele handelt, erscheint in diesem Zusammenhang zumindest problematisch. Die konischen Spielsteine des *sn.t*-Spiels haben eine ganz andere Form, als die *ṯ̣.w*-Kugeln. Darüber hinaus scheinen die *ṯ̣.w*-Kugeln wie Perlen aufgefädelt zu sein, und die Spieler halten mehrere Kugelstränge als Bündel in der Hand. Schon im Grab des *Ḥsj-Rˁ* (W. Deckers / M. Herb, Atlas zum Sport im Alten Ägypten, 14, S. 633f.) sind die Spielsteine des Schlangenspiels in einem Kasten abgebildet, wobei es sich um Tierfiguren und vergleichbare Kügelchen handelt; die Spielsteine des *sn.t*-Spiels sind dagegen extra abgebildet und von konischer Form. Fehlleitend bei der Interpretation der Kügelchen ist eine falsche Umzeichnung des Schlangenspiels aus dem Grab des *Rˁ-špss*, das die *mḥn*-Spieler mit Kügelchenbündeln in den Händen über dem Spielbrett zeigt. In Wirklichkeit scheint es sich um Tierfiguren gehandelt zu haben (vgl. hierzu W. Deckers / M. Herb, Atlas zum Sport im Alten Ägypten, 14, S. 634f., Taf. 355). Demzufolge wurden auf dem Spielbrett des *mḥn*-Spieles wahrscheinlich gar keine Kügelchen eingesetzt, die vom Brett auch viel zu leicht herunterrollen würden, sondern ausschließlich die Tierfiguren. Die schon bei *Ḥsj-Rˁ* abgebildeten Kügelchen könnten die Funktion von Würfeln gehabt haben, mit denen man die Spielzüge bestimmte.

72 Zu Entwicklung des *mḥn*-Spieles vgl. P. A. Piccione, Mehen, Mysteries, and Resurrection from the Colied Serpent, in: JARCE 27 (1990), S. 43ff.

(←) *[jr=j r] ḥs.(t)=k* (↓) ⌜*prr*⌝ *jm*
»Ich werde tun, was Du empfiehlst, der Sieg (liegt) darin.«[73]

3.5.2 Figur 14: Rechter Spieler der linken Auswahlgruppe

– Erhaltungszustand: Die Figur ist vollständig erhalten, wenige kleinere Oberflächenbeschädigungen. Das obere Viertel der Beischrift ist zerstört.
– Haltung: Ungleichmäßige Hockhaltung mit aufgestelltem rechten Knie; Körper nach links orientiert, Oberkörper aufgerichtet und frontal abgebildet. Beide Arme sind vor der Brust angewinkelt. Die linke Hand ist zur Faust geballt und hält ein Kugelbündel, deren unterer Teil von der rechten Hand verdeckt wird.
– Tracht: Kurzer Schurz, Kurzhaarfrisur.
– Attribute: Steinperlenbündel.
– Beischrift: Rechtsläufig mit Trennstrichen zu den Beischriften der Figur 13.
(↓) ⌜*mk*⌝ *nn* (→) ⌜*dd.w*⌝ (↓) *[mȝ.]n=k pr.w* (→) ⌜*jm*⌝
»Siehe dieses (Spiel), das entschieden ist: Du hast gesiegt.«[74]

3.5.3 Objekt e: Spielbrett des *mḥn*-Spiels

Die Darstellung zeigt das Spielbrett des Schlangenspiels mit einem Standfuß.[75] Der Bruch zwischen den Fragmenten V und VI verläuft schräg durch die Darstellung des Spielbretts. Obwohl durch den Verlust der Bemalung jegliche Innenstrukturen des Spielbretts verloren gegangen sind, ist die äußere Gestalt innerhalb des dargestellten Kontexts so charakteristisch, dass die Zuweisung unzweifelhaft ist. Das *mḥn* – »Schlangenspiel« – ist ein gut belegtes Motiv, das vor allem in der Frühzeit und im Alten Reich beliebt war,[76] und den Regenerationsprozess des Verstorbenen als eine Reise symbolisierte. Später wurde dieser Gedanke in das solare Konzept überführt und *mḥn* stand für den Schutz der Erneuerung des Sonnengottes bei seiner Fahrt durch die Unterwelt.

3.5.4 Figur 15: Linker Spieler der rechten Gruppe

– Erhaltungszustand: Die Figur ist vollständig erhalten, kleinere Beschädigungen sind an der linken Faust und am Nacken der Figur zu vermerken. Das obere Drittel der Beischrift ist zerstört.
– Haltung: Ungleichmäßige Hockhaltung mit aufgestelltem linken Knie; Körper nach rechts

73 Rekonstruktion der Beischrift mit Hilfe der Vergleichsinschriften im Grab des Ibi, vgl. K. P. Kuhlmann / W. Schenkel, Das Grab des Ibi, S. 82f., Taf. 28.
74 Der Spieler verweist in seiner Rede darauf, dass die Entscheidung gefallen und der Sieg für seinen Partner gesichert ist, wörtlich: »Du hast gesehen den Sieg darin«.
75 Vgl. W. Deckers / M. Herb, Atlas zum Sport im Alten Ägypten, 14, S. 637 (Q 1.10), Taf. 357; zur einer vergleichbaren Szene im Grab des Ibi (TT36) vgl. K. P. Kuhlmann / W. Schenkel, Das Grab des Ibi, S. 82f. sowie W. Deckers / M. Herb, Atlas zum Sport im Alten Ägypten, 14, S. 637 (Q 1.9).
76 Zum *mḥn*-Spiel vgl. H. Ranke, Das altägyptische Schlangenspiel, Heidelberg 1920 und P. A. Piccione, in: JARCE 27 (1990), S. 43ff.

orientiert, Oberkörper aufgerichtet und frontal dargestellt. Beide Arme sind leicht ange-
winkelt; der rechte Unterarm ruht auf dem rechten Oberschenkel, die Hand aufrecht zur
Faust geballt; der linke Ellenbogen ist auf das linke Knie aufgestützt, die Hand ebenfalls
geballt.

– Tracht: Kurzer Schurz, Kurzhaarfrisur.
– Beischrift: Rechts- und linksläufig mit Trennstrichen zu den Beischriften der Figuren 14
und 16.
 (←) ⌜ḏd⸗j n⌝[n]⸗k (↓) [ꜥ] pn (↓) [pr.w j] m
 »Dir gebe ich diese Spiel[77] (und) den Sieg damit.«

3.5.5 Figur 16: Rechter Spieler der rechten Gruppe

– Erhaltungszustand: Die Figur ist vollständig erhalten, kleinere Beschädigungen am Hin-
terkopf. Das obere Drittel der Beischrift ist zerstört.
– Haltung: Ungleichmäßige Hockhaltung mit aufgestelltem linken Knie; Körper nach rechts
orientiert, Oberkörper aufgerichtet und frontal dargestellt. Beide Arme weisen nach hinten
zu seinem Spielpartner. Der linke Arm ausgestreckt mit zur Faust geballten Hand, die ein
Steinperlenbündel hält. Der rechte Arm ist angewinkelt, die offene Handfläche weist nach
oben, um die Kügelchen aufzunehmen.
– Tracht: Kurzer Schurz, Kurzhaarfrisur.
– Attribute: Steinperlenbündel.
– Beischrift: Linksläufig mit Trennstrichen zu den Beischriften der Figuren 14 und 16.
 (↓) [mꜣ] n(⸗j) ꜥ pn pr.w (↓) ⌜jm⌝⸗f
 »Ich möchte dieses Spiel sehen (und) den Sieg damit.«

4. Komposition und Konzeption

Die Komposition der einzelnen Bildelemente und Szenen verstärkt die ikonischen und moti-
vischen Aussagewerte und verdeutlicht die dahinter stehende Gesamtkonzeption. Wichtige
Mittel sind dabei Größenverhältnis, Platzierung, Gruppenbildung und Ausrichtung, Isolation,
Körperhaltung und Gesten sowie Beischriften und Szenengestaltung.

4.1 Größenverhältnis

Das Ikon des Grabherrn ist doppelt so groß dargestellt wie alle anderen Figuren; es ist gleich-
zeitig verbindendes Element und Ziel der in den beiden Subregistern vor ihm dargestellten
Handlungen. Neben seiner Figur sind es vier weitere Bildelemente, die durch ihre besondere
Größe hervortreten: die beiden Harfen im oberen und die beiden Spielbretter im unteren Re-
gister. Durch diese Elemente werden die Hauptziele der Darstellungen verdeutlicht (d. h. jen-
seitige Initiation und Regeneration) und in der thronenden Wiedergabe der Person des Grab-
inhabers mit *mdw*-Stab das erfolgreiche Ergebnis.

77 Zur Auffassung, dass mit ꜥ »Arm« hier das Kugelbündelspiel gemeint ist, vgl. K. P. Kuhlmann / W. Schenkel,
 Das Grab des Ibi, S. 82, Anm 328.

Zu vermerken ist auch die besondere Größe der Lotosblüte vor dem Gesicht des Grabherrn, die seinem Maßstab, nicht aber dem des Überbringers entspricht.

4.2 Platzierung

Wie schon oben ausgeführt können die Darstellungen des Haupt- und der beiden Subregister als zweidimensionale Wiedergabe eines Geschehens innerhalb eines Raum/Zeitgefüges aufgefasst werden. Folgendes Bedeutungsspektrum wird dabei vermittelt:

Links (oben und unten) = das heißt dem Grabherrn gegenüber (Szenen **C** und **D**):
Rituelle Ebene: Erfreuen des Grabherrn durch Lobgesang und *sn.t*-Spiel;
Metaphysische Ebene: Initiations- und Regenerationsaspekt (= Priesterebene).
Mittlere Szenen oben = rechts vom Grabherrn (Szenen **B1** und **B2**):
Rituelle Ebene: Erfreuen des Grabherrn durch Musik und Opfergarantie;
Metaphysische Ebene: himmlisch/regenerativer Aspekt (= Hathorebene).
Mittlere Szenen unten = links vom Grabherrn (Szenen **E1** und **E2**):
Rituelle Ebene: Erfreuen des Grabherrn durch das *mḥn-/tꜣ.w*-Spiel;
Metaphysische Ebene: unterweltlich/totengerichtlicher Aspekt (= Osirisebene).
Rechts = direkt vor dem Grabherrn (Doppelszene **A**):
Rituelle Ebene: Garantieren von Ritualen durch die Nachfahren;
Metaphysische Ebene: Versorgungs- und Erneuerungsaspekt (= Nachfahrenebene).

4.3 Gruppenbildung und Ausrichtung

In jedem der drei imaginären Raumabschnitte vor dem Grabherrn befinden sich je zwei Paare und eine Einzelperson. Die Orientierung der Personen innerhalb der Abschnitte unterscheidet sich erheblich. Die Personen des rechten Abschnitts sind einheitlich auf den Grabherrn ausgerichtet; die Einzelperson des gegenüberliegenden Abschnitts wendet sich ihm ebenfalls zu, während das Cheironomen- und das *sn.t*-Spielerpaar aufeinander zu orientiert sind; die Personen des linken Abschnitts zeigen dagegen ganz unterschiedliche Ausrichtungen, wobei Körper, Kopf und Arme in unterschiedliche Richtungen weisen können. Das linke *tꜣ.w*-Spielerpaar ist aufeinander ausgerichtet, der linke Spieler blickt jedoch zurück zu den *sn.t*-Spielern. Zwar scheint das Abwenden des Kopfes eine spieleigene Haltung zu sein, gleichzeitig wird dadurch aber auch eine szenenübergreifende Verbindung geschaffen. Das rechte *tꜣ.w*-Spielerpaar ist gleich ausgerichtet und dem Grabherrn zugewandt, der rechte Spieler streckt seine Arme nach hinten zu seinem Partner aus, um somit das gemeinsame Spiel zu ermöglichen. Die Einzelperson in diesem Abschnitt stellt durch ihre Körperhaltung die Verbindung zum Grabherrn her. Der Körper ist den Spielern zugewandt, der Kopf und der linke Arm dem Grabherrn.

Der himmlisch/regenerative Aspekt wird somit durch eine gleichmäßige Anordnung und Orientierung zum Ausdruck gebracht, der jenseitig/totengerichtliche durch Vielfalt. Die Paare des dem Grabherrn gegenüberliegenden Abschnitts bilden zwei in sich geschlossene Bildeinheiten, in denen die Themen des rechten und linken Abschnitts (Regeneration und Initiation) in verkürzter Form zum Ausdruck kommen.

4.4 Isolation

Die drei einzeln dargestellten Personen in den Subregistern vermitteln den Kultaspekt, das heißt Lobpreis/Gebet (Figur 8), Opfer (Figur 2) und Ritualgarantie (Figur 3).

Die einzeln und ohne szenische Einbindung abgebildeten Gefäße im oberen Register können als Opfergarantien (für Salbe, Duft [?] und Rauschgetränk) verstanden werden.

Auffällig ist auch die Isolation des *mḥn*-Spielbrettes, dem die begleitenden Spielerpaare den Rücken zuwenden. Die Isolation erhöht neben der besonderen Größe die herausragende Bedeutung des Ikons, das für die jenseitige Initiation steht.

4.5 Körperhaltung und Gesten

Mit Ausnahme des Grabherrn und des Ritualisten im oberen Subregister sind alle Personen in ungleichmäßiger Hockhaltung dargestellt, so dass sie als gleichwertige Bedeutungsträger aufgefasst werden können. Bei zwei Figuren wird diese Einheitshaltung aber durch besondere Gesten modifiziert. So hockt der nach dem *mdw*-Stab greifende Sohn (Figur 3) zwar auch auf dem Boden, sein angehobener Kopf und sein empor gestreckter Arm weisen ihn als besonders aus, und verdeutlichen die direkte Beziehung zum Grabherrn. Ebenso lässt sich die auffällige Gestik des einzelnen Sängers/Cheiromomen (Figur 8) mit vorgestreckter linker und erhobener rechter Hand deuten, deren geöffnete Handfläche nach vorne zum Grabinhaber weist.

Auch die Schreithaltung des Ritualisten fällt aus dem Rahmen und vermittelt die aktive Kontaktaufnahme zum Grabherrn, der durch seine thronende Haltung klar als Kultziel definiert ist.

4.6 Beischriften

Die einzelne Inschriftzeile, die sich rechtsläufig über das gesamte Bildfeld erstreckt, kann sowohl als Titel, als auch als Beischrift zum Grabherrn gewertet werden. Sie bezeichnet die abgebildeten Aktionen und benennt den Grabherrn als Nutznießer. Die musikalischen Darbietungen des oberen Subregisters (Musik, Gesang/Rezitation) werden dabei unter dem Begriff *ḥs.t* subsumiert, die Spiele des unteren Registers dagegen einzeln genannt. Grund dafür mag sein, dass die Szenenbeischriften des oberen Registers die dargestellten Handlungen bezeichnen, die des unteren dagegen nicht.

Die Beischriften zu den beiden Instrumentalistenpaaren sind fast identisch und greifen die bildliche Modifikation von Flöte zu Klarinette nicht auf; auch die Beischriften zur Sänger/Cheironomengruppe zeigen wenig Varianz und bestätigen für jeden der drei Beteiligten, dass ihr Lobgesang für den Ka des Grabherrn vollzogen wird.

Die Beischriften des unteren Subregisters besitzen einen ganz anderen Charakter. Es handelt sich um die Reden der beteiligten Spieler, die für die Bedeutung des Spielverlaufs unerlässlich sind. In den Beischriften geht es jeweils um das Ergebnis des Spiels. Auffällig ist, dass jeweils der äußere *tȝ.w*-Spieler das Ergebnis noch nicht kennt, die beiden mit dem Rücken zum *mḥn*-Spielbrett hockenden Spieler dagegen schon eingeweiht zu sein scheinen. Die Antwort ergibt sich sowohl aus der Interpretation des Kugelbündels in der Hand des Spielpartners, als auch aus der Kenntnis des zentral zwischen den beiden Spielerpaaren befindlichen *mḥn*-Spiels.

Die Sekundärinschriften dienen ausschließlich der Individualisierung einiger abgebildeter Personen, die dadurch in Bezug zum Grabherrn gesetzt werden. Im Falle der Figuren 2 und 3 geht es um den Hinweis auf die Familienzugehörigkeit (Enkel und zweiter Enkel? oder Sohn?) und damit möglicherweise auch um die Legitimierung der in den Sekundärinschriften genannten Personen. Die Beischriften zu den *sn.t*-Spielern bezeichnen zwei unterschiedliche, miteinander verwandte Personen, die wohl ebenfalls als Nachfahren des *ꜥnḫ=f-n-Sḫm.t* (I.) anzusprechen sind (s. o. unter Datierung). Die Auswahl der *sn.t*-Spielszene für die Sekundärbeischriften spricht für den Bekanntheitsgrad und die angenommene Wirkungsmächtigkeit des Motivs.

4.7 Szenengestaltung

Die einzelnen Szenen werden voneinander durch Bild- oder Textelemente getrennt. Im oberen Subregister übernehmen die abgebildeten Gefäße diese Aufgabe, im unteren Register kommt dem *mḥn*-Spielbrett eine solche Rolle zu; darüber hinaus sind es aber Textkolumnen, welche die Szene **D** von **E1** und **E2** von **A** (Figur 3) trennen. Innerhalb der Inschriften werden extra Texttrenner eingefügt und nur im oberen Register haben die weit ins Inschriftfeld hineinragenden Harfenhälse die gleiche Funktion.

Die einzelnen Instrumentalisten im oberen Subregister werden zusätzlich noch durch Inschriftkolumnen innerhalb der Szenen von einander getrennt, so dass sie eher wie einzelne Ikone als zusammengehörige Motive wirken. Auch zwischen den Figuren des Cheironomenpaars findet sich eine Inschriftkolumne, deren trennende Wirkung aber durch die antithetische Ausrichtung der Personen aufgehoben wird.

Im unteren Subregister werden die Szenenbegrenzungen durch die Körper/Kopfhaltung der Figuren eingeschränkt, so dass eine Handlungsabfolge deutlich wird.

Innerhalb des imaginären Raumes stehen das Cheironomen- und das *sn.t*-Spielerpaar dem Grabherrn als geschlossene Einheiten gegenüber, und es stellt sich die Frage, ob zumindest im Falle des *sn.t*-Spiels eine der Figuren die Rolle des Grabherrn übernimmt, insbesondere da genügend Beispiele aus dem Alten Reich bekannt sind, in denen der Grabherr selbst aktiv am Spiel teilnimmt. Eine vergleichbare Deutung für das Cheironomenpaar ist jedoch zweifelhaft und ohne Parallele. Die Einbindung des Grabherrn wird hier aber durch die unmittelbar zwischen den Figuren befindliche Inschrift deutlich, die darauf verweist, dass die Rezitation für den Ka des Grabherrn vollzogen wird, und durch den einzelnen Cheironomen, der auf den Grabherrn ausgerichtet ist.

Vergleicht man zum Abschluss die Komposition dieses Reliefs mit seinen Vorbildern aus dem Alten Reich so fallen eine Reihe von Abweichungen auf. Somit wurden die Alten Reichs-Vorlagen nicht einfach übernommen, sondern in ein neues Konzept überführt, welches aus der Sicht der 26. Dynastie geeigneter erschien, die notwendigen Inhalte wirkungsvoll zu vermitteln.

Zu diesen Abweichungen gehört:
- die Verbindung des *mdw*-Stab- und des Lotosblütenmotivs;
- die räumliche Trennung von Instrumentalisten und Sängern/Cheironomen;
- der Darstellung von Opfergefäßen zwischen den Musikantengruppen;
- die Trennung in *tꜣ.w*- und *mḥn*-Spiel.

5. Stilistische Merkmale

Die Darstellung aus dem Grab des ⁽nḫ=f-n-Sḫm.t gehört zur der Gruppe von Denkmälern[78] aus der 26. Dynastie, die sich an der Formensprache des Alten Reiches orientieren. Diese Orientierung beschränkt sich jedoch auf die Übernahme von ikonographischen Elementen und nicht auf die stilistische Ebene. Die folgenden Merkmale charakterisieren den Stil des hier besprochenen Reliefs:[79]

5.1 Die Gesichter der Figuren

Hohe Stirn; lange Nase mit nur geringem Nasenwurzeleinzug; leicht verkürzte untere Gesichtshälfte mit sehr kleinem, volllippigen Mund und deutlich abgesetztem, kleinen Kinn; kleine Augen mit akzentuierten Lidrändern und kaum ausmodellierten Brauenbögen; hoch sitzende detailreich gestaltete Ohren; volle Wangenpartie; geschwungene Linienführung der Schläfenpartien des Haaransatzes.

Zusammenfassend lassen sich drei auffällige Besonderheiten in den Vordergrund stellen:
– Die kleinformatige Ausführung der Sinnesorgane im Verhältnis zu den vollen, breit angelegten Wangen,
– die lange Stirn- und Nasenpartie im Verhältnis zur verkürzten unteren Gesichtshälfte,
– das abgesetzte kleine Kinn.

5.2 Körper der Figuren

Leicht ausladender Schädel; kurzer Hals; breite Schultern, leicht fülliger Oberkörper; rundlicher Bauch, der deutlich über der Schutzkante hervortritt, mit stark eingetieftem Nabel; sehr schlanke, lange Gliedmaßen. Besonders zu vermerken ist die lässig wirkende Haltung des linken Armes des Grabherrn auf der Seitenlehne seines Stuhles.

Als besonderes Charakteristikum kann die Schädelform, und das Verhältnis von fülligem Rumpf zu sehr schlanken Gliedmaßen gelten.

Für die Gestaltung der abgebildeten Gegenstände kann keine detaillierte stilistische Bestimmung vorgenommen werden. Durch die fehlende Bemalung sind die meisten der für eine Beurteilung notwendigen Details nicht mehr erhalten. Die äußere Form der Gefäße, Instrumente und Spiele ist seit dem Alten Reich bekannt, und nur das Gefäß mit den Stoffstreifen (Objekt **a**) und die ṱ.w-Kügelchenbündel in den Händen der Spieler (**E1** und **E2**) haben in dieser Zeit keine Parallele.

All diese Merkmale unterstützen eine Datierung in die späte 26./frühe 27. Dynastie. Eine genauere Datierung allein auf der Basis stilistischer Kriterien ist bislang nicht möglich, da nicht genügend sicher datierte Parallelen vorliegen.[80]

78 In früheren Publikationen oft als neomemphitisch bezeichnet, ein Begriff, der von George Bénédite eingeführt wurde; vgl. G. Bénédite, in: Mon. Piot 25, 1921/1922, S. 1–28.

79 Zu den stilistischen Besonderheiten der 26. und 27. Dynastie vgl. L. Montagno Leahy, Private Tomb Reliefs, S. 55ff.

80 Vgl. zur Datierungsproblematik L. Montagno Leahy, Private Tomb Reliefs, S. 29ff.

6. Architektonischer Kontext

Das Relief dürfte, wie schon angesprochen, ursprünglich einen oberen Abschluss besessen haben, der aus Rundstab und Hohlkehle bestand. Dieser Umstand, die Höhe und Breite des Bildfeldes sowie die breite Rahmung unten und an den Seiten machen es wahrscheinlich, dass es sich um einen Türsturz gehandelt hat. Vergleichbare Motivkombinationen aus dem Alten Reich stammen in der Regel von Grabwänden, und auch die Parallelszene zu den Spielern aus dem Grab des *Jbj* in Theben stammt von einer Grabwand. Szenen mit Tänzern und Musikern sind auf Türstürzen der Spätzeit allerdings belegt, so dass hier eine erweiterte Variante vorliegt.[81] Ob dieser Türsturz zu einem überirdisch angelegten Grab, zum Eingang eines Felsgrabes oder einer Kapelle gehört hat, lässt sich bislang nicht ermitteln.

Die Bedeutung von Musik im Grab des *ꜥnḫ=f-n-Sḫm.t* ist noch auf einem weiteren Relieffragment belegt, das sich ebenfalls im Walters Art Museum (22.38) befindet und von einer Grabwand stammt.[82] Auf diesem Fragment ist der Verstorbene zusammen mit seiner Ehefrau und Tochter abgebildet. Vor dieser Gruppe hockt ein Harfner in identischer Haltung wie auf den Türsturzfragmenten auf dem Boden und spielt auf seinem Instrument. Hier liegt jedoch im Gegensatz zum Türsturz eine Individualisierung der Begleitpersonen vor, und es sind nicht nur die Namen von Ehefrau: *Ḥw.t-Ḥr-m-ḫꜣ.t* und Tochter: *Tꜣ-(n.t)-Nfr-tm*, sondern auch die des Harfners: *Psmṯk-snb* genannt, dessen Titel *ḥsw* ihn als »Sänger« ausweist. Die Darstellung dieses einzelnen Musikers/Sängers mit deutlichen Alterszügen, verweist auf ein ganz anderes Thema, das nicht aus dem Alten Reich stammt, sondern im Mittleren Reich definiert wurde und seine endgültige Ausprägung erst im Neuen Reich erfahren hat. Es steht in Zusammenhang mit den Harfnerliedern und hat dadurch mit Totenklage und Verklärung zu tun.

7. Programmatische Überlegungen

Auch wenn die thematische Einbindung der Türsturzszenen des *ꜥnḫ=f-n-Sḫm.t* in das Gesamtprogramm des Grabes nicht möglich ist, so lassen sich doch eine Reihe konzeptioneller Überlegungen anstellen. Durch die Verlagerung der Musikanten- und Brettspielszenen von der Grabwand auf den Türsturz haben sie entscheidend an Bedeutung gewonnen. Während diese Darstellungen im Alten Reich als Nebenszene zu werten sind, die den Opfer- und Ritualgarantien beigeordnet waren, erfahren sie in diesem Kontext eine erhebliche Aufwertung, die durch die Abgeschlossenheit des gesamten Szenenverbundes noch verstärkt wird.

Der imaginäre Raum, der sich hinter den Darstellungen verbirgt, ist mit dem realen Raum, der sich hinter dem Durchgang des Türsturzes befindet, gleichzusetzen und darüber hinaus als kosmische Einheit mit dies- und jenseitiger, irdischer und himmlischer Ebene anzusprechen. Das linke Ende der beiden Unterregister mit Cheironomen und *sn.t*-Spielern bildet den Eingang zu dieser Welt. In diesem/dieser imaginären Raum/kosmischen Einheit ist diesseitig-kultisches mit jenseitigem und himmlischem Geschehen verbunden. In der bildlichen Fassung müssen, wenn auch in verdichteter Form, alle für den Verstorbenen notwendigen Aspek-

81 Z. B. die Türstürze des *Pꜣ-dj-Wsjr*, Baltimore, Walters Art Museum 22.97 (vgl. B. V. Bothmer [Hg.], Late Egyptian Sculpture, S. 109f., Taf. 82–83); des *Tꜣ-nfr*, Alexandria, Greco-Roman Museum 380, (vgl. L. Montagno Leahy, Private Tomb Reliefs, S. 713ff.); des *Ḥp-jw*, Berlin ÄMP 23001 und Cleveland, Cleveland Museum of Art 14.525, (vgl. L. Montagno Leahy, Private Tomb Reliefs, S. 689ff.),

82 Vgl. G. Steindorff, Catalogue of the Egyptian Sculpture in the Walters Art Gallery, Baltimore 1946, S. 81, Taf. 54; vgl. auch L. Montagno Leahy, Private Tomb Reliefs, S. 592ff.

te auf dem Türsturz vertreten sein: Opfer- und Ritualgarantie, Schutz auf der Reise ins Jenseits, Hilfestellung beim Totengericht, und Regenerationszusicherung.

Während Opfer- und Ritualgarantie durch Nachfahren und Priester gewährleistet sind, stehen die Brettspieler für den osirianisch-jenseitigen Aspekt, und die Musikanten für den regenerativen Hathoraspekt. Dabei steht das *sn.t*-Spiel für den Weg vom Diesseits in die Gotteshalle, das *mḥn*-Spielbrett für die Initiation des Toten sowie für den Schutz und die Wiedergeburt des Sonnengottes und das in zwei Phasen dargestellte *tꜣ.w*-Spiel für die Kontinuität der Regeneration.

Erstaunlich ist, dass man sich bei der Konzeption ältester Vorbilder bediente, die sich in ihrer äußeren Gestalt erheblich von der späteren Formensprache unterscheiden. Vorraussetzung dafür waren interne Kenntnisse einer Elite, zu denen ꜥnḫ=f-n-Sḫm.t als Ptah- und Sachmetpriester gehört haben muss. In dieser Elite scheint das Bedürfnis groß gewesen zu sein, sich solcher Spezialkenntnisse zu bedienen. Eine bildliche Fassung wie sie auf diesem Türsturz angelegt ist, verweist darauf, dass hier nicht einfach eine Vorlage kopiert wurde, sondern einzelne in ihrer Bedeutung bekannte Ikone und Motive neu arrangiert und mit zusätzlichen Bildelementen verbunden wurden.[83]

Die Bedeutung, die dem Gesamtbild zukam, lässt sich auch daran ermessen, dass der Enkel oder Urenkel des Grabinhabers gerade hier seinen Namen und den seiner Verwandten anbringen ließ und nicht an einer leichter zugänglichen Stelle.

83 Es ist nicht davon auszugehen, dass für die Szenen im Grab des *Jbj* (vgl. K. P. Kuhlmann / W. Schenkel, Das Grab des Ibi) die gleiche Vorlage benutzt wurde (so J. Vandier, Manuel IV, S. 489), obwohl auch hier die Spieler, die neben dem *mḥn*-Spiel dargestellt sind, dem Spielbrett den Rücken zuwenden. Hier wurde eine vergleichbare Lösung gewählt wie für ꜥnḫ=f-n-Sḫm.t. Nur das Motiv ist vergleichbar, nicht aber der übergreifende szenische Kontext.

Frank Steinmann

Eine Stundenuhr aus Tuna el-Gebel

Im Verlauf der Grabungskampagne[1] im Frühjahr 2004 wurden östlich des 2002 und 2003 frei-gelegten Gebäudekomplexes C drei weitere Suchschnitte angelegt (Trench 1 bis 3; Taf. 20a).

Die interessantesten Ergebnisse brachte Trench 2 (Taf. 20b). Hier kamen zunächst die Re-ste eines römerzeitlichen Grabhäuschens (Tomb 1) mit etlichen weiteren, sekundären Bestat-tungen zum Vorschein. Als architektonisch sehr viel interessanter erwies sich dann aber Grab 2, das 2004 nicht vollständig freigelegt werden konnte. Es handelt sich um einen ptolemä-erzeitlichen Grabbau, der ebenso wie das Grab des Petosiris die Form eines Pronaos-Tem-pels aufweist, der allerdings noch nicht fertig gestellt worden zu sein scheint. Zumindest gibt es auf den Schranken keinerlei Reliefs, und auch die Rundstäbe sind lediglich vorgearbeitet (Taf. 21a). Leider ist der Bau – wie auch Grab 1 – von den Kalkbrennern im 18. und 19. Jahr-hundert größtenteils abgetragen worden, so dass stellenweise nur noch die Fundamentlagen zu erkennen sind.[2]

Während in Grab 2 außer einer sekundären Bestattung bisher nur wenige Kleinfunde zum Vorschein kamen, erbrachte Grab 1 (Taf. 21b) eine Fülle von Funden. Genannt seien hier ein vollständig erhaltenes Glasfläschchen, eine kleine flache Bronzeschale, verschiedene Tonge-fäße (Schalen, Töpfe, Krüge), zahllose Scherben (vor allem von Amphoren) und Terrakotta-Lampen, diverse Stuckelemente sowie Amulette.

Ebenfalls um ein Amulett schien es sich zunächst bei einem annähernd quaderförmigen Gegenstand zu handeln (24.03.04-104 = TG 5248). Nach einer gründlichen Reinigung erwies sich der Gegenstand jedoch als eine aus Knochen geschnitzte Stundenuhr (Taf. 22a). Ihre Länge beträgt 38 mm, ihre Breite 12 mm und ihre Höhe 16 mm. Sie hat, von der Seite gese-hen, die Form eines W; nicht ganz mittig ist ein Loch von 4,5 mm Durchmesser quer durch das Stück gebohrt (Taf. 22b). Von oben sind zwei Kerben und insgesamt fünf kleine, runde Vertiefungen sowie eine Grundbohrung von 2,5 mm Durchmesser zu sehen (Taf. 22c). Die Grundbohrung diente der Aufnahme eines Schattenstabes, entweder aus Metall oder aus Holz – für die experimentelle Überprüfung der theoretischen Überlegungen wurde ein kurzes Holzstäbchen verwendet (Taf. 22d).

1 Gemeinsame Mission des Instituts für Ägyptologie der Ludwig-Maximilians-Universität München und der Faculty of Archaeology der Universität Kairo seit 1989.

2 Die weiteren Details dieses aus verschiedenen Gründen hoch interessanten Gebäudes sollen hier nicht weiter betrachtet werden, zumal im Moment auch nur ein kleiner Teil der Anlage ausgegraben ist. Eine Bemerkung zur Ausdehnung der Nekropole soll aber erfolgen angesichts der Tatsache, dass immer wieder behauptet wird, das Grab des Petosiris liege am Anfang des Friedhofs und habe damit eine Sonderstellung inne (so zuletzt J. Willeitner, in: Ägypten. Die Welt der Pharaonen, Köln 1997, S. 318f.). In Wirklichkeit befand sich das Peto-siris-Grab mitten in einer kilometerlangen Nekropole – das seit längerem bekannte Grab des Djedthotefanch liegt 200 m nördlich des Petosiris-Grabes auf gleicher Höhe wie Grab 2 –, und über das gesamte Areal hinweg sind Reste von Gräbern zu finden. Der südliche Teil des Friedhofs mit dem Petosiris-Grab hat nur das Glück gehabt, so stark mit Sand bedeckt gewesen zu sein, dass die Kalkbrenner die Steine nicht gesehen haben.

Der Schattenstab bildet einen Winkel von 56° zur Unterseite des Stückes (Taf. 23a).

An dem Ende, das dem Schattenstab gegenüber liegt, ist auf beiden Seiten die Gesamtbreite im oberen Teil um knapp 1 mm verringert. Auf diesem abgesetzten Block sind oben eine quer verlaufende Rille über die ganze Breite und zwei kurze, nach innen zeigende Kerben angebracht. Letztere haben als inneren Abschluss je eine runde Vertiefung und bilden damit eine Art »Kimme« für den vom Stab geworfenen Schatten. Die Markierungen auf der Oberseite des Objekts ergeben eine relativ grobe Skala für die Schattenwinkelmessung: Von der »Kimme« zu den Kanten des abgesetzten Blocks ergeben sich Winkel von jeweils rund 15°, und die Markierungen auf der abwärts abgeschrägten Fläche befinden sich ungefähr dazwischen, bilden also Winkel von jeweils rund 7,5° zur »Kimme« (Taf. 23b).

In älteren Zeiten wurde in Ägypten, jedenfalls nach unseren bisherigen Kenntnissen,[3] meist die Schattenlänge gemessen: Auf einem Lineal mit einer »Nase« sind parallele Linien eingekerbt, die jeweils der Schattenlänge einer bestimmten Stunde entsprechen. Von solchen Schattenmessstäben sind etliche Exemplare erhalten, so zum Beispiel Berlin 19743 (20. Dynastie, Taf. 23c).[4]

Ein etwas anderes Exemplar ist ein Modell für drei Arten der Schattenlängenmessung (Kairo CG 33401), wobei die unterschiedlichen »Skalen« sich nur dadurch unterscheiden, dass die Schattenlänge erstens auf einer waagerechten Fläche, zweitens auf einer Treppe und drittens auf einer Schräge gemessen wird (Taf. 24a).[5] Interessant ist, dass die Form des Modells mit den beiden auf- und absteigenden Schrägen etwa der Form des Stückes aus Tuna el-Gebel entspricht. Nur dessen Funktionsweise ist anders.

Die Messung des Schattenwinkels ist für das alte Ägypten selten belegt. Das älteste bekannte derartige Stück stammt aus der 19. Dynastie. Es ist eine 13 mm dicke Elfenbeinplatte in Form eines Halbkreises von 57 mm Durchmesser.[6] Auf der einen Seite ist Re-Harachte im Sonnenschiff dargestellt, von Merenptah angebetet; auf der anderen Seite sind Mittelpunkt-Strahlen im Abstand von 15° angeordnet. Eine ganz ähnliche Sonnenuhr ist Berlin 20322, aus grün glasierter Kieselkeramik und wohl in griechisch-römische Zeit zu datieren (Taf. 24b).[7]

Beide Schattenwinkel-Sonnenuhren sind so gebaut, dass die Messfläche senkrecht auszurichten ist. Der Schattenstab war vermutlich waagerecht, also im rechten Winkel zur Messfläche angebracht, und die Skala umfasst 13 Linien (Mittelpunkt-Strahlen), so dass theoretisch die Zeit von 6 bis 18 Uhr gemessen werden konnte. Natürlich gehen diese Uhren[8] nur zur Zeit der Tag-und-Nacht-Gleiche und um die Mittagszeit herum genau. Zu allen anderen Zeiten ergeben sich erhebliche Differenzen. – »Die alten Ägypter haben eben für Genauigkeit in Zeitbestimmungen kein Gefühl gehabt. Es scheint ihnen genügt zu haben, dass alle diese Uhren … nur zur Mittagszeit gleich gingen.«[9]

3 Vgl. dazu L. Borchardt, Die altägyptische Zeitmessung. Die Geschichte der Zeitmessung und der Uhren, Bd. 1, Berlin / Leipzig 1920, S. 26ff. und R. W. Sloley, Primitive Methods of Measuring Time, in: JEA 17, S. 166ff.

4 L. Borchardt, Die altägyptische Zeitmessung, Taf. 12.

5 L. Borchardt, Die altägyptische Zeitmessung, S. 37f.

6 L. Borchardt, Die altägyptische Zeitmessung, S. 48.

7 L. Borchardt, Die altägyptische Zeitmessung, S. 48f.

8 Es sind noch einige stationäre Sonnenuhren bekannt, ebenfalls mit senkrechter Messfläche; vgl. L. Borchardt, Die altägyptische Zeitmessung, S. 49.

9 L. Borchardt, Die altägyptische Zeitmessung, S. 50. Man darf allerdings mit den Ägyptern nicht so scharf ins Gericht gehen wie Borchardt. Denn woher sollten sie wissen, in welchem Winkel der Schattenstab angeordnet sein muss, damit die Sonnenuhren gleich gehen? Dazu hätten sie wissen müssen, dass die Erde Kugelgestalt hat, und sie hätten wissen müssen, auf welchem Breitengrad sich die jeweilige Sonnenuhr befindet.

Das besondere an dem Stück aus Tuna el-Gebel ist nun zum einen die waagerechte Anordnung, zum anderen die Tatsache, dass nicht ein Zeitraum von 12 Stunden, sondern nur ein Zeitraum von zwei Stunden abgemessen werden kann. Und innerhalb dieses Zeitraumes konnten sogar halbe Stunden abgelesen werden. Die Skala ist zwar, wie oben schon dargestellt, nicht sehr genau, aber für die Messung von etwa 30 Minuten ausreichend exakt. Allerdings funktioniert auch diese Stundenuhr nur um die Mittagszeit herum ausreichend genau. Vielleicht ist auch nicht zuletzt deshalb nur der Zeitraum von zwei Stunden für diese Sonnenuhr gewählt worden? Der Schattenstab hätte, um in Tuna el-Gebel von Morgen bis Abend hinreichend genaue Ergebnisse zu bringen, einen Winkel von 27° zur Grundfläche haben müssen. Er bildet aber, wie oben beschrieben, einen Winkel von 56°, ist also mehr als doppelt so groß. Selbst wenn man annimmt, der Besitzer der Stundenuhr sei ein Römer gewesen und habe die Uhr aus seiner Heimat mitgebracht, ist der Winkel des Schattenstabs zu groß. Für Rom zum Beispiel wäre ein Winkel von 42° richtig – der Winkel von 56° entspricht der geographischen Breite von Kopenhagen.

Dazu kommt, dass eine genau gehende Sonnenuhr für mindestens jeden Monat eine eigene Skala bräuchte oder der Schattenstab-Winkel geändert werden müsste, um die durch die Neigung der Erdachse[10] verursachten erheblichen Unterschiede zwischen Sommer und Winter auszugleichen. Im Prinzip gilt für eine Sonnenuhr mit falschem Schattenstab-Winkel folgendes: Je tiefer die Sonne steht, desto größer ist die Abweichung, und je steiler der Schattenstab steht, desto größer ist die Abweichung. Die praktische Erprobung der Stundenuhr in Tuna el-Gebel bestätigte diese theoretischen Überlegungen. Um die Mittagszeit herum waren die Ergebnisse ausreichend genau (Taf. 25a). Der Schatten überstrich am 20. März zwischen 11.00 und 12.00 Uhr OZ den Winkel von 15° zwischen rechter Block-Kante und »Kimme«. Am Morgen des folgenden Tages (von 8.00 bis 10.00 Uhr OZ) brauchte der Schatten jedoch für den gleichen Winkel zwei Stunden.

Die erheblichen Unterschiede in der Ganggenauigkeit ihrer Sonnenuhren dürften auch die alten Ägypter bemerkt haben. Immerhin war ein Vergleich mit den seit der 18. Dynastie oft belegten Wasseruhren[11] möglich. Und es dürfte den Ägyptern aufgefallen sein, dass die Sonnenuhren nur um die Mittagszeit herum ausreichend genau gingen. Die Beschränkung auf die Erfassung von nur zwei Stunden ist also durchaus sinnvoll. Vielleicht diente die Uhr ja dazu, von Mittag an die Zeit für eine zweistündige Mittagspause zu bestimmen? …

10 Die »Schiefe der Ekliptik« beträgt 23,5°; d. h. pro Monat müsste der Schattenstab-Winkel um 7,83° korrigiert werden, so dass sich am 20. Dezember ein Winkel von 60,5° für Tuna el-Gebel ergäbe. Die Stundenuhr TG 5273 ginge also lediglich um den 5. Dezember herum den ganzen Tag über genau.

11 Vgl. dazu L. Borchardt, Die altägyptische Zeitmessung, S. 6ff.

Claude Vandersleyen

Méditation devant une œuvre d'art : le visage du trésorier Maya

On accepte aujourd'hui, à peu près sans réticences, l'idée que l'art égyptien est vraiment de l'art, que ses sculpteurs ou ses peintres sont des artistes au sens total du terme. Il n'est pas sûr néanmoins qu'on puisse évoquer en parallèle Raphaël ou Michel-Ange, Dürer ou Jan van Eyck, sans provoquer chez l'amateur une moue de prudence: «Il ne faudrait pas exagérer» dira-t-on! Et pourtant, quand les fouilleurs anglais et néerlandais à Saqqara ont pénétré dans les appartements souterrains de la tombe de Maya, trésorier de Toutankhamon, ils ont senti qu'ils se trouvaient devant des œuvres exceptionnelles[1].

Quiconque connaît suffisamment l'art égyptien sait que les chefs-d'œuvre y sont nombreux, à des niveaux divers, mais souvent au niveau le plus élevé. Ce qui a peut-être frappé les découvreurs, c'est de trouver des œuvres d'une aussi grande humanité en un lieu où personne n'entrerait plus jamais quand la tombe serait refermée sur Maya et les siens. Leur surprise et leur admiration furent d'autant plus grandes que rien ne les préparait à une telle rencontre. La meilleure démonstration qu'il s'agissait de chefs-d'œuvre était d'en sortir une image des profondeurs de la tombe et de l'offrir à notre contemplation: cette image forma, en 1991, la couverture du n°1 d'*Egyptian Archaeology*.[2]

Des milliers de visiteurs passent chaque année au Louvre pour voir «la Joconde», sans deviner sans doute ce que Léonard de Vinci a mis d'aussi extraordinaire dans ce tableau pour qu'il exerce une telle fascination. Elle est unique, dit-on! Soit! Tels sont les vrais chefs-d'œuvre. «La Joconde» (Taf. 26b) arrive à un moment-clé dans l'évolution de la Renaissance, entre le Quattrocento et le Cinquecento, entre l'objectivité et le raffinement de Raphaël et la passion parfois tragique de Michel-Ange; elle apporte à la figuration humaine une zone d'ombre, une part plus intérieure, plus mystérieuse, mais douce et sereine. Ce qui lui attache le regard du spectateur, c'est peut-être cette extrême humanité que Léonard de Vinci y a mise, et il a trouvé les moyens picturaux et l'inspiration nécessaires pour nous la faire ressentir. C'est pourquoi l'apprécier est autant, sinon plus, du domaine de la sensibilité, de l'instinct, que de la raison lucide.

Quel est le Léonard auquel nous devons le visage de Maya? (Taf. 26a). On n'en finit pas de contempler ce visage, car il offre la même fascination que «la Joconde». Comme elle, il se trouve aussi à un moment d'équilibre dans l'évolution de la civilisation, dans ce moment d'apaisement qui termine, en art égyptien, la période amarnienne. Comme chez «la

1 L'image qui est l'unique objet de cette méditation est reproduite à la (Taf. 26a). Dans sa première publication (cf. note suivante), elle est intitulée: «Head of Maya, from his tomb in Saqqara, Substructure, Room K»; la permission de reproduire cette image m'a été accordée par l'Egypt Exploration Society que je remercie ici.

2 Dans cette revue où il publiait ce visage dont il fut l'un des heureux inventeurs, Geoffrey Martin avait noté: «Most tomb chambers are unadorned, but three of Maya's chambers have reliefs showing funerary scenes with the tomb-owners adoring Osiris and other deities. The faces are in many instances major works of art» (G. T. Martin, Re-peopling Ancient Memphis, in: Egyptian Archaeology 1, Summer [1991], p. 25).

Joconde », nos yeux voient la matérialité du visage, mais au-delà de cette réalité, ils peuvent percevoir, par une longue contemplation, tout ce qu'un être vivant peut avoir de finesse, de tendresse, de hauteur de vue, une sorte de perfection humaine inaccessible dans la vie vécue et qui ne peut naître que dans la pensée d'un grand artiste. Seul un grand artiste a pu concevoir et rendre sensible ce type d'humanité.

Sans doute, la photographie qui nous fait connaître ce visage est parfaitement réussie, mais elle ne peut montrer que ce que la pierre a conservé, que ce que le sculpteur a sculpté. Bien des choses sont possibles en photographie, on peut varier les éclairages et les angles de vue à l'infini, mais on ne verra jamais que ce que le sculpteur a fait : la photographie ne crée rien ; elle révèle ce qui est. Et cette photo-ci a le mérite de révéler l'œuvre, de nous la montrer sans aucune distorsion. Elle assure simplement le contact immédiat avec le relief.

Ce relief unit le tracé à deux dimensions, comme un dessin, et le modelé qui donne le volume. C'est un « relief dans le creux » : l'ensemble de l'œuvre est comme enfoncé dans la pierre dont la surface, visible à droite du visage, conserve le niveau original de la paroi tel qu'il était avant toute intervention du sculpteur. Ce système permet de creuser la pierre à des profondeurs variables selon les besoins du modelé, lequel est aussi discret ici que serait celui d'une médaille. L'œuvre se lit comme un dessin rehaussé d'ombres. Le creux le plus profond est celui de la ligne du profil ; l'éclairage choisi par le photographe entre au fond du sillon, créant une ligne claire contre laquelle se détache le visage, limité à gauche par la ligne sombre projetée par la perruque.

Le front présente un faible creux suivi du bombement léger de l'arcade sourcilière. La ligne s'incline ensuite vers la racine du nez. Le nez est très droit et peu saillant. Le tracé de la bouche ne peut guère se décrire sans y inclure le modelé qui donne à cette partie du visage son épaisseur charnelle. La lèvre supérieure, qui part de la base du nez, est coupée en deux parties par la légère crête qui sépare le haut de la lèvre de la douce membrane rouge qui, dans le langage courant, est simplement : la lèvre ; cette ligne en saillie, très précise et nette, se courbe pour rejoindre la commissure des lèvres ; sous cette fine crête, la lèvre proprement dite s'enfle mollement. La lèvre inférieure, plus épaisse que la lèvre supérieure, est aussi moins modelée. À partir de l'aile du nez, on voit se former une très légère dépression séparant de la joue l'ensemble charnu de la bouche ; à partir de la commissure, enfoncée dans la joue, le creux, un peu plus profond, continue à descendre, révélant la rondeur juvénile de cette joue. La bouche est séparée du menton par un angle net et fortement marqué par l'ombre. Le menton est rond et l'artiste n'a pas oublié d'en indiquer la limite, très légèrement, sous le menton. Le cou est un cou de femme, héritage des conventions amarniennes : il n'y a pas de pomme d'Adam pour rompre la ligne droite qui va du sous-menton à l'épaule ; deux courts sillons perpendiculaires à cette ligne figurent le collier de Vénus, réalité anatomique propre au cou des femmes.

L'ombre portée sur le visage par la perruque à fines mèches varie de largeur ; cette largeur permet de mesurer la distance entre le bord de la perruque et le visage ; elle exprime la profondeur du modelé. L'ombre est très large là où l'espace se creuse, particulièrement à hauteur du cou, sous la mâchoire ; elle est très réduite là où la joue et la pommette ont leur plus grande épaisseur ; l'ombre s'élargit de nouveau en passant sur le bord de l'orbite et sur le creux de la tempe.

L'œil, comme la bouche, est spécialement important dans un visage. L'œil de Maya est d'ailleurs un peu agrandi par rapport aux proportions générales de la face ; c'est un souvenir atténué d'un procédé qui a fleuri spécialement sous Amenhotep III, un siècle plus tôt. Cet agrandissement de l'œil est encore accentué par le trait de fard noir qui le cerne. L'œil est en

outre assez saillant, comme le montre la zone d'ombre sous la paupière inférieure. A mi-chemin entre le sourcil et la paupière supérieure, un fin sillon correspond au pli palpébral, là où la paupière peut s'escamoter dans l'orbite; un second sillon, au bord de la paupière, indique l'implantation des cils. L'œil est de face, dira-t-on. C'est vrai, même si, pour suggérer le volume du visage, il est sur un plan légèrement oblique: le coin de la caroncule, à l'avant, plonge en effet dans l'ombre du coin de l'œil, alors que l'autre coin se trouve presque au niveau le plus élevé du modelé, à peine dépassé par la pommette. Le sourcil est simplement peint, bien au-dessus de l'œil auquel il accorde ainsi un espace qui l'agrandit encore.

L'œil de face a gêné les premiers admirateurs de l'art égyptien, parce que ce n'est pas ainsi qu'on voit l'œil quand on regarde un visage de profil; c'était – disait-on – une «erreur» de l'artiste. Les expériences graphiques et spatiales du début du 20ᵉ siècle, dès l'apparition du cubisme, nous ont peut-être habitués à traiter le visage comme un assemblage d'éléments libres et l'œil de face égyptien ne perturbe plus guère le spectateur d'aujourd'hui. Je ne pense pourtant pas que les Égyptiens se soient livrés à des expériences esthétiques, à des jeux dans la figuration: leur système était établi dès l'origine, et pour de bonnes raisons; il visait essentiellement le rendu le plus complet possible de la réalité sans jamais perdre le contact avec elle. Bien sûr, le visage de Maya, comme tout bas-relief égyptien, est jusqu'à un certain point une synthèse, une vue de l'esprit, mais le but du système est de mieux dire, dans une sorte d'hypernaturalisme. Le profil rend le mieux compte d'un visage, mais l'œil en est toutefois l'élément essentiel. «Comment voulez-vous que l'on s'aime sans se regarder dans les yeux?» disait avec mélancolie une poétesse aveugle[3]. Il fallait donc que l'œil ait son importance et l'artiste égyptien a procédé à son rabattement dans le plan du relief, comme il l'a fait, d'une façon qui nous frappe moins, pour la bouche, laquelle, vue sur le profil d'un être vivant, est moins allongée vers la commissure des lèvres. Imaginons le relief de Maya avec l'œil lui aussi réellement de profil, comme on le voit dans des portraits peints de la Renaissance; «Federigo de Montefeltre» (Taf. 26c) et son épouse «Battista Sforza», par exemple, dus au pinceau de Piero della Francesca: l'absence du regard direct nous exclut de leur compagnie; pour eux, nous ne sommes pas là. Le compromis égyptien conserve la vie du regard; il assure le contact avec l'interlocuteur; l'échange reste possible car l'œil nous regarde.

La description qu'on vient de lire montre le sérieux du sculpteur, la profondeur de son analyse du visage humain, sa virtuosité dans le rendu des moindres nuances du modelé de la face. Cela suffit-il à mettre le visage de Maya en rivalité avec «la Joconde»? On a parlé – abondamment – du sourire de «la Joconde». Il est discret, mais évident et ses yeux aussi sourient. Voit-on le sourire de Maya? Il est plus discret encore, mais on le perçoit nettement, diffus sur l'ensemble du visage, dans la commissure légèrement enfoncée dans la joue, dans l'œil pas trop ouvert, mais éveillé. Ce sourire diffus au point d'être difficile à cerner, peut-être faudrait-il plutôt l'appeler une expression de sérénité heureuse qui rayonne intensément. N'est-ce pas l'objectif d'un portrait funéraire, enfoui dans les ténèbres du tombeau, que de garder en vie son modèle, pour les seuls yeux de «son âme», pour son double qui vient se réincarner dans cette image parfaite?

Est-ce le portrait de Maya? Ce n'est pas démontrable, il ne faut toutefois pas l'exclure *a priori*. La comparaison de ce profil avec celui des statues de Leyde, qui figurent le même Maya, n'interdit pas cette idée, mais cela n'est pas ce qui importe ici. Ce qu'a fait l'artiste, c'est une figure d'une extrême beauté. Le mot est dangereux: ce qu'on appellerait beauté, ici, c'est une vive séduction. Sans doute la forme est parfaite, régulière, délicate, mais ce qui

3 Angèle Vannier, entendue en 1959.

monte aux yeux, et par là jusqu'au cœur, c'est la profonde humanité qui rayonne de ce simple visage ; une vie chaleureuse, une intelligence raffinée qui se cache derrière la maîtrise de soi.

On pourrait continuer à raconter le dialogue qui relie ce visage à celui qui le regarde, contemplation qui n'a pas de raison de s'interrompre et est source de bonheur. Tout ce qu'on vient de lire n'est pas rêverie d'un imaginatif trop sensible. Tout cela se voit dans l'œuvre et les mots de la description ne l'ont pas épuisée. Il a donc fallu que l'artiste chargé de ce travail – et peut-être d'autres parties du décor de la tombe – ait pu penser ce personnage, le vivre, le concevoir dans toute sa richesse, puis le reproduire dans la pierre, l'œil guidant la main, sans perdre aucune des nuances subtiles qui donnent vie à ce visage. Quel artiste donc ! Il n'a rien à envier à Léonard de Vinci. Autres temps, autres moyens, et peut-être, très probablement, autres intentions, aussi impénétrables pour nous en ce qui concerne Vinci qu'elles le sont en ce qui concerne l'auteur de Maya, mais « l'aboutissement de l'art, disait Cézanne, c'est la figure ». C'était déjà vrai vers 1325 avant notre ère.

Ce qu'on vient de lire est la réédition d'un texte qui a déjà paru dans ce qu'on appellera familièrement les « Mélanges Erika Feucht », notre collègue de Heidelberg ; l'ouvrage a comme titre complet : *Menschenbilder – Bildermenschen. Kunst und Kultur im Alten Ägypten*, herausgegeben von Tobias Hofmann und Alexandra Sturm, Norderstedt, 2003. L'article ci-dessus avait été accidentellement mutilé au point de ne plus être toujours compréhensible. Je remercie les éditeurs de la nouvelle revue *Imago Aegypti* d'avoir accepté de rééditer cet article. Je remercie aussi ma collègue Erika Feucht et les éditeurs de ses « Mélanges » d'avoir autorisé cette réédition.

Vera Vasiljević

Der König im Privatgrab des Mittleren Reiches[1]

Im Bildprogramm der Privatgräber des Alten bis zum Neuen Reich sind einige Innovationen zu erkennen. Diese lassen sich in zwei Gruppen unterteilen: a) In eine Gruppe mit neuen *Themen* (z. B. mit dem Thema der Handwerkerstätten – seit dem Alten Reich) und b) in eine Gruppe mit neuen *Szenen* (z. B. neues Handwerk wie die Weberei – seit dem Mittleren Reich) beziehungsweise deren Varianten. Die Einführung der neuen Szenen kann man damit erklären, a) dass sich Vorstellungen über das Jenseits geändert haben oder damit, b) dass eine neue Ausdrucksweise für bereits bestehende Vorstellungen gefunden wurde. Einige der Themen wurden aus dem königlichen Bereich übernommen; sie können entweder die neuen Vorstellungen über die Jenseitserwartungen des Privatmanns beziehungsweise die Übernahme der königlichen Privilegien widerspiegeln oder sie bestehen aus der Übernahme von Ausdrucksweisen für eine im Privatbereich schon bestehende oder neu geschaffene Vorstellung.

Zu den Themen, die relativ spät ins Bildprogramm der Privatgräber aufgenommen wurden, gehört das Bild des Königs. Es ist in keinem Grab des Alten Reiches belegt, tritt aber im Mittleren Reich auf. In der 18. Dynastie ist die Königsdarstellung oft ein Teil der Wanddekoration der Grabanlagen der hohen Beamten, um danach, mit anderen bis dahin verwendeten Themen, durch Bilder, zum Beispiel aus dem Totenbuch, verdrängt zu werden. In diesem Beitrag wird untersucht, ob die neu aufgenommenen Königsdarstellungen des Mittleren Reiches neue Themen sind beziehungsweise einen Ausdruck neuer Vorstellungen wiedergeben oder ob sie eine neue Ausdrucksweise für in älterer Zeit schon präsente und bis dahin anders ausgedrückte Ideen sind.

Im Alten Reich werden Götter und Könige nicht in den Privatgräbern dargestellt. H. Junker erklärte die Abwesenheit der Götter – mit Ausnahme von Anubis – und, wegen der Natur seines Wesens, des Königs, in den Gräbern dieser Zeit durch ein Verbot ihrer Darstellung, dessen Ursache die für den Götterkult unzureichende Reinheit der Gräber gewesen sein soll.[2]

Eine seit langem bekannte Königsdarstellung aus dem Mittleren Reich stammt aus dem Grab des Antefoker beziehungsweise aus dem seiner Mutter Senet (TT 60; PM I, 121ff.), das in die Zeit Sesostris' I. datiert. Die Szene auf der Südwand des Grabkorridors in der Nähe des Eingangs zeigt Antefoker, der sich dem in einem Kiosk thronenden König nähert (Abb. 1). Die Szene ist heute stark beschädigt. Erhalten sind nur wenige Elemente, darunter ein Himmelszeichen, das von einem *wꜣs*-Zeichen gestützt wird, ein Teil eines Kiosks, der aus einer Hohlkehle und einer Lotossäule besteht, die Spitze des linken Flügels der geflügelten Sonnenscheibe und das Fragment einer Kartusche. Die zwei menschlichen Figuren konnte N. de

1 Der erste Entwurf zu diesem Thema wurde für den 8. Internationalen Ägyptologenkongress in Kairo 2000 vorbereitet und ist als Abstract veröffentlicht (V. Vasiljević, Some Remarks on Royal Representations from Private Tombs of the Middle Kingdom, in: Z. Hawass / A. Milward Jones [Hg.], Eight International Congress of Egyptologists, Kairo, 28 March – 3 April 2000. Abstracts of Papers, Kairo 2000, S. 191f.).

2 H. Junker, Giza XII, Wien 1955, S. 132ff., 142.

Abbildung 1: Darstellung des Königs im Grab des Antefoker

G. Davies nur durch die Spuren der Tilgung erkennen,[3] die erhaltenen Teile des Reliefs weisen jedoch eindeutig auf die Königsikonographie hin. Der König konnte aufgrund der Angabe der Kartusche als Sesostris I. identifiziert werden.

Fragmente einer älteren, aus der Zeit Mentuhotep Nebhepetres stammenden Königsdarstellung sind aus dem Grab des Cheti bekannt (TT 311; PM I, 387). Zu dieser Königsdarstellung schreibt W. C. Hayes: »During the Late Dynastic period the fine reliefs in the corridor of the tomb, including two stelae with the figure of the king just inside of the entrance, were broken up and used in the manufacture of the stone dishes …«[4].

Aus dem Tiefgang des Grabes des Antef (TT 386; PM I, 473) stammen Bruchstücke, die zu einer auf einem Stuhl mit Rückenlehne und Löwenkopf sitzenden männlichen Gestalt rekonstruiert werden können. Die Figur selbst besitzt keine Merkmale, die erläutern könnten, ob es sich bei ihr um den Grabherrn oder den König handelt. B. Jaroš-Deckert zieht die letztgenannte Interpretationsmöglichkeit vor, unter anderem aufgrund der Form des Stuhls und der relativen Größe der Figur gegenüber der Größe der identifizierbaren Darstellungen des Grabinhabers. Möglicherweise ist dies die früheste bekannte Wiedergabe eines Königs in einem Privatgrab, älter noch als die aus Grab TT 311.[5]

Die drei oben erwähnten Belege aus den thebanischen Gräbern sind alle nur fragmentarisch erhalten, so dass über ihren genauen Inhalt und die Komposition nur spekuliert werden

3 N. de Garis Davies, Antefoker, S. 6, 13, merkt an, dass dort, wo im Grab die Figur des Antefoker beseitigt wurde, dies so gründlich getan wurde, dass von ihr keine Spur mehr zu erkennen ist; bei der Königsfigur folgt die Linie der Tilgung der Körperlinie, so dass diese Ausmeisselung seiner Meinung nach nicht unbedingt in der Antike geschehen sein muss.

4 W. C. Hayes, Scepter of Egypt I, New York 1953, S. 163f.

5 B. Jaroš-Deckert, Das Grab des *Jnj-jtj.f*. Die Wandmalereien der XI. Dynastie. Nach Vorarbeiten von Dieter Arnold / Jürgen Settgast, Grabung im Asasif 1963–1970, AV 12, Mainz 1984, S. 86, Taf. 29.

kann.[6] Allen drei Darstellungen ist aber gemein, dass es sich bei ihnen um eine Abbildung *der Figur eines Königs handelt.*

Ein vierter und zugleich der besterhaltene Beleg des Mittleren Reiches unterscheidet sich von den bisher betrachteten figürlichen Darstellungen des Königs. Es handelt sich dabei um ein Bild aus dem Grab des Djefai-Hapi aus Assiut, N°1 (PM IV, 261f.).[7] Auf der Ostwand des Saales südlich des Eingangs befindet sich über den Zeilen 210–222 eines Textes, der den größten Teil dieser Wand bedeckt, eine Fläche mit dem Horusnamen, Thronnamen und Geburtsnamen Sesostris' I., oben von einem Himmelszeichen und seitlich durch zwei *wꜣs*-Zepter eingefasst. Die Hieroglyphen der drei Königsnamen sind um ein Vielfaches größer als diejenigen des Textes auf der Wand. Djefai-Hapi, der rechts vor dem Königsnamen in ehrfurchtsvoller Haltung steht, hat seine linke Hand auf die rechte Schulter gelegt (Taf. 27 u. Abb. 2). Die ehrfurchtsvolle Haltung, in der er dargestellt ist, kann als Zeichen dafür gewertet werden, dass die Königsnamen das Bild des Königs ersetzten. Das Bild des seitlich durch die *wꜣs*-Zepter und oben von einem Himmelszeichen begrenzten »Kiosks« mit dem Königsnamen aus dem Grab des Djefai-Hapi kann mit Szenen verglichen werden, die einem aus dem Alten Reich bekannten Schema entsprechen, bei dem eine Person von höherer Stellung – oft sitzend – in einem Kiosk dargestellt ist, während vor ihr eine zweite Person von niedrigerer Stellung steht. Der personifizierte Königsname vertritt demnach eine figürliche Darstellung, der König ist durch seinen personifizierten Namen wiedergegeben beziehungsweise präsent.

Der Königsname erscheint auf den königlichen Denkmälern Sesostris' I. mehrfach auch in der unmittelbaren Nähe von figürlichen Darstellungen des Königs in Gestalt einer Personifikation.[8] Meist übergibt Amun dieser Personifikation ein Lebenszeichen. Personifizierungen von Königsnamen sind jedoch bereits von einigen frühen ägyptischen Denkmälern bekannt; J. Baines hat solche Darstellungen analysiert und sie als »emblematic mode of representation« bezeichnet. Unter ihnen befinden sich Hieroglyphen und Symbole mit menschlichen Armen, die unterschiedliche Tätigkeiten ausüben.[9] Ein gutes Beispiel liefert der Königsname des Narmer auf einem zylindrischen Siegel[10] und auf einem Jahrestäfelchen aus Elfenbein, das in Abydos gefunden wurde.[11] Beide stellen das gleiche Thema des »Erschlagens der Feinde« dar, das auch auf der Narmerpalette zu sehen ist. Auf dem Zylindersiegel ist das Wesen

6 N. de Garis Davies, Antefoker, S. 8, 13–14, hat die Königsszene im Grab der Senet als »mundane« betrachtet, die möglicherweise eine »hommage or official attendance« darstellt und deren Aufgabe im Grab die folgende war: »Partly as a magnification of office, partly as date, the latter being the more precise if it recalled a sed-festival of the king«. J. Vandier, Manuel d'archéologie égyptienne IV. Bas-reliefs et peintures. Scènes de la vie quotidienne, Paris 1964, S. 535, vermutet, dass es sich bei der Darstellung um das Sedfest des Königs handelt.

7 P. Montet, Les tombeaux de Siout et de Deir Rifeh, in: Kêmi 3 (1930), S. 70f., Taf. 2, schreibt, dass ein Bild derselben Art sich über den Zeilen 316–324 der Verträge befand, wovon aber kaum etwas übrig geblieben ist. F. L. Griffith, The Inscriptions of Sîut and Dêr Rîfeh, hat auf Taf. 8 in Bezug auf die Zeilen 305–324 notiert, dass dort der sitzende Djefai-Hapi dargestellt war. Dies schließt die Möglichkeit aus, dass sich dort, wie Montet meinte, eine weitere Darstellung des Königs befand, da der Grabherr nicht sitzend vor dem König wiedergegeben werden konnte.

8 D. Wildung, Sesostris und Amenemhet. Ägypten im Mittleren Reich, Darmstadt 1984, Abb. 58; P. Lacau / H. Chevrier, Une chapelle de Sésostris Iᵉʳ à Karnak, SAE, Kairo 1969, Taf. 13 (Szene 4).

9 J. Baines, Communication and display: the integration of early Egyptian art and writing, in: Antiquity 63 (1989), S. 473ff.

10 J. Baines, in: Antiquity 63 (1989), S. 475f., Abb. 5.

11 G. Dreyer / U. Hartung / T. Hikade / E. C. Köhler / V. Müller / F. Pumpenmeier, Umm el-Qaab: Nachuntersuchungen im frühzeitlichen Königsfriedhof. 9./10. Vorbericht, in: MDAIK 54 (1998), S. 138f., Abb. 29.

Abbildung 2: Djefai-Hapi vor den Namen Sesotris' I.

des Königs anstatt durch eine menschlich gebildete Königsfigur durch den Namen wiedergegeben. Das n^cr-Zeichen ist mit Armen versehen und hält mit beiden Händen einen Stab, den er den in drei Registern wiedergegebenen gefesselten und knienden Feinden entgegenschwingt. Beim Elfenbeintäfelchen aus Abydos ist der n^cr-Wels mit einer Keule bewaffnet (Abb. 3) und dadurch, dass die Personifikation des Königs den Feind an dem aus drei Papyruspflanzen bestehenden Schopf ergriffen hat, ikonographisch wie auch inhaltlich noch deutlicher mit der Narmerpalette verbunden.

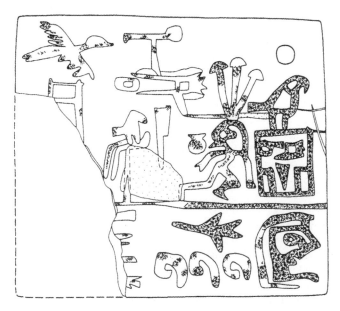

Abbildung 3: Elfenbeintäfelchen des Narmer

Obwohl die personifizierten Hieroglyphen sowohl auf den königlichen als auch auf den privaten Denkmälern des Mittleren Reiches in Aktion wiedergegeben sein können[12], betrifft dies meines Wissens nicht die Hieroglyphen der Königsnamen dieser Zeit. Da aber der Königsname zum Wesen des Königs gehört, dürfte man ihn wohl auch dann als mit der Person des Königs identisch betrachten,[13] wenn die Personifizierung durch keine zusätzlichen bildnerischen Mittel ausgedrückt ist – wie dies etwa bei den frühen Belegen mit den mit Armen versehenen Namenselementen der Fall ist oder indirekt durch eine Verehrungsgeste wie bei Djefai-hapi angegeben wird. Die Analyse der Personifikationen von J. Baines zeigt jedenfalls eindeutig, dass »[t]he limbs added to the hieroglyph in an emblematic personification are those necessary to express an action, or what is needed *to show* [kursiv von V. V.] that something is a personification and so indicate ›presence‹ …«.[14] Daraus ergibt sich, dass mit Armen versehene Hieroglyphen nicht unbedingt die Natur einer Hieroglyphe verändern oder die Hieroglyphe in etwas Neues verwandeln, sondern nur verdeutlichen und unterstreichen, dass etwas bereits die Qualität eines Wesens besitzt und damit anwesend sein kann. Der König ist in seinem Namen personifiziert, er ist durch seinen Namen präsent. Wenn kein Kontext oder Zusatz darauf hinweist, dass der Name personifiziert ist, bedeutet dies aber keineswegs, dass der Name nicht mit der Königsperson »aufgeladen« ist und auch nicht, dass der König durch den Namen nicht präsent ist.

Weitere Belege von *Szenen* mit eindeutig personifizierten Königsnamen sind im Privatbereich bisher nicht gefunden worden.[15] Doch sind in einigen Privatgräbern Königsnamen an prominenten Stellen des Grabes angebracht. Sie heben auf diese Art die enge Beziehung des Grabinhabers zum König hervor, so dass man sie auch als einen möglichen Beleg für die Präsenz des Königs im Privatgrab in Betracht ziehen darf.

Die Frage, ob der König im Grab des Antef im Asasif figürlich dargestellt war, muss zwar offen bleiben, doch ist zu erkennen, dass der Königsname in diesem Grab an einer anderen Stelle in prominenter Position aufgezeichnet war. Er kommt auf den Pfeilern V und VI vor, das heißt auf den Pfeilern, die links und rechts am Eingang des Grabes in der Grabachse liegen. Im Unterschied zu den anderen erhaltenen Pfeilern trug jeweils die Westseite dieser beiden Pfeiler keine bildlichen Szenen, sondern Inschriften in horizontalen Zeilen, von denen allerdings jeweils nur der unterste Teil erhalten ist. In diesen untersten Zeilen der beiden Inschriften befinden sich der Thron- und der Geburtsname des Königs Mentuhotep Nebhepetre (Abb. 4).[16] Auf dem südlichen Pfeiler (VIb) sind über der Zeile mit dem Namen des Königs die Reste einer weiteren Zeile erhalten. Das rechte Ende der beiden Zeilen ist durch ein seitlich angebrachtes *wȝs*-Zepter begrenzt, dessen unterer Teil erhalten ist; das gesamte Bild-

12 Z. B. *ꜥnḫ* und *wȝs*-Zeichen als Wedelträger (D. Arnold, Der Tempel des Königs Mentuhotep von Deir el-Bahari II. Die Wandreliefs des Sanktuares, AV 11, Mainz 1974, Taf. 9) oder *ḏd*, *ꜥnḫ* und *wȝs*-Zeichen, die schlachten, Speisen heranbringen oder als Schreiber wiedergegeben sind (Qaw el-Kebir, Grab Nr. 18 von Wahka: W. M. F. Petrie, Antaeopolis. The Tombs of Qau, BSAE 51, London 1930, Taf. 28). Einige Belege aus dem Alten Reich nennt J. Baines, Fecundity Figures. Egyptian Personification and the Iconology of Genre, Oxford 2001, S. 45, Abb. 14.

13 P. Vernus, »Name«, in: LÄ IV (1982), Sp. 320f.

14 J. Baines, Fecundity Figures, S. 45. Für eine andere Auffassung der Belege mit angehängten Armen vgl. W. Guglielmi, »Personifikation«, in: LÄ IV (1982), Sp. 980, Anm. 27; Sp. 982, Anm. 103.

15 Nach H. G. Fischer, Flachbildkunst des Mittleren Reiches, in: C. Vandersleyen, Das Alte Ägypten, Propyläen Kunstgeschichte 17, Frankfurt a. Main / Berlin / Wien 1985, S. 296, könnte sich im Grab des Sesostrisanch in Lischt eine Wiedergabe, die ähnlich der aus dem Grabe von Djefai-Hapi war, befunden haben.

16 Die wenigen Spuren der Inschrift auf der nördlichen Wand sind aber deutlich symmetrisch zu den südlichen und lassen sich entsprechend ergänzen: B. Jaroš-Deckert, Das Grab des *Jnj-jtj.f*, S. 62f., Abb. 14–15.

feld ist nach außen rechts mit einer Farbenleiter abgeschlossen. Bemerkenswert ist, dass die Reste des Königsnamens etwa in Augenhöhe liegen. Der untere Rand des Bildfeldes liegt im Verhältnis zum unteren Rand der anderen Pfeiler der Reihe deutlich höher, zum Beispiel mehr als 20 cm höher als auf der Westwand von Pfeiler IV (IVb) – die Sockel- und Farbstreifenzonen betragen auf dem nördlichen Pfeiler V 128,5 cm, auf dem südlichen Pfeiler VI 123 cm.[17] Das seitlich angebrachte *wȝs*-Zepter weist darauf hin, dass die Inschrift oben mit einem Himmelszeichen abschloss, so dass das Bildfeld ähnlich wie bei Djefai-Hapi gestaltet war. Auf diese Weise hat Antef die Präsenz des Königs in seinem Grab gesichert.

Abbildung 4: Namen Mentuhotep Nebhepetres im Grab des Antef

Auf der Fassade des Grabes von Djehutihotep aus Bersheh (Bersheh No. 2) und an den äußeren Ecken des Säulenportikus befinden sich vier senkrechte Kolumnen, die jeweils die Titulatur eines der Könige der 12. Dynastie (zweimal die von Sesostris II., jeweils einmal die von Amenemhet II. und Sesostris III.) sowie die Titel und den Namen des Grabinhabers nennen und dadurch die Beziehung des Grabbesitzers zum König spezifizieren.[18] Jede Kolumne begann mit dem in ein Serech eingeschriebenen Horusnamen, ohne dass weitere Teile der Königstitulatur mit dem Königsnamen im Grab gefunden wurden. Newberry bemerkt dazu, dass Djehutihotep offenbar den Wunsch ausdrücken wollte, »to put the royal titles prominently before the visitors«.[19] Es ist hinzuzufügen, dass die Titel und Namen des Djehutihotep in den Inschriften visuell wenig auffallen, visuell sind sie in den vier Inschriftkolumnen sekundär.

Die Frage, ob man einen Königsnamen verbindlich als Zeichen der königlichen Präsenz deuten darf und wo die Grenze zwischen den mehr oder weniger selbstständig vorkommenden Königstitulaturen und den Titulaturen, die Bestandteil eines Textes sind, zu ziehen ist, muss offen bleiben. Die visuelle Betonung, die die Königsnamen durch ihre Platzierung in der Grabdekoration oder in einem Bild- oder Inschriftenteil erhalten, kann auch aus Gründen der Verehrung für den König erfolgt sein, doch schließt sie nicht die zusätzliche Bedeutungsebenen aus. Königsnamen, die visuell nicht ganz so prominent wie in den beiden letztge-

17 Die gesamte Höhe des Sockels und der Farbleiter auf den Pfeilern variiert, da der untere Rand der Bildfläche auf allen Pfeilern dieselbe Höhe haben sollte: B. Jaroš-Deckert, Das Grab des *Jnj-jtj.f*, S. 20, Anm. 31, 32; S. 62, Anm. 400, 401.

18 P. E. Newberry, El Bersheh I, ASE 3, London 1894, S. 12, Taf. 5.

19 P. E. Newberry, El Bersheh I, S. 12.

nannten Fällen positioniert, aber immer noch deutlich hervorgehoben sind, kann man im Grab des Henenu aus der 11. Dynastie und in dem des Amenemhet aus der 12. Dynastie beobachten.

Im Grab des Henenu (TT 313) weist die Stele A, eine der vier Stelen dieses Grabes, die W. C. Hayes veröffentlicht hat,[20] einen langen autobiographischen Text auf. Henenu ist auf dieser Stele in sitzender Haltung vor verschiedenen Opfergaben dargestellt. Das Bild und der autobiographische Text sind oben von einer horizontalen sowie links und rechts von jeweils einer vertikalen Zeile eingerahmt. Die beiden senkrechten Kolumnen enthalten die Opferformel, die obere waagerechte Zeile ist mit der Titulatur Mentuhotep Nebhepetres versehen. Obwohl der autobiographische Text sich inhaltlich an die Zeile mit der Königstitulatur anschließt, ist die königliche Titulatur selbstständig – durch ihre Position sowie durch die größere Länge der Zeile; auch die Hieroglyphen der Zeile sind etwas größer als auf der Stele.

In Beni Hasan befindet sich um den Eingang des Grabes von Amenemhet (BH 2)[21] herum eine Inschrift mit der Opferformel, den Titeln und Namen des Grabherrn. Auch hier dominiert der Königsname in der obersten Zeile, die aus einer Kartusche mit den Titeln und Namen Sesostris' I. besteht. Die Namen des Königs sind ein weiteres Mal in dem auf den inneren Türpfosten geschriebenen autobiographischen Text genannt und dort durch die Regierungsjahre ergänzt.[22] Im Unterschied zum Königsnamen, der sich über dem Eingang befindet, haben die Namen auf der inneren Türlaibung eine stärkere inhaltliche Beziehung zur Inschrift.

Im privaten funerären Kontext, aber auch außerhalb des Grabes, kommen im Mittleren Reich Königsnamen vor. Die Königsnamen, die manchmal mit dem Regierungsjahr des Herrschers verbunden sind, sind kein seltener, aber auch kein obligatorischer Teil der Dekoration der Abydos-Stelen. Sie stehen im obersten Teil der Stelen und haben meistens keinen unmittelbaren inhaltlichen Bezug zu den weiteren Inschriften oder bildlichen Darstellungen. Der königliche Erlass, der mit ihnen verbunden sein dürfte, ist gleichzeitig ein Anzeichen dafür, dass die besondere Beziehung des Steleninhabers zum König hervorgehoben werden sollte.

Das Anbringen der Königstitulatur an prominenten Stellen auf den Privatdenkmälern ist eine Neuerung des Mittleren Reiches. Vermutlich ist am Ende der 1. Zwischenzeit während der Kämpfe um die Herrschaft über das ganze Land eine engere Beziehung zwischen dem König und seinen Beamten entstanden, die ihre Spuren in der nachfolgenden Zeit hinterlassen hat. Auf einer solchen Beziehung beruht wohl auch die Darstellung eines Privatmannes mit seinem König, die sich außerhalb des funerären Kontextes auf einem königlichen Relief befindet. Es handelt sich um Cheti, den Besitzer des Grabes TT 311, der auf zwei Steleninschriften in Shatt er Rigal vor Mentuhotep Nebhepetre wiedergegeben ist.[23] Auf der größeren der Stelen steht die Königsmutter, hinter dem mit der Doppelkrone dargestellten König Mentuhotep Nebhepetre, unmittelbar vor ihm befindet sich z3-Rᶜ Antef und weiter rechts der königliche Schatzmeister Cheti. Die Königsdarstellung besitzt einen wesentlich größeren Maßstab als die anderen Figuren. Die Bilder der beiden Männer erreichen kaum die Achselhöhe des Königs, das der Mutter des Königs geht bis zu seiner Taille. Cheti ist die einzige Figur, die im Verehrungsgestus gezeigt wird; bedeutsam aber ist, dass er ebenso groß ist wie

20 W. C. Hayes, Career of the Great Steward Ḥenenu under Nebḥepetrēᶜ Mentuḥotpe, in: JEA 35 (1949), S. 43ff., Abb. 1, Taf. 4.

21 P. E. Newberry, Beni Hasan I, ASE 1, London 1893, Taf. 7.

22 P. E. Newberry, Beni Hasan I, Taf. 8.

23 H. E. Winlock, The Rise and Fall of the Middle Kingdom in Thebes, New York 1947, S. 62ff., Taf. 12, 36, 37.

Antef. Die zweite und kleinere, etwas weiter westlich gemeißelte Stele zeigt nur Mentuhotep und den ihm zugewandten Cheti (Abb. 5). Mentuhotep ist in ein Sedfest-Gewand gekleidet. Bereits Winlock hat hervorgehoben, dass Cheti auf dem kleinen Relief mit Mentuhotep allein und dazu fast in demselben Maßstab wie der König wiedergegeben ist.[24] Cheti wird im Zusammenhang des Sedfestes von Mentuhotep auch in einem anderen Kontext, im Tempel von Deir el Bahari, genannt.[25]

Abbildung 5: Darstellung des Cheti vor Mentuhotep Nebhepetre

In der 12. Dynastie sind weitere Darstellungen eines Beamten vor dem König auf Denkmälern aus Serabit el Khadim belegt.[26] Auf dem Relief 72 bietet der Beamte Anchib dem sitzenden König Amenemhet II. zwei Türkis-Kegel dar.[27] Die Stele 404 zeigt denselben Anchib hinter Hathor stehend; die Göttin reicht dem sitzenden König ꜥnḫ und ḏd auf dem wꜣs-Zepter.[28] Eine ähnliche Szene ist auf dem Steinblock 116+164 belegt: Hathor hat das Menat in der einen Hand, und reicht dem sitzenden Amenemhet III. ꜥnḫ und ḏd auf einem wꜣs-Zepter; hinter der Göttin Hathor steht Sobekhotep mit einem Türkis-Kegel.[29] Ebenfalls aus Serabit el

24 H. E. Winlock, The Rise and Fall, S. 65.

25 Nach H. E. Winlock, The Rise and Fall, S. 65, Anm. 31: »Naville, XI Dyn. Temple I, p. 40, n.1; otherwise unpublished«.

26 Die Stelen und Teile der architektonischen Dekoration haben ein ähnliches Bildprogramm: D. Valbelle / C. Bonnet, Le sanctuaire d'Hathor, maîtresse de la turquoise. Sérabit el-Khadim au Moyen Empire, Paris 1996, S. 76f.

27 A. H. Gardiner / T. E. Peet / J. Černý, The Inscriptions of Sinai, Oxford 1952–1955, S. 87, Taf. 21; D. Valbelle / C. Bonnet, Le sanctuaire d'Hathor, S. 128f., Abb. 28, 150c.

28 A. H. Gardiner / T. E. Peet / J. Černý, The Inscriptions of Sinai, S. 205f., Taf. 84; D. Valbelle / C. Bonnet, Le sanctuaire d'Hathor, S. 136.

29 D. Valbelle / C. Bonnet, Le sanctuaire d'Hathor, S. 130, 144, Abb. 33, 153.

Khadim stammt der Altar von Imeni (95), auf dessen vorderer Seite Imeni einer Gruppe, die aus Hathor und der Personifikation des Königs besteht, einen Türkis-Kegel opfert: Die sitzende Göttin reicht dem auf dem Serech von König Amenemhet III. sitzenden Horus-Falken[30] wiederum ꜥnḫ und ḏd auf dem wꜣs-Zepter. Die Szene ist symmetrisch gestaltet, mit zwei nach links und rechts gewandten Figuren, von Imeni in der Mitte des Altars ausgehend, so dass er sich hinter Horus und der Göttin an den Enden des »Registers« befindet.

In diesem Zusammenhang sind zwei Funde aus Privatgräbern zu erwähnen: In der Mastaba eines Imhotep in Lischt sind zwei Holzstatuen Sesostris' I., eine mit der weißen, die andere mit der roten Krone, entdeckt worden.[31] Sie befanden sich in einem Serdab, der in die innere Umfassungsmauer der Mastaba eingebaut war. Die Statuen standen vor der Westwand und waren nach Osten gewandt. In demselben Raum befand sich auch ein Imiut in einem Kasten in Form einer oberägyptischen Kapelle. M. Seidel und D. Wildung betrachten die Statuen als ein Königsgeschenk.[32]

Auf der vorderen Seite eines Kästchens aus Theben sind in einem Bild der sitzende König Amenemhet IV. und der auf ihn zuschreitende Kemen, der zwei Salbgefäße darbringt, wiedergegeben. Die Inschrift auf dem Deckelrand gibt an, dass das Kästchen ein Geschenk des Königs an seinen Gefolgsmann Kemen anlässlich dessen Begräbnisses war.[33] Im Gegensatz zur üblichen Beschriftungsweise, bei der gewöhnlich die Inschrift am Knopf des Deckels mit der Opferformel beginnt, sind auf diesem Kästchen zu beiden Seiten des Deckelknopfes die Kartuschen des Königs angebracht. H. G. Fischer stellt fest, dass es zu einer Inversion gekommen sei, weil der Name des Königs, der stets der Schenkende ist, hervorgehoben werden sollte. Der König ist »… source de tous les biens de ses sujets« … »une telle idée est renforcée par le texte principal, qui comprend une formule funéraire: ›faveur qui donne le roi …‹«.[34]

Einen Sonderfall stellt das Grab des Uchhotep in Meir (C, No. 1) aus der Zeit Sesostris' II. dar. In diesem Grab wurde die Königssymbolik und die königliche Darstellungsweise vom Grabherrn direkt übernommen. Uchhotep ließ sich geradezu in der Art eines Königs darstellen: Ihm werden die Symbole der langen Regierung überreicht, auch die Symbole der Vereinigung der beiden Länder sind in diesem Grab wiedergegeben.[35] Es ist die unmittelbarste Übernahme von Königsprivilegien, die mir bekannt ist. Ob die Absicht des Uchhotep darin bestand, eine vollkommene Identifikation mit dem König zu erreichen, oder ob andere Gründe vorliegen, ist schwierig zu deuten, nicht zuletzt deshalb, weil das Grab auch andere Besonderheiten aufweist – fast alle Personen aus dem Gefolge des Grabherrn und fast alle Arbeiter in den Szenen der Landarbeit sowie der Arbeiten im Sumpf sind Frauen. Das Dekorationsprogramm des Grabes wird deswegen hier außer Betracht gelassen.

30 A. H. Gardiner / T. E. Peet / J. Černý, The inscriptions of Sinai, S. 103, Taf. 30; D. Valbelle / C. Bonnet, Le sanctuaire d'Hathor, S. 90, 130, 137, 145, Abb. 154.

31 A. M. Lythgoe, Excavations at the South Pyramid of Lisht in 1914. Report from the Metropolitan Museum, New York, in: AE IV (1915), S. 145ff., Abb. 1, 3; W. C. Hayes, Scepter of Egypt I, S. 193f., Abb. 117.

32 M. Seidel / D. Wildung, Rundplastik des Mittleren Reiches, in: C. Vandersleyen, Das Alte Ägypten, S. 235, Abb. 154, Taf. 13. Nach C. Aldred, Egyptian Art, London 1988, S. 137f. handelt es sich um Götterfiguren, die die Gesichtszüge des regierenden Königs tragen.

33 [G. H.] The Earl of Carnavon / H. Carter, Five Years Exploration at Thebes. A Record of Work Done 1907–1911, London, S. 55f., Taf. 48, 49.1–2; W. C. Hayes, Scepter of Egypt I, S. 246, Abb. 157. Das Kästchen ist im Grab von Ren-seneb (B. Porter / R. Moss, Topographical Bibliography of Ancient Egyptian Hieroglyphic Texts, Reliefs, and Paintings I, Part 2, Oxford 1964, S. 619) gefunden worden.

34 H. G. Fischer, L'écriture et l'art de l'Égypte ancienne, Paris 1986, S. 178f., Abb. 55–57.

35 A. M. Blackman / M. R. Apted, The Rock Tombs of Meir VI, ASE 29, London 1953, S. 20ff., Taf. 13.

A. Radwan[36] und H. G. Fischer haben die Szenen aus dem Grab des Antefoker/Senet in Theben (TT 60) und die Wiedergabe im Grab des Djefai-Hapi von Assiut als eine Besonderheit der Zeit Sesostris' I. hervorgehoben. Über die Szene bei Djefai-Hapi schreibt H. G. Fischer: »Eine solche Ehrenbezeugung vor dem im Bilde gegenwärtigen König tritt im Schmuck der Privatgräber erst im Neuen Reich wieder seit der Regierungszeit des Thutmosis III. auf.«[37] Die Innovation setzt jedoch chronologisch bereits früher in der Zeit Mentuhotep Nebhepetres ein. Es ist möglich, dass sie schrittweise eingeführt wurde – zunächst als Repräsentanz des Königs durch seinen Königsnamen, danach und erst später durch eine figürliche Darstellung. Leider bleibt unklar, ob die frühesten figürlichen Königsdarstellungen aus den Privatgräbern in die 11. oder 12. Dynastie datieren.[38] Unabhängig von der Frage, ob die Präsenz des Königs in einem Privatgrab in der 11. oder 12. Dynastie durch den (personifizierten) Königsnamen oder durch die figürliche Darstellung des Königs erfolgte, steht fest, dass diese Innovation die Abschaffung einer wichtigen ikonographischen Regel des Alten Reiches bedeutete. Denn in den Gräbern des Alten Reiches gibt es grundsätzlich keine figürliche Darstellung einer Person, deren Titel einen höheren Rang aufweist als die Titel des Grabinhabers.[39] Der Grund dafür war vermutlich, dass man die Kulthandlungen an die höchstrangige Person richtete und bei der Wiedergabe einer Person, die eine höhere Position als der Grabherr innehatte, die Gefahr bestand, dass diese dem Grabinhaber, der einen niedrigeren Status aufwies, bei den Kulthandlungen »im Weg stand«. Eine solche Komposition entsprach den Vorstellungen, in denen die Versorgung des Grabherrn den Mittelpunkt des Kultes darstellte.

Der König, *njswt*, als Begriff, als Abstraktum, dagegen ist, wohl im Sinne der Ewigkeit des Königtums, im Alten Reich in den Opferformeln ständig präsent. Die individuellen Königsnamen kommen in den Gräbern des Alten Reiches in den biographischen Inschriften der Grabinhaber, in der Titulatur der Beamten oder auch in Personennamen vor. So wird der König in den Inschriften als Quelle unterschiedlicher königlicher Erlasse und Geschenke erwähnt, oder der Privatmann rühmt sich seiner Taten, die er im Dienst für den König – und dadurch die königliche Zuneigung verdienend – geleistet hat. Der Grabherr betont also seine Verbindung zum König und hebt damit seinen durch die Beziehung zum Herrscher entstandenen besonderen Status hervor.

Einen Hinweis darauf, dass auch die Königsnamen, die primär funktionale Teile der Inschriften, Titel oder Namen sind, als Personifikation eines Königs aufgefasst werden konn-

36 A. Radwan, Die Darstellungen des regierenden Königs und seiner Familienangehörigen in den Privatgräbern der 18. Dynastie, MÄS 21, Berlin 1969, S. 1f.

37 H. G. Fischer, Flachbildkunst des Mittleren Reiches, S. 296.

38 Die fragmentarisch erhaltene Figur eines Mannes aus dem Grab des Antef könnte auch den Grabinhaber darstellen (B. Jaroš-Deckert, Das Grab des *Jnj-jtj.f*, S. 86, Taf. 29). Die Relieffragmente aus dem Grab des Cheti sind m. W. noch nicht veröffentlicht.

39 Dort, wo mehrere Personen in einem Grab ihre Kultstellen bzw. Scheintüren hatten, gilt das für den Raum, der dem Kult einer Person vorbehalten ist (z. B. die Scheintür und die Szenen, die sich auf den Inhaber der Scheintür beziehen). Beispiel: Im Grab von Ka-hay und Nefer, das Nefer für sich und für seinen Vater Ka-hay gebaut hat, ist Nefer, der während seiner Karriere einen höheren Rang als sein Vater erreicht hatte, vermutlich in einer Person namens Nefer, die ohne Titel auf der Scheintür von Ka-hay unter anderen Kindern dargestellt ist, identifizierbar; auf der eigenen Scheintür ist dagegen Nefer mit seiner voller Titulatur wiedergegeben (A. M. Moussa / H. Altenmüller, The Tomb of Nefer and Ka-hay, AV 5, Mainz 1971, S. 14f., 35, Anm. 209).

ten, bietet der Name des Anchmerire, der mit einem Himmelszeichen über der Kartusche geschrieben wird.[40]

Mit der Intensivierung des Osiris-Glaubens spielt sich das Verhältnis zwischen König und Privatmann auf zwei Ebenen ab: Einerseits steigt die Tendenz, sich mit Osiris zu identifizieren; dies eröffnete die Möglichkeit, königliche Insignien zu übernehmen (z. B. auf den Privatsärgen[41]). Andererseits wird die Abhängigkeit vom König nicht negiert, die Beziehung des Beamten zu seinem König, seine Abhängigkeit vom Herrscher bleibt weiterhin bestehen, auch im Augenblick des Todes – trotz seiner Gleichstellung mit Osiris. Denn durch die Identifizierung mit dem Gott wird ein Privatmann nicht mit dem König gleichgesetzt, er wird nicht »verselbständigt«. Genauso wie seine Karriere im Leben und die Vorbereitung der Grabanlage eines Beamten von seinem König abhing, blieb der König auch im Jenseits der eigentliche Bezugspunkt des Beamten. Die Abhängigkeit eines Privatmanns vom König während der Lebenszeit wird auf der gleichen Ebene im Jenseits fortgesetzt. Dies ist gewiss ein wichtiger Grund dafür, dass der Status einer Privatperson durch eine figürliche Darstellung des Königs oder durch den Königsnamen im Grab hervorgehoben wird und an Bedeutung gewinnt. Die historischen Umstände der 1. Zwischenzeit haben dazu beigetragen, die Bedeutung der Ideologie der Maat, der Ordnung, auf der realen Ebene herauszustellen. In einer geordneten Welt, deren Garant der König ist, kann der Einzelne auf die Erfüllung der Voraussetzungen für das Jenseits und auf die dauerhafte Sicherheit für sein Grab und die Erhaltung des Totenkultes hoffen. Da der König zugleich Garant der Wiederauferstehung ist,[42] stört seine Präsenz im Grab nicht den Totenkult des Privatmanns. Im Gegenteil: Die königliche Präsenz garantiert den Fortbestand des Kultes, denn die Opfergaben werden nach wie vor vom König verliehen. D. Franke betont: »Die Elite des Mittleren Reiches ist nicht in Konfrontation mit oder in Reaktion auf das Königtum entstanden, sondern gefördert durch die Könige von Herakleopolis, Theben und el-Lischt. Die Elite des Mittleren Reiches war auch keineswegs ökonomisch und geistig unabhängig von der Monarchie.«[43] So wird die in allen Gräbern vorhandene abstrakte Anwesenheit von *njswt*, die in einigen Gräbern konkretisiert ist, durch die Anwesenheit des gegenwärtigen Königs verstärkt.

Ein zusätzliches Element, das die Existenz des Herrschers in den Gräbern des Mittleren Reiches begünstigt haben mag, ist die Lage der Elitegräber. Da die hohen Beamten im Mittleren Reich ihre Gräber oft in den Nekropolen der Provinzzentren, in denen sie amtierten, bauen ließen,[44] benötigten sie zusätzliche Mittel, um ihre Beziehung zum König auszudrücken. Im Alten Reich genügte eine Grablage in der Residenznekropole.

Es besteht kein wesentlicher Unterschied, ob ein König in einem Privatgrab durch eine figürliche Darstellung oder durch seinen Namen präsent ist. Es handelt sich dabei um zwei Ausdrucksweisen derselben Idee. Schlüsse über die Kontinuität einer bestimmten Vorstellung lassen sich nur dann ziehen, wenn diese Vorstellung durch mehrere unterschiedliche Arten von Belegen bezeugt wird. Dieser Umstand ist zu vergleichen mit den Opfergaben, die dem Toten zur Versorgung dienen sollten. Auch hier spielte es keine Rolle, ob sie als reale Gabe, als Modell, in bildlichen Darstellungen oder in einer Opferliste erschienen.

40 H. Altenmüller, Die Wanddarstellungen im Grab des Mehu in Saqqara, AV 42, Mainz 1998, S. 63ff. Für den Hinweis auf den Beleg danke ich herzlich Herrn Prof. Dr. H. Altenmüller.

41 H. Willems, Chests of Life, in: »Ex Oriente Lux« 25 (1988), S. 221ff.

42 M. Seidel / D. Wildung, Rundplastik des Mittleren Reiches, S. 235.

43 D. Franke, Kleiner Mann (*nḏs*) – was bist Du?, in: GM 167 (1998), S. 38.

44 C. Aldred, »Grablage, Auszeichnung durch«, in: LÄ II (1977), Sp. 860.

Die Beziehung zum König kann auf verschiedene Weise ausgedrückt werden: durch die Auszeichnung mit einer Grablage,[45] durch die durch einen königlichen Erlass gestiftete Scheintür beziehungsweise Skulptur oder durch das Bild respektive den Namen des Königs im Grab selbst.[46] Die Deutung, dass die Präsenz des Königs eng mit der Wiederauferstehung und dem Jenseitsleben eines Privatmanns verbunden ist, schließt nicht aus, dass sie den Status des Grabinhabers auch in den Augen der Lebenden erhöhte.[47]

Zusammenfassung

Zu den ikonographischen Innovationen des Mittleren Reiches gehört die Königsdarstellung im Privatgrab. Die Abbildung des Königs im Grab stellt dabei eine neue Ausdrucksweise der Idee vom König als einem Garanten und Patron des Privatmanns im Jenseits dar. Diese Idee ordnet sich in die Kontinuität der Tradition ein und war schon früher präsent, nur wurde sie in älterer Zeit in anderer Weise ausgedrückt. Die Anwesenheit des Königs im Privatgrab war vor dem Mittleren Reich stets abstrakt, der König war als *njswt* präsent, gelegentlich auch durch den Namen eines konkreten Herrschers. Die in den Privatgräbern des Mittleren Reiches neu vorgenommene Personifizierung des Königsnamens stellt eine Wiederaufnahme einer älteren Ausdrucksweise dar, die bereits in den Denkmälern des Narmer bezeugt ist.

Neu ist jedoch die figürliche Darstellung des Königs im Privatgrab. Die Möglichkeit, das Königsbild in das Grab hineinzunehmen, ist dabei vermutlich eine Folge der engen Gefolgschaftsverhältnisse von König und Fürst, die sich aus den Kämpfen für die Wiedervereinigung des Landes am Ende der 1. Zwischenzeit ergeben haben und die ihren Ausdruck ebenso darin fanden, dass das Bild des Königs auf den Denkmälern hoher Beamter auch außerhalb des Grabes auftreten kann. Der zu Lebzeiten erreichte Status eines Grabinhabers wird dadurch ins Jenseits übertragen, dass die Präsenz des Königs auch im Grab hervorgehoben wird. So gesehen ist das Vorkommen der Königsdarstellungen in den Gräbern der 18. Dynastie nicht eigentlich eine Innovation des Neuen Reiches. Die Besonderheit der Königsbilder in den Gräbern des Neuen Reiches besteht in deren Anzahl und in ihrer weiten Verbreitung.

45 C. Aldred, in: LÄ II (1977), Sp. 859ff.

46 Die Titulatur eines Privatmanns drückt oft nur mittelbar, durch die Position in der gesellschaftlichen Hierarchie, die Stellung eines Beamten zum König aus. Der Rang einer Person innerhalb der Beamtenschaft muss nicht koinzidieren mit deren persönlicher Beziehung zum König (z. B. die persönlichen Diener, Mitglieder – wie etwa die Ammen – des Königshaushalts).

47 So z. B. der Königsname am Grabeingang, der für alle sichtbar ist und nicht nur für diejenigen, die ins Grab eintreten.

Zeit	König im Grab eines Privatmanns				Privatmann und König außerhalb des Grabes	
	figürliche Darstellung		personifizierter Name	hervorgehobener Name	figürliche Darstellung	personifizierter Name
	Wanddekoration	Funde				
11. Dynastie	Antef (TT 386) Cheti (TT 311)		Antef (TT 386)	Henenu (TT 313)	Cheti (Shatt er Rigal)	
12. Dynastie	Senet (TT 60) Sesostris I.	Imhotep (Lischt) Sesostris I. Kemen (Theben) Amenemhet IV.	Djefai-hapi (Assiut No 1) Sesostris I.	Amenemhet (BH 2) Sesostris I. Djehuti-hotep (Bersheh No 2) Amenemhet II., Sesostris II., Sesostris III.	Anchib – (Serabit el Khadim) Amenemhet II. Sobekhotep (Serabit el Khadim) Amenemhet III.	Imeni (Serabit el Khadim) Amenemhet III.

Chronologische Übersicht der in dem Aufsatz erwähnten Denkmäler

Alexandra Verbovsek

»Imago aegyptia«

Wirkungsstrukturen der altägyptischen Bildsprache und ihre Rezeption.[1]
Ein programmatischer Ausblick

Ein nicht unwesentliches Manko der ägyptologischen Forschung ist die gerade im Vergleich zu den Nachbardisziplinen stark vernachlässigte heuristische Komponente.[2] Dies betrifft neben der Text- oder Literaturwissenschaft,[3] der Archäologie und Bauforschung besonders die so genannte ägyptische Kunstgeschichte. Diesem Desiderat in geeignetem Maße zu entsprechen, fehlt hier der Raum.[4] Eingangsvoraussetzung für die Entwicklung einer angemessenen fachimmanenten Methodik ist jedoch die Prüfung einiger grundsätzlicher Fragestellungen, denen auch in diesem begrenzten Rahmen nachgegangen werden kann.

Der im folgenden vorgestellte Ansatz, der sich mit der kritischen Behandlung des Bildbegriffes in seiner Semantik und Anwendbarkeit beschäftigt, sei daher als methodische Grenzerweiterung der ägyptologischen Kunstforschung zu verstehen. Gegenstand der Betrachtung sind bildtragende oder bildhafte Artefakte, die vom modernen Rezipienten aufgrund ihres vermeintlich ästhetischen Gehalts und in Abgrenzung zu anderen darstellenden, sinnbildenden oder explizit funktionalen Ausprägungen der altägyptischen Kultur gemeinhin als *Kunstwerke* aufgefasst werden.

1. Der Kunstbegriff und seine Verwendung in der Ägyptologie

Wer von altägyptischer Kunst beziehungsweise bildender Kunst spricht, meint üblicherweise Skulptur, Relief und Malerei. In dem sich generell eher schwach abzeichnenden terminologischen Diskurs innerhalb unseres Faches scheint sich diese Determinierung des ägyptologischen Kunstbegriffs[5] längst ohne weitere Ausdifferenzierung legitimiert zu haben. Die begriffliche Grenzsetzung vollzieht sich irgendwo an der Schwelle zwischen ästhetischem und

1 Der vorliegende Beitrag stellt die überarbeitete Fassung eines Vortrags dar, der am 12.7.2003 im Rahmen der Ständigen Ägyptologenkonferenz in Basel unter dem Titel: »Wirkungsstrukturen der Bildsprache und ihre Rezeption. Korrelationen von Bild, Inschrift und Funktionskontext am Beispiel der Hebseddarstellungen« gehalten wurde.

2 Vgl. auch die Eingangsdiskussion im Beitrag »Ägyptische Körper-Bilder in physischen, visuellen und textuellen Medien« von G. Moers, S. 9ff.

3 S. hierzu beispielsweise G. Moers, Der Spurensucher auf falscher Fährte? Überlegungen zu den Voraussetzungen einer ägyptologischen Literaturwissenschaft, in: G. Burkard / A. Grimm / S. Schoske / A. Verbovsek (Hg.), Kon-Texte. Akten des Symposions »Spurensuche – Altägypten im Spiegel seiner Texte«, ÄAT 60, Wiesbaden 2004, S. 37ff.

4 Vgl. dazu A. Verbovsek, Zwischen »Theorie und Praxis« – Heuristische und ontologische Modellierungen der ägyptologischen Kunstbetrachtung. Unveröffentl. Habilitationsschrift, München, Juni 2005.

5 Zur Diskussion desselben s. auch M. Müller, Die Ägyptische Kunst aus kunsthistorischer Sicht, in: M. Eaton-Krauss / E. Graefe (Hg.), Studien zur ägyptischen Kunstgeschichte, HÄB 29, Hildesheim 1990, S. 39ff. und J. Baines, On the Status and Purposes of Ancient Egyptian Art, in: Cambridge Archaeological Journal Vol. 4, No. 1, April (1994), 67ff.

funktionalem Charakter der kulturellen Erscheinungsform, die konkrete Definition einzelner Kunstkategorien verbleibt dabei oft verhältnismäßig unklar. So existiert in der Ägyptologie neben dem Kollektivsingular »Kunst« der Begriff »Kleinkunst«. Unter diesem werden, anders als in den Bereichen Rund- und Flachbild sowie Malerei, auch Gegenstände subsumiert, deren funktionale Eigenschaften deutlich die ästhetischen überwiegen. In diesem Zusammenhang sind beispielsweise Dienerfiguren, kleinformatige Götterstatuetten, menschen- und tiergestaltige Amulette oder Ähnliches zu nennen.

Andere Gattungen wie Mumienmasken, Schmuck, Fayencegegenstände oder Keramik bewegen sich unterdessen, je nach *künstlerischem Ausdruck*, in der terminologischen Grauzone. Der ägyptischen Architektur werden vorrangig zweckgebundene Eigenschaften zugesprochen, daher unterliegt sie wiederum nicht dem ägyptologischen Kunstbegriff in seiner allgemeinen Verwendung. Auch die Literatur findet in diesem Kontext, mit Ausnahme des von Günter Burkard am *Schiffbrüchigen* entwickelten Konzeptes des Gesamtkunstwerkes,[6] nur selten Berücksichtigung.[7]

Dennoch soll an dieser Stelle keine Neudefinition des ägyptologischen Kunstbegriffs vorgelegt werden.[8] Es erscheint eher geboten, den Blick zunächst zurückzurichten auf die originäre Wirkungsweise der materiellen Hinterlassenschaften, die wir aus heutiger Sicht als Kunst bezeichnen.

Da sich jede moderne Betrachtung der kulturellen Zusammenhänge und Abläufe einer antiken Kultur mit der mangelnden Situationskompetenz des Betrachtenden konfrontiert sehen muss, soll hier mit generalisierbaren Paradigmen gearbeitet werden, die es erlauben, sich der altägyptischen Darstellung – dem Bild – in ihrer Wirkungsstruktur anzunähern, und zwar abgelöst vom Kunstbegriff und seinen Implikationen. Das Bild soll als operierender Bestandteil eines sozialen Systems verstanden werden, was, so Niklas Luhmann, »theoretische Vorgaben erfordert, die nicht aus einer Beobachtung von Kunstwerken herausgezogen werden können, gleichwohl aber am kommunikativen Gebrauch von Kunstwerken nachgewiesen werden müssen«.[9] Als Voraussetzung für eine solche Fokussierung gilt zum einen die vom wissenschaftlichen Beobachter vorzunehmende Zurückstellung der ästhetischen Komponente der Objekte, die vor allem im Museumsbereich in vielen Fällen Priorität besitzt. Zum anderen ist eine Differenzierung des als Kunstwerk angesprochenen Gegenstands in:

=> die Darstellung,	und	=> seinen Träger,
also DAS BILD		das BILDMEDIUM

erforderlich. In einem weiteren Schritt muss eine Auseinandersetzung mit der Dekontextualisierung erfolgen, der die Bilder nicht selten durch heutige Präsentationskonzepte unterliegen; dazu ist eine Analyse ihrer soziokulturellen und historisch-funktionalen Einbindung durchzuführen. Dieser Vorgang kann in Form eines Modells veranschaulicht werden:

6 G. Burkard, Überlegungen zur Form der Literatur. Die Geschichte des Schiffbrüchigen als literarisches Kunstwerk, ÄAT 22, Wiesbaden 1993, S. 45ff.

7 Vgl. auch R. B. Parkinson, Poetry and Culture in Middle Kingdom Egypt. A Dark Side to Perfection, London / New York 2002.

8 Siehe dazu einen neuen Ansatz in A. Verbovsek, »Theorie und Praxis«, S. 55ff.

9 N. Luhmann, Die Kunst der Gesellschaft, Frankfurt a. Main 1997, S. 9.

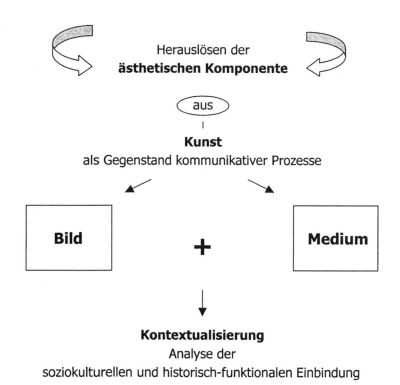

Abbildung 1: Extraktion des Bildbegriffs aus dem Kunstbegriff

Im Rahmen dieses methodischen Exkurses sollen die Möglichkeiten aufgezeigt werden, die die Einführung einer ägyptologischen Bildwissenschaft in Ergänzung zur Praxis einer eher formalistisch geprägten Denkmälerkunde beziehungsweise Kunstgeschichte anzubieten hat.

2. Bild, Bildsprache und Bildwissenschaft

So steht am Anfang die Frage: Was überhaupt ist ein Bild?[10] Anders als in der Ägyptologie[11] wird die Diskussion dieser Fragestellung in den so genannten Bildwissenschaften wie etwa der Kunstgeschichte, der Klassischen[12] und Vorderasiatischen Archäologie bereits seit eini-

10 Die hier vorgestellte Antwort kann natürlich nur ein weiterer Ansatz innerhalb einer seit der Antike geführten philosophischen Diskussion sein; vgl. dazu auch O. R. Scholz, Bild, Darstellung, Zeichen. Philosophische Theorien bildlicher Darstellungen, Frankfurt a. Main 2004, S. 13ff. Zur allgemeinen Diskussion einer Bildtheorie vgl. auch O. R. Scholz, Bild, Darstellung, Zeichen, 1ff.; M. Fauser, Einführung in die Kulturwissenschaft, Darmstadt 2003, S. 94ff.; W. J. T. Mitchell, Picture Theory. Essays on Verbal and Visual Representation, Chicago / London 1994.

11 Zur Funktion von Bildern s. die Beiträge von Roland Tefnin, Image, écriture, récit. A propos des représentation de la bataille de Qadesh, in: GM 47 (1981), S. 55ff.; Tefnin, Image et histoire. Réflexions sur l'usage documentaire de l'image égyptienne, in: CdE 54 (1979), S. 218ff.; Tefnin, Èlements sur une semiologie de l'image égyptienne, in: CdE 66 (1991), S. 60ff.

12 Vgl. zur Diskussion in der Klassischen Archäologie die grundlegenden Beiträge von T. Hölscher, Bilderwelt, Formensystem, Lebenskultur. Zur Methode archäologischer Kulturanalyse, in: Studi italiani di filologia classica 3. serie, 10, 1–2, 1992, S. 460ff.; Bildwerke; Darstellungen, Funktionen, Botschaften, in: A. H. Borbein, T. Hölscher, P. Zanker (Hg.), Klassische Archäologie. Eine Einführung, Berlin 2000, 147ff.; P. Zanker, Bild-Räume und Betrachter im kaiserzeitlichen Rom, in: A. H. Borbein, T. Hölscher, P. Zanker (Hg.), Klassische Archäologie. Eine Einführung, Berlin 2000, S. 205ff.

gen Jahren deutlicher geführt. In diesem Zusammenhang sind vor allem Titel wie »Bild-Anthropologie«[13] und »Der zweite Blick. Bildgeschichte und Bildreflexion«[14] von Hans Belting sowie »Was ist ein Bild?«[15] und »Homo pictor«[16] von Gottfried Boehm als Herausgeber zu nennen. Im Umfeld der Vorderasiatischen Archäologie haben kürzlich Marlies Heinz, Dominik Bonatz und weitere Autoren in der Aufsatzsammlung »Bild – Macht – Geschichte. Visuelle Kommunikation im Alten Orient«[17] auf diese Thematik reflektiert. Da die in den Nachbardisziplinen entwickelten Ansätze ebenso ihre Geltung in Anwendung auf die altägyptischen Bildwerke besitzen, sollen die wichtigsten Punkte dieses Diskurses im Folgenden zusammengetragen werden. So sei also noch einmal die Frage gestellt: Was ist ein Bild, wie funktioniert es und wie wirkte insbesondere ein altägyptisches Bild? Auch dieser Zusammenhang kann in Form eines Modells verdeutlicht werden:

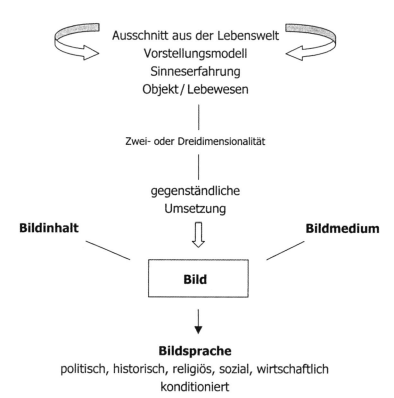

Abbildung 2: Definition des Bildbegriffs

Im Rahmen der visuellen Kommunikation ist ein Bild eine zwei- oder dreidimensional gegenständlich gewordene oder konstruierte Umsetzung eines Objekts oder Lebewesens, eines Ausschnitts aus der Lebenswelt, einer Sinneserfahrung oder eines Vorstellungsmodells.[18] Bilder besitzen in historischen Medien und Techniken eine Zeitform, gehen aber zumeist aus

13 H. Belting, Bild-Anthropologie, München 2001.

14 H. Belting / D. Kamper (Hg.), Der zweite Blick. Bildgeschichte und Bildreflexion, München 2000.

15 G. Boehm (Hg.), Was ist ein Bild? München 1994.

16 G. Boehm (Hg.), Homo pictor. Colloquium Rauricum Band 7, München / Leipzig 2001.

17 M. Heinz / D. Bonatz (Hg.), Bild – Macht – Geschichte. Visuelle Kommunikation im Alten Orient, Berlin 2002.

18 Vgl. zu den »Körperbildern« den Beitrag von G. Moers im vorliegenden Band. Dieser Aspekt wurde hier ausgeklammert.

überzeitlichen und kulturell übergreifenden Themen wie Welterfahrung und Weltrepräsentation – Belting stellt in diesem Zusammenhang die Bereiche Tod, Körper und Zeit in den Vordergrund – hervor, die in unterschiedlichen Formen und Kontextualisierungen in Erscheinung treten.[19] Von einer Bilderfahrung ist zu sprechen, wenn etwas als etwas *im Bild* sichtbar wird.[20] Ein Gegenstand fungiert dabei als Träger, er transportiert die Information, kann jedoch auch unabhängig von der Bildaussage betrachtet werden. Bernhard Waldenfels redet hier von einer ikonischen Differenz, also einer Disjunktion der Bildaussage: dem, was bildhaft sichtbar ist, und dem Medium, in dem es manifest wird.[21]

Am Wirkungsprozess von Bildern sind nicht nur verschiedene, in unterschiedlichem Maße korrelierende Funktionsebenen beteiligt, hinzu kommen die Komponenten der Bildintention und -rezeption. Die Wirkungsstrukturen der Bildsprache entwickeln sich in und orientieren sich an ihrem jeweiligen kulturellen Aktionsbereich. Die an sie gestellten Ansprüche sind durch politische, historische, religiöse, soziale oder wirtschaftliche Faktoren konditioniert.

3. Wirkungsstrukturen der Bildsprache

Es kann als Grundeigenschaft eines jeden, so auch des altägyptischen Bildes gelten, dass dieses etwas vergegenwärtigt, was nicht gegenwärtig ist. Es transformiert, um erneut mit Waldenfels zu sprechen, Ferne in Nähe, lässt Abwesendes anwesend sein.[22] Die repräsentative Funktion des Bildes, die als Voraussetzung dafür anzusehen ist, dass das Abbildende auf das Abzubildende referiert, wird durch die Verwendung eines spezifischen, zumeist ikonischen Zeichenrepertoires erreicht. Das Signifikans muss dem Signifikat dazu nicht notwendigerweise ähnlich sein; der Bezug kann ebenso kausal oder konventionell zustande kommen.[23]

Das Bild ist gebunden an eine individuelle oder kollektive Codierung, die sich im Rahmen kultureller Konventionen bewegt und auf einen gesellschaftlichen Konsens abhebt. Die Wahrnehmung des Bildes vollzieht sich über Rezeptionstechniken, die in Abhängigkeit von eben jenem Konsens in verschiedenen kulturellen, sozialen und historischen Räumen auf unterschiedliche Weise eingeübt werden. Die mediale Vermittlung und kulturelle Inszenierung ermöglicht dabei die korrekte Auffassung respektive Decodierung des Bildgegenstands.

Sehen wir uns auch nicht in der Lage, die antike Darstellung in vollem Umfang ihrer ursprünglichen Semantik lesen zu können, so besitzt sie doch ihren Ort im kollektiven Gedächtnis unseres Bilddenkens.[24] Die im Grundsatz vorhandene und empirisch geschulte Fähigkeit, das Korrelat von Bild und Medium zu erfassen, erlaubt es uns, mit jenem Gegenstand, der außerhalb unserer eigenen kulturellen Kompetenz angesiedelt ist, zu arbeiten. Innerhalb dieses Wahrnehmungsprozesses sollte sich die Interpretation der antiken Darstellung jedoch so weit wie möglich von Bewertungskategorien entfernen, die, im Zuge der mo-

19 H. Belting, Bild-Anthropologie, S. 23.

20 B. Waldenfels, Spiegel, Spur und Blick. Zur Genese des Bildes, in: G. Boehm (Hg.), Homo pictor. Colloquium Rauricum Band 7, München / Leipzig 2000, S. 15.

21 B. Waldenfels, Spiegel, Spur und Blick, S. 15.

22 B. Waldenfels, Spiegel, Spur und Blick, S. 23.

23 B. Waldenfels, Spiegel, Spur und Blick, S. 24f.

24 »Die Krise der Repräsentation ist in Wahrheit ein Zweifel an der Referenz, die wir den Bildern nicht mehr zutrauen. Die Bilder scheitern nur dort, wo wir in ihnen keine Analogien mehr für das finden, was den Bildern vorausgeht und auf das sie sich in der Welt beziehen können.« H. Belting, Bild-Anthropologie, S. 18.; vgl. auch J. Assmann, Religion und kulturelles Gedächtnis, München 2000, bes. S. 116f.

dernen Kunstbetrachtung, »Qualitäten wie Perspektiven heutiger Wahrnehmung und Klassifi-
kation transportieren«[25]. So stellt der heutige Betrachter dieser Objektivationen zumeist die
Frage nach dem ästhetischen Wert und der künstlerischen Qualität derselben, vernachlässigt
daneben aber allzu häufig den Praxisbereich: ihre Funktionalität und kontextuelle Einbin-
dung.

4. Ästhetik[26]

Die Ästhetik des altägyptischen Bildwerkes erhält vor allem im Umfeld seiner musealen Vi-
sualisierung und Konzeptionalisierung einen deutlichen Akzent. Der Begriff »Schönheit« be-
sitzt nicht nur für den laienhaften Betrachter ägyptischer Denkmäler immer noch einen hohen
Stellenwert, auch im wissenschaftlichen Diskurs der Ägyptologie findet er bisweilen Akzep-
tanz, verbleibt aber, zumeist eher oberflächlich behandelt,[27] im Bereich des Undefinierten
oder undefinierbar Erscheinenden.[28]

 Auch im Zusammenhang mit der Frage nach der Definition des ägyptologischen Kunstbe-
griffs treffen wir nicht selten auf die quasi rechtfertigende Argumentation, das ägyptische
Bild sei, im wesentlichen aufgrund seines ästhetischen Gehaltes, als Kunstwerk anzuspre-
chen. Diese eher unreflektiert anmutende Übertragung eines europäischen Kunstbegriffs[29] im
Sinne des Primats gezielt intendierter Schönheit verstellt jedoch die Sicht auf die Andersar-
tigkeit der antiken Kultur zugunsten einer expliziten Anerkennung derselben.[30] Die ästheti-
sierende Ausdeutung der Bilder reduziert diese auf die Projektionen subjektiver Kennerschaft[31],
codiert sie in diesem Sinne sogar um und verliert im Zuge dessen die primär funktional orien-
tierte Konzeption aus dem Blick, deren Durchsetzungsvermögen für die eigentliche Qualität,
besser: Kontinuität des ägyptischen Bildes steht. Zweifellos besitzt ein nicht geringer Teil der
altägyptischen Darstellungen eine ästhetische Komponente, die einer bloßen Regelhaftigkeit
»Richtigkeit« gegenüberstellt. Diese liegt jedoch weniger im motivlichen als im gestalteri-
schen Bereich. So spricht Friedrich Junge von der »ästhetischen Wohlgefälligkeit ägyptischer
Kunstwerke« als der »Essenz ihres Gelungen-Seins«.[32] Dieses Moment der Schönheit oder

25 M. Leicht, Die erste Pflicht der Bildwissenschaft besteht darin, den eigenen Augen zu mißtrauen, in: M.
 Heinz / D. Bonatz (Hg.), Bild – Macht – Geschichte, S. 23.

26 Zu einer Definition der »ägyptischen Ästhetik« vgl. auch A. Verbovsek »Theorie und Praxis«, S. 60ff.

27 Anders dagegen M. Müller, die sich sehr intensiv mit diesem Thema auseinandergesetzt hat: M. Müller,
 Egyptian Aesthetics in the Middle Kingdom, in: C. J. Eyre (Hg.), Proceedings of the Seventh International
 Congress of Egyptologists, OLA 82, Leuven 1998, S. 785ff.; M. Müller, Schönheitsideale in der Ägyptischen
 Kunst, in: H. Györy, Mélanges offerts à Edith Varga, in: Bulletin du Musée Hongrois des Beaux-Arts, Supplé-
 ment – 2001, S. 239ff.

28 Vgl. zum Problem der Definition F. Junge, Versuch einer Ästhetik der ägyptischen Kunst, in: M. Eaton-
 Krauss / E. Graefe (Hg.), Studien zur ägyptischen Kunstgeschichte, HÄB 29, Hildesheim 1990, S. 1ff.

29 Die Definition des europäischen Kunstbegriffs und seiner Entwicklung würde uns hier vor eben dieselben
 Probleme stellen. Zum Wesen der Kunst und zum Kunstbegriff s. H. Kuhn, Die Ontogenese der Kunst, in:
 D. Henrich / W. Iser (Hg.), Theorien der Kunst, Frankfurt a. Main 1992, S. 81ff.; s. hierzu auch M. Müller,
 Ägyptische Kunst aus kunsthistorischer Sicht, S. 39ff.

30 M. Leicht, Die erste Pflicht, S. 33.

31 F. Junge, Ästhetik, S. 3ff.

32 F. Junge, Ästhetik, S. 22.

Vollkommenheit, das auf dem Gelingen des bildhaften Gegenstands aufruht, sollte jedoch lediglich als *ein* Element der Bildintention aufgefasst werden.[33]

5. Rezeptionsästhetik

Bevor wir uns intensiver mit den diversen Funktionsebenen des ägyptischen Bildes auseinander setzen, sei die Konzentration zunächst auf die Rolle des Bildbetrachters gelenkt. Dazu möchte ich den in der deutschen Kunstwissenschaft noch recht jungen[34] und in der ägyptologischen Kunstforschung bis dato nicht verwendeten Begriff der Rezeptionsästhetik[35] einführen, der die konstruktive Rolle des Publikums im schöpferischen oder ästhetischen Prozess hinterfragt und die Kommunikationswege beziehungsweise -modi zwischen Auftraggeber, Produzent, Werk und Adressat nachzeichnet. Diese Form der Betrachterforschung versucht unter anderem ursprüngliche Rezeptionssituationen zu rekonstruieren und die im Bild vorgegebene Rezipientenfunktion zu erfassen.[36] Darüber hinaus bezieht die Rezeptionsästhetik die Zugangsbedingungen des Bildes, also die Rezeptionssituation und Rezeptionsrealität ein.[37]

 Auch in Anwendung auf die altägyptischen Bilder besitzt die Rolle des respektive der Adressaten eine spezifische Relevanz. Gerade für die antike Darstellung sind verschiedene Betrachterebenen anzunehmen, die sich an mehrere Rezipientengruppen – die Königsfamilie, die Priester- oder Beamtenschaft, die Besucher eines Tempels oder Grabes – oder auch an die Götter richteten, die eine ikonische Botschaft in unterschiedlicher Weise decodierten. Der altägyptische Betrachter besaß, anders als der moderne interpretierende, nach Bedeutung suchende und distanzierte Museumsbesucher oder Ägyptentourist, der das Denkmal isoliert wahrnimmt, situative Präsenz und die erforderliche kulturelle Kompetenz. Er war in den Funktionsablauf des Bildgeschehens integriert, stand in einer direkten existenziellen Verbindung zu den Bildern, die für ihn eine, so Michael Leicht, »ganz diesseitige lebensweltliche Wirkkraft« besaßen.[38] Die Rezeptionssituation wurde determiniert durch Kontextualität, beispielsweise durch die architektonische Abgrenzung und mediale Exposition, durch funktionale Einbindung, epigraphische Ausstattung sowie formale Konventionalisierung. Im Rahmen dessen agierte der Produzent des Bildes, der Künstler beziehungsweise Handwerker, nach den Vorgaben seines Auftraggebers unter der Prämisse funktionaler Vollkommenheit: der idealen Korrelation von Bild, Inschrift und Funktionskontext.

33 S. an dieser Stelle auch die Unterscheidung von »freier« und »anhängender Schönheit« in: I. Kant, Kritik der praktischen Vernunft. Kritik der Urtheilskraft. Akademie-Textausgabe Bd. 5, Berlin 1968 = 1908–1913, S. 231,

34 W. Kemp, Kunstwissenschaft und Rezeptionsästhetik, in: W. Kemp (Hg.), Der Betrachter ist im Bild. Kunstwissenschaft und Rezeptionsästhetik, Berlin 1992, S. 8.

35 Vgl. auch den Beitrag »Die Königsplastik des Mittleren Reiches und ihre Schöpfer: Reden über Statuen – Wenn Statuen reden« von M. Müller in diesem Band, S. Seite 27.

36 W. Kemp, Kunstwerk und Betrachter: Der rezeptionsästhetische Ansatz, in: H. Belting et al. (Hg.), Kunstgeschichte. Eine Einführung, Berlin 1996, S. 244.

37 W. Kemp, Kunstwissenschaft und Rezeptionsästhetik, S. 24.

38 M. Leicht, Die erste Pflicht, S. 28.

6. »Imago aegyptia« – Korrelationen von Bild, Inschrift und Funktionskontext

In einem exakt determinierten und mit komplexer Information versehenen Kontext isoliert das altägyptische Bild das Signifikat aus seinem Existenzzusammenhang und transformiert es in einen anderen Existenzmodus.[39] Das Dargestellte wird in einen abstrakten Aktionsraum integriert, der lebensweltliche Qualitäten, wie zum Beispiel Vergänglichkeit und Tod, Verantwortlichkeit und Schwäche sowie Abnormität, ausgrenzt beziehungsweise als Zeichen des Fremden oder Untergeordneten konstituiert. Durch diese Form der Verwendung erhält das aufgrund seiner Konnotierung nun als Ikon anzusprechende Bild einen neuen, zumeist zur Anschauung geeigneten Wirkungsbereich, in dem es als Element eines Funktionsablaufs im Sinne eines Referens konkreter Inhalte bestimmte Aufgaben übernimmt. Die Inszenierung des Darzustellenden durch ein Medium begründet dabei den Prozess der »Sinnaufladung durch Isolation«[40] und somit einen Akt kulturspezifischer Wahrnehmung. Durch ihre körperhafte Präsenz im sozialen, das heißt im öffentlichen oder privaten Raum, konnte die Objektivation am Kultgeschehen teilhaben, Rituale empfangen und interaktiv agieren.[41] Dazu wird sie häufig mit erläuternden Inschriften verbunden, die eine Identifikation des wiedergegebenen Motivs gewährleisten, seine magische Belebung initiieren oder seine rituelle Einbettung manifestieren. Umgesetzt in eine Graphik kann die Kontextualisierung des Bildes folgendermaßen beschrieben werden:

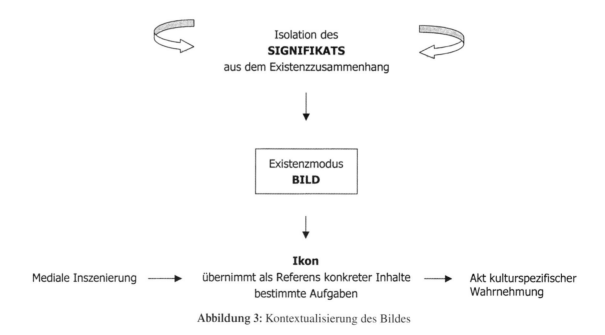

Abbildung 3: Kontextualisierung des Bildes

39 M. Leicht, Die erste Pflicht, S. 28; F. Junge, Ästhetik, S. 19.

40 F. Junge, Ästhetik, S. 19.

41 H. Belting, Bild-Anthropologie, S. 25.

7. Repräsentation von Herrschaft in der Antike und Moderne

Die Etablierung eines gesellschaftlichen Systems, in dem eine institutionalisierte Herrschafts-
form verankert ist, kann als Voraussetzung für eine differenzierte Rezeption von Bildern gel-
ten.[42] Das Bildschaffen der altägyptischen Kultur ist im Allgemeinen nicht als subjektiv inten-
dierter Akt des einzelnen Künstlers zu verstehen; vielmehr geht es von gesellschaftlichen
Triebkräften aus, die auf die Vorgaben der Bildproduktion einwirkten[43]. Die Bilder fungierten
somit als Agitatoren der personalen Kräfte, die den Zugang zur Herstellung von Bildern domi-
nierten.[44] Für die altägyptische Kultur waren dies im Wesentlichen der König und sein unmit-
telbares Umfeld.

Die persuasive Vermittlung einer autoritär geprägten Weltsicht[45] über das Medium Bild
treffen wir aber nicht nur in alten,[46] sondern auch in modernen Kulturen des Nahen Ostens
an. Raum- und zeitübergreifend erfasst Marlies Heinz in einem Satz den Kern solcher Kon-
zepte von Machtrepräsentation. Indem sie sagt: »Um ›in aller Munde‹ zu sein, muss man ›im
Bild‹ sein,«[47] betont sie einerseits die Machtpotenzierung derjenigen, die in autoritären oder
totalitären Systemen über die Bildproduktion verfügen, andererseits stellt sie heraus, dass
diese ebenso der sich verselbstständigenden Wirkung des Bildes ausgesetzt sein können.[48] So
waren ähnlich ambivalente Prozesse in der jüngsten Vergangenheit im Zusammenhang mit
der Entmachtung Sadam Husseins zu verfolgen.[49]

Anders jedoch als die Bilder des Autokraten, die machtpolitische Potenz evozieren und ein
breites, heterogenes Publikum ansprechen sollten,[50] wurden die altägyptischen Darstellungen
im Sinne machtaufgeladener Instrumente herrschaftlicher oder religiöser Agitation einge-
setzt, die auf bestimmte Rezipientenschaften zielten. In diesem Sinne sind auch die bereits in
der Zeit der Dynastie 0 belegten und bis in die Spätzeit eingesetzten Hebseddarstellungen zu
verstehen, an denen im folgenden die im Vorfeld zusammengetragenen Überlegungen kurso-
risch exemplifiziert und dokumentiert werden sollen.

42 M. Leicht, Die erste Pflicht, S. 29.

43 S. dazu auch A. Verbovsek, Pygmalion in Ägypten? oder »Einer, der sein Handwerk versteht ...« – Diskursi-
 ve Überlegungen zum Berufsstand des »Künstlers« (Aufsatz im Druck).

44 M. Leicht, Die erste Pflicht, S. 30.

45 M. Leicht, Die erste Pflicht, S. 29.

46 Vgl. z. B. die Diskussion um die Medialität von Bildern in der Klassischen Archäologie. S. dazu S. Muth,
 Gewalt im Bild. Das Phänomen der medialen Gewalt im Athen des 6. und 5. Jh. v. Chr. Bild und Kontext /
 Image and Context 1, Berlin 2006.

47 M. Heinz, Bild und Macht in drei Kulturen, in: M. Heinz / D. Bonatz (Hg.), Bild – Macht – Geschichte, S. 72.

48 Zum Verhältnis von Kunst und Politik s. K. von Beyme, Die Kunst der Macht und die Gegenmacht der Kunst.
 Studien zum Spannungsverhältnis von Kunst und Politik, Frankfurt a. Main 1998.

49 In den Medien wurde gerade der Bildersturm zum wirksamen Zeichen für die abrupte und gewaltsame Ände-
 rung der Machtverhältnisse im Irak: http://www.3sat.de/kulturzeit/themen/45339 (Stand 15.7.2005).

50 Vgl. z. B. eine Darstellung, die Hussein als Assyrer auf der Löwenjagd zeigt in M. Heinz, Bild und Macht in
 drei Kulturen, Abb. 22.

8. Darstellungen des Hebsed

Bei der Durchsicht der von Elisabeth Staehelin und Erik Hornung in Aegyptiaca Helvetica zusammengestellten Quellen[51] fällt sogleich die unterschiedliche mediale Bindung der Hebseddarstellungen auf. Die frühesten Beispiele dieses Motivs sind in szenisch aufgebauten Reliefs auf Keulenköpfen anzutreffen.[52] Die narrative Struktur des zweidimensionalen Bildes verweist, über die rein personale Repräsentation des Königs hinaus, auf bestimmte Formen und Aspekte von Herrschaft. Sie zeichnet den Ablauf des Festes nach und fokussiert die rituellen Ereignisse. Dieser politisch wie religiös äußerst wichtige Ausschnitt aus der altägyptischen Lebenswelt, der nicht auf eine reale Begebenheit, also ein tatsächlich durchgeführtes Hebsed referieren muss, wird kanonisiert und zeitlich zerdehnt[53]. Er wird aus seinem realen oder virtuellen Existenzzusammenhang – dem Festgeschehen – gelöst und in einen anderen Existenzmodus – das Ikon – überführt. Somit wird auch hier bereits Vergangenes in Gegenwärtiges transformiert.

Das Bildmedium »Keule« erscheint als Waffe im Kampf wie im Ritual ausschließlich als Instrument königlicher Machtdemonstration und wird als solches unmittelbar mit dem Herrscher assoziiert. Die Verwendung des Gegenstands im Kontext des Tempelareals von Hierakonpolis konkretisiert seine Funktion: Die dargestellten und somit situationsrelevant abrufbaren Handlungen waren der Interaktion mit den Göttern gewidmet. In den Bildern erscheint der Herrscher prominent. Er thront, seiner Bedeutung gemäß durch die Platzierung in einer Kapelle herausgehoben und ausgestattet mit den entsprechenden ikonographischen Denotationen, im Zentrum des Geschehens. Gottheiten treten in dieser Szenerie nicht explizit auf; die anwesenden Personen sind dem Herrscher eindeutig untergeordnet. Durch diese deutliche Akzentuierung seiner eigenen Stellung positioniert sich der König in der kosmischen Gesamtordnung sowie gegenüber seiner Sakralelite. Die frühesten Hebsedbilder auf den Keulenköpfen fungierten somit als Zeichen herrschaftlicher Legitimierung im historischen Kontext der Etablierung des Königtums.

Die Keulenköpfe werden als Bildträger jedoch bald obsolet.[54] Bereits aus der Zeit des Djoser liegen uns die ersten Belege des Hebsedmotives in großformatigen Wandszenen vor, die bis zum Beginn der 12. Dynastie zum Bildprogramm der königlichen Kultanlagen gehören.[55] In diesem Aktionsraum wird der König nicht nur als Thronender, sondern auch, aus dem Gesamtzusammenhang gelöst, als aktiv Agierender im Hebsedlauf gezeigt.[56] Es erscheint plausibel, dass der König gerade im funerären Kontext vor allem den Aspekt der Regeneration beziehungsweise Verjüngung prononciert und diesen durch die Wiedergabe in den Innenräumen des Toten- oder Taltempels dauerhaft im Kultgeschehen verankert.

Vom Beginn der 12. Dynastie an sind die Sedfestdarstellungen dann, neben anderen Kon-

51 E. Hornung / E. Staehelin, Aegyptiaca Helvetica, Studien zum Sedfest, Genf 1974.

52 Oxford, Ashmolean Museum 1896–1908 E.3631; London, University College 14898. Vgl. B. Adams, Ancient Hierakonpolis, Warminster 1974, Taf. 1ff.; K. M. Ciałowicz, Les têtes de massues des périodes prédynastique et archaïque dans la vallée du Nil, Warschau / Krakau 1987, S. 31ff.; J. E. Quibell, Hierakonpolis I, Taf. 25; 26 B; H. Sourouzian, L'iconographie du roi dans la statuaire des trois premières dynasties, in: DAIKS 28, 1995, S. 133ff.

53 J. Assmann, Die Macht der Bilder. Rahmenbedingungen ikonischen Handelns im Alten Ägypten, in: Visible Religion 7, 1989, S. 3.

54 J. Assmann, in: Visible Religion 7, 1989, S. 6.

55 E. Hornung / E. Staehelin, Sedfest, S. 20ff.

56 Dazu in C. M. Firth / J. E. Quibell, Excavations at Saqqara. The Step Pyramid II, Kairo 1935, Taf. 15ff.; 42ff.

texten, verstärkt in der bildlichen Ausstattung von Göttertempeln nachzuweisen.[57] Auch in diesem Zusammenhang kann weder zwingend auf die Historizität des Abgebildeten noch auf die tatsächliche Funktion der Raumeinheit als Ort des wiedergegebenen Geschehens geschlossen werden. Die Hebsedszenen erhalten hier einen exponierteren Zugang, indem sie, hieroglyphisch verkürzt und emblematisch verdichtet, als Zeichen der Doppelherrschaft und dauerhaften Regierung des Königs auf Architraven von Tordurchgängen angebracht werden.[58]

Das Rundbild, in dem sich die verjüngte Erscheinungsform des Herrschers spätestens seit der 1. Dynastie manifestiert,[59] ist das Medium, in dem die Bedeutung, die der Königs innerhalb des Sedfestes einnimmt, die deutlichste Konkretisierung erfährt.[60] Die dreidimensionale Wiedergabe, die sowohl im Grab als auch im Tempel Aufstellung fand, akzentuiert seine durch das Ritual kontinuierlich gestärkte Stellung oder die Aussicht auf eine solche und ermöglicht die gezielte Inszenierung dieser Konnotation.

Die kurzen Beischriften der Hebseddarstellungen beziehen sich vorrangig auf die Identität des Wiedergegebenen oder auf die abgebildete Handlung. Daneben kann, in Form einer standardisierten Götterrede, auf den Wunsch bezug genommen werden, die königliche Herrschaft dauerhaft werden zu lassen. Inschriften, die auf ein tatsächliches historisches Ereignis rekurrieren, erscheinen dagegen eher auf bildfrei gestalteten Medien.[61]

9. Resümee

Wie durch eine ganzheitliche Betrachtung von Bildinhalt, -medium, -funktion und -kontext gezeigt werden konnte, ist die Konnotation der Hebseddarstellung nicht nur als Wiedergabe eines historischen beziehungsweise rituellen Zusammenhangs konzipiert. Die im Bild verkürzte und ikonisch kanonisierte Sinneinheit der altägyptischen Lebenswelt konstruiert, ohne auf ikonographischer oder kompositorischer Ebene deutliche Modifizierungen zu erfahren, in verschiedenen Aktionsräumen und in Verbindung mit unterschiedlichen Medien neue und differenzierte Wirklichkeiten: In bezug auf das Sedfestthema sind dies die verschiedenen Komponenten der herrschaftlichen Repräsentation des ägyptischen Königs.

57 E. Hornung / E. Staehelin, Sedfest, S. 27ff.

58 Vgl. z. B. einen Architrav aus dem Tempel des Month in Medamud, der, in antithetischer Anordnung, zweimal Sesostris III. im Hebsedornat und mit unterschiedlichen Kronen in einem Pavillon zeigt, in K. Lange / M. Hirmer, Ägypten. Architektur, Plastik, Malerei in drei Jahrtausenden, München 1967, Abb. 104.

59 E. Hornung / E. Staehelin, Sedfest, 18ff.

60 Als frühestes Beispiel gilt eine Elfenbeinstatuette in London, British Museum 37.996; vgl. H. Sourouzian, in: DAIKS 28, 1995, S. 133ff.

61 Vgl. zum Nachweis tatsächlich gefeierter Sedfeste E. Hornung / E. Staehelin, Sedfest, S. 51ff.; 65ff.

Christiane Ziegler

Nouvelles découvertes à Saqqara

Depuis 1991 la Mission archéologique du musée du Louvre étudie un secteur de Saqqara situé au nord de la chaussée d'Ounas. Il s'agit bien entendu d'un travail collectif pour lequel, sous l'autorité du chef de la mission, chacun des collaborateurs apporte sa contribution. L'équipe rassemble des chercheurs et techniciens du musée du Louvre, du CNRS et quelques spécialistes d'institutions étrangères[1]. Les recherches sont financées par la Mission Recherche et Technologie du ministère de la Culture.

Rappelons les raisons qui ont amené le Louvre à conduire une fouille à Saqqara: il s'agissait de retrouver l'emplacement originel du mastaba d'Akhethetep dont la publication était programmée par le musée. En effet, sa chapelle magnifiquement décorée, vendue en 1903 par le gouvernement égyptien, avait été démontée puis transportée au musée du Louvre; depuis, elle y illustre pour le public occidental un des temps forts de l'art égyptien, celui de l'époque des pyramides. Elle date sans doute du règne de Niouserrê (vers 2453-2420 avant J.-C.).

Aujourd'hui le principal objectif a été atteint: le mastaba dans lequel s'insérait la chapelle décorée du Louvre a été localisé et suffisamment dégagé pour qu'un plan d'ensemble soit dorénavant dressé. La zone actuellement fouillée mesure environ 7000 m² et, en plusieurs points, le dénivelé atteint entre le niveau du sol actuel et le niveau de l'Ancien Empire est de 10 mètres.

A l'automne 1999, le monument d'où provient la chapelle est découvert. Long de 32 mètres, large de 16 mètres, c'est un des plus grands mastabas de Saqqara (Taf. 28a). Ses murs sont conservés jusqu'à une hauteur de plus de 6 mètres ainsi que son parement extérieur de beau calcaire blanc, très rare sur le site. La façade orientale porte en creux l'emplacement où venait s'insérer la chapelle du Louvre; aucun doute n'est possible: on y a retrouvé des inscriptions de tâcherons dont une mentionne Akhethetep. Non loin de là, on a découvert trois statues qui lui appartiennent. Le puits, profond de 23 mètres, exploré à l'automne 2000, aboutit à un caveau rupestre. Un monumental sarcophage de granit fermé par un couvercle de calcaire y attendait les fouilleurs; hélas, dès l'Antiquité il avait été violé par des pillards. Les vestiges encore en place dans le caveau suffisent pour imaginer la splendeur du trousseau funéraire d'Akhethetep: précieux vases d'albâtre et de schiste sombre, perle d'or en forme d'un coléoptère, vase canope ayant contenu les viscères extraites du corps lors de la momification. Vraisemblablement à la suite d'une erreur de livraison, les ouvriers du temps des pyramides avaient abandonné dans un angle du caveau, un second couvercle trop petit pour s'adapter au sarcophage.

1 La direction de la mission est assurée par C. Ziegler assistée de J.-P. Adam. Membres de la dernière campagne menée en avril-mai 2004 : Dr. P. Bourrier, C. Bridonneau, N. Couton-Perche, C. Décamps, T. Herbich, Dr. F. Janot, S. Labbé-Toutée, C. Lapeyrie, G. Lecuyot, M. F. de Rozières. Le Conseil Supérieur des Antiquités était représenté par S. M. el Assy et Y. Hassan. Les ouvriers étaient encadrés par le reis R. A. Chahat. Tous nos remerciements vont à Mr. Kamel Wahid, Directeur général du site de Saqqara.

Le mastaba d'Akhethetep se distingue par sa taille imposante, la qualité exceptionnelle de son architecture ainsi que l'existence d'un important complexe funéraire, jusque là inconnu, dont il forme le cœur. En octobre 1993 est apparue une petite chapelle anépigraphe dont le toit, parfaitement conservé, est constitué de trois grandes dalles de calcaire. A l'automne 1995 une autre chapelle a été mise au jour : c'est celle à laquelle l'archéologue Auguste Mariette avait attribué le numéro E 17 au milieu du XIX^{ème} siècle. L'intérieur montre un riche décor évoquant la vie quotidienne. Les inscriptions indiquent que son propriétaire était prêtre de la pyramide du roi Ounas.

Certaines parties de la nécropole de Memphis se présentent comme une « cité des morts », avec un quadrillage dense de rues bordées de tombes. Le secteur d'Akhethetep est particulièrement intéressant à cet égard. La façade est de son grand mastaba est longée par une vaste rue orientée nord-sud et qui sert d'axe à diverses constructions : portes sud et nord, cour d'entrée, chapelle symétrique à celle d'Akhethetep. La partie orientale de la rue est bordée par un haut mur de calcaire. Dans un angle de la cour, on a découvert encore en place sur le sol, un ensemble de petites tables d'offrandes ; elles portent les noms de différents prêtres funéraires. En mars 1997, une grande fausse porte magnifiquement sculptée au nom d'un autre Akhethetep a été découverte dans la partie nord-ouest de la rue.

Les trois dernières saisons de fouilles menées à l'est de la zone ont révélé que le complexe funéraire se poursuivait dans cette direction avec une série de chapelles anonymes bâties en calcaire le long d'une « Rue de mastabas » devant la façade orientale d'un mastaba s'étend une cour dans laquelle 26 puits funéraires ont été creusés : 9 ont été aujourd'hui fouillés. Tous sont de section plus ou moins carrée, creusés à faible profondeur dans le *gebel*, et donnent accès à une chambre funéraire de petite taille et de forme irrégulière aux murs juste épannelés. Les caveaux contenaient des corps non momifiés enveloppés dans des roseaux ainsi que du mobilier funéraire simple, peu abondant et particulièrement intéressant car dans sa disposition originale : ainsi le puits 10, profond de 2,55 mètres, était rempli de *taffla* ; au fond est creusé un caveau irrégulier orienté vers l'ouest. Le squelette d'une femme âgée d'une soixantaine d'années, témoignant d'une longévité exceptionnelle pour l'époque, y reposait dans un cercueil de roseaux. Tout près de la tête se trouvait un chevet de bois. D'autres caveaux ont livré des perles de faïence, des étoffes de lin et des bottes de roseaux ainsi que de la céramique typique de l'Ancien Empire. La plupart des corps appartiennent à de jeunes adultes d'environ 25 ans. C'est donc tout un ensemble de l'époque des pyramides qui peu à peu se dessine.

Au fur et à mesure de la fouille, des vestiges d'autres périodes ont été mis au jour, en particulier un très intéressant ensemble de bâtiments remontant à l'époque copte (VII^{ème}–IX^{ème} siècle après J.-C.) ainsi qu'une très vaste nécropole tardive (VI^{ème}–IV^{ème} siècle avant J.-C.) comprenant près d'une centaine de sarcophages déposés, à même le sable.

La poursuite des fouilles en octobre 2003 et avril 2004 nous a permis de dégager en deux points du site plusieurs tombes réutilisées à la Basse Epoque qui contenaient encore leur mobilier funéraire : dans deux caveaux découverts inviolés le mobilier avait conservé sa disposition d'origine. Ces derniers, accessibles par un puits profond de plus de 5 mètres, sont situés au nord-est de la fouille.

Le premier est une galerie rupestre dont la paroi occidentale est ornée d'une série de fausses portes. Il est probable qu'elle fut aménagée à l'Ancien Empire puis réutilisée plus tardivement comme en témoigne le matériel retrouvé en place. Sa partie nord est occupée par un beau sarcophage de bois placé transversalement (Taf. 28b). On a déposé devant lui tout un matériel en rapport avec l'enterrement et l'embaumement, comme de grands vases de terre

cuite intacts utilisés par les embaumeurs ; il y avait également des nattes de roseaux roulées. Ce sarcophage servait d'appui à une accumulation de momies bandelettées (une quinzaine bien visibles) qui ont été introduites après coup, par l'entrée originelle de cette longue galerie que nous n'avons pas encore découverte. Nous avons également décelé l'existence d'un caveau contigu, accessible par une porte murée dans l'Antiquité et que nous laissons intacte pour le moment. La galerie contenait un autre sarcophage de bois et un sarcophage de calcaire (Taf. 29a). Ils abritaient des momies très bien conservées. Les sarcophages de bois peuvent être datés des XXV$^{\text{ème}}$–XXVI$^{\text{ème}}$ dynasties.

Le second caveau est une petite salle rectangulaire creusée dans le *gebel*, et dans laquelle reposait un magnifique sarcophage de bois stuqué et peint à décor polychrome (Taf. 29b) : le fond noir est entièrement recouvert de textes funéraires et de petites scènes religieuses. Il était accompagné d'un petit coffret surmonté d'un oiseau *akhem*, contenant les organes retirés de la momie, et d'une statuette d'un Ptah-Sokar-Osiris. La date proposée pour cet ensemble, XXVI$^{\text{ème}}$–XXVII$^{\text{ème}}$ dynastie, s'appuie sur le nom du propriétaire Iahmès fils de Psametikseneb.

Dans l'espoir de localiser l'accès du premier caveau nous avons exploré des puits adjacents. Ils ne conduisaient pas au but que nous nous étions fixé mais à un réseau de galeries et de salles souterraines qui ont livré un abondant matériel du I$^{\text{er}}$ millénaire avant J.-C. : sarcophages intacts, ouchebtis rangés dans leur boite, Ptah-Sokar-Osiris ainsi qu'une collection de sarcophages au décor superbe, retrouvés démontés et empilés.

L'exploration du secteur ouest de la fouille nous a aussi réservé de belles surprises. Après le dégagement du puits principal du mastaba d'Akhethetep, il restait encore à déterminer si un autre puits ne correspondait pas à la stèle fausse porte décorant la face est du mastaba. Le dégagement a fait apparaître l'ouverture de deux puits moins grands et moins profonds que le puits principal. Ils ont été utilisés pour des sépultures collectives : ils donnent accès à une chambre principale pourvue de grandes niches dans les parois latérales, à une quinzaine de mètres de profondeur. Malgré le bouleversement général des lieux, l'une des tombes conservait de nombreux vestiges des inhumations qui y avaient été pratiquées : environ 60 personnes dont les momies ont été retrouvées dans un grand désordre, du au passage de pillards. Cependant plusieurs sarcophages étaient encore intacts et à leur place d'origine. Le plus spectaculaire possède un visage doré à la feuille encadré par une perruque bleu lapis avec, sur la poitrine, une scène d'offrande à Osiris rehaussée d'or. Un autre sarcophage porte la datation très précise de l'enterrement, inscrite en démotique : l'an II, premier mois de l'Inondation, de Nectanébo II, c'est-à-dire entre le 2 novembre et le 20 décembre 360 avant J.-C. Les défunts étaient accompagnés d'un mobilier réduit mais richement décoré : coffrets funéraires en bois stuqué et peint, résilles et amulettes en faïence, céramiques, bandelettes inscrites de chapitres du Livre des morts, masques et colliers à décor floral ; on a retrouvé 4 superbes oiseaux *akhem* qui devaient prendre place sur le couvercle des boîtes funéraires.

Exhumé des sables de Saqqara, c'est tout le paysage du temps des pyramides qui ressurgit peu à peu en un lieu où la carte archéologique est vierge. La découverte d'une vaste nécropole du premier millénaire avant J.-C., avec son labyrinthe de tombes rupestres partiellement inviolées, apporte des informations nouvelles sur l'occupation du site et sur les coutumes funéraires d'une période peu étudiée. Un des intérêts majeurs de son exploration, qui doit se poursuivre en avril 2005, réside dans la grande homogénéité du matériel découvert et dans la datation très précise d'une des inhumations.

Die Autorinnen und Autoren

Jun.prof. Dr. Gerald Moers
Seminar für Ägyptologie und Koptologie
Weender Landstrasse 2
D-37073 Göttingen
Deutschland

Dr. Dr. Maya Müller
(ehem.) Museum der Kulturen
Augustinergasse 2
CH-4001 Basel
Schweiz

Prof. Dr. Karol Myśliwiec
Uniwersytet Warszawski
Instytut Archeologii
Zaklad Archeologii Egiptologu
Department of Egyptian Archaeology
ul. Zwirki i Wigury 97/99
PL-02-089 Warszawa
Polen

Dr. Silvia Rabehl
Institut für Ägyptologie
Meiserstrasse 10
D-80333 München
Deutschland

Prof. Dr. Regine Schulz
The Walters Art Museum/Egyptian Collection
600 North Charles Street
Baltimore, Maryland 21201-5185
USA

Dr. Frank Steinmann
Ägyptologisches Institut/Ägyptisches Museum
Burgstrasse 21
D-04109 Leipzig
Deutschland

Prof. Dr. Claude Vandersleyen
Université Catholique de Louvain
Centre d'archéologie égyptienne
Département d'archéologie et d'histoire de l'art
Collège Erasme, Place Blaise Pascal 1
B-1348 Louvain-la-Neuve
Belgien

Dr. Vera Vasiljević
University of Beograd
Filozofski fakultet
Odeljenje ze Archeologiju
Cika Ljubina 18–20
YU-11000 Beograd
Serbien

PD Dr. Alexandra Verbovsek
Institut für Ägyptologie
Meiserstrasse 10
D-80333 München
Deutschland

Prof. Dr. Christiane Ziegler
Musée du Louvre
Département des Antiquités égyptiennes
F-75058 Paris Cedex 01
Frankreich

Tafel- und Abbildungsverzeichnis

Silvia Rabehl
Eine Gruppe von Asiaten im Grab
Chnumhoteps II. (BH 3)

Taf. 16a: P. E. Newberry, Beni Hasan, ASE 1, London 1893, Taf. 31.
Taf. 17a: P. E. Newberry, Beni Hasan I, Taf. 38.2.
Taf. 17b: P. E. Newberry, Beni Hasan I, Taf. 47.

Regine Schulz
Musikanten und Brettspieler
Gedanken zur Bild- und Textanalyse eines
bekannten Reliefs

Taf. 18 a: The Walters Art Museum, Baltimore.
Taf. 18 b: The Walters Art Museum, Baltimore.
Taf. 19 a: The Walters Art Museum, Baltimore.
Taf. 19 b: The Walters Art Museum, Baltimore.
Abb. 1: The Walters Art Museum, Baltimore/ Schema R. Schulz.
Abb. 2: Schema R. Schulz.

Frank Steinmann
Eine Stundenuhr aus Tuna el-Gebel

Taf. 20a: Plan F. Steinmann.
Taf. 20b: Plan F. Steinmann.
Taf. 21a: F. Steinmann.
Taf. 21b: F. Steinmann.
Taf. 22a: F. Steinmann.
Taf. 22b: F. Steinmann.
Taf. 22c: F. Steinmann.
Taf. 22d: F. Steinmann.
Taf. 23a: Zeichnung F. Steinmann.
Taf. 23b: Schema F. Steinmann.
Taf. 23c: L. Borchardt, Die altägyptische Zeitmessung. Die Geschichte der Zeitmessung und der Uhren, Bd. 1, Berlin / Leipzig 1920, Taf. 12.
Taf. 24a: L. Borchardt, Die altägyptische Zeitmessung, Abb. 12.
Taf. 24b: L. Borchardt, Die altägyptische Zeitmessung, Abb. 23.
Taf. 25a: F. Steinmann.

Claude Vandersleyen
Méditation devant une œuvre d'art : le visage
du trésorier Maya

Taf. 26a: Egypt Exploration Society.
Taf. 26b: C. Vandersleyen.
Taf. 26c: C. Vandersleyen.

Vera Vasiljević
Der König im Privatgrab des Mittleren
Reiches

Taf. 27: F. L. Griffith, The Inscriptions of Sîut and Dêr Rîfeh, London 1889, Taf. 4.
Abb. 1: N. de Garis Davies, The Tomb of Antefoker, Vizier of Sesostris I, and his Wife, Senet (N° 60), The Theban Tomb Series 2, London 1920, Taf. 16.
Abb. 2: P. Montet, Les tombeaux de Siout et de Deir Rifeh, in: Kêmi 3 (1930), Taf. 2.
Abb. 3 : G. Dreyer / U. Hartung / T. Hikade / E. C. Köhler / V. Müller / F. Pumpenmeier, Umm el-Qaab: Nachuntersuchungen im frühzeitlichen Königsfriedhof. 9./10. Vorbericht, in: MDAIK 54 (1998), Abb. 29.
Abb. 4: B. Jaroš-Deckert, Das Grab des *Jnjjtj.f.* Die Wandmalereien der XI. Dynastie. Nach Vorarbeiten von Dieter Arnold / Jürgen Settgast, Grabung im Asasif 1963–1970, AV 12, Mainz 1984, Abb. 15.
Abb. 5: H. E. Winlock, The Rise and Fall of the Middle Kingdom in Thebes, New York 1947, Taf. 37.

Alexandra Verbovsek
»Imago aegyptia«
Wirkungsstrukturen der Bildsprache und ihre
Rezeption. Ein programmatischer Ausblick

Abb. 1: Schema A. Verbovsek.
Abb. 2: Schema A. Verbovsek.
Abb. 3: Schema A. Verbovsek.

Christiane Ziegler
Nouvelles découvertes à Saqqara

Taf. 28a: C. Décamps/Musée du Louvre.
Taf. 28b: C. Décamps/Musée du Louvre.
Taf. 29a: C. Décamps/Musée du Louvre.
Taf. 29b: C. Décamps/Musée du Louvre.

Tafelteil

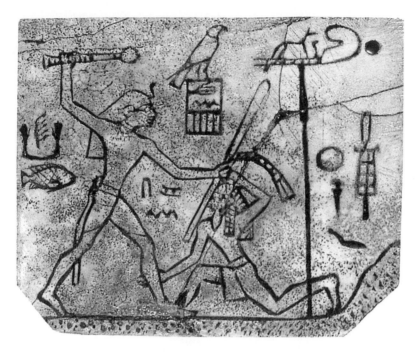

a) König Den beim Erschlagen der Feinde

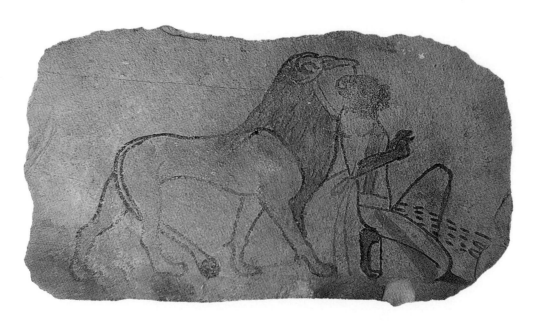

b) Löwengestaltiger König subjugiert angsterfüllten Nubier

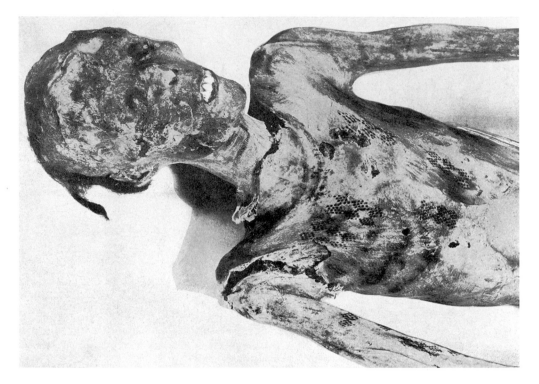

b) Mumie einer tätowierten Frau
aus dem Mittleren Reich

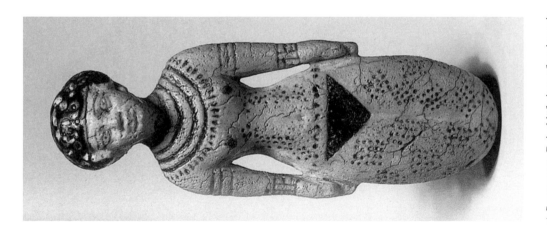

a) Sogenannte Beischläferinnenfigurine mit
Tätowierungen aus dem Mittleren Reich

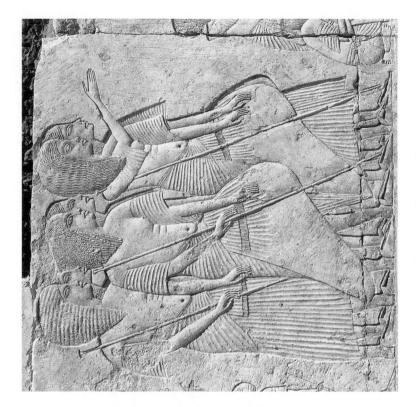

b) Noble aus dem Grab des Haremhab

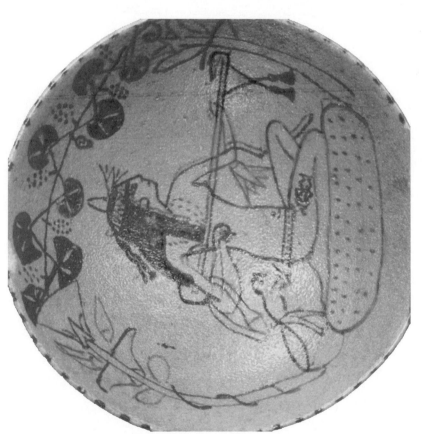

a) Musikantin mit Bes-Tätowierung
auf einer Fayence-Schale aus dem Neuen Reich

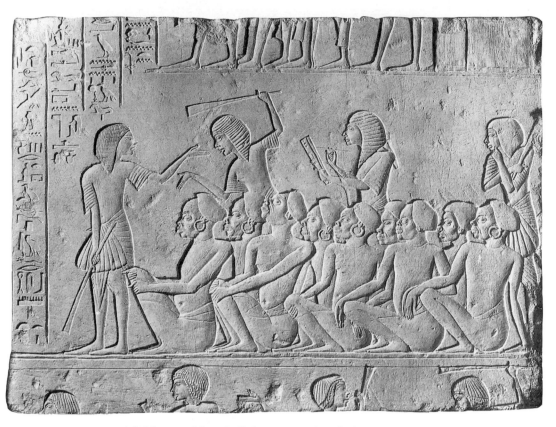

a) Soldaten und fremde Gefangene aus dem Grab des Haremhab

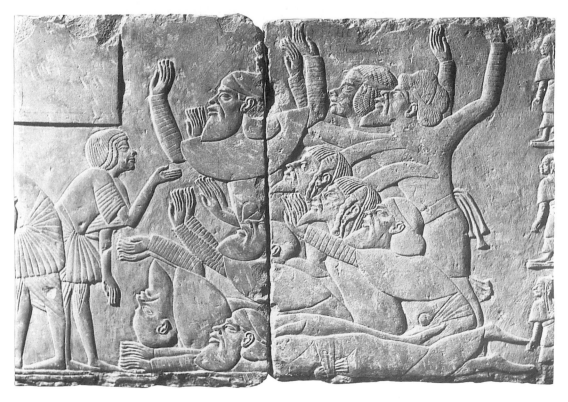

b) Fremde Fürsten aus dem Grab des Haremhab

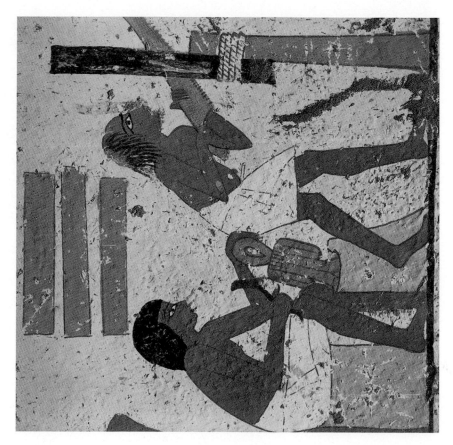

b) Holzhandwerker mit Halbglatze,
Bart und offenem Mund aus TT 181

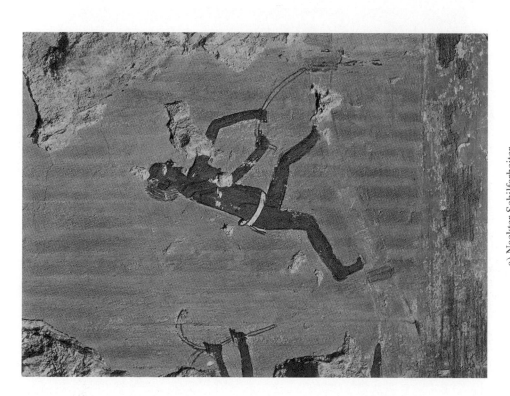

a) Nackter Schilfarbeiter
aus TT 82

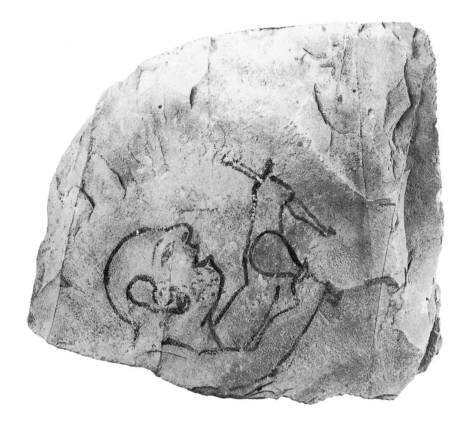

b) Unrasierter glatzköpfiger Steinmetz
mit offenem Mund

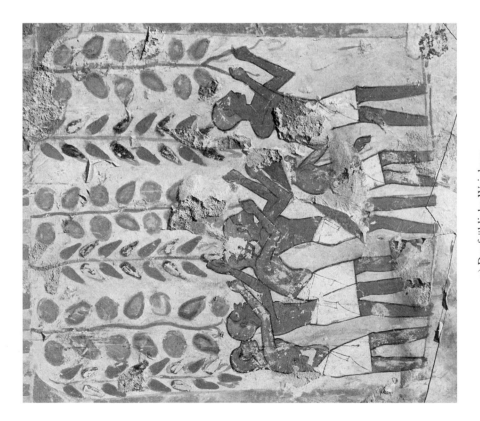

a) Der fröhliche Weinberg
aus TT 56

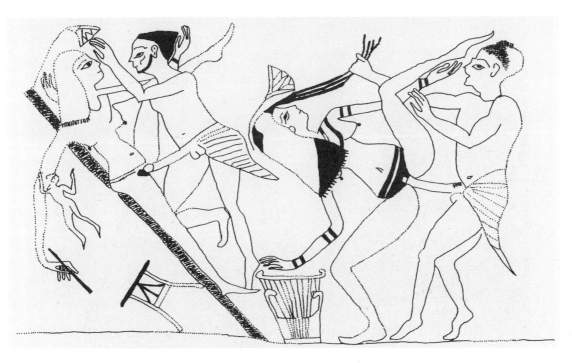

a) Derangierte Damen aus dem erotischen pTurin 55001 (Szenen 11 u. 12)

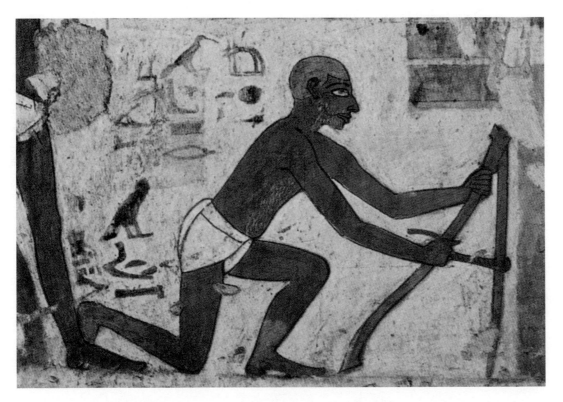

b) Älterer fremder Arbeiter mit starker grauer Körperbehaarung aus TT 100

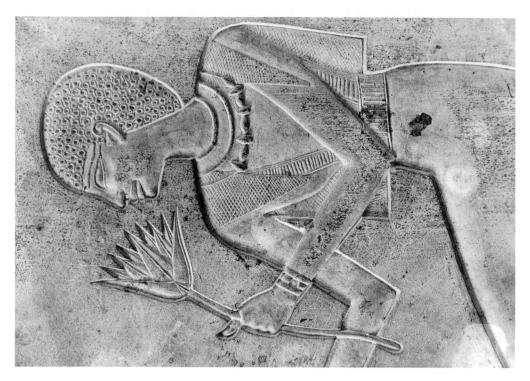

b) Ägyptisches Museum, Kairo JE 47397: Sarkophag der Kawit;
Fundort: Deir el-Bahari, Tempel Mentuhoteps II.; Kalkstein

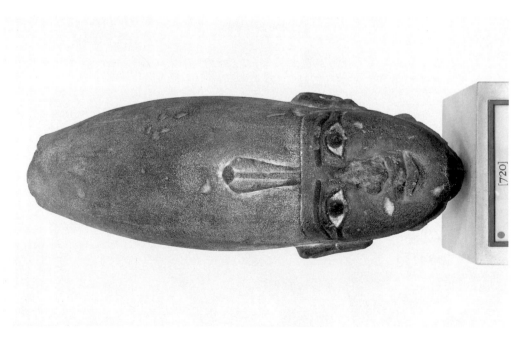

a) British Museum, London EA 720: Kopf Mentuhoteps II.;
Fundort: Deir el-Bahari, Tempel Mentuhoteps II., Sandstein; H. 38 cm

a) Museum of Fine Arts, Boston 38.1395; Mumiengestaltige Statue Mentuhoteps III.;
Fundort: Armant, Monthtempel; Sandstein; H. 213 cm

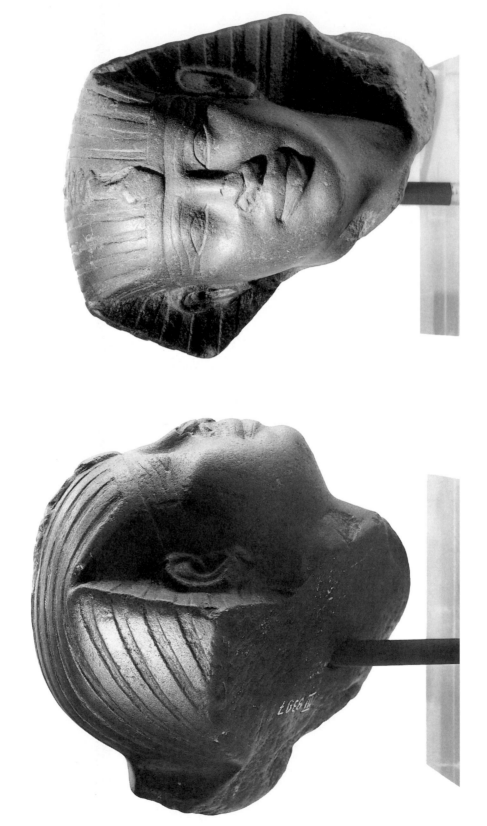

a) und b) Museum der Kulturen, Basel III 8397: Kopf von einer Gruppenstatue Mentuhoteps III.; Fundort unbekannt; Dunkelgrauer Quarzit; H. 15 cm

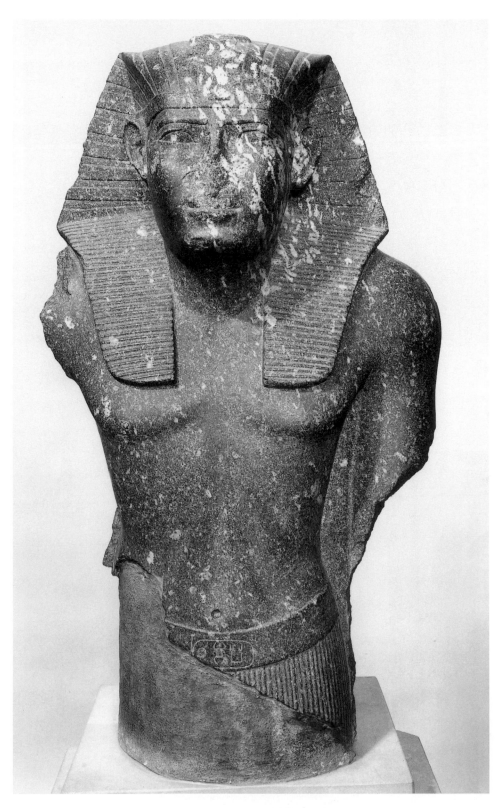

a) British Museum, London EA 44; Standbild Sesostris' I.;
Fundort: Karnak; Granit; H. 76 cm

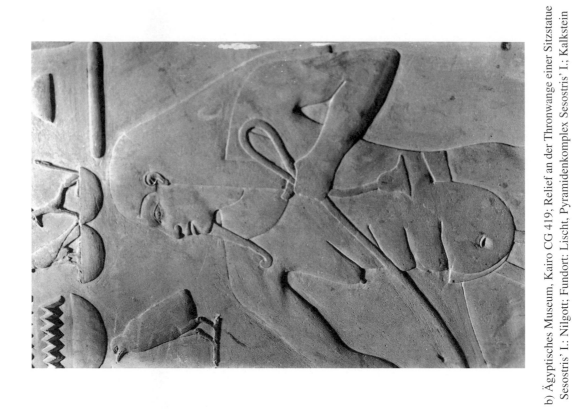

b) Ägyptisches Museum, Kairo CG 419; Relief an der Thronwange einer Sitzstatue Sesostris' I.: Nilgott; Fundort: Lischt, Pyramidenkomplex Sesostris' I.; Kalkstein

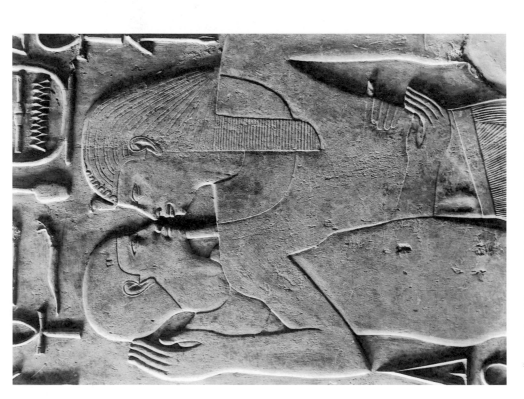

a) Ägyptisches Museum, Kairo JE 36809; Pfeiler Sesostris' I. mit Ptah; Fundort: Karnak; Kalkstein

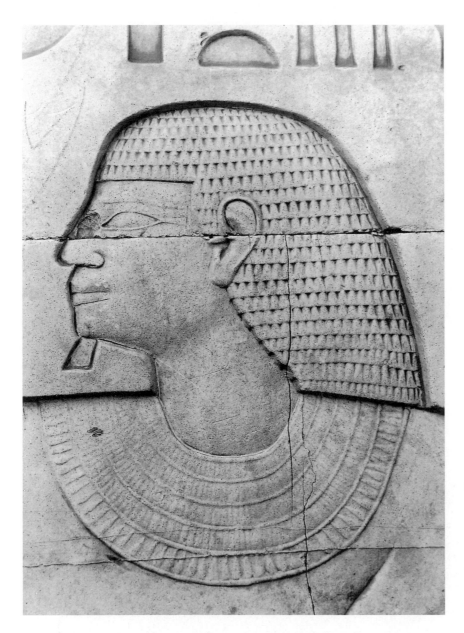

a) Assuan, Grab Sarenputs I.; Pfeiler am Eingang mit Sitzfigur des Grabherrn;
Regierungszeit Sesostris' I.

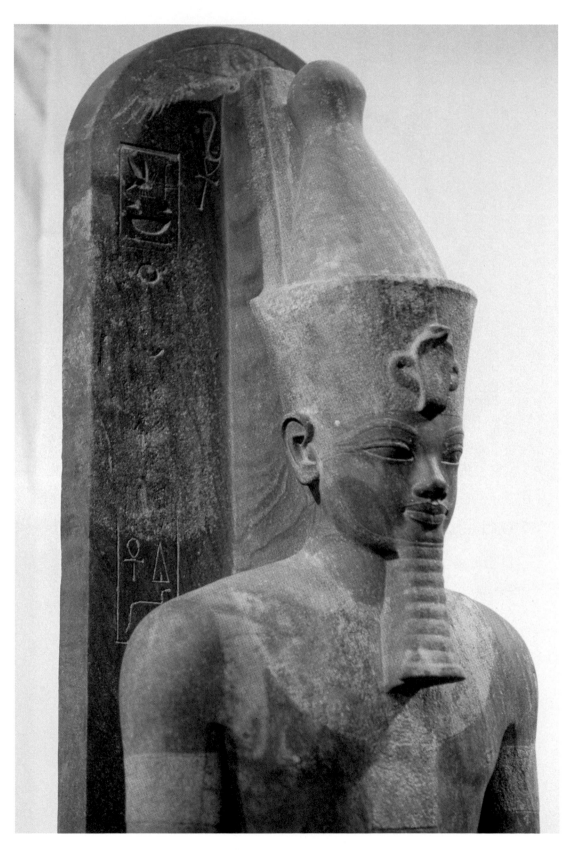

a) Statue of Amenhotep III

b) Left Side

a) Right Side

a) Die Asiatengruppe aus BH 3

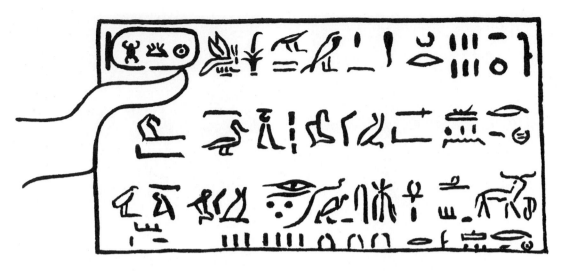

a) Die Tafel des *Nfr-ḥtp*

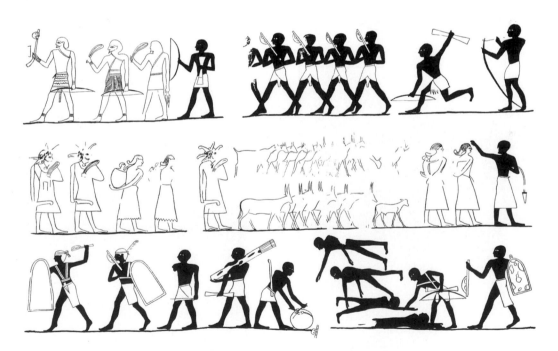

b) Friedliche Libyer auf der Ostwand von BH 14

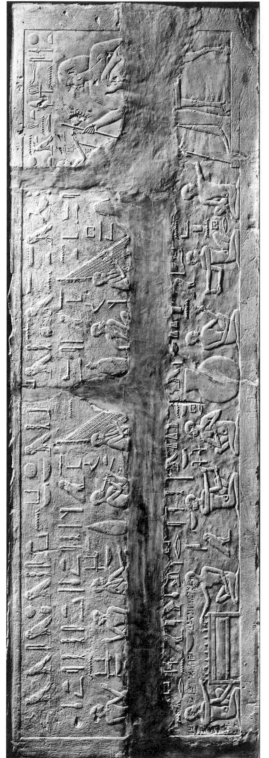

a) Türsturz des ꜥnḫ=f-n-Sḫm.t, Baltimore, Walters Art Museum 22.152/22.153

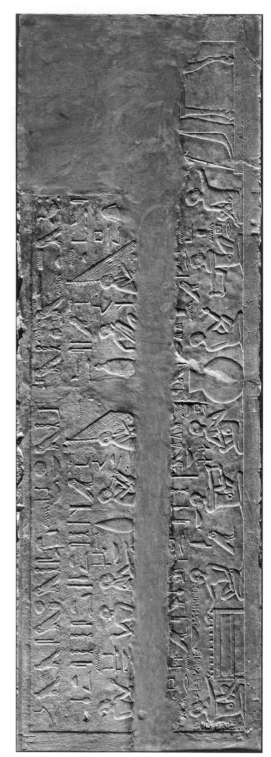

b) Baltimore, Walters Art Museum 22.152/22.153, Archivfoto vor 1957

a) Baltimore, Walters Art Museum 22.152/22.153, Archivfoto 1934

b) Baltimore, Walters Art Museum 22.152/22.153, Archivfoto vor 1934

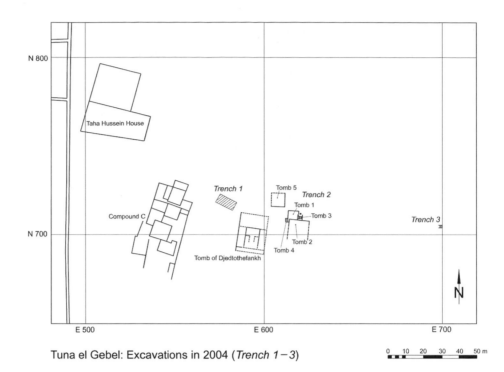

Tuna el Gebel: Excavations in 2004 (*Trench 1 – 3*)

a) Tuna el-Gebel, Lageplan der Grabungen 2004

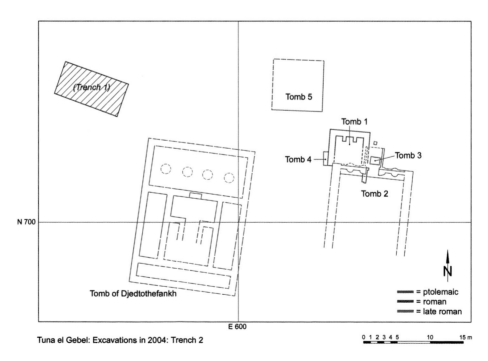

Tuna el Gebel: Excavations in 2004: Trench 2

b) Lageplan (Detail)

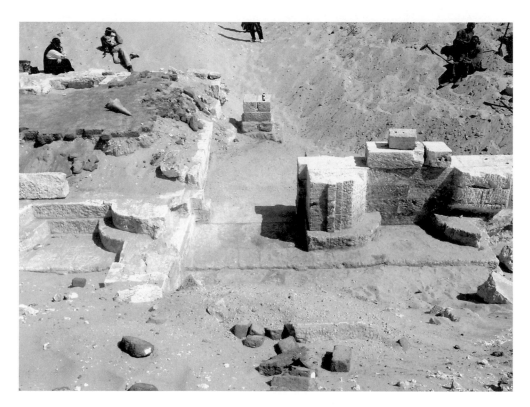

a) Grab 2, Blick auf Eingang und Schranken des Pronaos von Süden

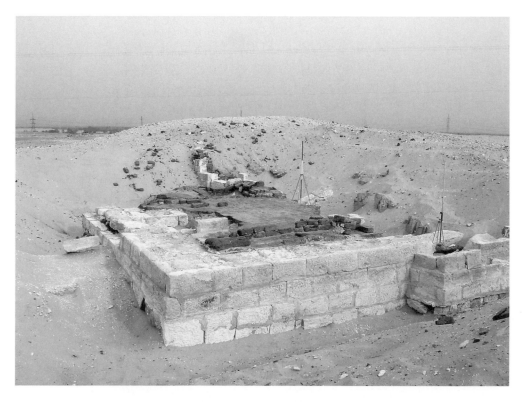

b) Grab 1, Blick auf Fundament und Fußboden von Nordwesten

a) Stundenuhr TG 5248

b) Stundenuhr TG 5248, Seitenansicht

c) Stundenuhr TG 5248, Draufsicht

d) Stundenuhr TG 5248 mit ergänztem Schattenstab

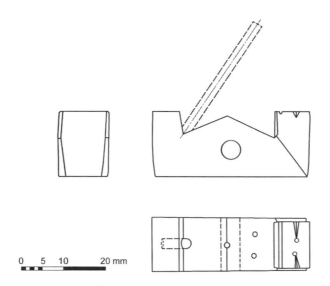

a) Stundenuhr TG 5248, Zeichnung

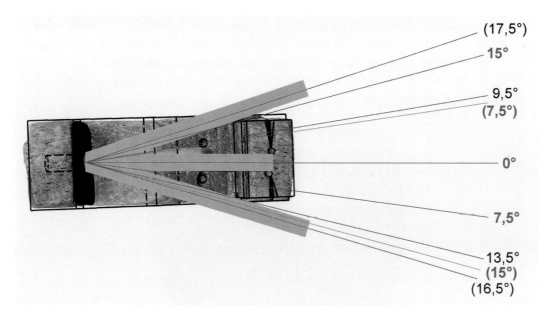

b) Stundenuhr TG 5248, Schema der Skala

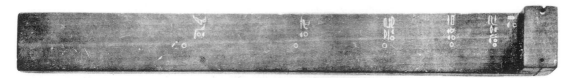

c) Schattenmeßstab, Berlin 19743

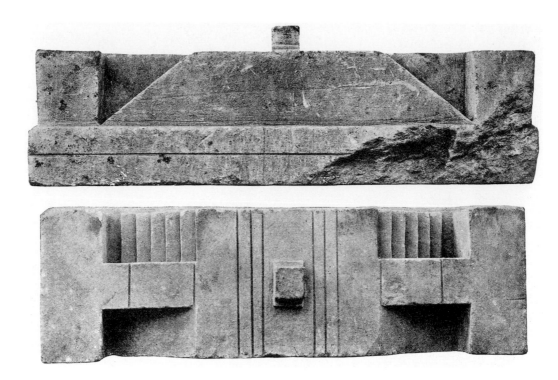

a) Modell für drei Arten der Schattenlängenmessung, Kairo CG 33401

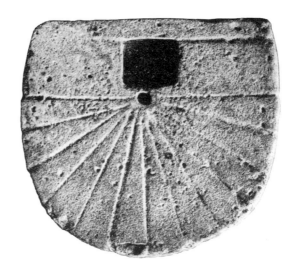

b) Sonnenuhr mit senkrechter Anordnung der Meßfläche, Berlin 20322

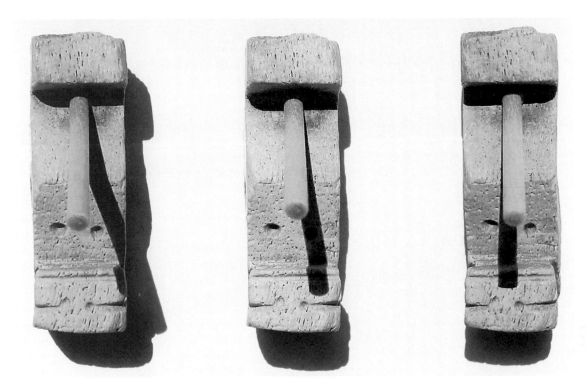

a) Stundenuhr TG 5248, Probemessung 11.00 Uhr OZ (links),
11.30 Uhr OZ (Mitte) und 12.00 Uhr OZ (rechts)

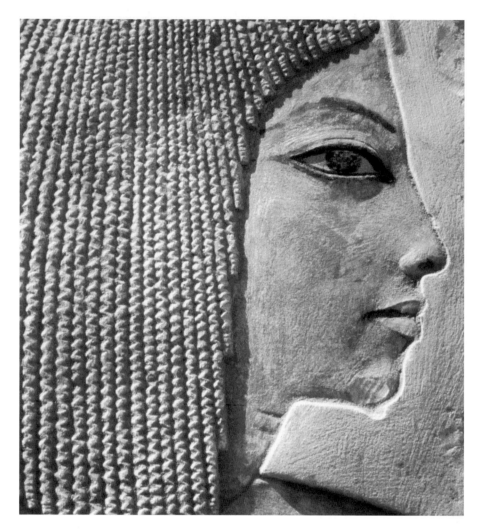

a) Le trésorier Maya

b) «La Joconde»
(Musée du Louvre, Paris)

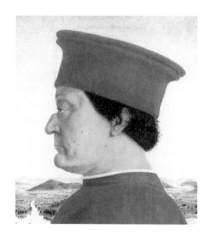

c) Federigo de Montefeltre
(Musée des Offices, Florence)

a) Djefai-Hapi vor den Namen Sesostris' I.

a) Mastaba d'Akhethetep

b) Sarcophage de bois

a) Sarcophages de calcaire et bois

b) Sarcophage de bois stuqué et peint à décor polychrome

Hinweise für die Manuskriptgestaltung

- Die beim Herausgeber eingegangene Manuskriptfassung sollte endgültig sein, umfangreichere Korrekturen durch die Herausgeber oder den Verlag sind nicht vorgesehen. Korrekturabzüge werden einmalig an alle Autoren verschickt. Veränderungen sind aus Kosten- wie aus Zeitgründen nach dem Setzen nur in geringem Umfang möglich.
- Das Manuskript ist als Papierausdruck und auf einem digitalen Datenträger oder per E-Mail an einen der Herausgeber zu schicken.
- Schriftfonts für Umschriften und Hieroglyphen sind mitzuliefern.
- Abbildungen sind entweder als für den Druck taugliche Dateien (in hoher Auflösung und entrastert) oder als Vorlagen in Form von Fotos, Dias, Grafiken oder Zeichnungen einzureichen. Die Vorlagen sollten mit dem Namen des Autors/Beitrags gekennzeichnet sein. Bildunterschriften sind kenntlich zu machen und in einer eigenen Datei unformatiert mitzuliefern.
- Das Manuskript sollte als Word-Programm verfasst sein.
- Es ist die neue deutsche Rechtschreibung zu verwenden.
- Schriftgröße: 12 pt (Haupttext) und 10 pt (Fußnoten); Zeilenabstand 1,5 (Haupttext) und einzeilig (Fußnoten).
- Die Daten sollen möglichst neutral formatiert vorgelegt werden: Überschriften und Formatierungen werden vom Verlag vereinheitlicht. Der Text ist linksbündig ohne Silbentrennung, Blocksatz und Einrückungen einzurichten.
- Hervorhebungen sind im Allgemeinen nur als Kursive zu formatieren.
- Zitate sowie im Fließtext zitierte Buchtitel stehen in doppelten Anführungszeichen; Zitate innerhalb von Zitaten werden durch einfache Anführungszeichen vermerkt; Auslassungen in Zitaten werden durch drei Punkte in eckigen Klammern – […] – verzeichnet; eigene Kommentare, Erläuterungen oder Ergänzungen stehen ebenfalls in eckigen Klammern.
- Abkürzungen werden im Fließtext immer ausgeschrieben, in Klammereinschüben und Anmerkungen kann abgekürzt werden.

Literaturangaben/Zitierweise

- Anmerkungen werden fortlaufend durch das ganze Manuskript mit arabischen Ziffern nummeriert. Die Fußnotenziffern stehen hinter dem Satzschlusspunkt, wenn sie sich auf den Satz als ganzen, davor, wenn sie sich auf das unmittelbar vorausgehende Wort oder den vorausgehenden Satzteil beziehen.
- Jede Fußnote beginnt in Großschreibung und wird durch einen Punkt beendet.
- In den Fußnoten wird die Quelle bei der ersten Nennung komplett zitiert. Danach wird nur

noch der Name und ein Kurztitel (vgl. die Abkürzungen im Lexikon der Ägyptologie) angeführt. Bei Zeitschriften wird zuerst der gesamte Titel ausgeschrieben, an zweiter Stelle werden, eingeleitet durch »in: …«, der Zeitschriftenname, die Ausgabe sowie das Erscheinungsjahr genannt.

- Die Vornamen der zitierten Autoren werden abgekürzt und immer angegeben.
- Mehrere hintereinander genannte Autorennamen werden durch Querstriche getrennt: (B. Porter / R. L. B. Moss); verschiedene Verlagsorte werden ebenfalls durch Querstriche angeschlossen (Frankfurt a. M. / New York).
- Verlagsnamen werden nicht angeführt.
- Die Abkürzung für »Herausgeber« lautet »Hg.«.
- Die Abkürzungen »Taf.« und »Abb.« sollten im Deutschen sprachlich einheitlich verwendet werden (nicht Fig., Tav. o. Ä.).

Manuscript layout

- The manuscript submitted to the editor should be the final version, as the editor and publisher will not allow further corrections. Only one round of galleys will be sent to contributors. Due to financial and time constraints only minimal changes will be possible once the text has been typeset.
- The manuscript should be sent to the editor as a paper printout and in digital form: floppy disc, CD or e-mail.
- Type fonts for transcriptions and hieroglyphs should be sent along with the electronic manuscript.
- Images should be submitted either as digital files suitable for printing (i.e. high resolution and unrasterized) or as photos, slides, line art or drawings. Each image should be labelled with the author's name or the title of the article. The captions should be clearly marked and sent along with the manuscript in a separate, unformatted document.
- The manuscript should be composed in Word for Windows.
- Type size: 12pt (main text) and 10pt (footnotes). Line spacing: 1.5 (main text) and single (footnotes).
- The documents should be submitted with as little formatting as possible: the publishers will standardize headings and formatting. The text should be aligned on the left-hand side without hyphenation, justification or indents.
- Emphasizes should be formatted in italics.
- Quotations and book titles in the running text should be enclosed in double quotation marks and quotations within quotations in single quotation marks. Omissions within quotations should be marked with three periods enclosed in square brackets […]. Comments, annotations or additions made by the contributor should also be placed within square brackets.
- Avoid using abbreviations in running texts. Terms placed in brackets and in notes can be abbreviated.

Bibliographical references/Quotations

- Notes should be numbered consecutively throughout the text with arabic numerals. Numerals denoting footnotes should be placed after the final punctuation of the corresponding sentence when referring to the sentence as a whole. If referring to a word or part of a sentence, the numeral should be placed before the final punctuation.
- Every footnote should begin with a capital letter and end in a final punctuation.
- In the footnote section the first reference to a particular source should be cited in full. Thereafter only the name and an abbreviated title should be used (see the list of abbreviations in the Lexikon der Ägyptologie). Journals should be cited by using the title in full, the name of the journal introduced by »in: …«, the volume number and the year of publication.
- The first and middle names of the authors quoted should be abbreviated, and must always be given.
- Reference sources with more than one author should be cited with a back slash as follows: (B. Porter / R.L.B. Moss). This also applies to sources with more than one place of publication (Frankfurt a. M / New York).
- The names of publishers should not be given.
- The abbreviation for »editor« is »Ed.«.

Présentation des manuscrits

- Les manuscrits doivent être présentés à l'éditeur dans leur version définitive ; ni l'éditeur ni la maison d'édition ne prévoient la correction des textes remis. Les auteurs ne recevront les épreuves pour relecture qu'une seule fois. Pour des raisons temporelles et financières, les auteurs sont priés de se limiter à de simples modifications.
- Tous les articles doivent être adressés à l'éditeur saisis sur support informatique accompagné d'une sortie papier ou par e-mail.
- Les polices de caractères (fontes de translittération et de hiéroglyphes) sont à joindre au dossier informatique.
- Les illustrations sont à remettre soit sur un fichier informatisé apte à l'impression (sans trame et avec une haute définition en pixels), soit sous forme de clichés photographiques, diapositives, schémas ou dessins. Le nom de l'auteur/l'article doit être noté précisément sur chaque support. Les légendes des photos et des illustrations doivent être signalées clairement et doivent être remises, non formatées, séparément sur un fichier numérique.
- Les articles doivent être saisis au format PC sous le logiciel Word.
- Le texte principal doit être dactylographié en corps 12 et en interligne 1,5 ; les notes en corps 10 et en simple interligne.
- Les textes doivent être présentés non formatés : Titres et formats seront uniformisés par la maison d'édition. Le texte entier y compris chaque nouveau paragraphe doit être aligné à gauche, sans être justifié et sans séparation de syllabes.
- Les passages à mettre en évidence doivent apparaître en italique.
- Les citations ainsi que les titres de livres mentionnés dans le texte doivent être signalés à l'aide de double guillemets ; une citation à l'intérieur d'une citation doit être marquée à l'aide de simples guillemets ; les citations incomplètes sont à noter de 3 points entre cro-

chets [...] ; les commentaires personnels, les explications ou les suppléments d'information sont aussi à consigner entre crochets.
- Les abréviations doivent toujours être écrites en toutes lettres dans le texte courant ; elles peuvent apparaître abrégées dans les parenthèses ou dans les annotations.

Bibliographie/références

- Les références sont numérotées consécutivement tout au long du manuscrit en chiffre arabe. Les références sont à insérer dans le texte en fin de phrase, après la ponctuation, si elles se rapportent à l'ensemble de la phrase ; elles sont à placer devant la ponctuation si elles se rapportent au mot ou à une partie de la phrase qui les précèdent.
- Chaque note commence par une majuscule et finit par un point.
- Les références bibliographiques seront citées la première fois dans leur entier. Ensuite, seul le nom de l'auteur et un bref titre seront cités. Pour les articles, seront mentionnés, le nom de l'auteur, le titre complet, le nom de la revue introduit par « *in* », suivi du numéro de tome et de l'année de parution.
- Les prénoms des auteurs cités seront abrégés mais toujours indiqués.
- Tous les noms d'auteurs ainsi que les différents lieux des maisons d'édition doivent être énumérés et séparés par des traits obliques : (B. Porter / R. L. B. Moss ; Frankfurt a. M. / New York).
- Les noms des maisons d'édition ne seront pas cités.

V&R

Dieter Vieweger

Wenn Steine reden

Archäologie in Palästina

2004. 480 Seiten mit 296 Abb., z.T. 2-farbig, gebunden
€ 39,90 D
ISBN 10: 3-525-53623-2
ISBN 13: 978-3-525-53623-0

Wenn Steine reden könnten, was hätten sie uns alles von vergangenen Zeiten zu berichten? Diese Einführung in die Archäologie Palästinas vermittelt grundlegende Informationen über archäologische Methoden und Entdeckungen. – Grafiken, Landkarten, zahlreiche Abbildungen von Gebrauchs- und Kultgegenständen, Literaturhinweise, eine umfassende Zeittafel und ein Vokabular für Reisende erschließen den Stoff sehr anschaulich.

Folgende Fragen leiten durch das Buch: Was hat die Archäologie mit der Bibel zu tun? Was erforscht die Archäologie? Wo spielte sich alles ab? Was findet man? Wie entdeckt man Spuren der Vergangenheit? Wie gräbt man aus? Wann geschah es? In welcher Umwelt lebten die Menschen?

»A ›must‹ for German academic libraries.« *International Review of Biblical Studies*

»Ein hervorragendes Sachbuch zur Archäologie und Kulturgeschichte der biblischen Welt ..., das sich auch durch seine souveräne didaktische Gestaltung auszeichnet.« *Zeitschrift für katholische Theologie*

Vandenhoeck & Ruprecht

Orbis Biblicus et Orientalis.
Series Archaeologica

V&R

Band 25: Jürg Eggler / Othmar Keel
Corpus der Siegel-Amulette aus Jordanien

Vom Neolithikum bis zur Perserzeit

In Zusammenarbeit mit Daphna Ben-Tor, Denyse Homes-Fredericq, Melanie Jaggi, Nancy Lapp, Stefan Münger, Christoph Uehlinger und mit Zeichnungen von Ulrike Zurkinden-Kolberg.
2006. XVIII, 510 Seiten mit zahlreichen Abb., gebunden
€ 112,– D
ISBN 10: 3-525-53014-5
ISBN 13: 978-3-525-53014-6

Band 24: Christian Herrmann
Ägyptische Amulette aus Palästina/ Israel

Band III

2006. XII, 252 Seiten und 107 Seiten farbigen Bildtafeln, gebunden
€ 104,– D
ISBN 10: 3-525-53011-0
ISBN 13: 978-3-525-53011-5

Band 23: Markus Wäfler
Tall al-Hamidiya 4

Vorbericht 1988–2001

2004. 272 Seiten mit 90 Abb., 31 Farbabb., 33 Tafeln und 20 Plänen, gebunden
€ 116,– D
ISBN 10: 3-525-53003-X
ISBN 13: 978-3-525-53003-0

Band 22: Christian Herrmann
Die ägyptischen Amulette der Sammlungen BIBEL+ORIENT der Universität Freiburg Schweiz

Anthropomorphe Gestalten und Tiere

2003. IX, 294 Seiten mit zahlreichen Abb. und Tafeln auf CXXIII Kunstdruckseiten, gebunden
€ 94,– D
ISBN 10: 3-525-53972-X
ISBN 13: 978-3-525-53972-9

Band 21: Markus Wäfler
Tall al-Hamidiya 3

Zur historischen Geographie von Idamaras zur Zeit der Archive von Mari (2) und Subat-enlil/Sehna

Mit Beiträgen von Jimmy Brignoni und Henning Paul.
2001. 304 Seiten und 14 Karten in einer Einsteck-asche, gebunden
€ 96,– D
ISBN 10: 3-525-53002-1
ISBN 13: 978-3-525-53002-3

Band 20: Dominique Beyer
Emar IV. Les sceaux

Mission archéologique de Meskéné-Emar. Recherches au pays d'Aštata

2001. XI, 593 Seiten mit 2 Karten, 107 Abb., 11 Tab. und 65 Seiten Tafelanhang, gebunden
€ 146,– D
ISBN 10: 3-525-53001-3
ISBN 13: 978-3-525-53001-6

Band 19: Andrea M Bignasca
I kernoi circolari in Oriente e in Occidente

Strumenti di culto e immagini cosmiche

2000. XI, 325 Seiten mit 4 Karten, 12 Tab. und 36 Seiten mit Abb., gebunden
€ 86,– D
ISBN 10: 3-525-53000-5
ISBN 13: 978-3-525-53000-9

Band 18: Astrid Nunn
Der figürliche Motivschatz Phöniziens, Syriens und Transjordaniens vom 6. bis zum 4. Jahrhundert v. Chr.

2000. XI, 269 Seiten mit 35 Abb. im Text und einem 78seitigen Tafelanhang sowie einer Faltkarte, gebunden
€ 79,– D
ISBN 10: 3-525-53899-5
ISBN 13: 978-3-525-53899-9

Vandenhoeck & Ruprecht